Frontispiece (OVERLEAF) Sintra. The Sala dos Brasões
or Hall of Blazons in the Royal Palace, c. 1518

Contents

List of illustrations

Architecture III *pages 89–100*

Architecture IV *pages 109–124*

The Gilt Wood Church Interior
pages 133–152

Furniture and Textiles *pages 289–304*

Map and plans

List of colour plates

Acknowledgements

The author and publishers wish to thank the following who supplied photographs for this book (references are to plate numbers):

Abreu Nunes, X, XI, XII, XV, 154, 156, 159, 169, 203, 204; Alvão, 4, 5, 12, 13, 48, 52, 57, 58, 59, 79, 82, 113, 220, 228, 232, 233, 256; Bobone, 145, 160, 197; Castelo Branco, 254; Manuel Serejo, 71; Coutinho, 144, 146, 151, 163, 214; Hipólito, 218; Luís Keil, 198, 202; Mário Novaes, 26, 29, 35, 36, 38, 80, 89, 93, 94, 95, 98, 99, 104, 105, 121, 129, 130, 138, 147, 148, 149, 155, 161, 162, 170, 171, 172, 173, 174, 181, 200, 207, 208, 210, 212, 213, 217, 219, 221, 223, 224, 229, 245, 262; Teófilo Rego, 164, 165, 168, 196, 199, 205, 209, 211, 227, 230, 231, 234, 248, 252; Scala (Giulio Guzzoni), I, II, III, IV, V, VI, VII, VIII, XIII, XVI, 41, 51; Museum of Fine Arts, Boston, 261; British Museum, London, 150; Direcção da Fazenda Pública, Lisbon, 152; Hispanic Society of America, New York City, 235; Kunsthistorisches Museum, Vienna, 216; Victoria and Albert Museum, London (Crown copyright), 201, 206, 215, 222, 236, 260, 263.

All other photographs were taken by the author.

Endpapers

The endpapers show Portuguese tiles of the early eighteenth century. Those at the front, which were made in Lisbon, are from the Sala da Matemática of the former Jesuit college in that city, now the municipal hospital of São José. Above the ships at the right appear the lines 'Through seas which never ship had sailed before', from the beginning of *The Lusiads*, the sixteenth-century Portuguese national epic poem by Luís de Camões. The ships and the inscription symbolize the Portuguese discoveries and their impact on the civilization of the Renaissance.

The endpapers at the back show tiles from the church of Nossa Senhora da Conceição at Portalegre, which were probably made in Coimbra in the early eighteenth century. They present a Europeanized version of a Chinese theme, recalling the fact that the Portuguese were the first people of the West to import Ming porcelains and to imitate them in their own faience.

Explanatory note

The numbers of plates representing material discussed in the text appear in the page margins immediately opposite, along with numbers (in italics) corresponding to related material considered in other parts of the text.

Throughout the book the names of foreign architects and artists are cited in the forms generally used in Portugal, and these are followed on the first mention by what appear to have been their original forms.

Preface

This is the first volume written in English to be devoted entirely to the general history of Portuguese art. It is intended to serve as an introduction to the subject and makes no claim to be exhaustive, although it includes a considerable amount of new material drawn from the researches of the author, who has been studying various aspects of Portuguese art since the 1930s.

This book is limited to the three centuries from 1500 to 1800, the period of the chief flowering of Portuguese art, but various references are made to outstanding achievements before and after this time. In the case of painting the scope is somewhat widened to admit the great fifteenth-century paintings associated with Nuno Gonçalves and to include the later career of Domingos António Sequeira in the early nineteenth century. Unlike many studies of this sort, this book contains a survey of the decorative arts, a field to which the Portuguese have always made distinguished contributions. The accomplishments of the goldsmiths, ceramists, furniture makers and embroiderers have been related, wherever possible, to those of architects, painters and sculptors, in a search for the elements most characteristic of the arts of Portugal.

Each chapter of this book is devoted to one of these arts, with an essential bibliography of the subject at the end of the volume. There is no general bibliography, but the following works on Portuguese art as a whole are recommended: the chapters on this subject in George Kubler and Martin Soria, *Art and architecture in Spain and Portugal and their American dominions, 1500 to 1800*, Harmondsworth, 1959; Aarão de Lacerda and others, *História da Arte em Portugal*, Oporto, 3 vols., 1942-53; Reynaldo dos Santos, *Oito Séculos de Arte Portuguesa: História e Espírito*, Lisbon, 3 vols., 1963-8. For a concise and accurate history of Portugal in English the reader should consult H. V. Livermore, *A History of Portugal*, Cambridge, 1947. The following guide books are recommended: *Guia de Portugal*, Lisbon, 4 vols., 1924-65; *Portugal, Madère, Açores*, Guides Bleus, Paris, 1964; Ann Bridge and Susan Lowndes, *The Selective Traveller in Portugal*, New York, 1953.

In preparing this book during the years 1964 to 1966 the author received invaluable assistance from a great many kind and generous people. He wishes particularly to express his gratitude to Abel de Moura, Acting Director of the Museu Nacional de Arte Antiga in Lisbon, for permission to use negatives of paintings and other objects in the museum's collection. He also thanks the officials of the Ministries of Education, Finance and Public Works of the Portuguese government for the opportunity given him to photograph at will in museums, national monuments and palaces in search of fresh illustrations for this book. To João Miguel dos Santos Simões, Director of the Brigada da Azulejaria of the Calouste Gulbenkian Foundation in Lisbon go the author's special thanks for many explanations of the mysteries of the making of tiles and for the opportunity so generously accorded him of working in the new Museu do Azulejo before the

latter was opened to the public. He wishes also to express his deep appreciation of the many favours granted him by Sir Trenchard Cox, former Director of the Victoria and Albert Museum in London, and L. G. G. Ramsey, editor of *The Connoisseur* of that city. For their gifts of photographs the author thanks João de Lacerda, Guilherme Possolo and the late Prof. Luís Reis Santos, directors respectively of the museums of Caramulo, Fundação Ricardo Espírito Santo Silva and Coimbra. His thanks go also to a number of private collectors who granted him permission to study and photograph their collections, to the photographers José Fernandes in Oporto and José Pereira in Lisbon, who printed with unfailing promptness and precision large quantities of the author's negatives, and finally to a host of Portuguese in all walks of life who over the years have informed him and guided his studies and with their friendship have enriched his life.

Introduction

Of all the nations of Western Europe none has a more glorious history or a richer artistic patrimony than tiny Portugal, a country of some nine million people occupying less than one-fifth of the Iberian peninsula, along the Atlantic coast. Enveloped and overshadowed by the endless provinces of Spain, Portugal has not only maintained its independence, first won in the twelfth century, but succeeded in building the first great European empire on which the sun could never set. At the same time the Portuguese, in the course of their long history, have developed a language, a literature and a temperament quite different from those of Spain.

This is also true of much of the national art, which like the spirit of the people is alien to the dark mysticism, the tragic exaltation, the brooding cruelty of Spain. For the Portuguese life is gentler and brighter, a reflection no doubt of their warm and beautiful country, and there is a serenity and confidence that pervade every aspect of the national being, surviving, it appears, from Portugal's ancient communion with and conquest of the sea. These kindly qualities are constantly expressed in Portuguese painting and sculpture, the arts that most closely reflect a people's soul.

Portuguese architecture and the decorative arts, on the other hand, were profoundly affected by certain national experiences. One was the long period of the Moorish occupation from the eighth to the thirteenth centuries, which among other Muslim practices established the use of whitewashed walls, shuttered balconies and luxurious, complex patterns in rugs and tiles. Another was the epic expansion beyond the seas in the fifteenth and sixteenth centuries, which brought the Portuguese in contact with the arts of Africa, India and the Orient and thereby implanted influences that were to linger for hundreds of years. At the same time the exploits of the Portuguese navigators opened the way to all subsequent European overseas colonization and, by vastly widening the range of human knowledge, made a profound and fertile contribution to the Renaissance.

There is no entirely satisfactory explanation of the cause of this enormous achievement, but there were several contributing factors. One was the geographical position of Portugal, poised in continual confrontation with the Atlantic Ocean, its back wedged against the mass of Spain. Another factor was the determination of wise men, like Prince Henry the Navigator, who, realizing that the nation's destiny was with the sea, and that no other form of combat could bring success and give the nation grandeur, encouraged daring voyages of exploration. There was also the factor of a long period of peace at home and the good will of the people, which enabled princes to plan and execute the programme of the voyages, free from concern with civil disturbances. These were some of the circumstances that launched Portugal on its career of greatness.

On two occassions in the past the nation has risen to pinnacles of power and riches. This happened first in the early sixteenth century, with the discovery of Brazil and the sea

routes to India and the Orient, a double triumph that gave Portugal possessions girdling the globe and flooded Lisbon with exotic treasure. It happened again two centuries later when gold and diamonds were found in such abundance in Brazil that the Portuguese king became for a second time one of the wealthiest sovereigns in Europe.

On both occasions this fabulous prosperity was short-lived, for it lasted little more than half a century; but fortunately Portugal has a great deal to show for it today. The two kings who presided over the golden eras, Dom Manuel in the sixteenth century and Dom João V in the eighteenth, were lavish spenders in the realm of art. Both invested huge sums in palaces and churches, both created princely monasteries and endowed the country-side with costly works of art, setting a royal precedent for bishops and noblemen to follow. Thus the riches of the Indies and of Brazil gave to Portugal a body of monuments far out of scale with the modest resources of men and money that such a small nation intrinsically could provide.

Both Dom Manuel and Dom João V called to their service the best foreign artists obtainable. This in itself was nothing new, for their less opulent predecessors had on occasion enlarged the limited band of native architects with men from Spain and beyond the Pyrenees, and other foreigners had found their way quite independently to Portugal. The results are plain to see. The four Romanesque cathedrals have many features drawn from France and Spain. The royal monastery of Alcobaça has one of the largest and finest groups of Cistercian buildings in Europe. Dom João I's late fourteenth-century church of Batalha is almost pure English Perpendicular. The greatest fifteenth-century paintings are profoundly Flemish in style and in technique.

But with the empire building of the sixteenth century these tendencies were amplified and whole colonies of foreign artists entered Portugal, which was then among the richest lands in Europe. Now for the first time their leaders emerge as personalities whose lives and work are documented. Foreigners like the French sculptors Nicolau Chanterene (Nicolas Chanterene) and Cláudio de Laprada (Claude de Laprade), the Italian architect Filipe Terzi (Filippo Terzi), the German goldsmith-builder João Frederico Ludovice (Johann Friedrich Ludwig) and the Tuscan painter-architect Nicolau Nasoni (Niccolò Nasoni) became dominant figures who set styles and created masterpieces which the Portuguese used as a point of departure for their own expressions.

The results are handsome and sometimes quite distinguished but seldom do they achieve the greatness that comes from profound and unmistakable originality. That indispensable ingredient was furnished by a legion of Portuguese who through three centuries created the splendid decorative settings in which so many of the major works of art were placed. These dazzling compositions in which fantasy and realism are sensuously intermingled in schemes of all-over ornamentation, that go back to the days of Moorish rule, offer the most original and the most national aspects of Portuguese art. Out of doors these decorative ensembles take the form of screens of sculpture varying in their colour and texture from one region to another. Inside, the Portuguese made constant use of gilt woodcarving and polychromed tiles for effects of utmost richness and exoticism. In the span of the three centuries with which this book is concerned, these two arts, together with Manueline and Rococo architecture, represent the most original expression of the genius of Portugal and constitute its greatest contribution to the art of Europe. In the strength and freshness of their forms and in the richness of their colour they seem forever to celebrate the robust will that produced the overseas conquests, the wealth that came from them and the sensuous pleasures they provided.

(OPPOSITE) Map of Portugal

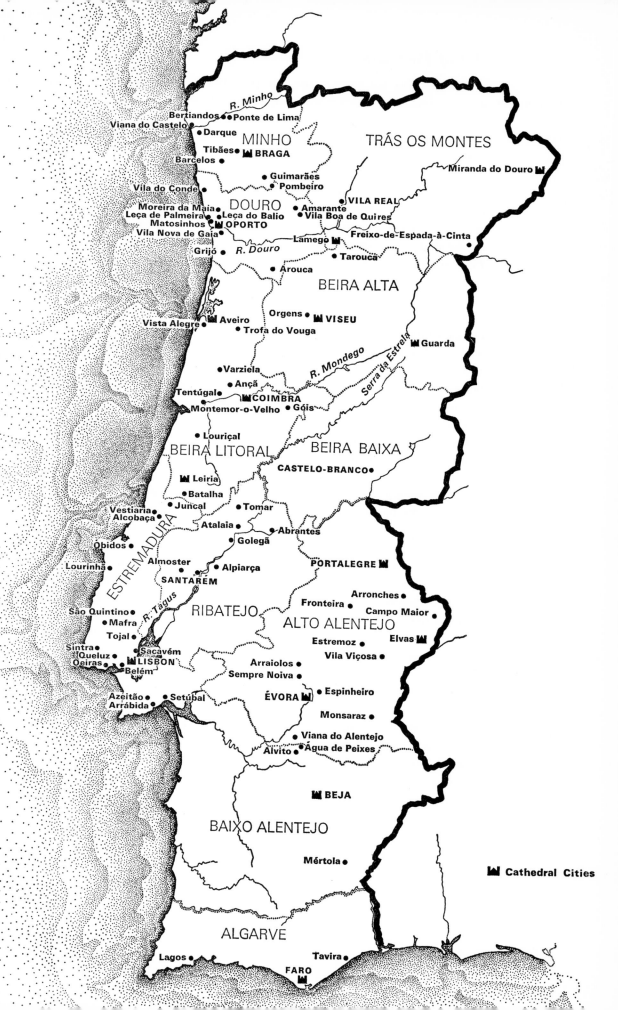

R. Minho

Bertiandos ● ● Ponte de Lima
Viana do Castelo ●
● Darque
MINHO
TRÁS OS MONTES
Tibães ● ▲ **BRAGA**
Barcelos ●
● Guimarães
● Pombeiro
Miranda do Douro ▲

Vila do Conde ●
DOURO
● **VILA REAL**
Moreira da Maia ●
Leça de Palmeira ● ● Leça do Balio
● Amarante
Matosinhos ● ▲ **OPORTO**
● Vila Boa de Quires
Vila Nova de Gaia ●
Freixo-de-Espada-à-Cinta
Grijó ● *R. Douro*
Lamego ● ▲
●

● Tarouca

● Arouca
BEIRA ALTA

Orgens ● ▲ **VISEU**
Vista Alegre ● ▲ ● Aveiro
● Trofa do Vouga
▲ Guarda

● Varziela
R. Mondego
Serra da Estrela
● Ançã
Tentúgal ● ▲ **COIMBRA**
Montemor-o-Velho ● ● Góis

● Louriçal
BEIRA LITORAL
BEIRA BAIXA

▲ Leiria
CASTELO-BRANCO ●
● Batalha
Vestiaria ● ● Juncal ● Tomar
Alcobaça ●
● Atalaia
Óbidos ● ● Golegã
● Abrantes
Lourinhã ●
● Almoster ● Alpiarça
PORTALEGRE ▲
ESTREMADURA
SANTARÉM
São Quintino ●
R. Tagus
● Arronches
Fronteira ●
● Mafra
RIBATEJO
● Campo Maior
Tojal ●
ALTO ALENTEJO
Sintra ●
Sacavém ●
Estremoz ●
Elvas ▲
Queluz ● ▲ **LISBON**
Oeiras ●
Vila Viçosa ●
● Belém
Arraiolos ●
Azeitão ● ● Setúbal
Sempre Noiva ●
Arrábida ●
ÉVORA ▲ ● Espinheiro

Monsaraz ●

● Viana do Alentejo
Alvito ● ● Água de Peixes

▲ **BEJA**

BAIXO ALENTEJO

● Mértola
▲ **Cathedral Cities**

ALGARVE

Lagos ●
● Tavira
FARO

Art of Portugal

Frontispiece Occasionally the work of the two great periods of Portuguese decoration, the Manueline and the Joanine, coalesce in a single work like the Sala dos Brasões, the Hall of Blazons, added by Dom Manuel to the royal palace of Sintra near Lisbon. This large square room, which appears as the frontispiece of this volume, is covered by a panelled ceiling of many geometric forms constructed according to a system that goes back to the time of the Moors and remained for centuries a prime characteristic of Portuguese architecture.

Following this scheme the angles are enriched with false squinches of wood imitating masonry construction, to which have been added wooden ribs with heavy late Gothic bosses. Most of the panels have paintings of prancing stags displaying shields with the arms of the principal families of Portugal, from which the room, which is also known as the Hall of Stags, derives its names. Here in a profusion of heraldry that is truly Iberian are Noronhas, Ataídes, Costas, Coutinhos, Almeidas and others whose deeds in Africa and Asia are celebrated in the stanzas of the national epic poem *The Lusiads* composed by Luís de Camões before his death in 1580. At the top of the ceiling a ring of royal shields appears and in the centre, an eighteenth-century addition, the national arms of Portugal and the dragon crest of the Bragança dynasty, sumptuously set in plume-like woodcarved acanthus leaves, richly gilt in high relief. The same Baroque motif appears again in the border of the high dado of early eighteenth-century blue-and-white tiles at the base of the walls, framing hunting scenes suggestive of the stags above. To complete the picture of this room as it would have existed in the eighteenth century, one must imagine the vivid velvets of the door curtains called *reposteiros*, the tables covered with crimson damask loaded with objects of glittering silver, ebony and ivory, the immense Persian carpets and the sumptuously carved and turned furniture of lustrous rosewood, the superb Brazilian material which the Portuguese were the first Europeans to employ.

Plate 149 When the paintings of the Sala dos Brasões were completed about 1518, the reign of Dom Manuel, the 'Fortunate Monarch', was nearing its close. He began to rule in 1495 and died in 1521. As early as 1502 he had assumed for himself and his successors the grandiose title of 'Lord of the conquest, navigation and commerce of Ethiopia, Arabia, Persia, India', with which for centuries most Portuguese state documents were to begin. These words were a proud though exaggerated symbol of Portugal's mastery of the sea and the daring overseas exploits that commenced in 1415 with the capture of Ceuta on the Moroccan coast. This was the first great accomplishment of Prince Henry the Navigator, who then worked until his death in 1460 to make the Portuguese the best pilots and map-makers in Europe and to provide the scientific knowledge that was subsequently applied to the commercial exploitation first of Africa and then of large portions of Asia and South America.

The march was rapid. In 1482 the Portuguese built the fort of São Jorge da Mina on the Guinea coast to protect their valuable outtake of gold, ivory and slaves. In the same year they entered the kingdom of the Congo and in 1487 Bartolomeu Dias sailed around the Cape of Good Hope, five years before Columbus reached the West Indies. Simultaneously Pero da Covilhã was making his famous overland journey, which took him to the Malabar coast of India and later to the court of Ethiopia. The sea route to the East was secured by Vasco da Gama's epoch-making expedition of 1497-9 in search of 'Christians and spices', which made Portugal the first European nation to establish contacts and open trading with the great emporia of Malindi in East Africa and Calicut, Cochin and Goa in India.

The last of these cities, taken by Afonso de Albuquerque in 1510, became the capital

of the Portuguese State of India, which lasted until 1961. It was the seat of a viceroy and an archbishop and an outpost of European civilization from which the Portuguese continued their conquests and their trading. Malacca, captured in 1511, opened the way to the wealth of the Spice Islands. Ormuz, an island in the Persian Gulf, which fell in 1515, secured the traffic of Arabia. Chinese waters were visited as early as 1517, regular trade with Japan began in 1549 and continued for a century, until the Portuguese were expelled from the Flowery Kingdom. In 1557 the city of Macau was founded for the purpose of trading with China and to this day has remained Portuguese. Meanwhile, Pedro Álvares Cabral had discovered Brazil in 1500 and various colonies were planted along the coast. Bahia, the first capital, was founded in 1549; Rio de Janeiro, the second, was settled in 1565. Brazil remained a Portuguese possession until 1822.

From all these activities came the wealth that built the convents of Belém and Tomar, the chapels and cloister of Batalha. It also produced for a time in Europe the image of the Portuguese as supermen who ranged the world in pursuit of booty to offer to Dom Manuel, *'le roi épicier'*, as Francis I of France enviously called him. That moment is symbolized by a series of tapestries woven in Flanders in the early sixteenth century showing an expedition of Portuguese hunting and trading in Africa. They are represented as huge, ungainly figures towering above their native servants, their faces caricatured with enormous bulbous noses. The same exaggeration of features is seen in numerous Japanese screens *(nambam byōbo)* decorated with late sixteenth- and early seventeenth-century watercolour paintings of traders from Portugal, who are shown with very long noses. Instead, however, of lusty adventurers, the Japanese portrayed seasoned merchants, government officials and missionaries, surrounded by Negro and Mulatto servants, bargaining for lacquers, silks, porcelain and tea, which are spread out before them in sacks, jars and boxes. This was but one part of the wide world in which the Portuguese traded and in which his language became the first European lingua franca of commerce. It remained so long after the political empire began to disintegrate.

At home the trade with the East affected the Portuguese language and way of living. Sixteenth-century houses were furnished with Chinese porcelains and textiles and with the embroidered quilts and ivory-inlaid furniture of India. In the seventeenth century Oriental porcelain was imitated in faience in Lisbon before this was done in other parts of Europe, and reproductions of Near-Eastern rugs were made in the province of Alentejo. Indian designs appear in furniture and silver and, although the major arts were never Orientalized, a new feeling for colour and all-over ornament came from the East to strengthen tastes which the Portuguese had inherited from the Moors and made itself felt in the decoration of convents, palaces and churches throughout the kingdom.

By the middle of the sixteenth century, in the reign of Dom João III (1521-57), the successor of Dom Manuel, the 'fumes of India' had created a craving for wealth and grandeur that permeated all layers of society and threatened the tiny nation with economic ruin. To this was added a national disaster of overwhelming proportions. On August 4, 1578, on the battlefield of al-Ksar al-Kabir (in Portuguese Alcácer-Quibir), in Morocco, the young and childless king, Dom Sebastião (1557-78), who had led a romantic crusade against the infidel, was killed along with the flower of the Portuguese nobility, and the country was further impoverished by the necessity of paying ransom for those who had survived. Two years later, in 1580, with the death of Cardinal Dom Henrique, Sebastião's great-uncle who succeeded him, the crown of Portugal was joined to that of Spain by Philip II, Sebastião's next of kin. This unhappy union lasted until 1640, when on December 1 the

Duke of Bragança proclaimed the independence of Portugal, establishing a new dynasty with himself as King Dom João IV. The Braganças ruled until the abolition of the monarchy in 1910.

The rest of the seventeenth century in Portugal was a period of economic and artistic austerity, a time of depression in contrast to what had preceded and was to follow. The country was for long periods at war with Spain to maintain its independence and there was little money to spend on rich building and elaborate decoration. At the same time the Holy Office of the Inquisition acted as a relentless watchdog to stamp out in painting and sculpture the slightest suggestion of levity or sensuality. In architecture certain grave effects were repeated over and over again, according to international Mannerist formulas. But Portuguese art of the seventeenth century was saved from bleakness and banality by the vivacious variety of the gilt woodcarving and the *azulejos*, the wonderful polychrome tiles which cover entire walls with brilliant tapestries of geometric or stylized textile patterns.

The severe dispirited attitude of the Counter-Reformation endured into the first years of the long reign of Dom João V (1706-50), who brought peace, prosperity and the Baroque to Portugal. He was the king of gold and diamonds, the builder of the convent-palace of Mafra, one of the largest structures in Europe, and the importer from Rome of tons of marble statues and objects of gold and silver, including an entire chapel made of precious metals and rare stones. These sumptuous objects served as the basis for the stately style called Joanine, in which, as in Manueline times, foreign artists played a major role.

The next king, Dom José (1750-77), is forever famous because of another disaster, comparable with Dom Sebastião's defeat, the terrible earthquake of November 1, 1755, which destroyed most of Lisbon and the incalculable treasure from all over the world accumulated there. It also brought to power the Marquis of Pombal, under whose direction the city was in part reconstructed. The plan was so novel and the style so attractive that they constitute a major contribution to the history of city planning and gave to Lisbon one of the handsomest waterfront squares in Europe.

Pombal's government coincided with the flowering of the Rococo in Portugal, a style which seems to have been especially happy in that country of exquisite landscapes and beautifully mannered people. The proof is the abundance of fine local centres that appeared in various parts of the country, of which probably the most distinguished and certainly the most original was that of Braga and the province of Minho, from which went the seeds that produced the brilliant school of architecture and sculpture in Minas Gerais in Brazil, a phenomenon in the American wilderness.

During the long reign of Dona Maria I (1777-1816) there occurred in Portugal as all over Europe the no less extraordinary phenomenon of the Classical Revival in all its stages, from the first eighteenth-century 'Pompeian' innovations of Robert Adam and Piranesi to the archeological rigours of Canova, Flaxman and David. Dona Maria's name is, however, chiefly associated with the style of the first years of her reign, when the Rococo was first tempered by classical overtones in the decorations of the royal palace of Queluz, one of the most delightful country residences in Europe, made memorable by the descriptions of William Beckford, the wealthy English dilettante who visited Portugal twice in the late eighteenth century.

He portrayed a world of extravagant quasi-Oriental luxury and exotic display, with customs from India, China and Brazil kept alive since the great days of the sixteenth century. But it was also a world that was coming to an end as, one by one, a series of national mis-

fortunes overwhelmed the country. The gold boom had waned, creating throughout the kingdom an economic decline that repeated the cycle of the sixteenth century, for which this time Brazil instead of India had served as catalyst. There were also dynastic disasters. In 1792 Maria I lost her mind. Her son, the future Dom João VI, served as regent until her death in 1816, bedevilled by a shrewish wife and the discord between his sons, Pedro and Miguel, which eventually led to a tragic civil war. Late in 1807 Portugal was invaded by an army of Napoleon I. This caused the royal family and the court to flee to Brazil, escorted by a British squadron, and plunged Portugal into the miseries of the Peninsular Campaigns.

By the time Dom João returned from Brazil in 1820, two years before that immense colony declared its independence, the great tradition of Portuguese art had come to an end, like the world that produced Mafra, Queluz and the Ajuda palace in Lisbon. But it ended in a burst of glory, thanks to the portraits and allegories of Domingos António Sequeira, the greatest Portuguese painter since the fifteenth century, who designed the spectacular Wellington silver and, like Francisco Goya, his distinguished contemporary in Spain, effected the transition from the art of the eighteenth to that of the nineteenth century.

architecture displayed a variety of substyles derived from various parts of Europe. One strain came from the Flamboyant style of the North, another from Plateresque Spain, a third represents a revival of Moorish taste. A final ingredient is found in naturalistic and sometimes fantastic forms used in a robust way that is eminently Portuguese and which in its concepts of space and lighting created effects that are essentially Baroque. All this architecture is called Manueline for want of a better name, in honour of the sovereign Dom Manuel I, who reigned from 1495 to 1521. The style, which continued well beyond his death, contains a good deal of Italian Renaissance ornament applied to Gothic forms of building.

If the Manueline style can be said to have originated in any particular structure, the most likely candidate for the honour is the church of the former Francisan nunnery of Jesus at Setúbal, a seaport to the south of Lisbon. Erected between 1494 and 1498, at the beginning of Dom Manuel's reign, it is a long, horizontal three-aisled building planned according to a late fifteenth-century formula seen also in the handsome parish church of Caminha, on the far northern coast, begun in 1488. The prominence given to the rectangular apse and to the choir loft, at the other extremity of the Setúbal church, suggests the characteristic Isabelline plan of certain Spanish churches of the time, which seems to have been introduced at San Juan de los Reyes, built by Juan Guas in Toledo after 1476. These two features will be repeated in many Manueline churches, both of vaulted and unvaulted form.

The church of Jesus at Setúbal belongs to the former category and it is here, in the vaulting and in its supports, that the originality of the building reveals itself. Diogo Boitac (Jacques Boitac [?]), the architect (active *c.* 1490-1525), who seems to have come from France and possibly from Languedoc, introduced piers formed of plaited colonnettes, which give a bizarre and exciting quality to the whole interior. During the next quarter century the motif was repeated so many times by Boitac and other architects that it became a prominent symbol of the Manueline style.

Colour plate II

It is rendered especially effective at Setúbal by the use of a dark breccia marble from the nearby quarries of Arrábida, which contrasts in typical Portuguese fashion with the whitewashed walls and the surface of the nave vaults, constructed of brick. In the great vault of the apse, which is entirely of stone, the multiplied ribs assume the appearance of ropes, boldly, almost roughly, carved, like the prominent bosses and the central pendant. These are all characteristic of Manueline style, as are also the twisted corbels on which the ribs rest and the chamfered surfaces of the arched supports called squinches, a device imitated in wood in the ceiling of the Sala dos Brasões of the palace of Sintra. All are angular spiral forms, full of rhythmic motion like the waves of the sea, an element that is constantly suggested in Manueline buildings, which were all in a sense products of the Portuguese conquest of the seas. The strange, exhilarating effect reaches its climax in the long twisted motifs that frame the lateral windows. Here to the bizarre forms themselves is added the powerful stimulus of deep undercutting, producing bold shadows that enliven a design later used in countless other Manueline doorways and window frames. These spatial devices are an essential part of the Portuguese contribution to late Gothic style.

Plate 1

Frontispiece

Other important concomitants are found in the grandest of all Dom Manuel's royal buildings, the former Hieronimite church and monastery of Santa Maria at Belém (Bethlehem), a short distance to the west of Lisbon. Standing on what was once the beach of Restelo, near the broad mouth of the Tagus River guarded by the spectacular Tower of Belém, the church of Santa Maria de Bélem commemorates the journey of

Plates 3-6

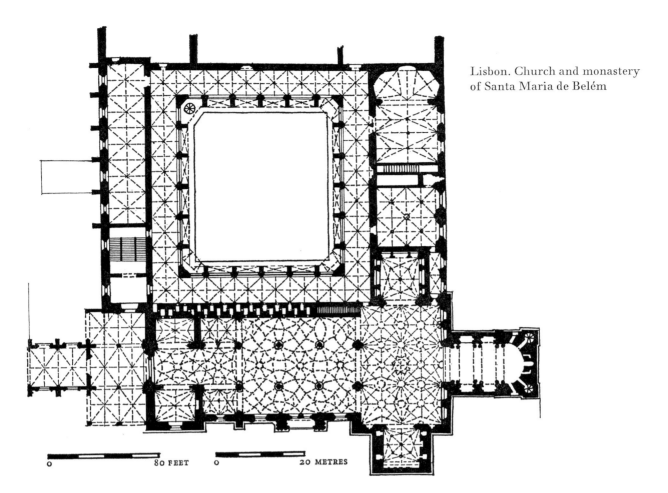

0 80 FEET 0 20 METRES

Vasco da Gama, who in 1497 sailed from near this site to India, accomplishing a daring exploit that was to bring fabulous wealth to his country. Work began in 1502 and continued until after 1519. The material employed was the local *pedra lioz*, a pseudo-marble which gives the city of Lisbon a glittering appearance not unlike that of Venice. The original architect was again Diogo Boitac, who used for the church a greatly enlarged version of his plan for that of Jesus at Setúbal. In 1517, however, a new architect appeared, who altered the building and provided it with a rich overlay of classical ornament.

Plate 2

This was the Spaniard João de Castilho (Juan de Castillo, active *c.* 1505- after 1535), a native of a village near Burgos, who before 1511 had constructed the apse of the cathedral of Braga in northern Portugal.[1] There and in the handsome façade of the church at Vila do Conde, just above Oporto, which he constructed immediately afterwards, Castilho used small, rather flat and complex ornament, very different from that of Boitac, which the Spanish call Plateresque, because of its resemblance to things made of silver (*platería*). At Braga this is entirely Gothic, but at Vila do Conde there is cresting of Renaissance vase forms, and these also appear around the twin doors of the enormous

Plate 3

south portal of the church at Belém, which is João de Castilho's chief addition to the exterior, along with canopies and bands of foliate ornament very similar to those used in his earlier monuments.

On either side of this vast shrine-like projection rise long windows ending in the round arches which Manueline architects preferred to those of pointed forms. The decoration of their deeply flanged frames is also typical of the style, both in the large-scale repetition of a single motif and in the choice of decoration. This includes chain-like devices set

 1 (OPPOSITE) Boitac: Setúbal. Church of Jesus. Apse vault, begun in 1494

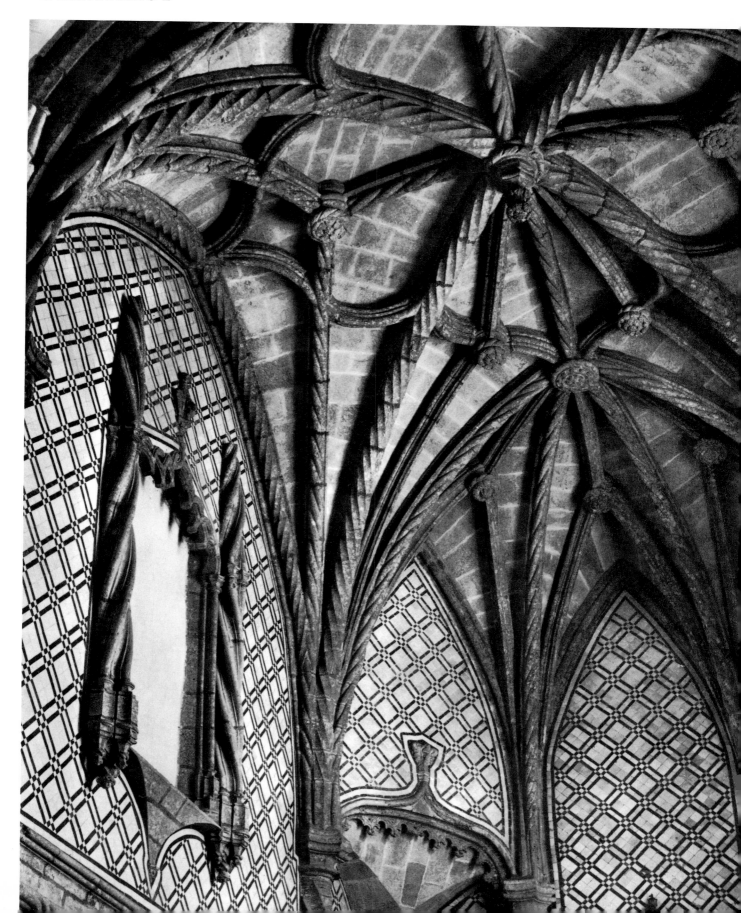

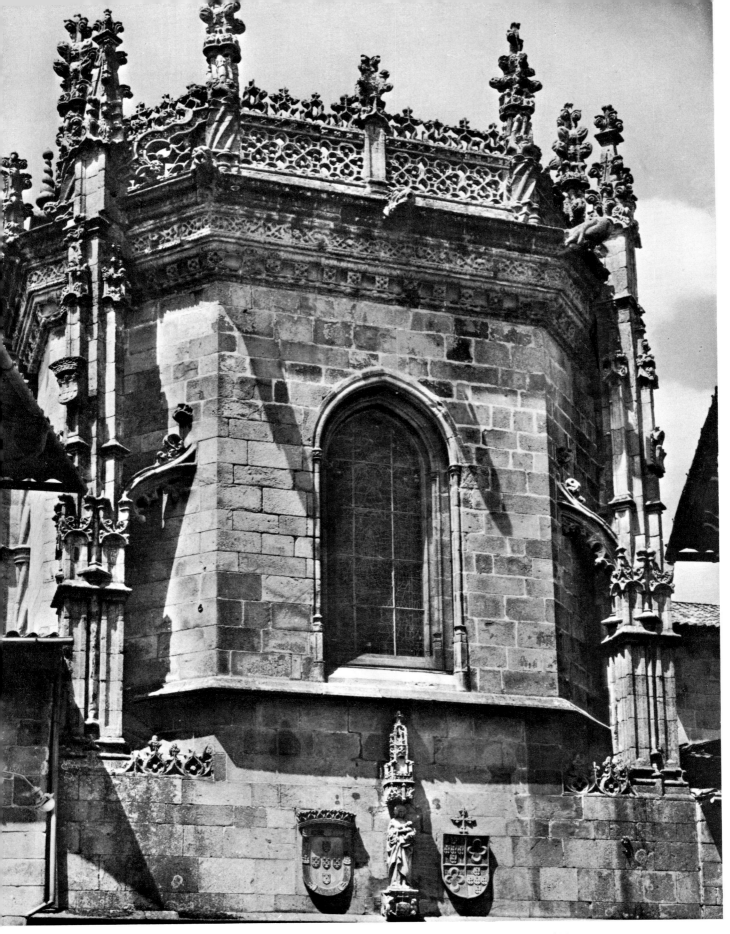

2 João de Castilho: Braga. Cathedral. Exterior of the apse, before 1511

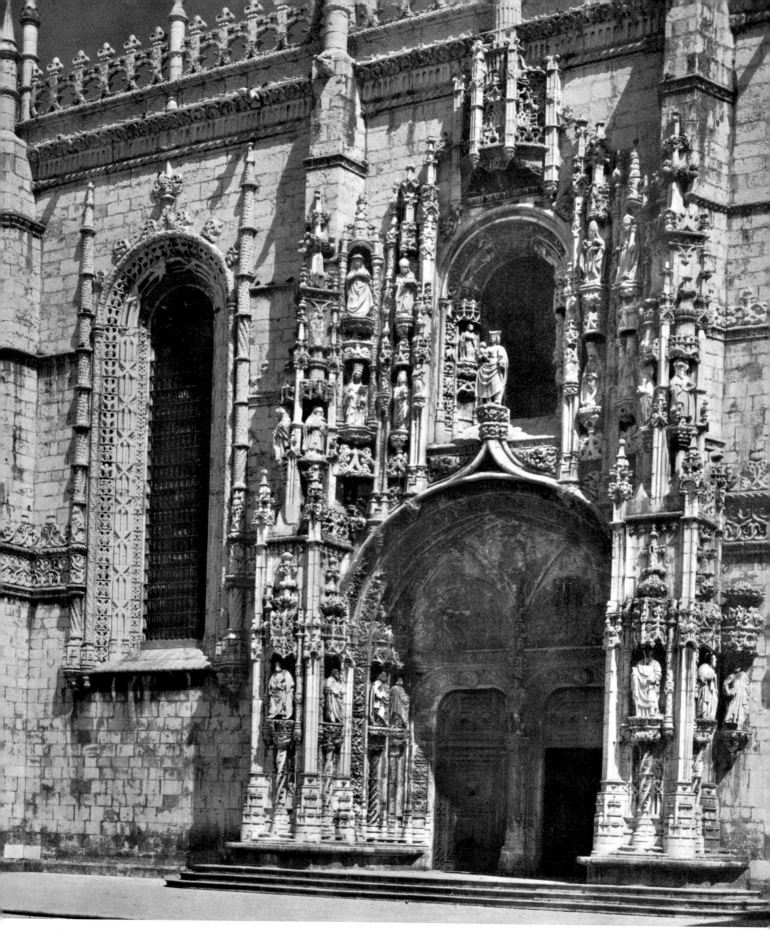

3 João de Castilho: Lisbon. Church of Santa Maria de Belém. South portal, *c.* 1517

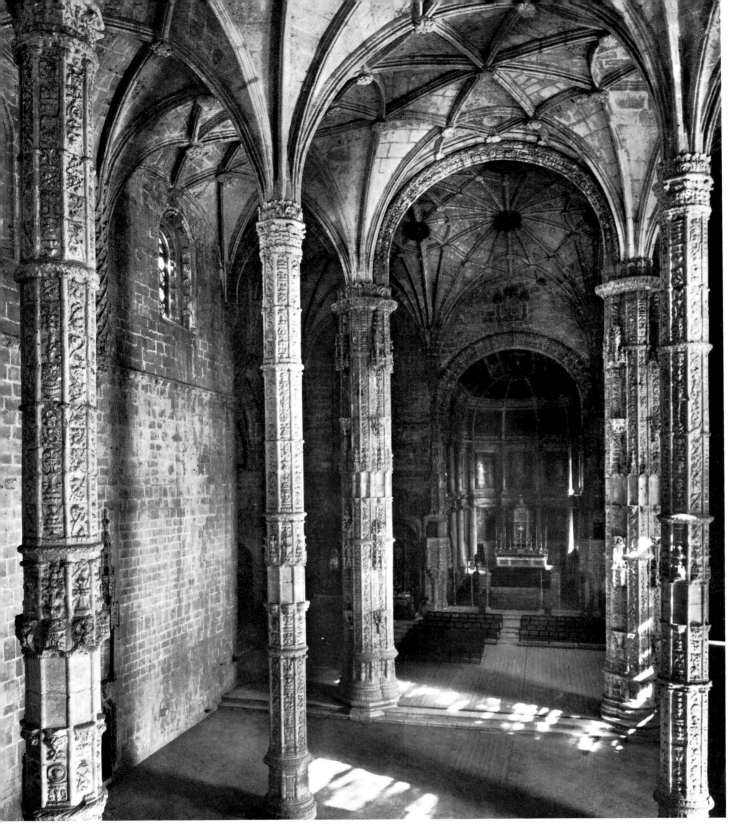

4 Boitac and J. de Castilho: Lisbon. Church of Santa Maria de Belém. The nave looking toward the apse, 1502–after 1519

5 (OPPOSITE) Boitac and J. de Castilho: Lisbon. Church of Santa Maria de Belém. The nave looking toward the choir loft, 1502–after 1519

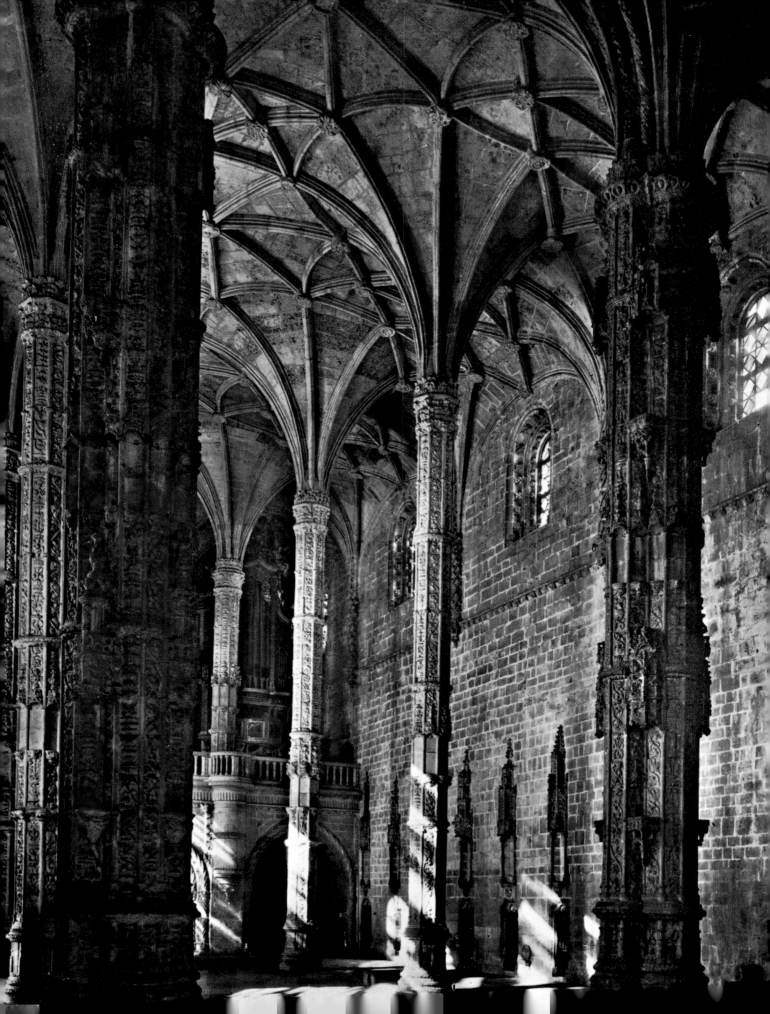

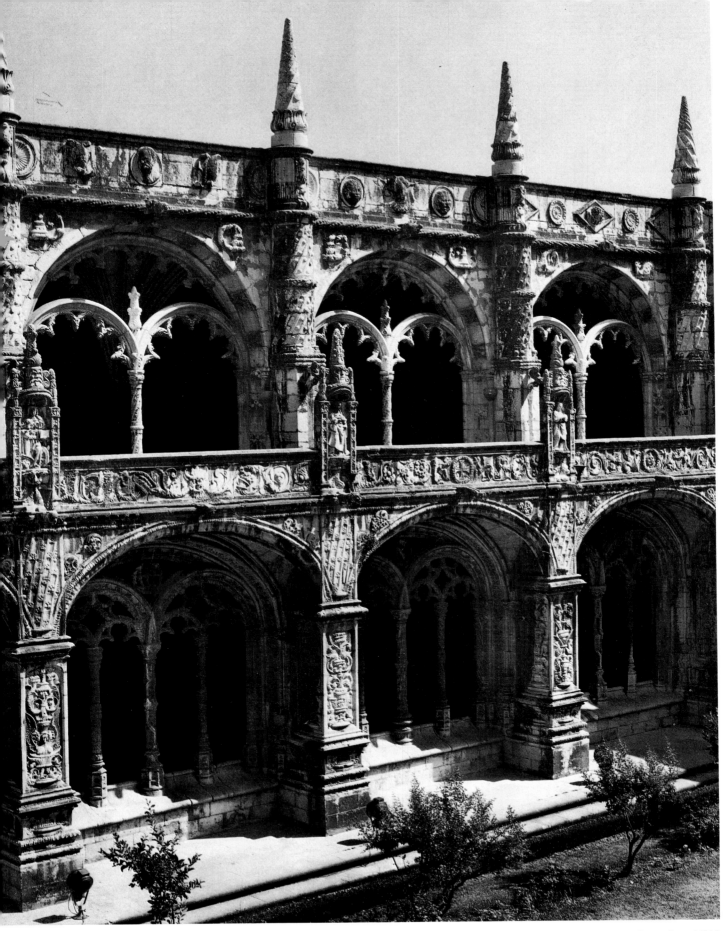

6 Boitac and J. de Castilho: Lisbon. Convent of Santa Maria de Belém. The cloister, 1502–after 1519

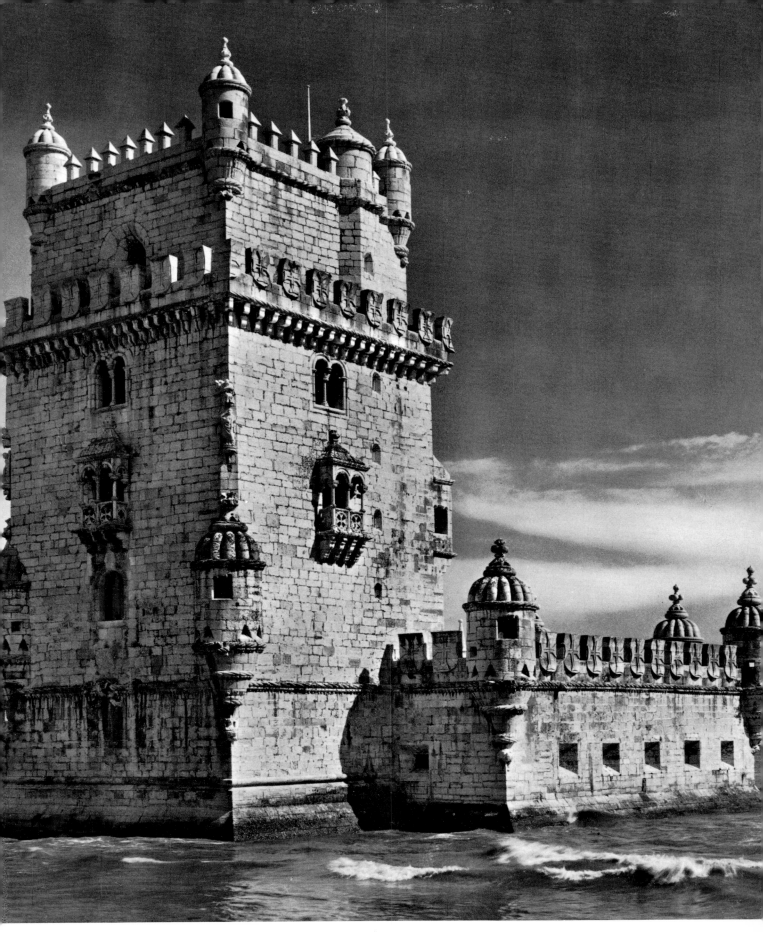

7 Francisco de Arruda: Lisbon. The Tower of Belém, 1515–20

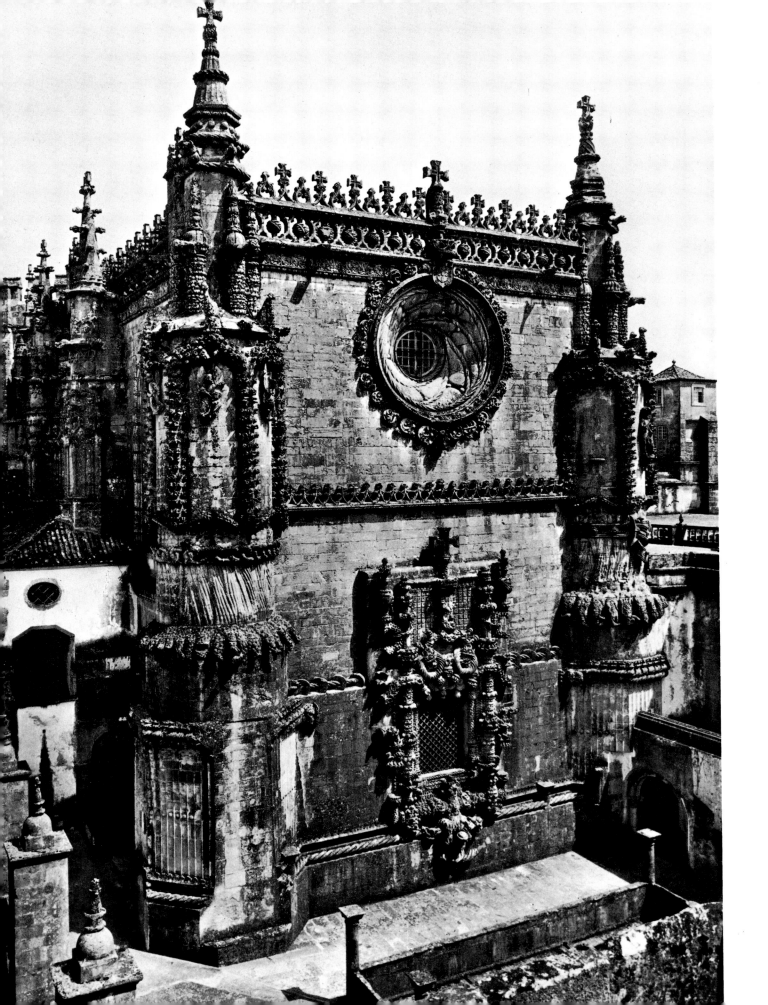

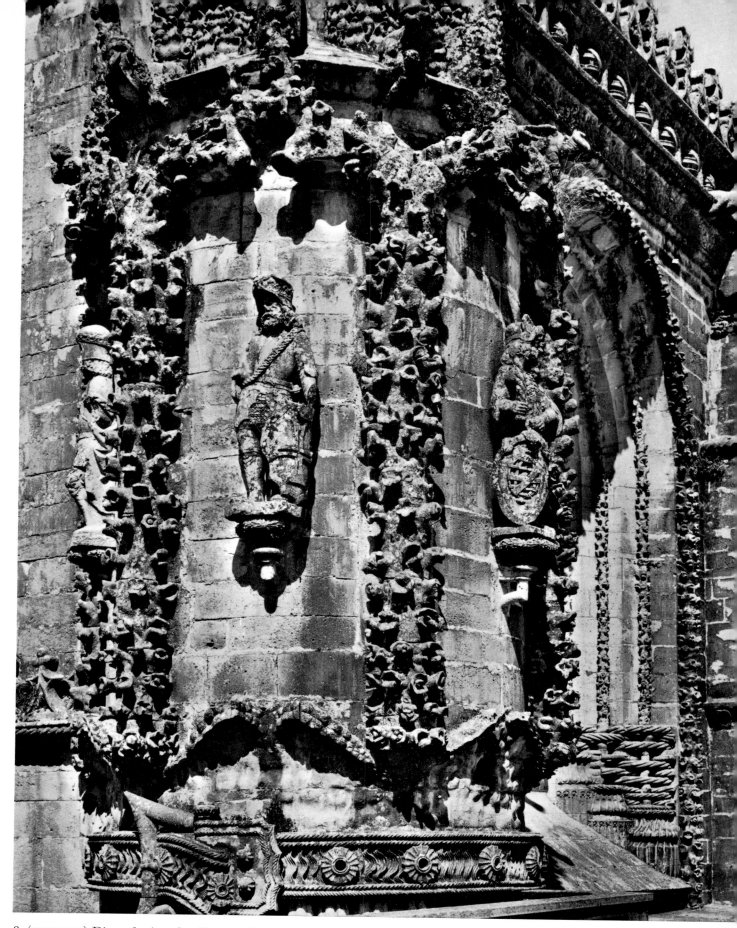

8 (OPPOSITE) Diogo de Arruda: Tomar. Convent of Christ. Exterior of the church, 1510–14
9 (ABOVE) Diogo de Arruda: Tomar. Convent of Christ. Detail of the exterior of the church, 1510–14

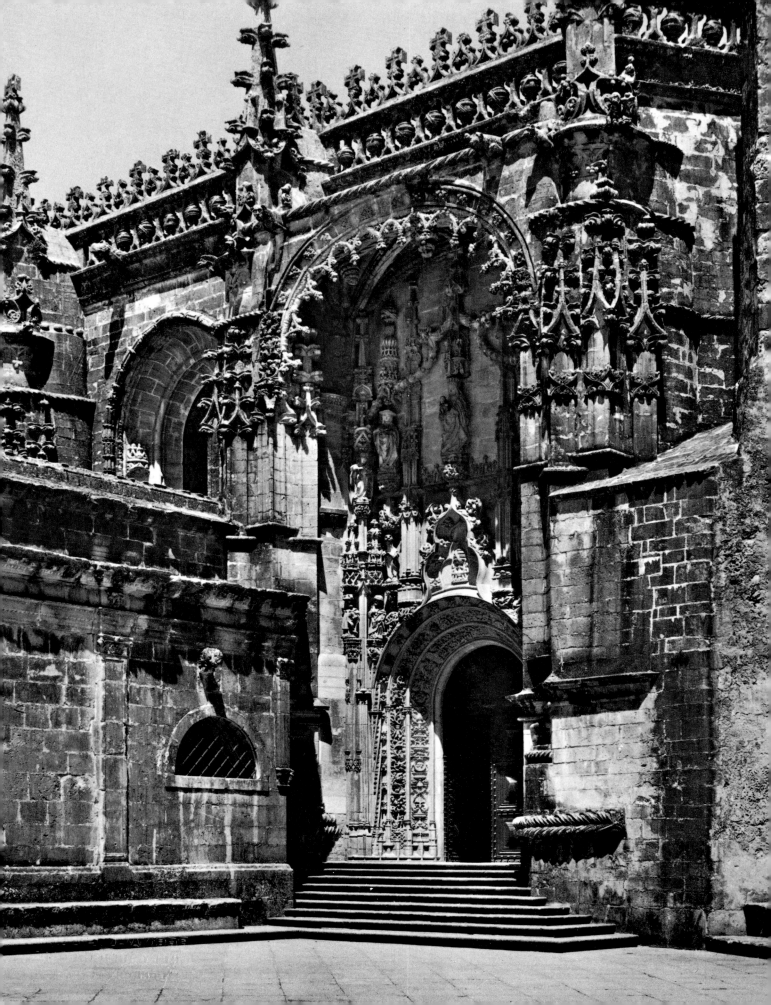

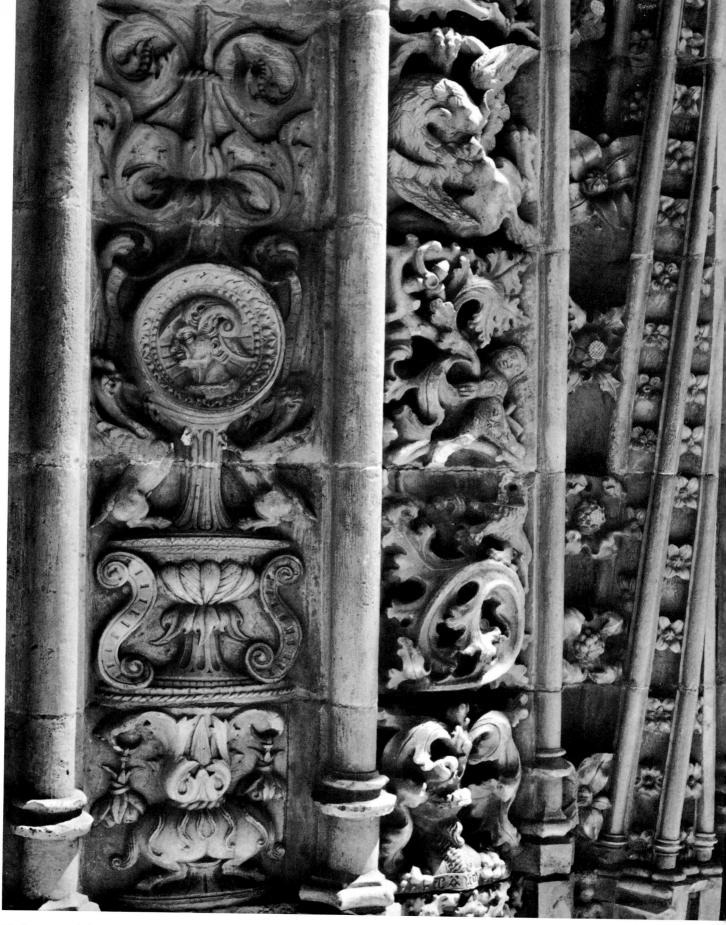

10 (OPPOSITE) João de Castilho: Tomar. Convent of Christ. The main portal, 1515
11 (ABOVE) João de Castilho: Tomar. Convent of Christ. Detail of the main portal, 1515

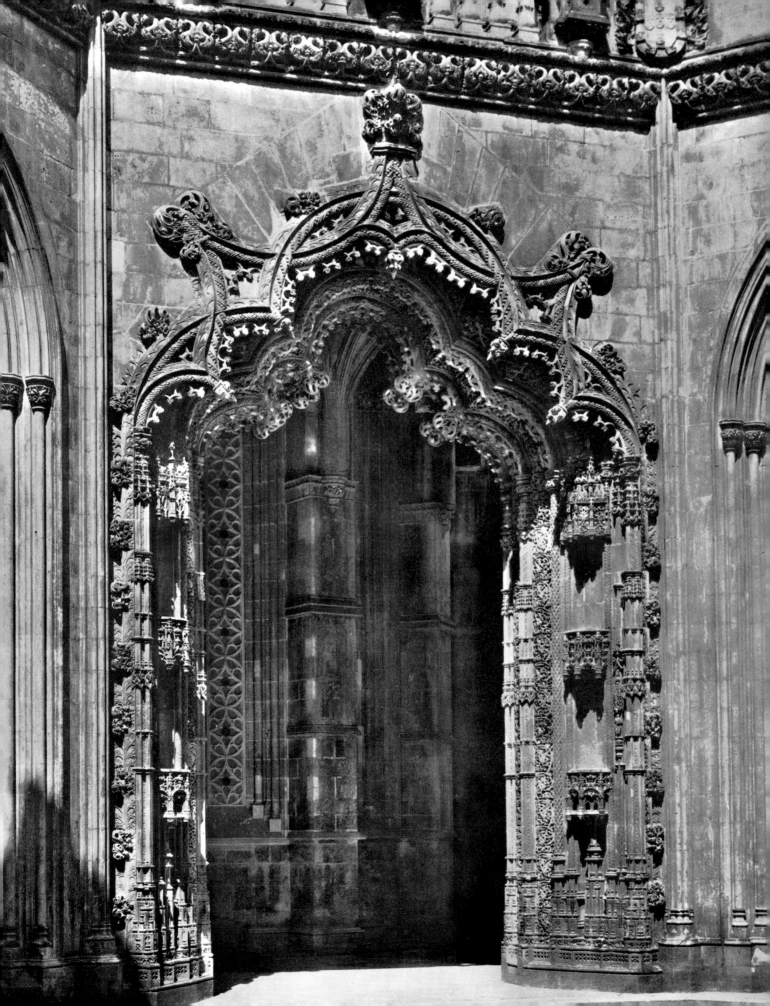

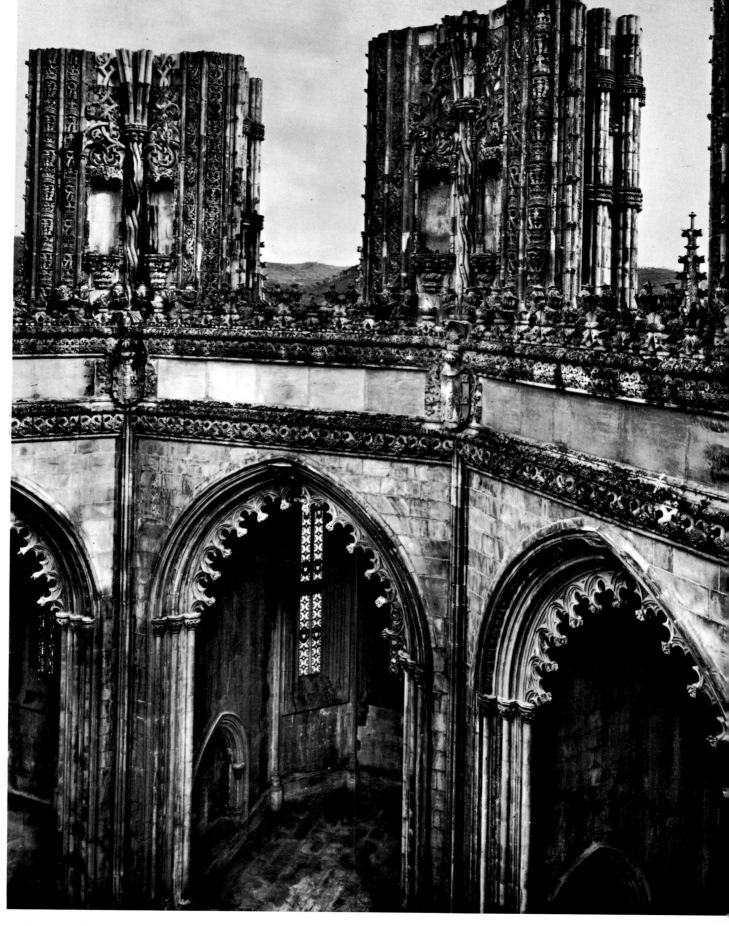

12 (OPPOSITE) Mateus Fernandes: Batalha. Capelas Imperfeitas. The portal, 1509
13 (ABOVE) Ouguete and others: Batalha. Capelas Imperfeitas, *c.* 1435–1519

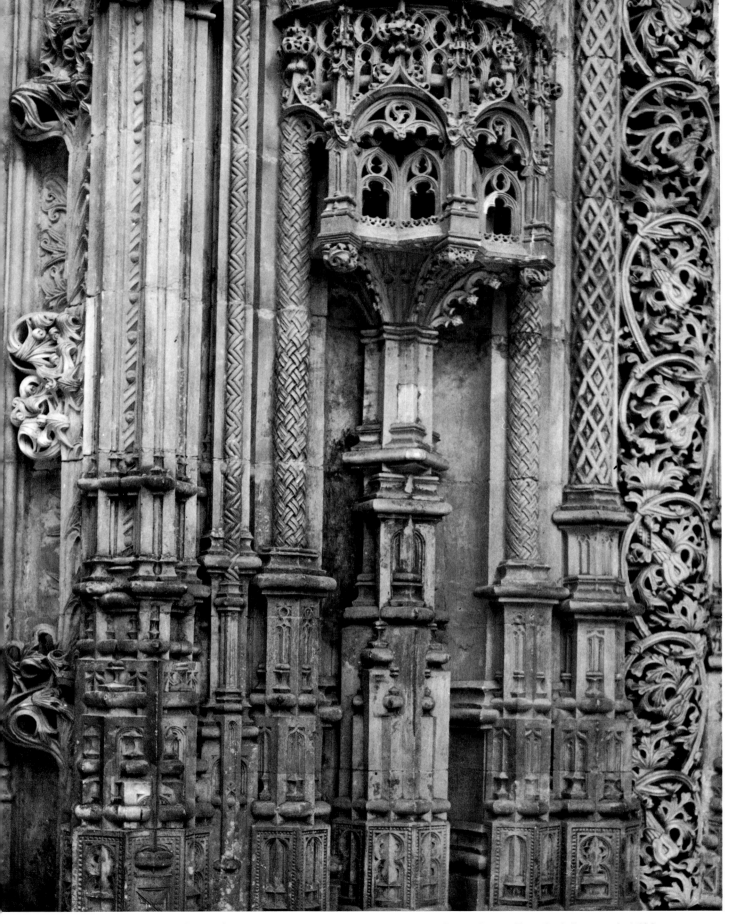

14 (ABOVE) Mateus Fernandes: Batalha. Capelas Imperfeitas. Detail of the portal, 1509
15 (OPPOSITE) Mateus Fernandes: Batalha. Capelas Imperfeitas. Detail of the portal, 1509

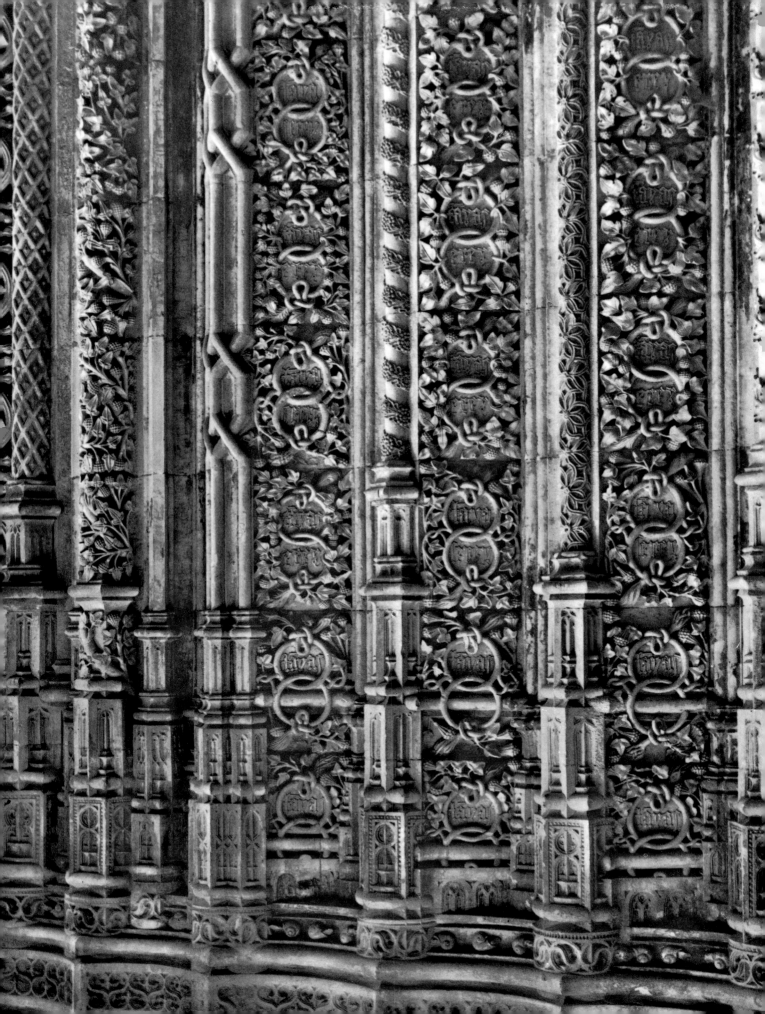

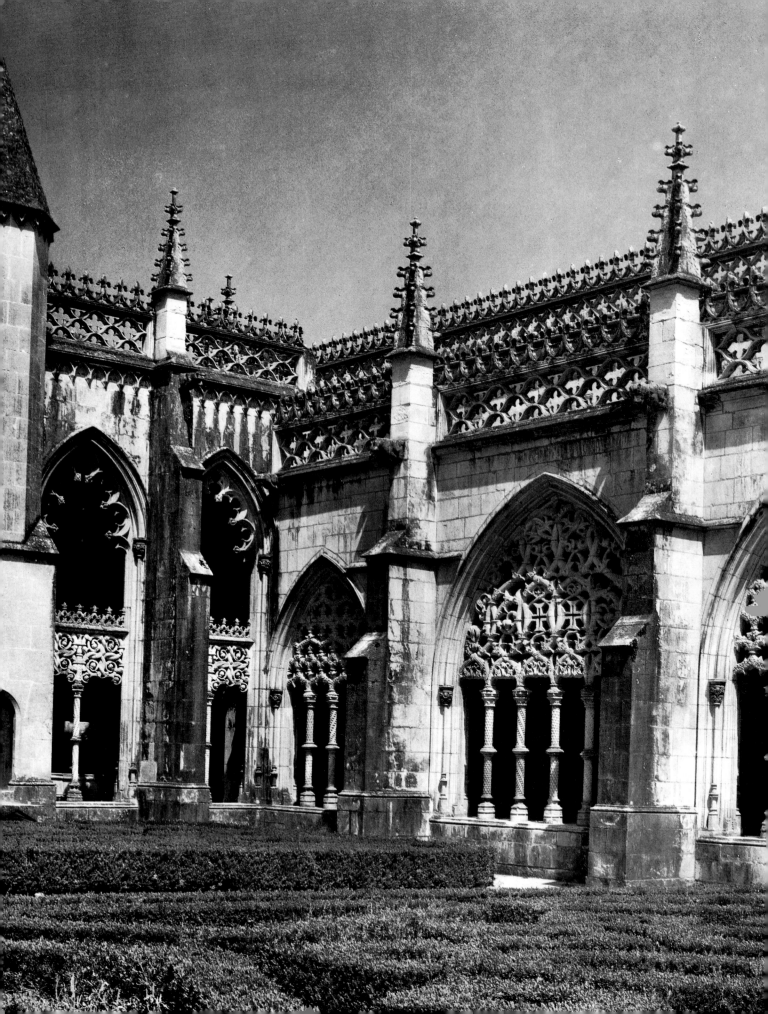

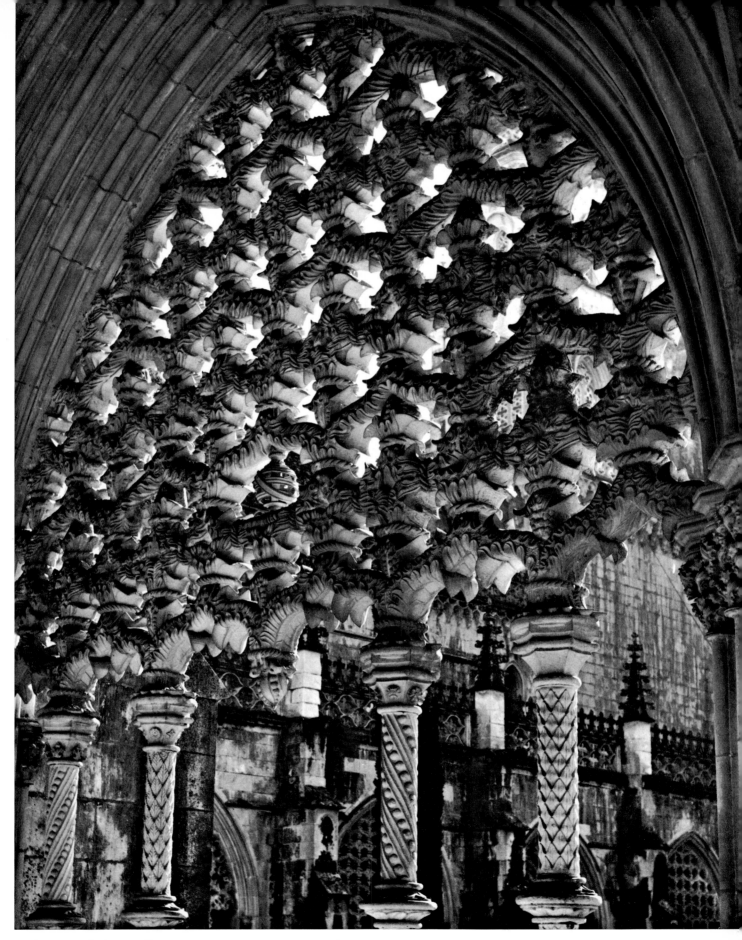

16 (OPPOSITE) Afonso Domingues and others: Batalha. The Royal Cloister, early 15th and early 16th centuries
17 (ABOVE) Afonso Domingues and others: Batalha. Detail of the Royal Cloister, early 15th and early 16th centuries

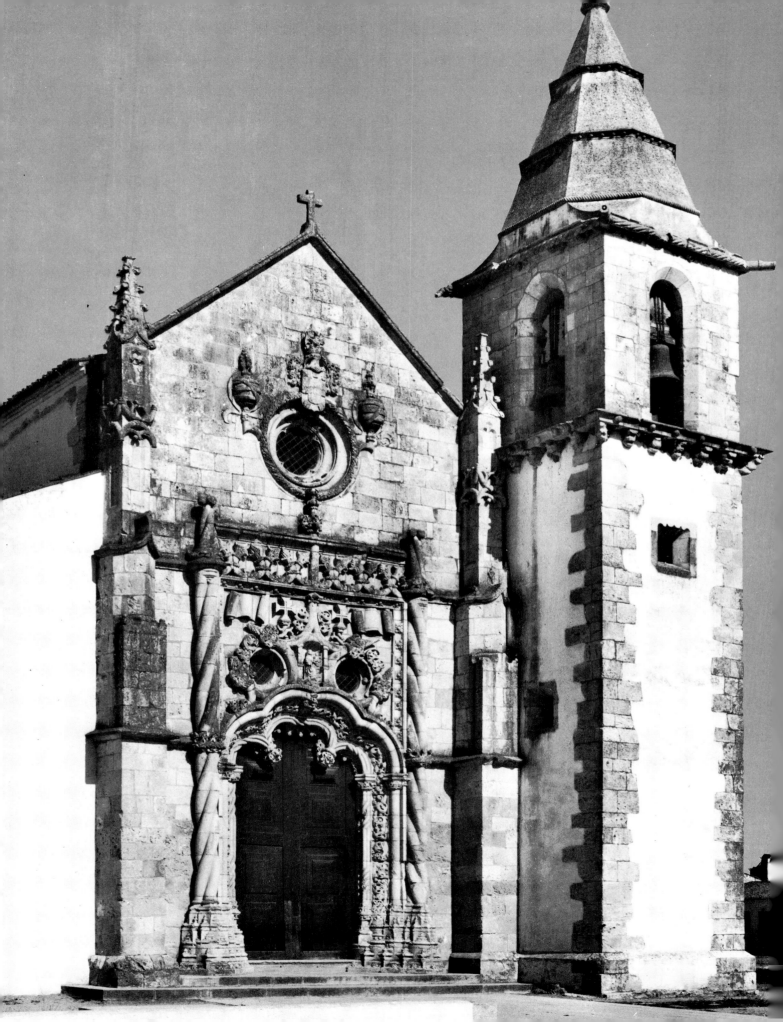

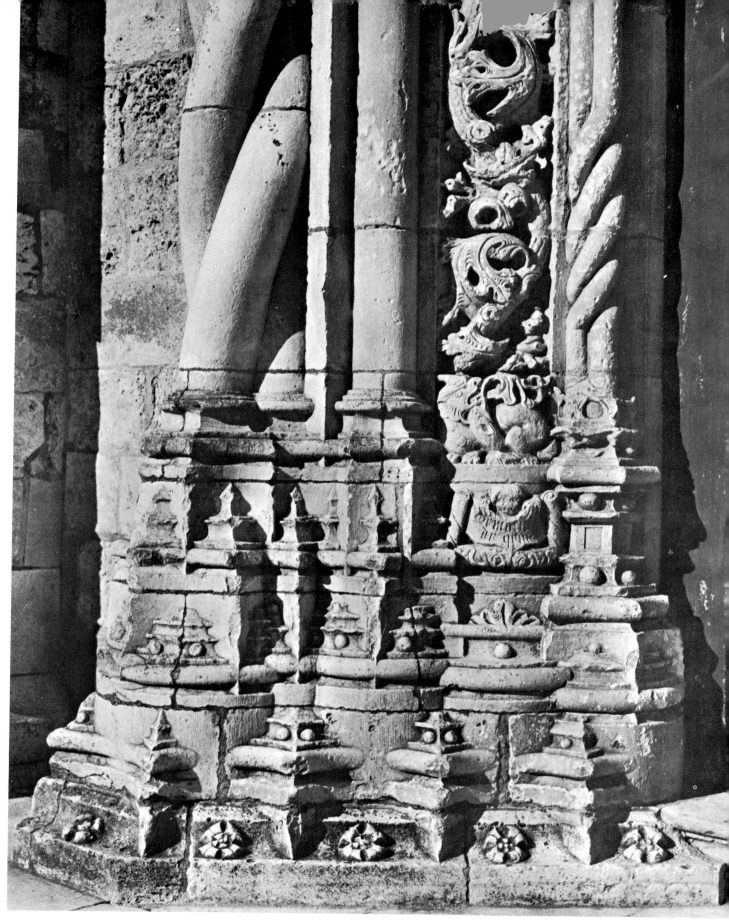

18 (OPPOSITE) Golegã. Church of Nossa Senhora da Conceição. The façade, *c.*1510–20
19 (ABOVE) Golegã. Church of Nossa Senhora da Conceição. Base of the portal, *c.*1510–20

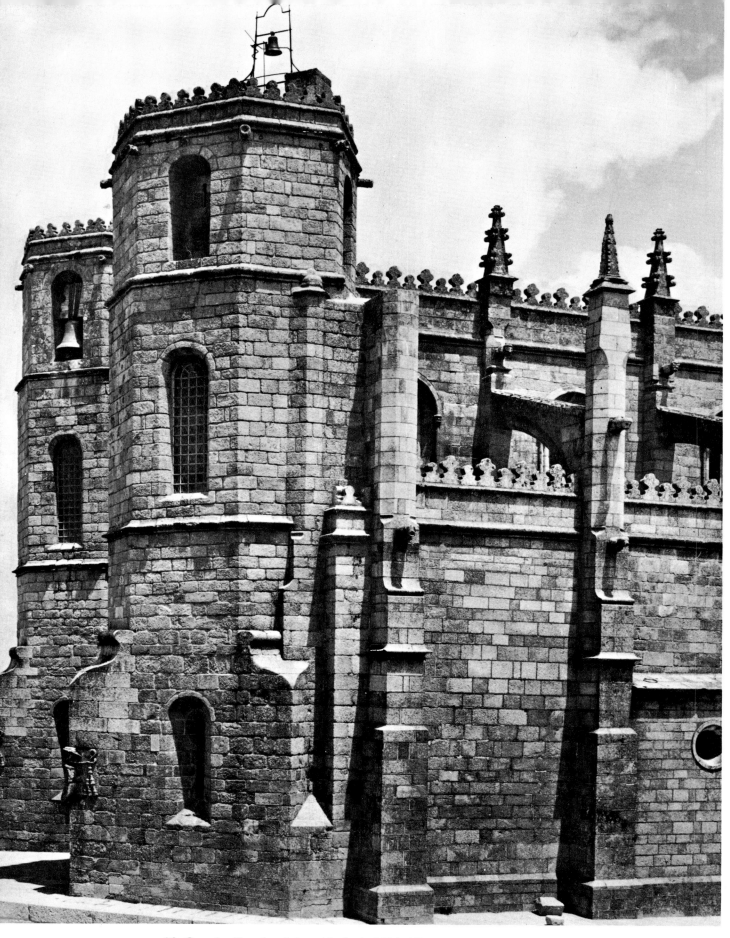

20 Guarda. Façade of the cathedral, 1504–17
21 (OPPOSITE) Guarda. Interior of the cathedral, 1504–17

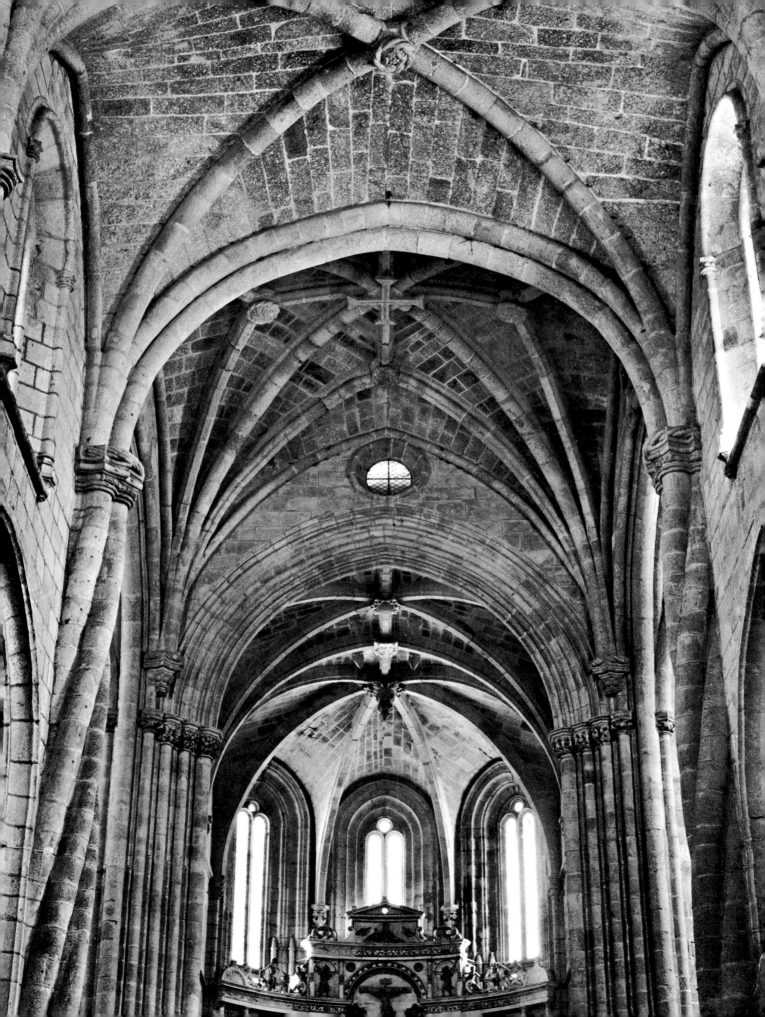

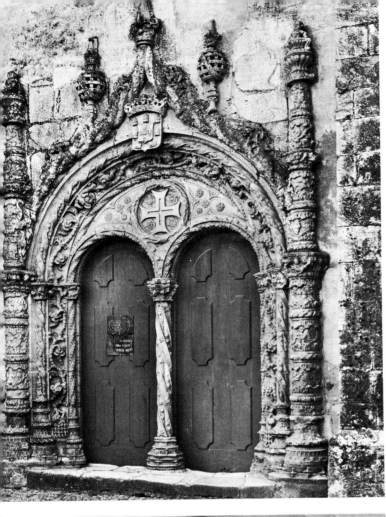

22 Viana do Alentejo. Church of Nossa Senhora da Annunciação. The portal, early 16th century

23 Évora Convent of Lóios. Portal of the chapter house, early 16th century

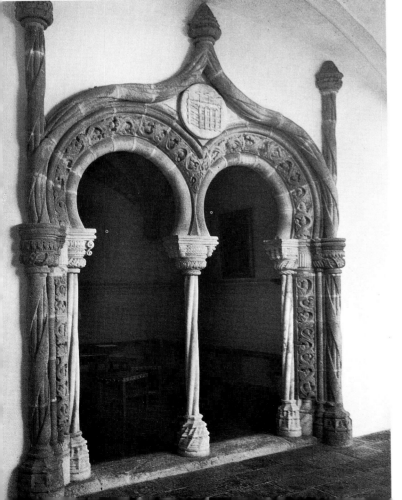

24 (OPPOSITE) Vestiaria. Church of Nossa Senhora da Ajuda. The portal, early 16th century

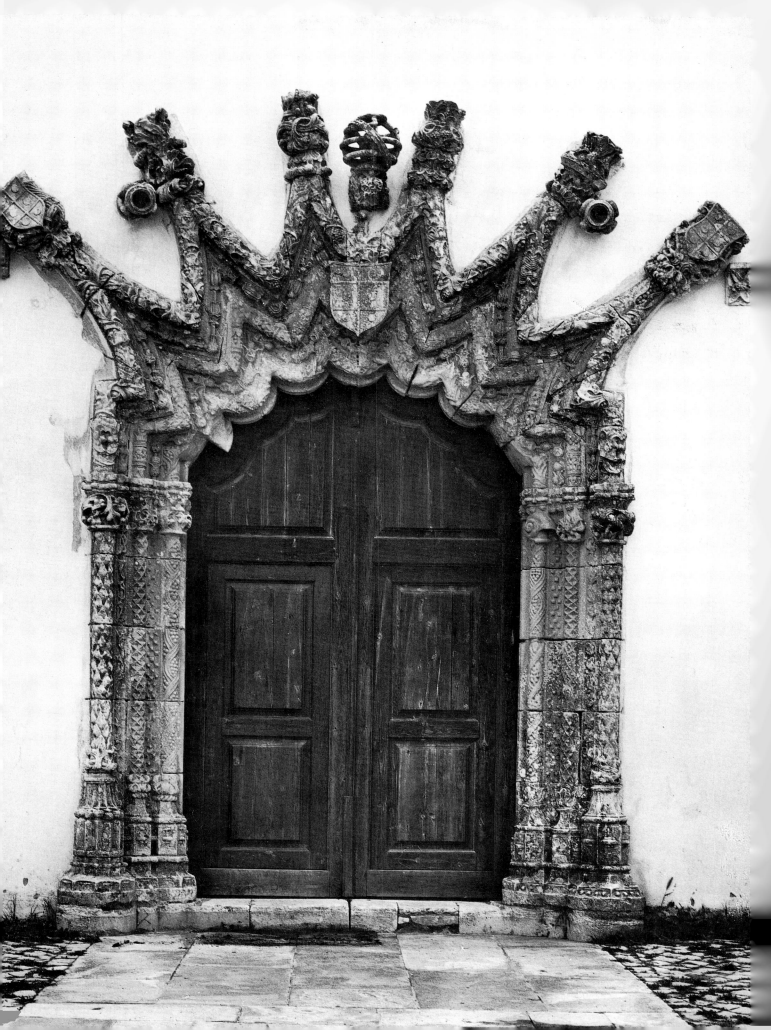

against pierced arabesques of vaguely Oriental appearance and in the outer frame a spiral pattern of ribbons and balls, which is repeated in the features resembling poles ending in cones that flank the windows. These clearly recall the window at Setúbal and so do the various bands of exotic ornament including ropes that run across the long façade. These distinctively Portuguese elements suggest Diogo Boitac's hand rather than that of João de Castilho, the Spaniard.

Plate 1

Inside, however, the latter's style predominates in the breathtaking vaulting of the nave and the great polygonal piers that support it. These are covered with a flat incrustation of vases, medallions and other classicizing objects that suggests the Spanish Plateresque. These in turn contrast with the Boitacian long spiral corbels set on the wall to receive the ribs of the immense sail-like vault, which with that of the transept is Castilho's greatest achievement.

Plates 4, 5

Supported by a minimum of buttressing at a height of approximately seventy-five feet, the nave vault presents a single convex span of over seventy-five feet spread at equal distance above the three aisles, according to the hall church system which appeared in various parts of Europe at the close of the Middle Ages. Introduced at Belém, this equidistant type of vaulting was to be used at Arronches, Freixo-de-Espada-à-Cinta and other Manueline churches, as well as the three Renaissance cathedrals of the mid-sixteenth century – Leiria , Portalegre and Miranda do Douro. Audacious as the lofty vaults of the nave appear, that of the transept is even more daring, for it rises to a height of more than eighty feet without supporting piers and is one of the major marvels of medieval building. Mário Chicó has shown that the rib system of the nave is like the one used by Juan Guas at San Juan de los Reyes in Toledo, while that of the transept is like the rib system of Tewkesbury Abbey in England.[2] These observations emphasize the diversity of influences encountered in this extraordinary building, which in spite of them and the different styles of the two architects impresses by its own personality and not by the borrowings. At Belém the Manueline construction, completed after 1519, ends with the transept; the apse, completed by Jerónimo de Ruão in 1572, is in the very different Mannerist style of that period.[3]

Plate 26

Plate 154

When João de Castilho was appointed architect of Santa Maria de Belém in 1517 he expressly engaged himself to finish the great octagonal cloister, one of the most monumental in Europe. Vaulted throughout in two stories and sumptuously decorated with sculpture, the design appears to owe a great deal to Boitac, who must have devised the deep recessions that provide in each story the same dramatic spatial contrasts found at Setúbal. His also appear to be the scheme of paired arches within the major openings that reappears in the cloister of Santa Cruz at Coimbra, where Boitac worked in 1510-13, the rope mouldings and the fantastic spiral decoration of the second-story buttresses, encircled and capped by cones like the frames of the windows of the church.

Plate 6

To João de Castilho, on the other hand, can be attributed the classical overlay of the lower story, including large-scale reliefs of putti with military trophies and portrait medallions that are the most conspicuous evidence of the Renaissance in the entire building. The conical canopies with masks of the niches, which are the same as those on the south portal, suggest that Castilho was influenced by the fantasies of Boitac. The presence in the parapet between them of two of the supreme heraldic devices of the Manueline age, the cross of the Military Order of Christ and an armillary sphere, the personal badge of the sovereign, provide a link between the great votive monument of Belém and the other royal buildings of this reign.

25 (OPPOSITE) Viana do Castelo. Távora house, early 16th century

The Military Order of Christ was established in 1320 by Dom Diniz (1279-1325) to provide a home in Portugal for the disbanded Knights Templar, who had assisted in the successful reconquest of the country from the Moors. The new order prospered under his successors and especially Dom Manuel, who served for a time as its grand master. He not only rebuilt the knights' headquarters at Tomar but assigned to them revenues from the overseas conquests, in which they had taken part, as well as a role in their administration. In token of this the red-and-white cross of the Military Order was displayed on the sails of Portuguese ships and was carved on stone markers and buildings erected along the coasts of Africa, Asia and South America where the Portuguese held sway. The cross of the Order of Christ became the chief symbol of the discoveries and the conquests and, with the crown and national arms, of the sovereignty of Portugal itself. It was appropriate therefore that it should appear conspicuously on the fortress erected to guard the harbour of Lisbon not far from the monastery of Belém, before which all vessels entering or leaving were obliged to pass.

Plate 7 This fort or Tower of Belém, as it is called, was constructed of *pedra lioz* between 1515 and 1520 by Francisco de Arruda (active 1510-47), an architect and military engineer who had served in Morocco and with his brother Diogo inherited the dramatic spirit of the architecture of Boitac. That appears in the bold silhouette of the tower and in the retraction and expansion of the fortress wall. This is crowned, like the tower itself, by a series of circular casemates, topped by melon-shaped domes that prove a knowledge of Muslim architecture learned either in North Africa or in Andalusia. Between and below these there are rows of shields displaying the cross of the Order of Christ and rope mouldings redolent of shipping and the sea, which originally surrounded the building. This ornament, at once realistic and fantastic, reaches a climax in the carving of one of the angle corbels that represents a weird sea monster inspired perhaps by seafarers' frightening tales.

This novel concept of a building offering a romantic picture of something with which it is associated leads directly to Diogo de Arruda (active 1508-31) and his rebuilding for Dom Manuel of the church of the Military Order of Christ at Tomar, where, as George Kubler has stated, he invented 'an iconography for the oceanic adventures of the Portuguese nation'.[4] In the rebuilding (1510-14) the old octagonal church of the Templars

Plate 8 became the apse *(capela-mor)*, while a large new vaulted nave was added to the west.

Some aspects of the building recall Boitac at Belém, particularly the fat angle buttresses ending in cones and the horizontal bands of ornament which now appropriately contain the cross of the Order and the benefactor's sphere. The buttresses are girdled, like those at Belém, but the ornament used here is new and sensational. There are masses of seaweed and algae, the *sargaço* of Portuguese beaches, which, dripping and oozing, project from the octagonal bases, then climb the curved upper section to reach, like some aquatic ivy, a group of final pinnacles. Around one of the angle buttresses a sea chain is clasped, about the other is strapped an enormous buckled garter, symbolizing, it appears, the British order of that name presented by Henry VII to Dom Manuel. Between the two buttresses ropes and cork floats are stretched, while from above angels on one side and

Plate 9 armoured knights on the other look toward the major spectacle of this whole exotic *mise-en-scène*. This is the culminating feature of the two great windows set in the west wall of the church, which provide an apotheosis for this architectural epic of the sea.

Above appears a round window resembling one in the north façade of the Tower of Belém, whose wide dish-like frame is filled with the paraphernalia of the sea — furled

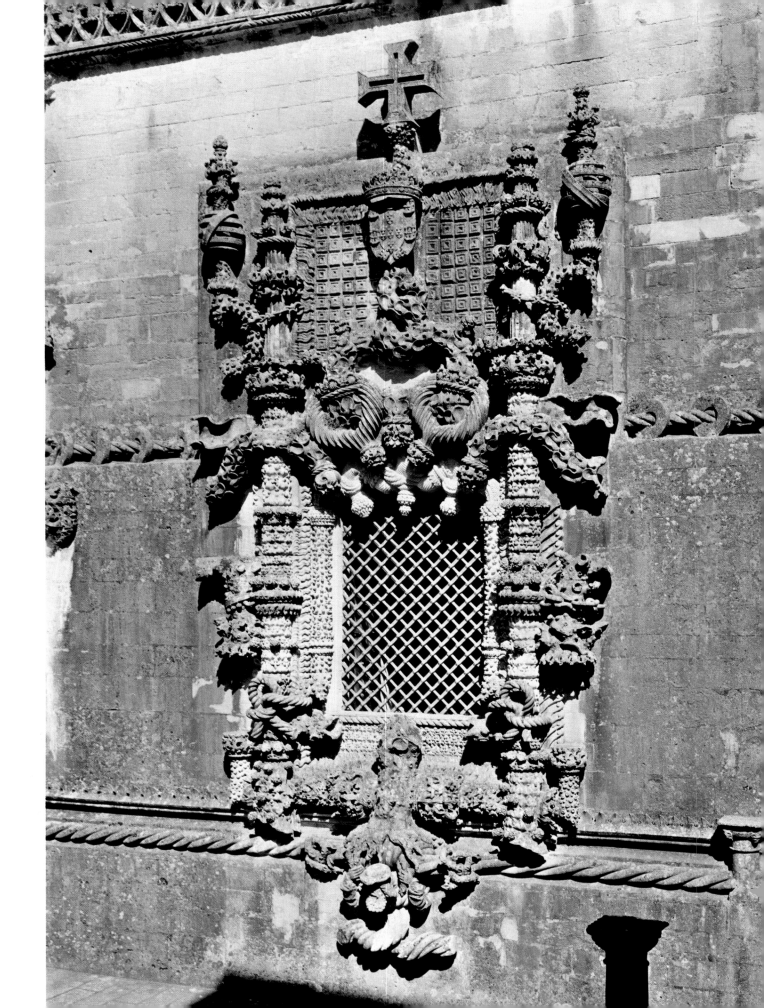

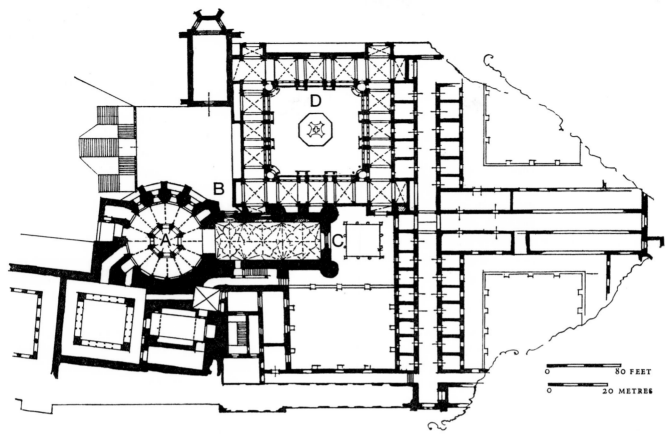

Tomar. Church and convent of Christ. A CHURCH;
B PORTAL; C WINDOW; D GREAT CLOISTER

sails, coiled cables and a scattering of buoys. Surmounted by the royal arms, it is circled
by a wreath of plume-like acanthus fronds, a motif destined to endure in Portuguese art
well into the eighteenth century, from which peers a brooding bearded mask.

Below is set the huge rectangular window of Tomar, designed like those of Setúbal
and Belém with great finial motifs rising at the sides. But these are now covered with a
watery mass of foliage like that of the buttresses above and ropes in spiralling coils intrude
to create a series of leaping forms that lead straight back to the piers of the church of Jesus
at Setúbal. At the base the gigantic root of a tree is enigmatically borne on the shoulders
of another bearded ancient, a kind of old man of the sea, who plays the role of Jesse in a
Jesse Tree. Directly above, beyond the grated opening and the twisting ropes, against a
background of decorated squares that vaguely recall Mayan ornament, is set the royal
shield, mystically dominated, in this sanctuary of the Order, by the military cross. Pro-
jecting at the sides from the lateral finials others bearing armillary spheres seem to emerge
before one's eyes, while the whole voluptuous composition appears to sway in the roll of a
mighty wave.

This great window of Tomar, probably the best-known single motif in Portuguese art,
is the outstanding example of Manueline preoccupation with exotic naturalism. It is used
for dramatic purpose in a fashion that clearly anticipates the seventeenth-century Italian
Baroque and radiates a spirit that animates every part of the building's decoration ex-
cept the main portal, which, following the monastic custom observed also at Setúbal and
Belém, is set in the right side of the church.

Here there are obvious connections with the portal of Belém, for the doorway of
Tomar, dated 1515, is another work of João de Castilho, which directly preceded his

*Colour
plate III*

*Colour
plate II*

Plate 10

III (OPPOSITE) **Diogo de Arruda: Tomar. Window of
the church of the Military Order of Christ**, *c.* 1510-14

employment at the Hieronimite monastery. In it can be seen in embryo the retable-like mass of niches and statues that will emerge in finished form at Belém and Santa Cruz of Coimbra, where Castilho also worked. This time the portal is recessed beneath a shallow vault and there is little relation between the design of the superstructure and the portal proper. The latter is of great importance for Portuguese architecture and sculpture, because the scheme of concentric arches goes back to a pattern popular in Romanesque architecture and established a model for a number of Manueline doorways. It also seems to have served as the basis for a type of woodcarved altarpiece common in the late seven-

Plates 98, 99 teenth and early eighteenth centuries which uses the same kind of sensuous foliage embracing birds and children that appears in the centre compartment of the frame of the

Plate 11 Tomar doorway. This was itself inspired by Flemish woodcarving of the early sixteenth

Plate 89 century, like the main altarpiece of the Old Cathedral of Coimbra. In the compartment at the left appears a Plateresque arabesque similar to those at Belém, while the section to the right contains spiral motifs with various rosettes that represent Castilho's rather wiry interpretation of Manueline motifs of Portuguese origin.

While work was under way at Belém and Tomar, Dom Manuel turned his attention to the vast Dominican monastery of Batalha near Leiria, some hundred miles to the north of Lisbon, with a view to erecting his own tomb there. Batalha was an outgrowth of the Portuguese victory over the Spanish at the battle of Aljubarrota in 1388, in gratitude for which Dom Manuel's ancestor Dom João I (1385-1433), the founder of the dynasty of Aviz, had begun the construction of a large monastic community dedicated to Our Lady of Victory. This was largely built by the architect Afonso Domingos. He was succeeded by the master Ouguete who in 1426-34 constructed the large square lateral Founder's Chapel, where Dom João I, his English wife Philippa of Lancaster, their son Prince Henry the Navigator and a number of other princes of the House of Aviz lie buried. Dom João's oldest son and successor Dom Duarte (1433-8) employed Ouguete to design a spacious octagonal structure just beyond the apse of the church of Batalha containing seven chapels, in one of which he intended to be buried. When the king died the work stopped, with the building far from completed. This was the part of Batalha which Dom Manuel resolved to finish, but when he later decided to be buried in his new monastery of Belém work was again abandoned and has never been completed. The great mortuary edifice is therefore called the *Capelas Imperfeitas* or Unfinished Chapels. It contains some of the richest architectural sculpture in Portugal.

Plate 12 The building is entered through a broad doorway some forty-five feet high which terminates in a series of interlacing arches and flaring mouldings that suggest the Flamboyant Gothic architecture of northern Europe. The inner profile in fact specifically recalls a detail of the English church of St Mary's Redcliffe at Bristol, and this is within the tradition of Batalha itself, where, perhaps in honour of the British queen, the church shows many resemblances to Perpendicular-style architecture. The great Manueline doorway of the Capelas Imperfeitas, which is dated 1509, is the work of Mateus Fernandes, active at Batalha from *c.* 1490 to 1515, who of all the contemporary masters reveals the closest affinity to northern Europe and the greatest delicacy in handling stone, which throughout Batalha is an ivory-like limestone.

In spite of these differences, however, the portal has a number of specifically Manueline features. One is the multiplicity of graduated polygonal blocks from which the colonnettes rise. This scheme, found also at Belém and all the great Manueline buildings, is especially apparent on the outer face, where it gives the impression that the designer

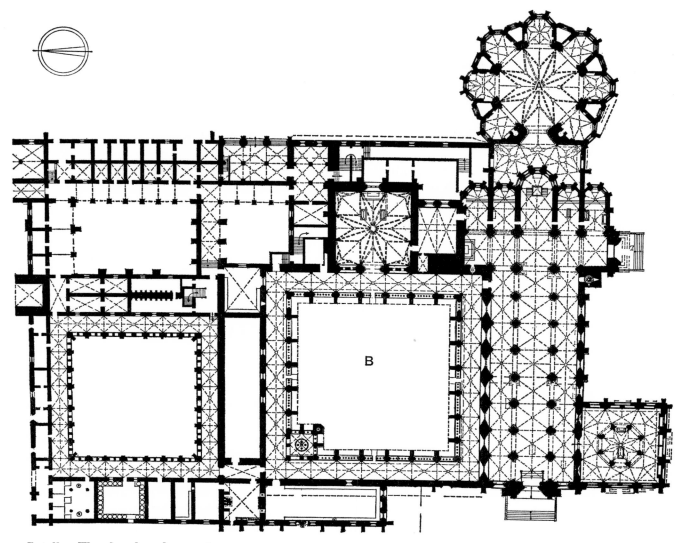

Batalha. The church and monastery. A CAPELAS IMPERFEITAS;
B ROYAL CLOISTER

was loath to relinquish the motif. On the inner face it is combined with a Manueline Plate 14
chain device and another practice characteristic of the style, which points to a Moorish
origin, the all-over carpet-like repetition of a single design. In this case it is the French
words of Dom Duarte's personal motto *'leauté faray tam yaserey'* ('loyal I shall ever be').
These are carved more than two hundred times within a typical late Gothic enframe- Plate 15
ment of links made of fruit and foliage. Another Manueline characteristic is the carv-
ing of a cone-shaped vegetable form called *massaroca*, thought to represent a magnolia
kernel, the surface of which is covered with beads that suggest the grains of an ear of
corn. In contrast to the slightly stiff and stylized aspect of this part of the decoration is the
incomparable grace of the flowing foliage of a water plant surrounding the outer rim of
the doorway. The sumptuous and elegant decoration is completed by the canopies of the
now empty niches, which are like medieval silver in the complexity of their designs, based
like those of the arching on Flamboyant Gothic forms.

Mateus Fernandes seems also to have been responsible for the richly ornamented vaults
with coats of arms in the radiating chapels of the octagonal rotunda. Apparently this

was to have been covered by a gigantic masonry lantern which James Murphy, an English eighteenth-century architect who wrote a book about Batalha, attempted to recreate in one of his illustrations.[5] In the drum area containing fragments of ribs intended for the vaults of this roofing there is a tapestry of decorative sculpture in a bold and at times fantastic style very different from the delicate grace of the portal. To explain this difference Reynaldo dos Santos has suggested that Mateus Fernandes was replaced after his death in 1515 by Diogo Boitac, who in his capacity as royal architect is known to have worked at Batalha in 1514 and again in 1519, as well as on two earlier occasions, in 1509 and 1512.[6] This would account for the wildly contorted branches above the niches, the girdling of the window colonnettes, which are spread across the exterior, the spiral shafts below what exists of the ribs and the convex pierced panels of stylized husk and leaf forms, that recall the windows of Belém. It does not explain, however, the presence of foliage like that at the rim of the great portal, unless we are to assume that Boitac copied it from the work of Fernandes.

To Boitac likewise are attributed the sculptured screens carried on colonnettes which under Dom Manuel were set in the twenty-four arches of the Royal Cloister of Batalha, which had been constructed by the original architect Afonso Domingos early in the fifteenth century. The attribution seems just because of the resemblance of the multiple curved bars covered with vigorous boldly stylized leaves to the decoration of the cloister arches at Belém. On the exterior of the Batalha screens, which contain both armillary spheres and crosses of the Order of Christ, carved branches are emphasized. Inside the foliage is stressed in myriad crinkled shapes that produce the same exciting rhythm felt inside Boitac's church at Setúbal. Because of its sensuous repetition of stylized forms the Manueline ornament of the cloister of Batalha has often been compared to monumental Indian architectural sculpture, memories of which could have been brought back from the conquest and which would certainly have been known from its reflections in ivories and woodcarving. The Batalha cloister ensemble was completed by two exquisite miniature screens inserted in the loftier arches of the structure at the north-east corner housing an alabaster fountain in two stages, which is the forerunner of countless others in later cloisters and city squares. The light filtering through the intricate openings of the screens in combination with the soft splashing of the fountain's water creates an atmosphere comparable to that of Moorish Spain.

Apart from these great royal buildings, three cathedrals (Elvas, Funchal and Guarda) and a number of large parish churches were built in one or more aspects of the Manueline decorative style, having plans resembling that of Jesus at Setúbal, single towers with octagonal or conical turrets and sculptured portals which sometimes dominate the entire façade.

One of the handsomest of these is the church at Golegã in the province of Ribatejo, not far from Tomar. Constructed with royal funds, probably between 1510 and 1520, and therefore entitled to display Dom Manuel's arms, its spectacular decoration shows the influence of Boitac with something added of the style of Diogo and Francisco de Arruda. Characteristic of the latter are the three deep bull's-eye windows and especially the one at the top of the entrance façade, from which sprout armillary spheres flanking the royal arms in a pattern like that of the great window at Tomar. The two below are combined with the doorway to form a gaping mask, the frame of which is pure Boitac. It also suggests what is known of the façade of the Lisbon church of Todos os Santos, destroyed in the earthquake of 1755. Here again are the plaited colonnettes of Setúbal springing

Plate 13

Plates 16, 17

Plate 18

from high bases composed of many small blocks of varying forms that seem like coral to have grown together. Across the top of the great portal runs a frieze of *massaroca* branches drawn into the same curved bar motifs seen in the Batalha cloister screens and in the cresting above the arches of the Capelas Imperfeitas. The marked recession of planes in the buttresses at the sides of the façade is very much like the setbacks in the cloister of Belém and also the pointed buttresses of the towers of the cathedral of Guarda. These in turn are almost identical with the buttresses and squinches of the apse of Boitac's church of Jesus in Setúbal.

For this and other reasons it is easy to see in the cathedral of Guarda, a frontier fortress town of north-eastern Portugal, high in the Serra da Estrela, another work of Boitac. Rebuilt to replace most of an earlier structure between 1504 and 1517, it is constructed of granite, the chief building material of the north of the country, which gives it a hard, gaunt look very different from the soft and sensuous buildings of the south below the Mondego River. The façade has the extraordinary feature of a pair of towers that are octagonal in shape, exactly like those of the great Augustinian church of Santa Cruz in Coimbra, on which Boitac also worked. Analogies between Golegã and the cathedral of Guarda continue in the latter's façade, which displays, crowded between the towers, a modest portal with a pair of plaited colonnettes at the sides. The same motif reappears with spectacular effect in the transept arch, recalling once again the interior of the church at Setúbal, with ribs whose heavy surfaces and specific positions are very similar to those of the earlier building.

Piers with spiral shafts like these appear also in the naves of Santa Maria do Castelo at Montemor-o-Velho, near Coimbra, and the church of Madalena in Olivença (Olivenza), a town taken in 1801 by Spain, both of which have been attributed to Boitac. They are also found at the sides of the elegant entrance to the chapel of the University of Coimbra and in decorated form in the strangely beautiful portal of the great church at Viana do Alentejo, another royally financed structure near Évora, whose battlemented walls and cylindrical towers relate it to a group of fortified churches built in this area of the province of Alentejo before and during the Manueline era. The Viana doorway, carved in granite, is a member of a large category designed with concentric round arches, like the portal of Tomar, to which belong such famous and diverse examples as those of Alvor, Torres Vedras and Vilar de Frades. At Viana do Alentejo, however, these bizarrely decorated arches are overshadowed by fantastic finials including a portly pair at the sides on which are crudely carved Renaissance putti, masks and vases. Another impressive category of doorways uses polylobed arches in a wide gamut of designs, one of the most original of which is the sandstone portal of the little church at Vestiaria, just outside Alcobaça, where one of the capitals contains a snail shell and the whole composition explodes in diagonal finials bearing shields with the arms of the Melos. There is a somewhat similar doorway in the Cadaval house in Olivença, across the frontier in Spain.

In the adjacent area of southern Alentejo horseshoe arches of Muslim derivation were constantly used in door and window frames during the early years of the sixteenth century. They are part of a Luso-Moorish movement stimulated, it appears, by a visit which Dom Manuel made to Andalusia that led him to rebuild the old palace of Sintra with a lavish use of tiles, in recollection of the *mudéjar* monuments he had seen in Seville.

The centre of this exotic tendency in Manueline architecture was the city of Évora, capital of the Alentejo and a favourite residence of the court. Here the king constructed another palace in the Moorish style, part of which is still standing, surrounded by white-

Plate 19

Plate 17

Plate 13

Plate 6

Plate 1

Plates 20, 21

Plate 21

Plate 22

Plate 10

Plate 24

Plate 172

washed houses with terraced roofs, picturesque chimneys and splashing fountains in secluded patios that constantly remind the visitor to Évora that the border with Spain is not far away.

Plate 23

One of the handsomest of these buildings of the late fifteenth and early sixteenth centuries is the former monastery of the Lóios (Canons of the Order of St John the Evangelist), which has recently been turned into a luxurious government *pousada*, or country inn. This contains one of the masterpieces of Luso-Moorish decoration which is the entrance to what was the chapter house of the Lóios. The frame, which bears the stockade badge of Dom Afonso V (1438-81), conqueror of Arzila in Morocco and patron of the great Melo family, some of whose members were buried in the adjacent cloister, is a simplified and wonderfully rhythmic version of the doorway at Viana do Alentejo. It is built of a combination of local granite and marble that is typical of Évora. There are similar windows and doorways, made of both stone and brick, in the Manueline castle of Alvito and the country houses of Água de Peixes and Sempre Noiva, near Évora.

Plate 25

Luso-Moorish decoration grows increasingly rare as one travels above the Tagus River. There is scarcely any to be found in the granite architecture of the north. In this section, where there are relatively few examples of Manueline building, so far was it from the court which rarely came beyond Coimbra, the finest surviving residence of this period is the Távora house at Viana do Castelo, on the far northern coast. Rebuilt in the eighteenth century, it preserves a number of handsome door and window frames whose flatter forms and stylized linear carving were dictated by the hard, unyielding character of the local granite.

THE RENAISSANCE

The first quarter of the sixteenth century was a great period in Portuguese architecture, which gave the nation some of its most celebrated buildings, among the largest and handsomest of the time in Europe. Several of them show, as we have seen, reflections of Italian Renaissance style, but up to about the year 1530 this was exclusively in the field of ornament, despite the fact that before the turn of the century the sculptor Andrea Sansovino, sent by Lorenzo the Magnificent from Florence, had built a palace decorated with sculpture and frescoes, all designed in contemporary Italian style. But Sansovino's Renaissance work, now destroyed, had apparently not found great favour in Portugal, which was not yet ready to understand it. To please the king, he then built, as his biographer Vasari informs us, 'several fanciful and difficult architectural works in the manner peculiar to that country',[7] all of which have perished, and shortly after returned to Italy, leaving unchallenged in Portugal the fantastic late Gothic style.

And so it remained until the third decade of the sixteenth century, when an artistic revolution led by men from abroad produced the same changes that had taken place in France and Spain ten years or so before. A new style based on the Graeco-Roman system of columns, pilasters and entablatures, which had been established in Italy in the fifteenth century, finally reached the Portuguese court, and Renaissance structure began to take the place of Gothic as Renaissance ornament had already done.

Plate 27

From 1533 dates the tribune of two bays above the great portal of Batalha, an addition which has been attributed to João de Castilho, who at Tomar and Belém had been moving in this direction. The style is clearly transitional, containing old Manueline elements like the richly carved railing and the rosettes of the arches. The rest of the design,

26 (OPPOSITE) Afonso Álvares: Leiria. Interior of the cathedral, *c.* 1551-71

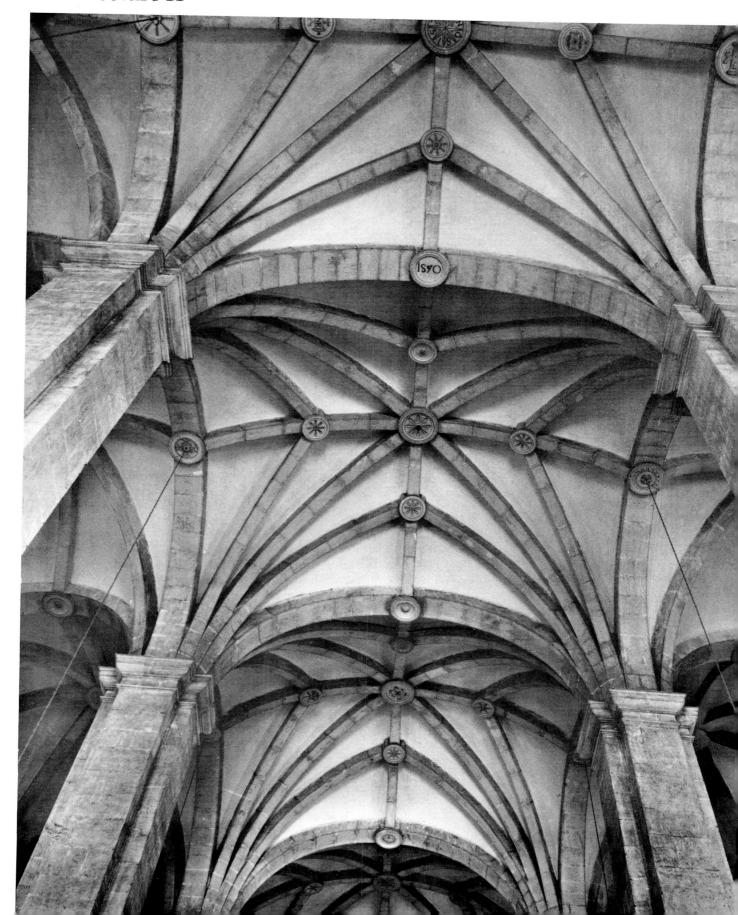

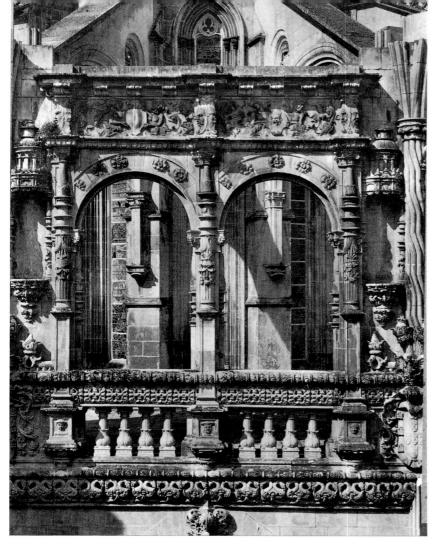

27 Batalha. Capelas Imperfeitas. The tribune, 1533

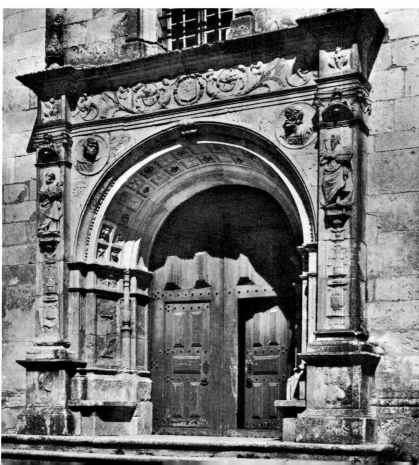

28 (LEFT) Atalaia. Church of Nossa Senhora da Assunção. The portal, *c.* 1545
29 (OPPOSITE) Santarém. Church of Marvila. The nave, first half of the 16th century

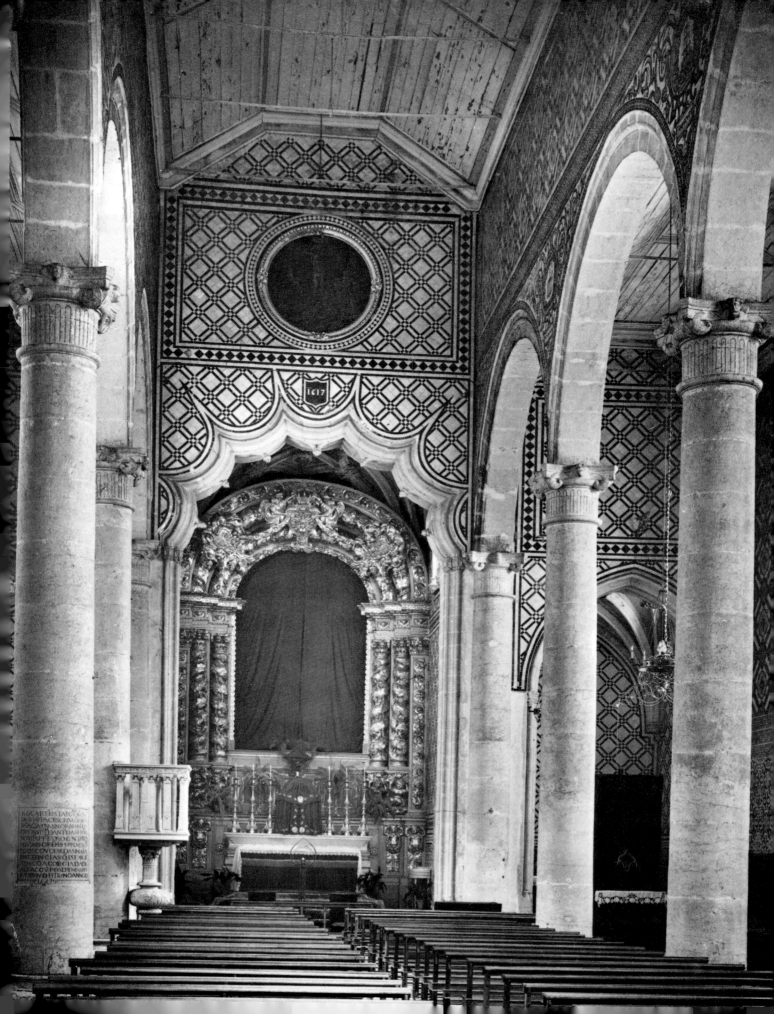

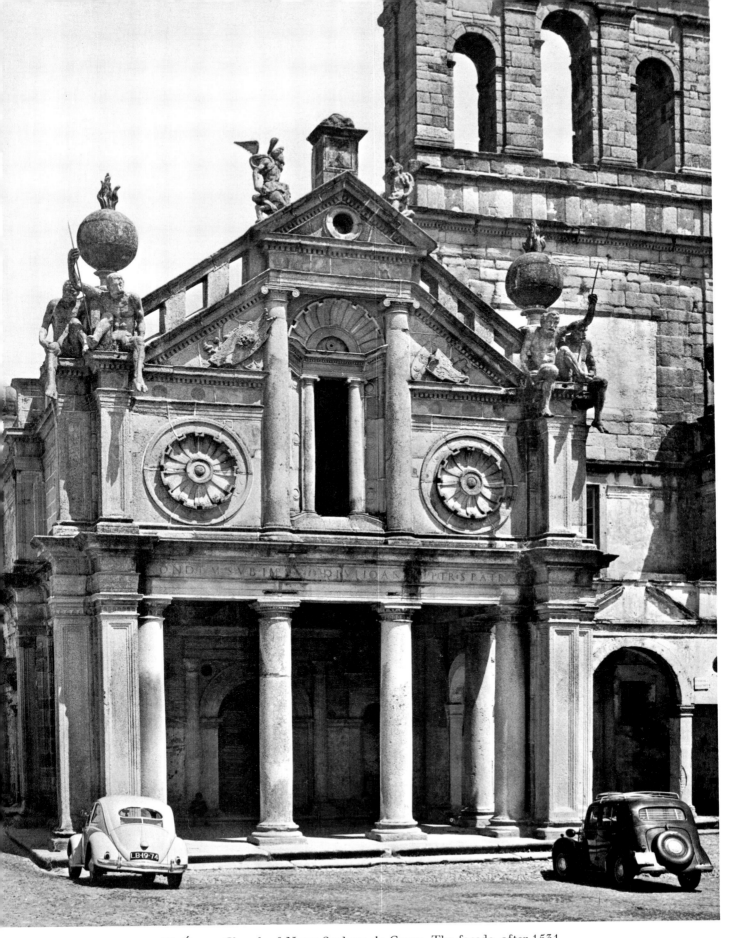

30 Évora. Church of Nossa Senhora da Graça. The façade, after 1531

31 (OPPOSITE) Diogo de Torralva: Tomar. Convent of Christ. The great cloister, begun in 1557

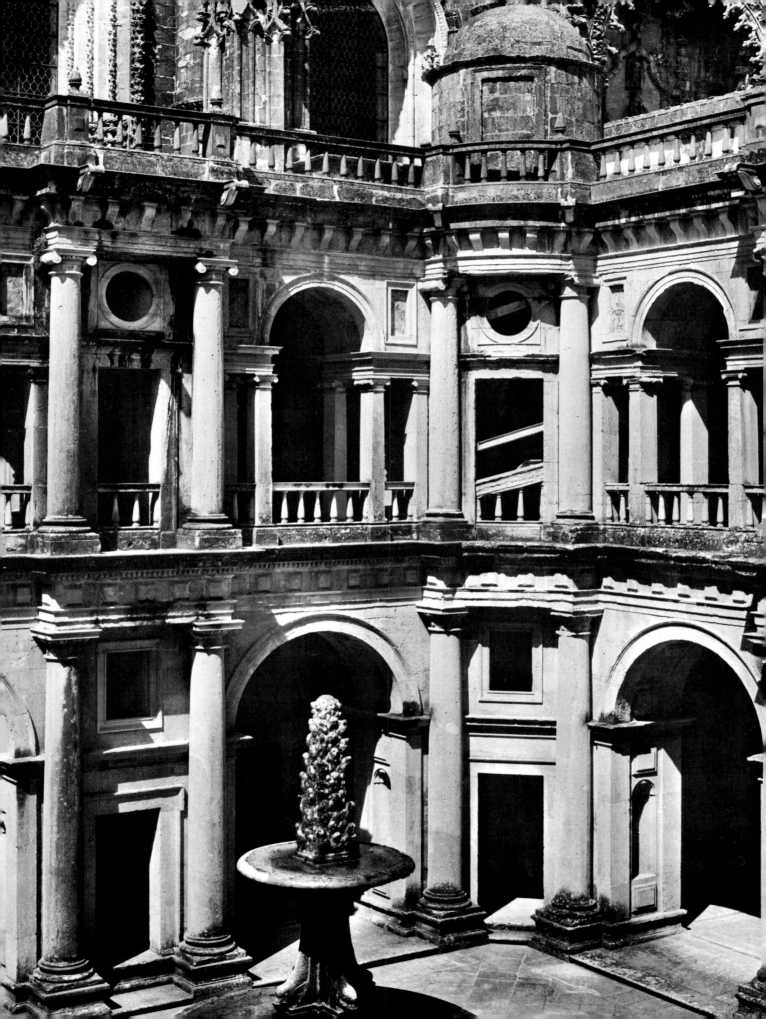

32 João Lopes: Guimarães. Convent of São Francisco. The cloister, *c*. 1600
33 (OPPOSITE) João Lopes and Jerónimo Luís: Vila Nova de Gaia. Convent of Serra do Pilar. The cloister, 1576−83

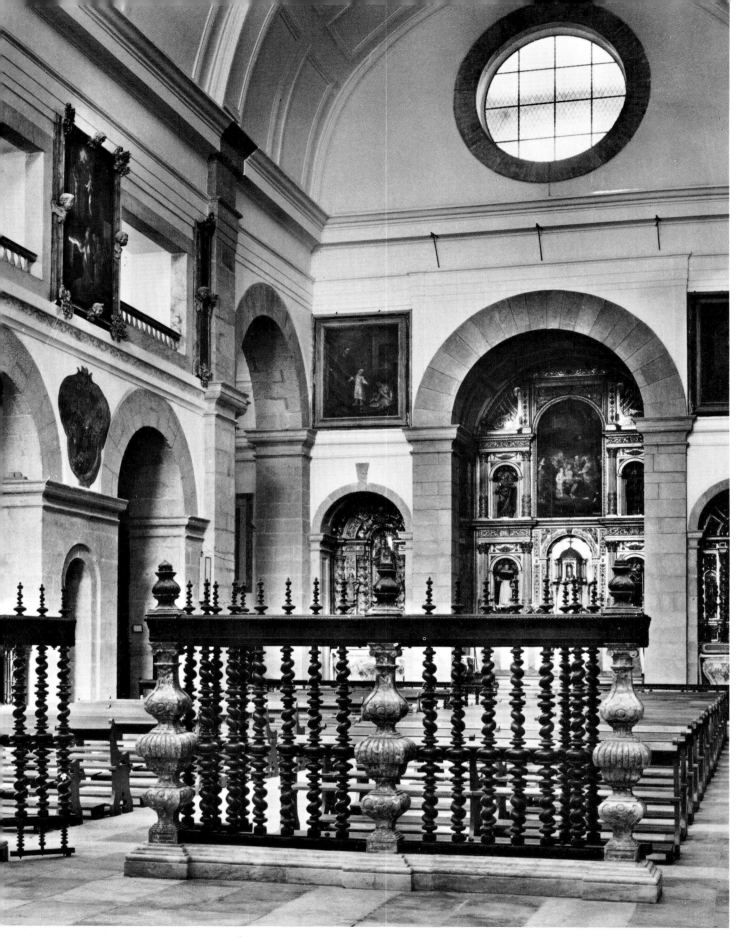

34 Afonso Álvares and Manuel Pires: Évora. Church of Espírito Santo. The interior, 1567–74

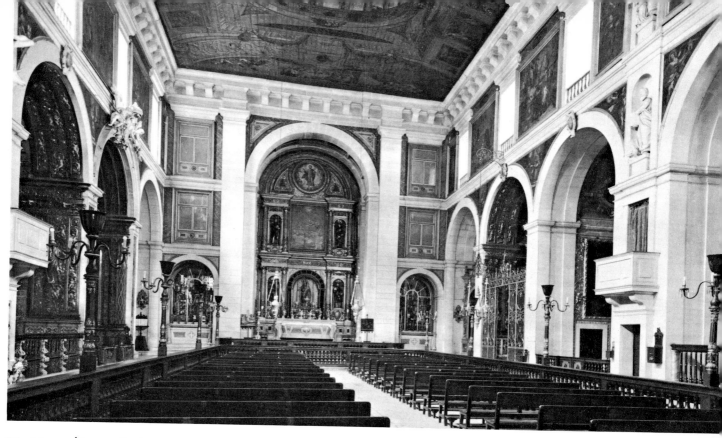

35 Afonso Álvares: Lisbon. Church of São Roque. The interior, begun in 1567
36 Santarém. Church of the seminary. The interior, *c.* 1676

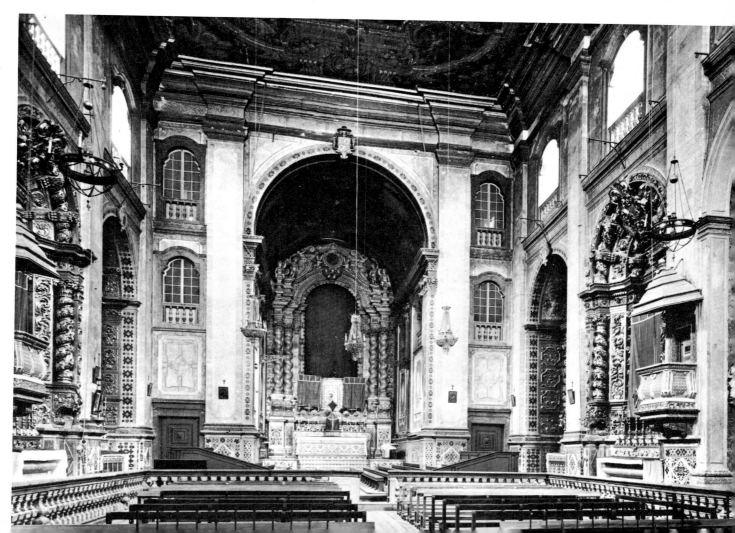

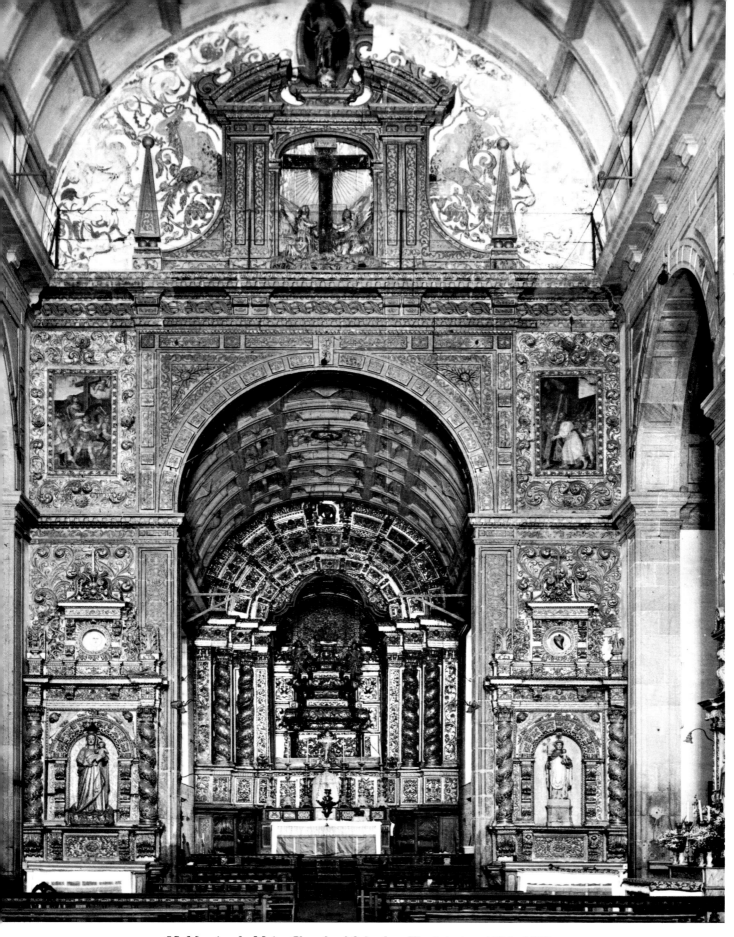

37 Moreira da Maia. Church of Salvador. The interior, 1588–1622
38 (OPPOSITE) Baltasar Álvares: Coimbra. Interior of the New Cathedral, begun in 1598

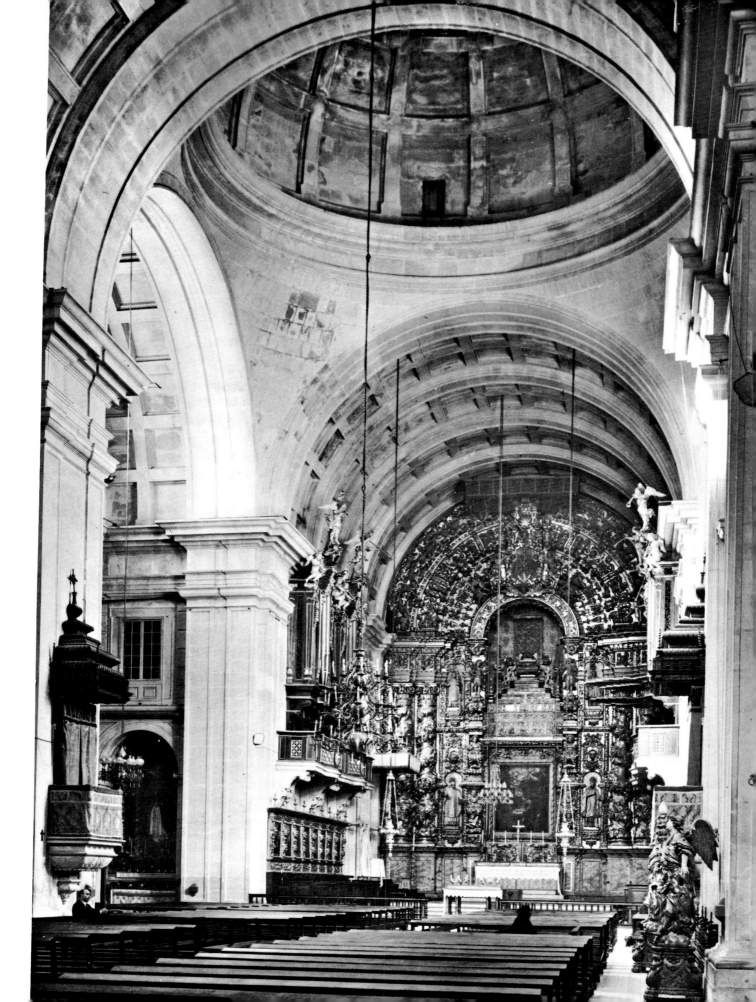

39 Miguel de Arruda: Miranda do Douro. Façade of the cathedral, begun in 1552

40 Évora. Courtyard of the former Jesuit university, late 16th century

41 Filipe Terzi: Lisbon. Church of São Vicente de Fora. The façade, begun in 1582
42 (OPPOSITE) Baltasar Álvares: Oporto. Church of São Lourenço. The façade, 1614—22

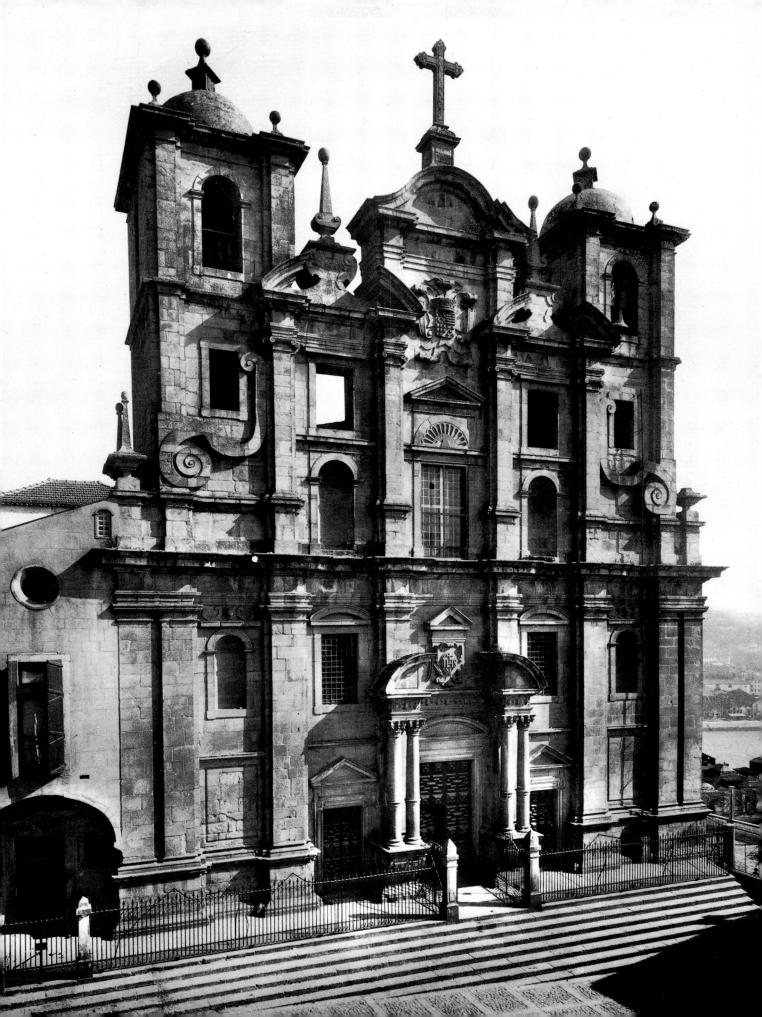

43 Guarda. Alarcão house. The courtyard, *c.* 1686

44 Bertiandos. The façade, 16th–18th centuries

45 Viseu. The cathedral buildings, 16th–18th centuries

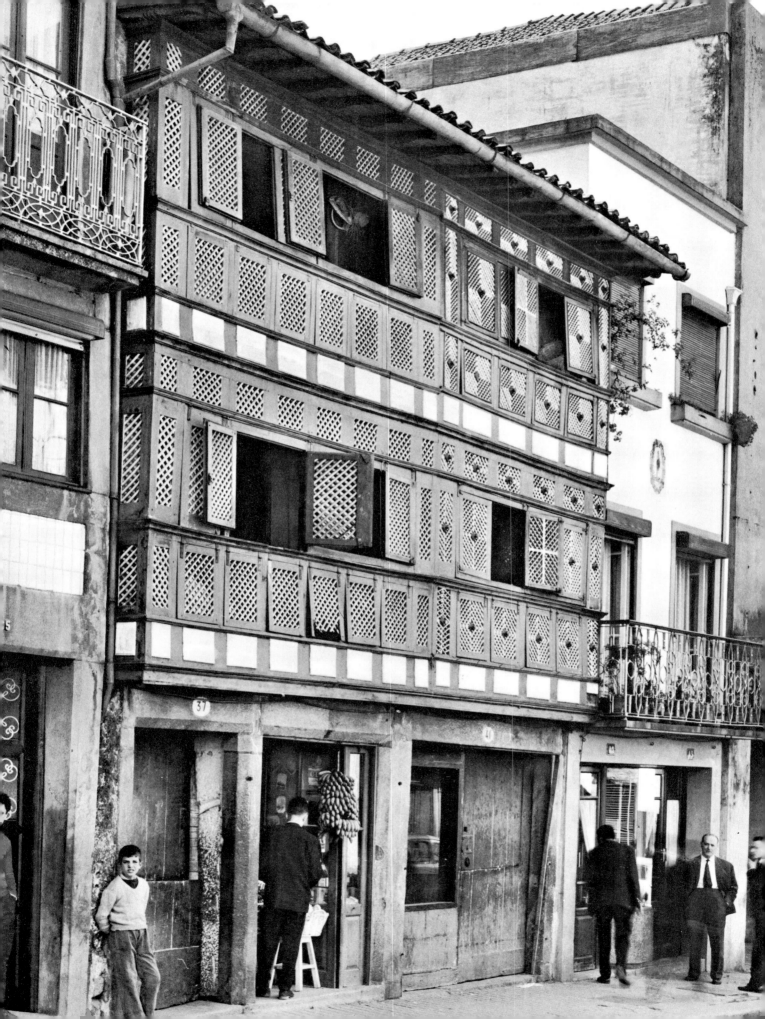

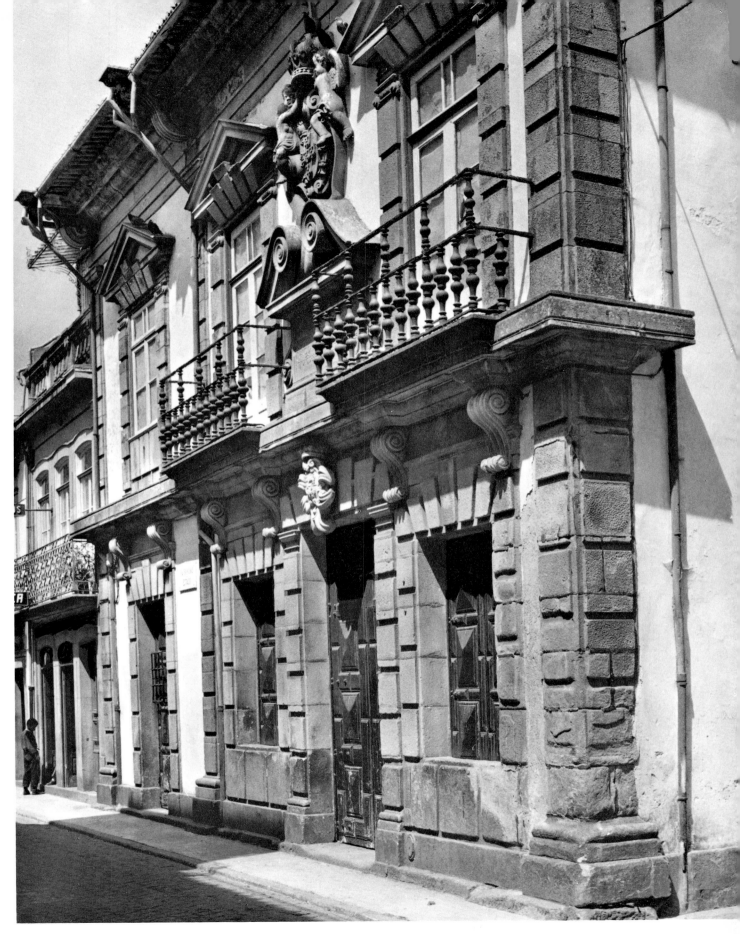

46 (OPPOSITE) Braga. House in the Rua de São Marcos, 17th or 18th century
47 (ABOVE) Manuel Pinto de Vilalobos: Viana do Castelo. Casa da Vedoria, 1691

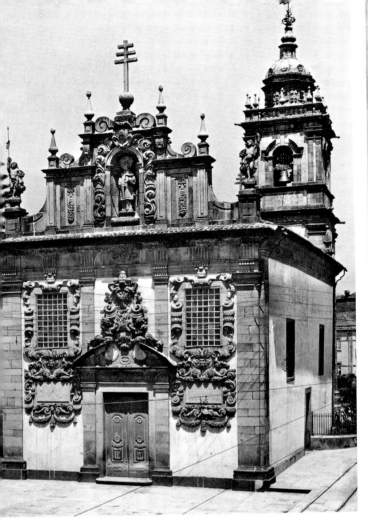

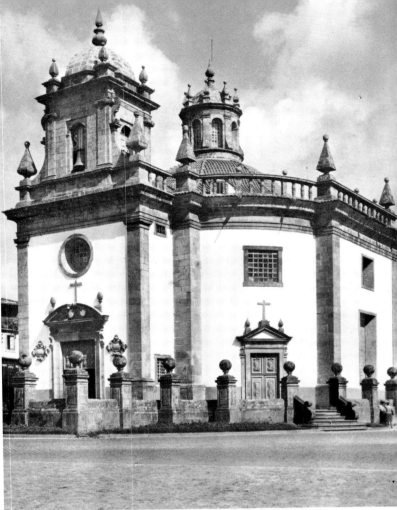

48 Braga. Church of São Vicente, completed in 1691 49 Barcelos. Church of the Senhor da Cruz, *c.* 1708

50 (OPPOSITE ABOVE) João Nunes Tinoco and João Antunes:
Lisbon. Church of Santa Engracia, begun in 1682
51 (OPPOSITE BELOW) João Frederico Ludovice: Mafra. The
Palácio Nacional, begun in 1717

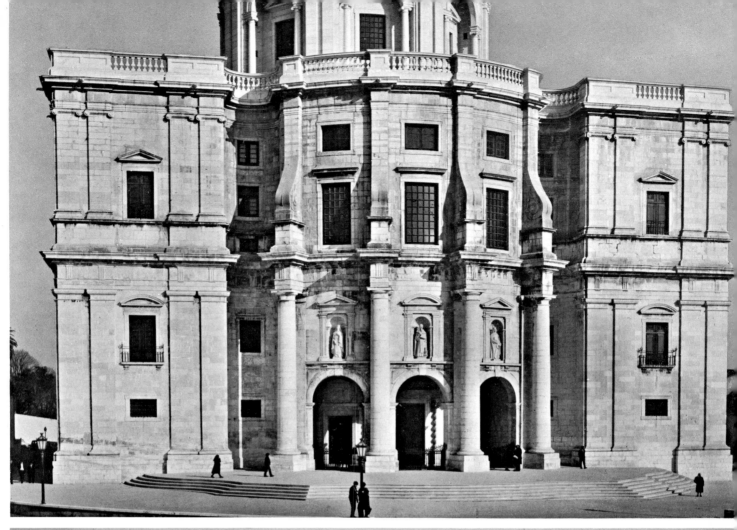

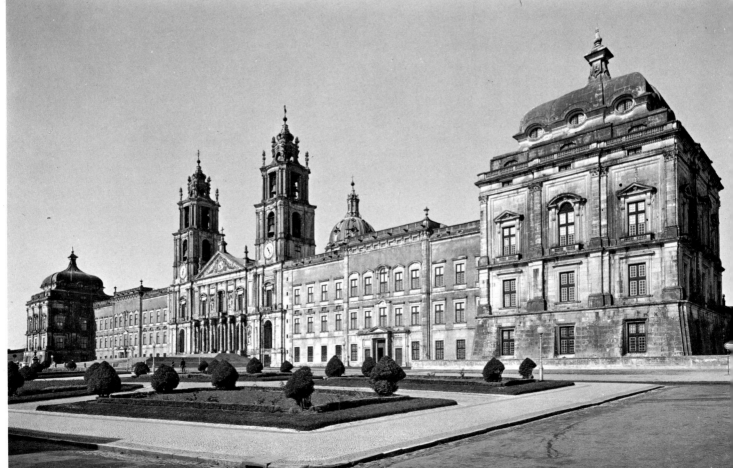

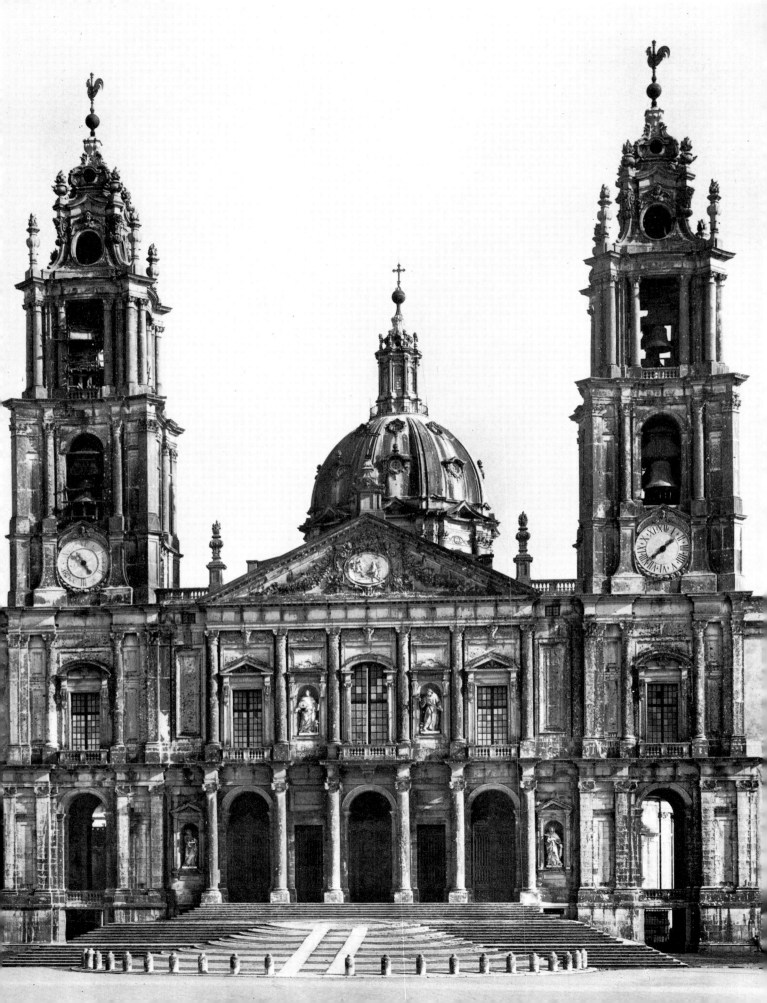

52 (OPPOSITE) João Frederico Ludovice: Mafra. The basilica of Nossa Senhora e Santo António, begun in 1717

53 (ABOVE) António Canevari: Santo Antão do Tojal (Lisbon). Fountain of the former Quinta do Patriarca, *c.*1750

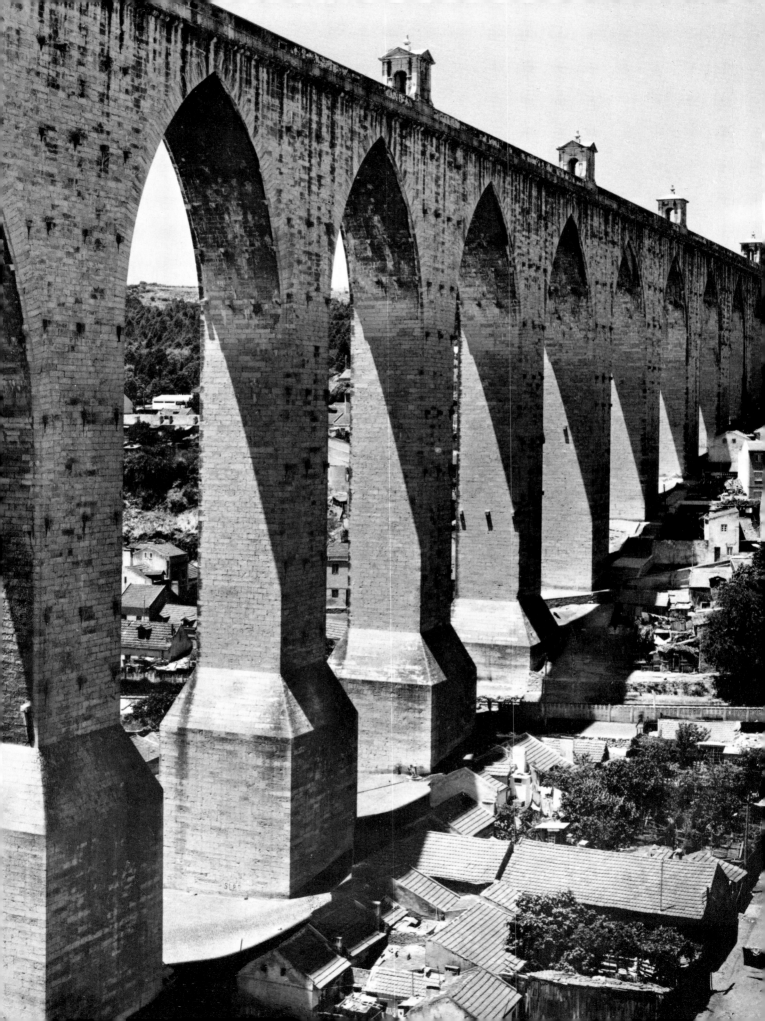

however, is new. There are 'candelabrum' columns and foliated balusters with lion-paw feet derived from the luxuriant fanciful ornament developed in Lombardy in the late fifteenth century which had infiltrated the architecture of France and Spain in the first quarter of the sixteenth. The loggia at Batalha, an abortive effort to Romanize the Capelas Imperfeitas, ends in a sculptured frieze containing Renaissance masks and satyrs holding shields, on one of which the 'candelabrum' columns are applied.

Most of these motifs reappear on the portal of the church at Atalaia, a village near Tomar, which is designed like a Roman triumphal arch. 'Candelabrum' columns not unlike those illustrated in the first Spanish treatise on Renaissance style, Diego de Sagredo's *Medidas del Romano* (Toledo, 1526) are used with the deep broad arch and reappear in the form of reliefs on the pilasters. The portal ends in a sculptured frieze similar to that of the Batalha tribune, but the figures that compose it have a flowing grace associated with French reliefs of stone and wood of the very early sixteenth century. The coffering of the arch also looks French, and the fine heads of the spandrel discs as well as those in much lower relief on the bases of the pilasters suggest the great French sculptor Nicolau Chanterene, active in the area between Coimbra and Évora from 1518 to 1550. The Atalaia doorway, set in a projecting entrance tower, like those of the cathedrals of Elvas and Faro, may date from just after 1542, when the village was transferred from the Crown to Dom Fradique Manoel, from whom descend the Counts of Atalaia. It is typical both in form and decoration of the richest church entrances of this period.

Church plans continued to be designed with rectangular apses, a basic feature of Portuguese architecture, without transepts but with nave arcades, which now were provided with classical columns like those of the Renaissance churches of Italy. One important group has wooden ceilings of the tripart 'casket' form (so named for their resemblance to coffin lids). A famous example of this type is the church of the ancient parish of Marvila at Santarém, an historic town on the Tagus above Lisbon. It was begun by Dom Manuel and finished under his successor Dom João III, who reigned from 1521 to 1557. This accounts for the contrast between the Renaissance nave piers in the form of Ionic columns and the Gothic arches and vaults of the chancel and collateral chapels, which were the first part built. Both sections of the church are now agreeably brought together by the colourful dated tiles of the seventeenth century which cover most of the wall surface. Outstanding churches of this sort were erected in the second half of the sixteenth century at Fronteira in the Alentejo (1570), Abrantes in the Ribatejo (São Vicente, of 1579 and São João Baptista, 1580) and the most sumptuous of all, Santa Maria of Óbidos, a restored walled town near Caldas da Rainha, on the road from Lisbon to Coimbra.

A second group of churches represents the survival of the hall-type plan, with the vaults of nave and aisles constructed on the same level. But instead of a single self-supporting span as at Belém, these later buildings have rows of individual ribbed vaults, set on attenuated columns or piers formed by four elongated pilasters. This was the system followed in the large impressive cathedrals of the three new bishoprics created in 1545 for Leiria, Portalegre and Miranda do Douro. In that of Leiria, begun in 1550-1 by the royal architect Afonso Álvares (active 1550-75), the vaults, some of which are dated 1570, have decorative ribs that are flat and thin in comparison with the heavy rounded ones of the Manueline age, and the new disc ornaments are dry and wan in comparison to the opulent bosses and pendants of the earlier style.

The hall-church plan was especially popular in the province of Alentejo, probably because of its proximity to and cultural ties with Spain, where the cathedral of Jaén

Plate 28

Plate 29

Plate 26

54 (OPPOSITE) Manuel da Maia and Custódio Vieira: Lisbon. Aqueduct of Águas Livres, 1729-48

(1546) established a vogue for this kind of vaulting that extended to those of Spanish America.

A third tendency apparent in the mid-sixteenth century is the use of barrel vaults, which are associated with a new phase of the Renaissance based on a more accurate use of Graeco-Roman forms, '*ao bom romano*', as many contracts of the period specify. This purist attitude, which put an end to extravagant and fanciful decoration, brought Portuguese architecture up to date with the Mannerist fashions of Italy, reducing decisively the time lag that had formerly obtained. The same thing had already happened in France and in Spain, where one of the causes had been the return from Italy of native artists who had gone to study there. This occurred in Portugal with the painter Francisco de Holanda, who came back from Rome in 1541 deeply interested in both architecture and city planning. Much more important, however, was the use of the publications of Sebastiano Serlio (1475-1554), an Italian writer on architecture whose influence throughout western Europe was enormous. These had begun to appear in 1537 and were translated into Spanish by Francisco de Villalpando in 1552.

The treatises of Serlio emphasized pseudo-archeological effects of colonnades combined with arches in rhythmic arrangements where pairs of columns or pilasters alternate with niches, panels or apertures. He recommended the use of geometric ornament and plans based on geometric figures. The effect of such teaching can probably be seen in the small church of Valverde, near Évora, by Manuel Pires, where four octagons form a domed Greek cross, in the octagonal church of the Dominican nuns at Elvas, of 1543-57, and the circular chapel of Santo Amaro in Lisbon, which dates from 1549. These buildings launched a tradition of unusual plans for small churches and chapels that endured for two centuries in Portugal.

Another aspect of Serlio's influence is seen in the Corinthian colonnades and barrel vaults decorated with lozenges within squares of the nave of the little church of Nossa Senhora da Conceição (Immaculate Conception) at Tomar, which was completed in 1551. It is of great importance for Portuguese architecture because of the tower behind the apse, later to be extensively employed at Braga, Oporto and other northern centres, as well as for the V-like arrangement of windows and doorway beneath a triangular pediment, which became a basic scheme for Portuguese building all over the world. The church is attributed to Diogo de Torralva (1500-66), the Spanish son-in-law of Francisco de Arruda. Between 1557 and 1562 he designed and nearly completed the main cloister of the convent of the Order of Christ at Tomar, the style of which permits the attribution to Torralva of the little Augustinian church of Nossa Senhora da Graça at Évora, rebuilt in the years from 1531 to 1537, although its façade may be later in date.

Both buildings show a skilful manipulation of Doric and Ionic columns for bold and theatrical effects and a common fondness for circular forms. These appear as balls above the statues of sprawling giants attributed to Nicolau Chanterene and as decorated discs in the Graça façade. At Tomar they are seen in the round apertures of the cloister and the domed circular stair towers that recall the casemates of Arruda's Tower of Belém and similar motifs at the apse of the nearby Hieronimite church. At the cloister of Tomar they are related to the convex walls of the angle bays, a diverting feature of the façade design, which is composed of a number of Serlio's favourite features. These are the paired columns separated by openings that appear on both stories, the arches incorporating niches of the lower level and the Venetian openings of the upper, where arches are carried on paired piers. This design is very similar to a motif proposed by Serlio in 1546 for

Plate 31
Plate 30

Plate 7
Plate 154

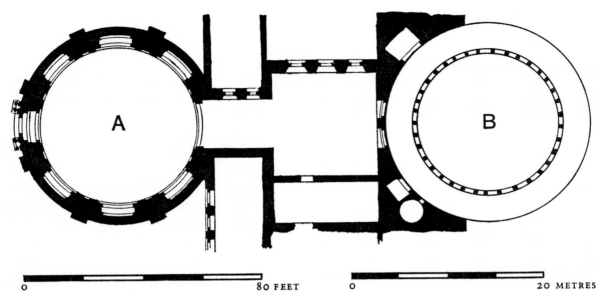

Vila Nova de Gaia. Church and convent of Serra do Pilar. A CHURCH; B CLOISTER

what is now part of the courtyard of the Louvre in Paris; it was constantly repeated in the late sixteenth and seventeenth centuries in Portugal, as, for example, in the porch beside the façade of Nossa Senhora da Graça.

Another constantly recurring element in the architecture of the Renaissance period that can be traced back to this extraordinary small church is the colonnade before a deep recess, which was used for the entrance. This was to become a favourite solution for Portuguese cloisters during the next two centuries. A typical example is that of the Franciscan convent at Guimarães, near Braga, built by the master mason João Lopes about 1600, which resembles the atrium of a Pompeian dwelling. A circular one-story version of the scheme accompanies the Augustinian round church of the Serra do Pilar at Vila Nova de Gaia, which thanks to a recent discovery of Eugénio da Cunha e Freitas[8] is now known to have been constructed, along with the church, by another João Lopes and an associate named Jerónimo Luís between 1576 and 1583. Above the plain panelled parapet of the attic is set a row of ornaments combining an obelisk with a vase and ball which are constantly found on the façades of churches and palaces of the long period of late Renaissance architecture extending from the mid-sixteenth century into the eighteenth.

Plate 32

Plate 33

The circular cloister of the Serra do Pilar, which like the earlier round courtyard of the palace of Charles V in Granada is a forerunner of the nineteenth-century bullring, overlooks the city of Oporto, beyond the green waters of the Douro River. This city, the second in size in Portugal and the capital of the north, possessed very little monumental architecture before the eighteenth century. After 1725 Oporto had a rapid and extensive development, thanks to the port wine trade with England, and this was accompanied, as we shall see, by the work of a brilliant Italian architect, Nicolau Nasoni.

Plates 57-60

During the long period from about 1550 to 1710, which corresponds to the chilling ascendancy of the Holy Office of the Inquisition, architecture of all types became a solemn sober thing that austerely reflects a series of grim historical events already mentioned in the introduction to this book. In 1578 the childless young king Dom Sebastião and many of the nobility were slain at al-Ksar al-Kabir in an ill-fated crusade against the infidel in Morocco. From 1580 to 1640 Portugal was annexed to Spain and this unhappy experience was followed by a long struggle to maintain the national independence.

Évora. Jesuit church of Espírito Santo

The architecture of this period was by no means a Portuguese invention, for a similar bare and rigorous style had appeared in Italy in the first half of the sixteenth century, had entered Spain with Juan Bautista de Toledo and Juan de Herrera, the architects of Philip II's Escorial, and was apparently one of the lessons that Francisco de Holanda taught his compatriots when he returned to Portugal from Rome in 1541. These men were all protagonists of the Mannerist movement in art, a doctrine which, in reaction to earlier Renaissance styles, preached plain, flat surfaces, advocated severe linear effects and, wherever possible, emphasized verticality.

This brooding, pessimistic, essentially negative style was of short duration in Italy, for it soon provoked a counter-reaction in the form of the positive, dynamic Baroque style of the early seventeenth century. Mannerism lasted much longer in the Iberian peninsula and especially in Portugal, where it remained unchallenged until the coming of Ludovice and Juvara from Italy in the eighteenth century. Even then it was never entirely dispelled and again made itself felt as an important ingredient of the Classical Revival of the late eighteenth and early nineteenth centuries.

Portuguese Mannerist churches have three principal characteristics. The first of these involves the plan, first applied in the Jesuit church of Évora, built by Manuel Pires and Afonso Álvares between 1567 and 1574. It consists of a broad undivided nave, designed to accommodate a maximum of congregation and fix attention upon preacher and celebrant, according to the Jesuits' programme. At the sides of the nave lateral chapels are joined by passageways to facilitate circulation. To this crypto-collateral plan, which anticipated that of the Jesuit mother church of Il Gesù in Rome, begun by Vignola in 1568, are added two other Portuguese elements. The first is the narthex-like vestibule formed by the supports of the traditional choir loft at the beginning of the nave. The second is the row of tribunes above the side chapels. These eventually brought corridors and stairs which along with a sacristy set behind the apse provided a complete envelope for the vessel of the church.

Plate 34

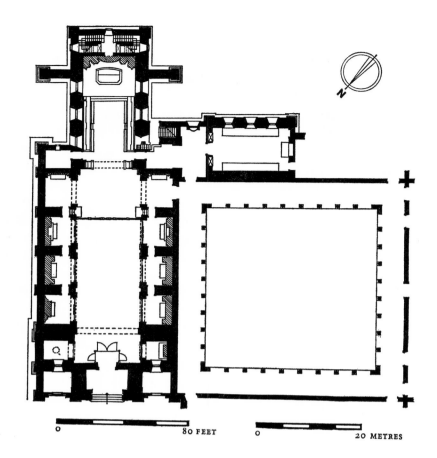

Tibães.
Church of São Martinho

0 80 FEET 0 20 METRES

At the Jesuit church of Évora the nave is covered by a barrel vault of brick; at the Jesuit church in Lisbon, begun by Álvares at precisely the same time, the nave is covered by a painted ceiling built of wood brought from Germany, and colossal pilasters frame the chancel arch. Practically the same formula was used in the Jesuit church of Santarém, the front of which is dated 1676, although the interior window and tribune frames seem to have been added in the eighteenth century. The only significant change from the original sixteenth-century disposition is the greater depth of the barrel-vaulted apse.

 Plate 35

 Plate 36

The tunnel-like covering, which is the second of the general characteristics of Portuguese Mannerist churches, may first have appeared in the present apse of Santa Maria at Belém, begun about 1540. It was soon widely accepted and came to be decorated either with plain coffering as at Belém or the Serlian architectural ornament seen in the late sixteenth-century church of Nossa Senhora da Luz in Lisbon, whose apse is of rose-coloured Portuguese marble. In the great sacristy of Santa Cruz at Coimbra, built by Pedro Nunes Tinoco in 1622-3, along the lines of that of San Esteban of Salamanca in Spain, the multiple compartments of the tunnel vault are repeated in broad pilasters and entablature.

 Plate 4

 Plate 92
 Colour
 plate XIII

In some of the large monastic churches of the late sixteenth and seventeenth centuries these masonry barrel vaults are projected into the nave, as in the Benedictine churches of Oporto (1602-1707) by Diogo Marques, or Tibães (1628-61) by Manuel Álvares or in the anonymous Augustinian church of Moreira da Maia just outside Oporto (1588-1622), where the compartments of the vault are restated in an immense arch of granite at the entrance to the chancel. In a few of the most important churches tunnel vaults are combined with drumless coffered cupolas set above the crossing. One of the finest examples is the Jesuit church of Coimbra, begun in 1598 by Baltasar Álvares (active 1570/75-1624), the nephew of the royal architect Afonso. Neither this church nor the one at

 Plate 105
 Plate 37

 Plate 38

Art of Portugal

Moreira da Maia have nave tribunes, which were sometimes omitted along with the connecting doorways in the lateral chapels.

Plate 10

Plate 40

The third characteristic of these Mannerist churches is the compartmented façade suggesting an altarpiece or retable, a device constantly employed in Spanish architecture, going back to the close of the fifteenth century. It does not appear in Portugal, however, until the mid-sixteenth century, although there is a suggestion of a retable in the portal of Tomar of 1515, designed by the Spaniard João de Castilho. The theme of a Renaissance altarpiece appears in embryo in the façade of the former Jesuit university of Évora, now a secondary school, set in a courtyard of two-story arcades which may have been inspired by those of Bartolomé de Bustamente's hospital of Tavera at Toledo, in Spain, of 1547-8. The design includes prominent geometric ornament, called *almofadas* or pillows in Portuguese, which also appears conspicuously in the miniature retable motif at

Plate 39

the centre of the broad façade of the cathedral of the frontier town of Miranda do Douro. Planned in Lisbon before 1549, the building was constructed by a Spanish builder, Francisco Velázquez, between 1552 and 1576, who may have been responsible for the Escorial-like severity of the entire façade and the strong Serlian flavour of the central composition. There are retables of the same type in the façades of the Dominican churches of Amarante and Viana do Castelo, constructed under the direction of an architect of the Order, Frei Julião Romero, in the period 1549-70. At São Vicente de Fora, the royal

Plate 41

Augustinian church in Lisbon, begun by Philip II's Italian architect Filipe Terzi (1520-97) in 1582, two years after the sixty-year annexation of Portugal to Spain, the concept of a great retable of stone takes possession of the entire façade, which it fills with severe rectangular panels and pedimented niches. This was the most popular formula of the seventeenth century, serving as a model for a great many churches not only in Portugal but in the colonial centres in India and Brazil.

The motif appears at its best in the designs of Baltasar Álvares for the fronts of the great Jesuit churches of Coimbra and Oporto (1614-22). The latter is a masterful com-

Plate 42

position of overlaid planes and architectural orders spectacularly fused in the upper section, which George Kubler has traced back to Mannerist engravings published by the German ornamentalist Wendel Dietterlin in 1598.[9] The design has a vehement force more reminiscent of Boitac than the cold immobility of Terzi's São Vicente de Fora or the

Plate 45

mechanical apathy of the new façade of the Manueline cathedral of Viseu, constructed by Juan Moreno, a minor Spanish builder of Salamanca, in 1635. Here the retable motif is limited to the middle section, between the paired towers, another Serlian feature, which became a constant characteristic of Portuguese architecture, as it did of that of Spain.

These three churches, all of which have double-tower façades, illustrate the three common types of late Renaissance doorways. At São Vicente de Fora there is an Italianate loggia of three arches framed by giant pilasters, which became a commonplace of Carmelite and Benedictine churches. At Viseu there is a single broad opening and this solution was long preferred by the Capuchin branch of the Franciscan order. In the Jesuit church of Oporto there are three Serlian doorways, the centre one framed by a retable motif of double columns and broken pediment, like that of the chancellery of the cathedral of Granada, completed in 1587. This type of entrance is found in Jesuit churches all over the Portuguese world.

The façade of the cathedral of Viseu is part of one of the finest ensembles in Portugal of architecture of the seventeenth-century style, although some of it dates from the eighteenth century. The former episcopal palace on the left, which now houses the Museu

de Grão Vasco, the chapter house at the right, with the typical columnar *cruzeiro* or monumental crucifix in the centre, all constructed of granite, emphasize this style of severe and stately geometric forms that remained so long in fashion.

They also are an essential part of the celebrated residences on the country properties called *quintas* in northern Portugal, where paired or single towers of cubic form are combined with colonnades like those of monastic cloisters. The house of Bertiandos near Ponte de Lima in the province of Minho goes back to a fortified tower built by the lady Inés de Pinto in 1566, which joins two handsome and similar structures of the seventeenth and eighteenth centuries. In front of the house there is a milestone of a Roman highway. The courtyard of the town house of the Alarcão family in Guarda has a colonnaded gallery built over a depressed arch like those of Bertiandos, and this abuts in characteristic fashion an austerely designed chapel dated 1686. Plate 44 Plate 43

A somewhat richer style, with panelled surfaces like the compartment vaults of the churches, is seen in the houses built by Manuel Pinto de Vilalobos (died 1734), a military engineer of Viana do Castelo, who like many of his colleagues in Portugal and Brazil did a great deal of civic building. His Casa da Vedoria, constructed for the royal intendant or *vedor* Dom João de Sousa in 1691, provided the model for a group of handsome dwellings in Viana, one of which is now the museum of that northern seaport. Characteristic of the period are the iron balconies with balusters imitating turned vase forms of wood and the wooden shutters of the lower windows, which were the common form of fenestration before sash glazing became common in the second half of the eighteenth century. Another type of window covering was the old Moorish system of latticed screens, now almost extinct. An illustrated manuscript of 1750 in the library at Braga[10] shows whole streets of the city filled with houses whose façades were composed almost entirely of these *rótulas*, which were generally painted green. Houses of this sort were occupied by merchants and other wealthy middle-class persons rather than by noblemen, who lived in palaces built around courtyards like that of the Alarcão family in Guarda. Plate 47 Plate 46

At Braga in the late seventeenth century anonymous masons enlivened the façades of a number of small churches (São Vitor, 1686; Terceiros de São Francisco, 1690; São Vicente, 1691) with animated carving in granite. The last of these buildings, which possesses a rear tower characteristic of Braga added in the eighteenth century, has a façade in which window panels and a niche are surrounded by high-relief compositions of volutes and garlands executed in a fat style that is already Baroque. It seems to have been inspired both by the puffy gilt woodcarving that was appearing at the time in Portuguese churches and by imported Netherlands engravings. Above the portal is a deliriously framed panel and over the cornices are statues that explain the style of the armorial targes on the face of the Casa da Vedoria at nearby Viana. Plate 48

This kind of decoration, which lasted well into the eighteenth century, is not found in other towns close to Braga. At Barcelos, for example, there is the prominent church of the Senhor da Cruz, constructed about 1708 from a design, it seems likely, of João Antunes (active *c.* 1678-1712), the prolific royal architect of Dom Pedro II (1683-1706). The structure has a central plan of great interest which combines a Greek cross with a cylinder rising to a low, typically Portuguese tiled cupola. Plate 49

The plan is related to that of the large Lisbon church of Santa Engrácia, which has recently been proclaimed the national pantheon of Portugal. It was begun in 1682 by João Nunes Tinoco (1631-90), to whom the Jesuit church at Santarém has been attributed and who was succeeded at Santa Engrácia by João Antunes. This spacious building was Plate 50 *Plate 36*

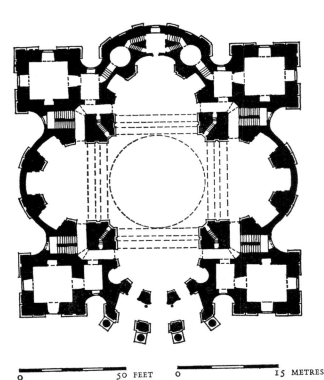

Lisbon. Church of Santa Engrácia

0 50 FEET 0 15 METRES

not finished until 1966, when government architects put the last touches on a specially contrived cupola, thus invalidating the old Portuguese expression – *obras de Santa Engrácia* – meaning work that is never completed.

The central-type plan is that of a Greek cross with rounded arms framed by four square towers, which might have been suggested by Bramante's scheme for St Peter's. On the entrance front four gigantic Doric columns frame a triad of arches and pedimented niches that repeat virtually without alteration the Italian Mannerist spirit of São Vicente de Fora of a century before. The interior of Santa Engrácia, which with its four semi-domes is spatially one of the handsomest in Portugal, has a new splendour of coloured marbles set in brilliantly contrasting stripes and geometric patterns typical of the late seventeenth century, which João Antunes was to use in the tomb of the Infanta Joana at Aveiro.

Plate 41

Colour plate VIII

Santa Engrácia was the most ambitious of a large number of buildings of all categories – churches, convents, public structures and private palaces – erected in Lisbon in the last phase of the Mannerist style. Many of them can be partially seen in old panoramas made before the earthquake of 1755, when the great majority of them were destroyed or severely damaged. No one can now say how great was their influence in other parts of the country, how many in fact are reflected in provincial buildings like the church of the Senhor da Cruz at Barcelos.

Plate 49

This building, in spite of its unusual plan and handsome proportions, has exterior decoration of a brutally simple sort quite similar to what was in favour a century before. The exterior, like so many others of this period, relies almost entirely for effect upon the contrast between sparkling white walls and the sombre tonality of the granite trim. In the course of the eighteenth century this combination will remain a basic scheme of Portuguese architecture but the design of the trim will undergo revitalizing changes, when Mannerism is succeeded by the Baroque and Rococo styles. These changes will also reflect, especially in the second half of the century, the same strong regional characteristics found in the woodcarved interiors of that period.

55 (OPPOSITE) José Francisco de Abreu: Vila Viçosa. Church of Nossa Senhora da Lapa, *c.* 1756

56 Gregório das Neves: Évora.
Doorway of the church of the Santa
Casa da Misericórdia, c. 1767

57 Nicolau Nasoni: Oporto. Doorway of the church of Nossa Senhora do
Terço, 1756–71

58 (OPPOSITE) Nicolau Nasoni: Oporto. House of Dr Domingos Barbosa
(Casa-Museu de Guerra Junqueiro), before 1747

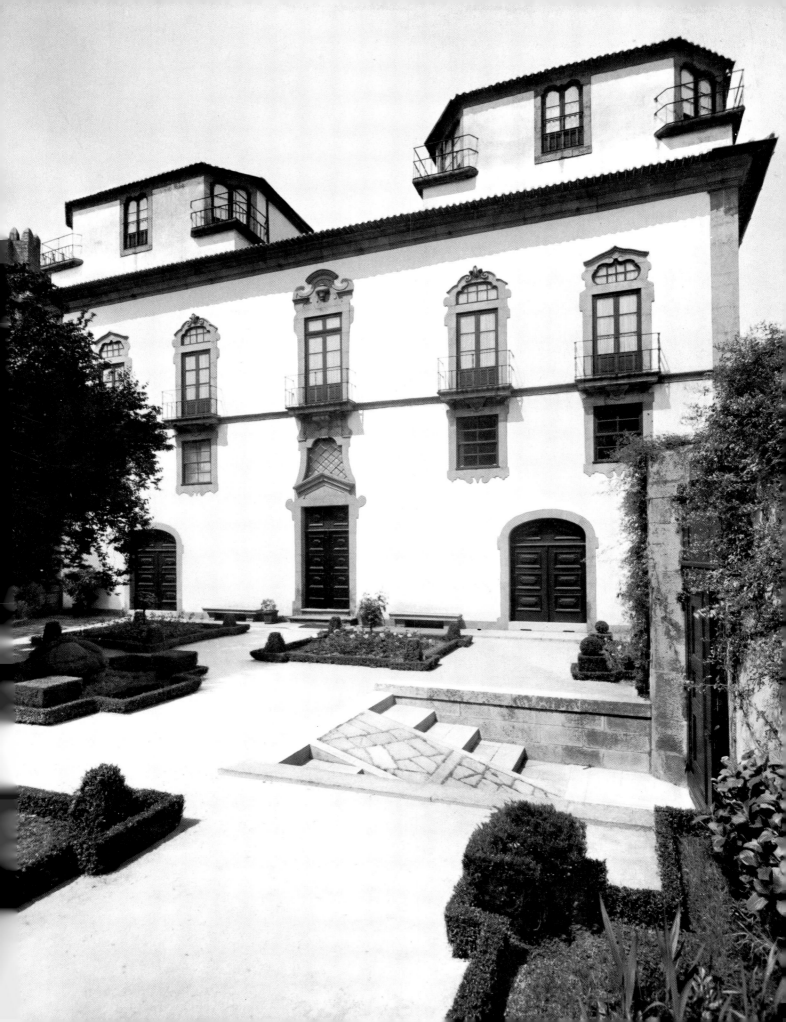

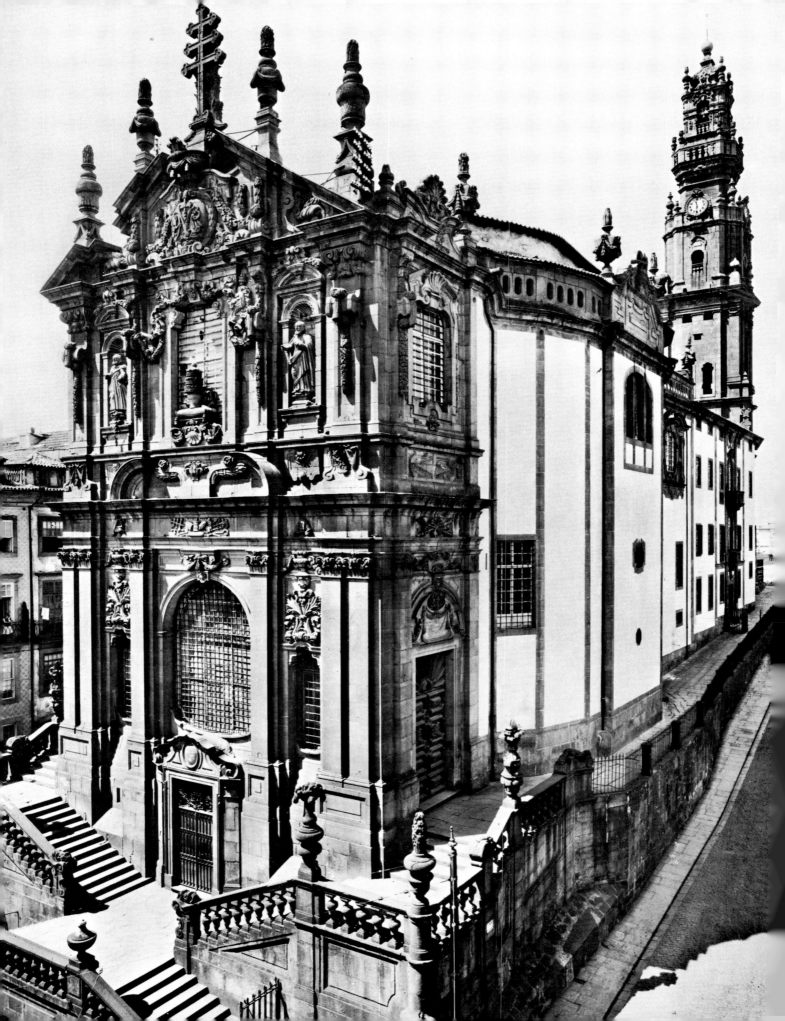

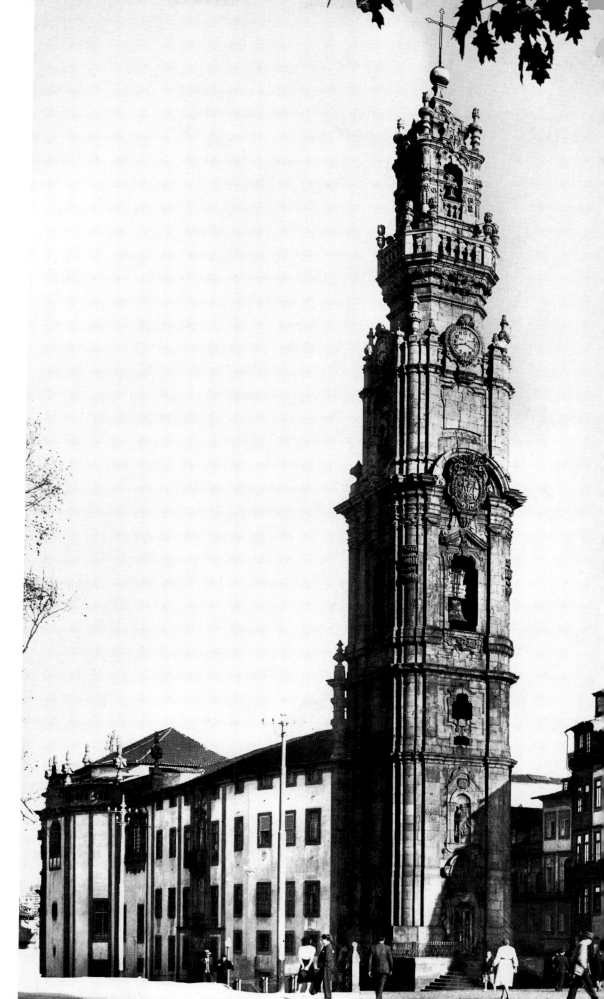

59 (OPPOSITE)
Nicolau Nasoni:
Oporto. Church of
the Clérigos, 1731–49
60 (RIGHT) Nicolau
Nasoni: Oporto.
Tower of the
Clérigos, 1754–63

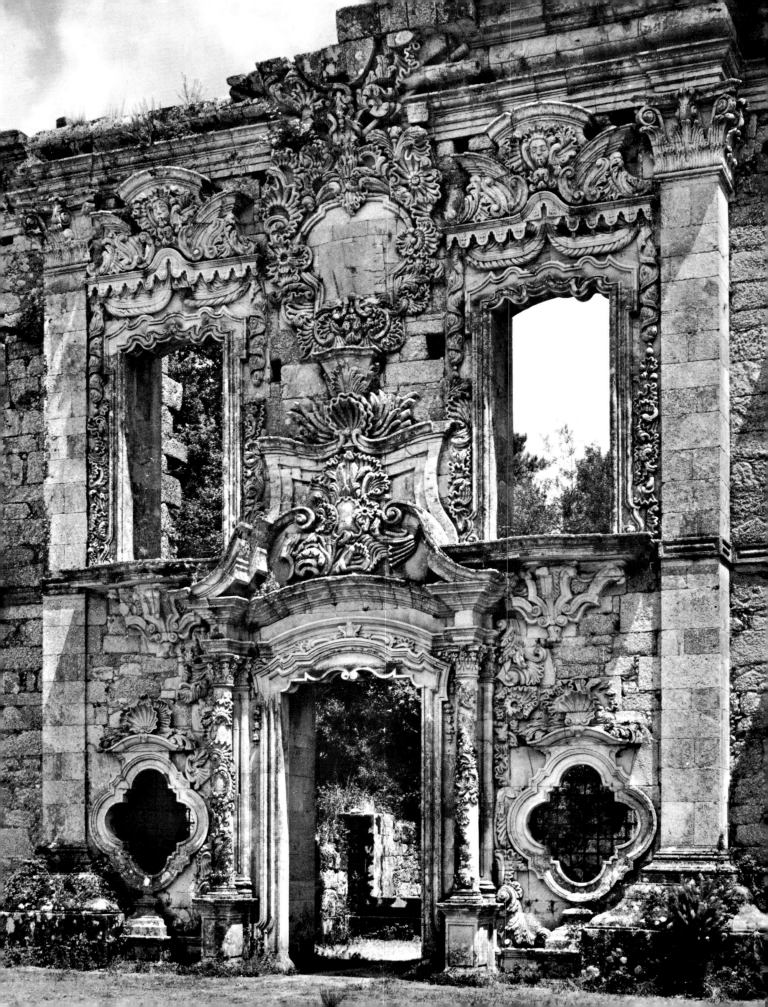

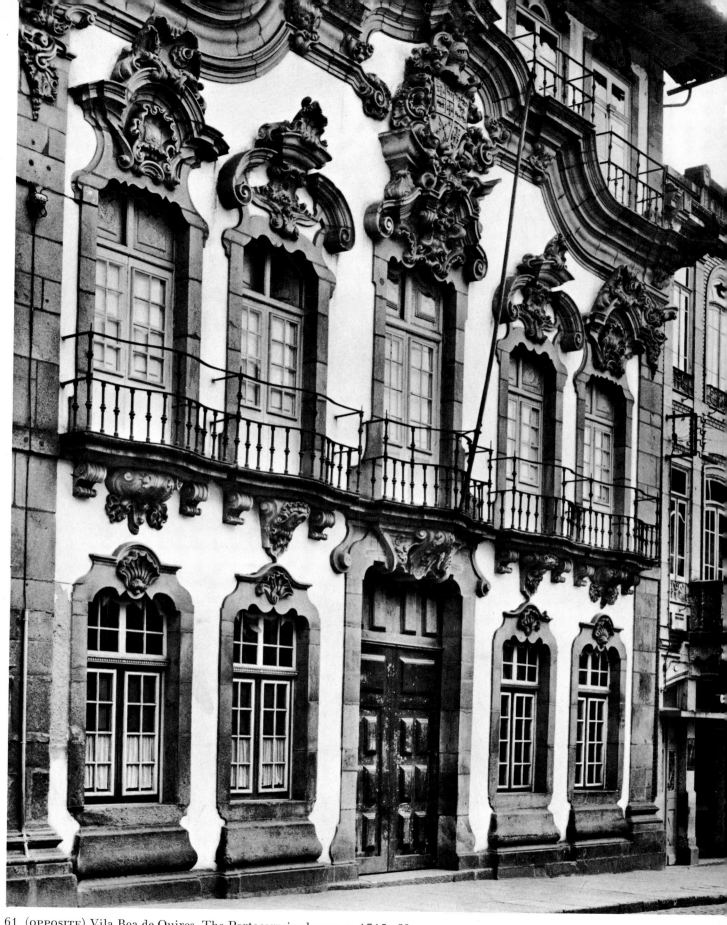

61 (OPPOSITE) Vila Boa de Quires. The Portocarreiro house, *c.* 1745–50
62 (ABOVE) Guimarães. The Lobo Machado house, *c.* 1750–75

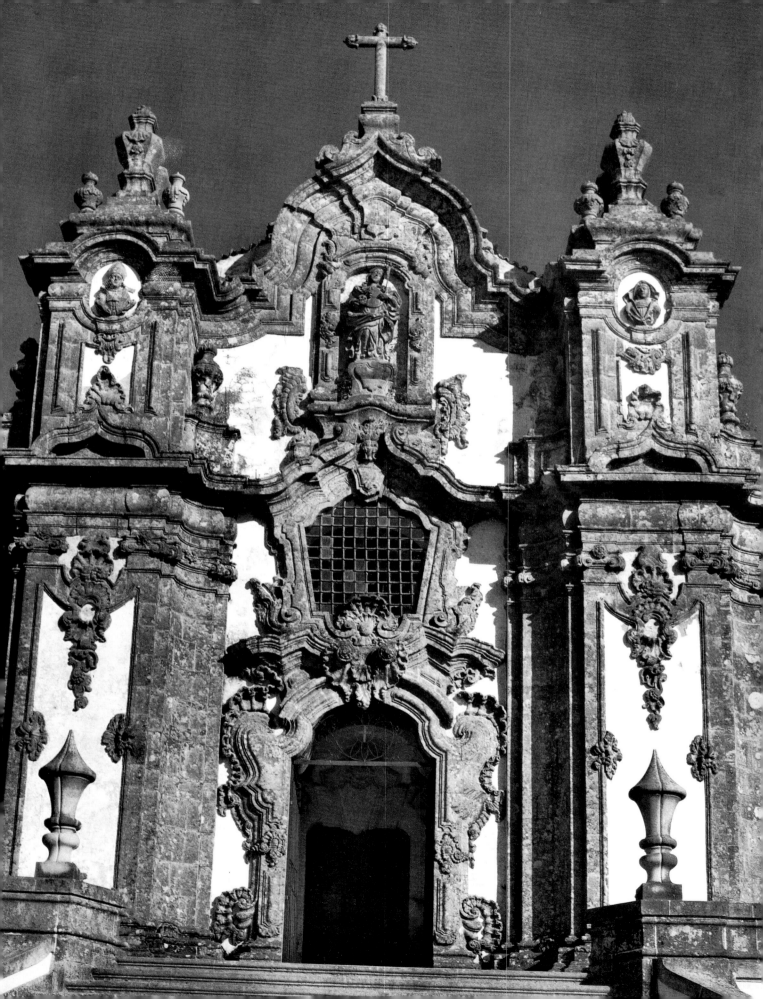

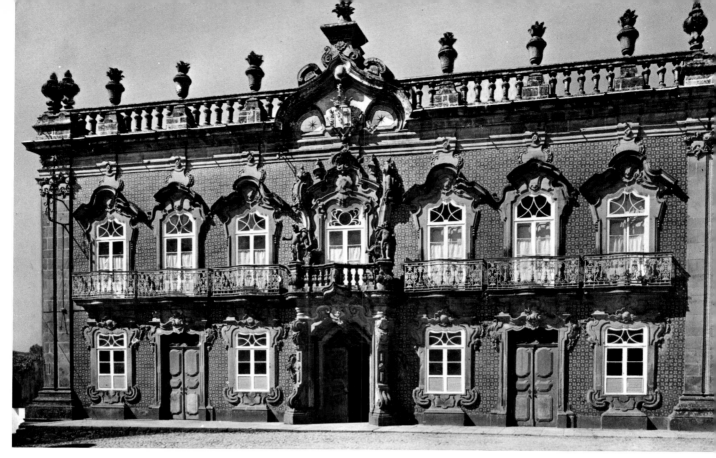

64 André Ribeiro Soares da Silva: Braga. The Raio house, 1754–5

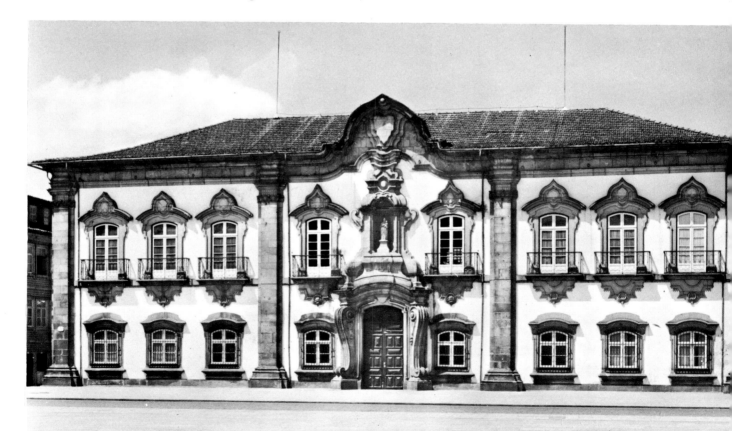

65 (ABOVE) André Ribeiro Soares da Silva: Braga. The city hall, 1753–6

63 (OPPOSITE) André Ribeiro Soares da Silva: Falperra. Chapel of Santa Maria Madalena, 1753–5

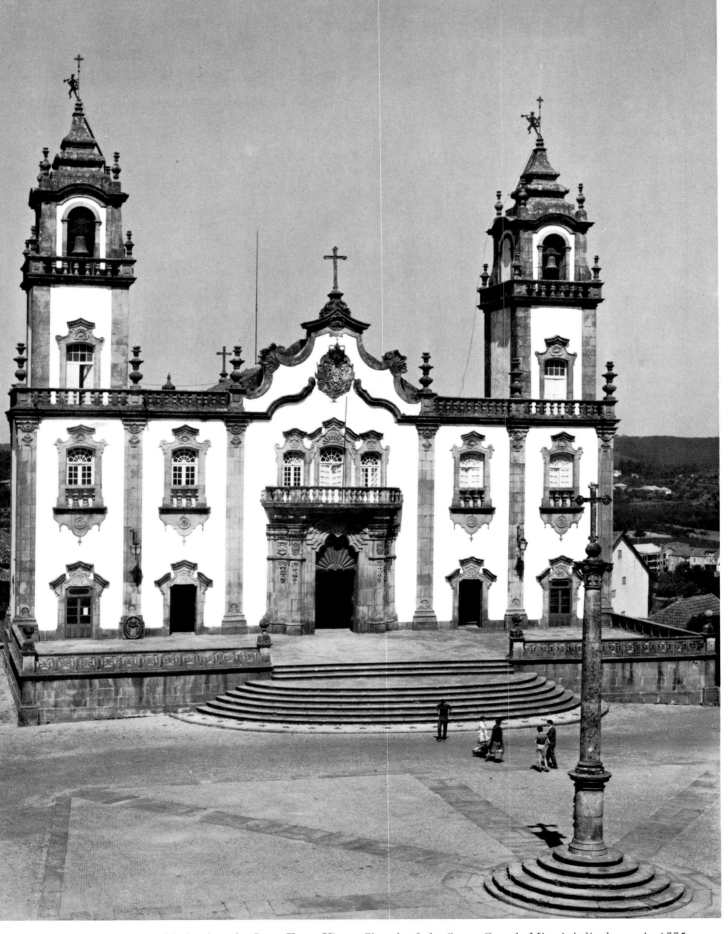

66 António da Costa Faro: Viseu. Church of the Santa Casa da Misericórdia, begun in 1775
67 (OPPOSITE) Lamego. Church of Nossa Senhora dos Remédios, 1750–60

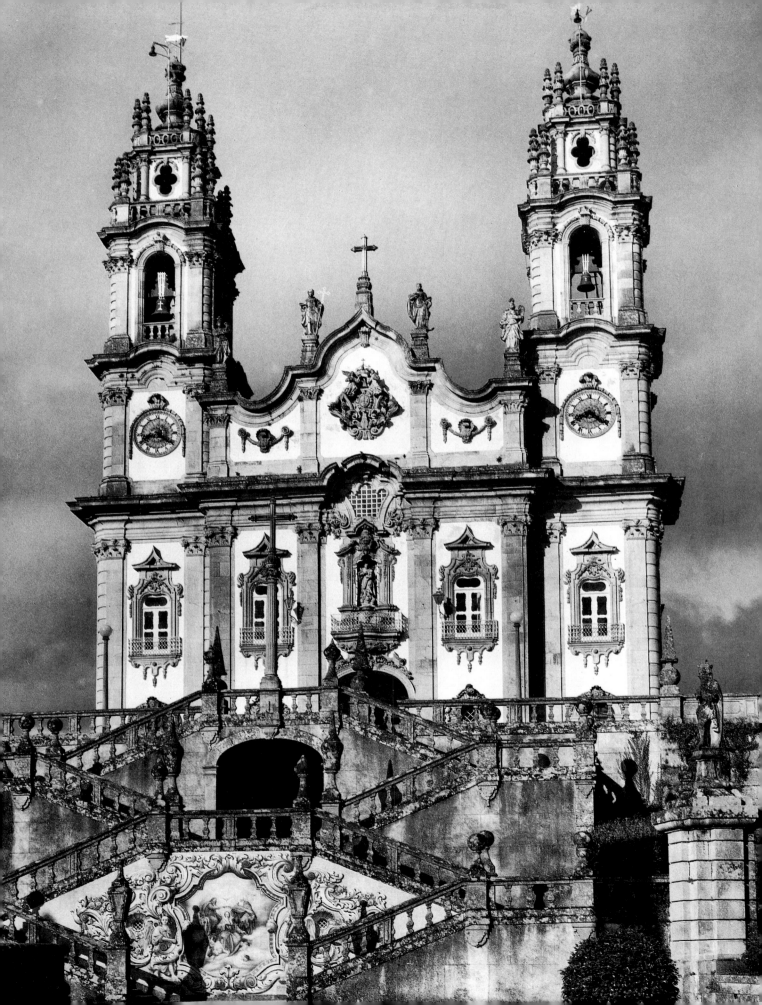

THE EIGHTEENTH CENTURY

This was the state of Portuguese architecture when in 1706 the young Dom João V began a reign that was to last until 1750. Colossally rich from the tax of a royal fifth he received on all the gold and diamonds of Brazil, the king spent fortunes on buildings and works of art, distributed throughout the country with the same generosity that had distinguished his great predecessor Dom Manuel. In the Joanine era Portuguese architecture was again brought up to date with that of Italy, this time with the Baroque style of Bernini and Borromini and their eighteenth-century followers, several of whom worked for Dom João V.

The first was Filippo Juvara (*c.* 1676-1736), the great architect of Turin, who in 1719 spent six months planning a new palace in Lisbon and a large church for the Patriarchate recently created for the city. These plans, known through sketches in the museum at Turin, came to nothing and the king turned his attention to Mafra, a site just north of Sintra, where in gratitude for the birth of an heir he had decreed a votive church and convent for thirteen Capuchin friars. Begun late in 1717, the scheme was gradually enlarged until it became a colossus capable of lodging three hundred, with half as many novices as well. Mafra was designed by João Frederico Ludovice (1670-1752), a German goldsmith trained in Augsburg and Rome, who in 1701 came to work for the Jesuits in Lisbon. He was assisted by the Italian builder Carlos Baptista Garbo (Carlo Battista Garbo) and later his son António (Antonio), who took charge of some thirty thousand craftsmen drawn from all over the kingdom to carry out the vast undertaking as speedily as possible. The church was consecrated in 1730.

Mafra. The basilica
and Palácio Nacional

68 (OPPOSITE) Guimarães.
Lobo Machado house.
The stair, *c.* 1750-75

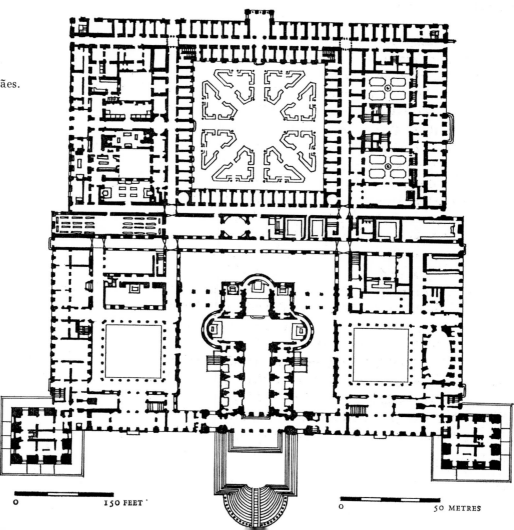

0 150 FEET

0 50 METRES

Art of Portugal

Plate 51

Plate 52

Plate 153

Colour plate IV

Colour plate V

Plate 133

Plate 54

The plan of Mafra is an enormous gridiron some 850 feet square, with a church in the centre of the main façade, which houses a palace surrounded by courtyards. In this respect it resembles certain great Baroque abbeys of Austria and Germany, while the elevations evoke the grand thoroughfares and *piazze* of seventeenth-century Rome, from which the amateur architect selected his models. The front of the church suggests Maderna's St Peter's, the towers Sant'Agnese by Francesco Borromini, the two flanking blocks the palace of Montecitorio, by Bernini and Carlo Fontana, while the end pavilions are reminiscent of Terzi's great sixteenth-century tower of the Casa da Índia, adjacent to the royal palace in Lisbon, destroyed in the earthquake of 1755. Finally, the bulbous cupolas suggest south German architecture. The interior of the church of Mafra, covered with Portuguese marbles like that of the apse Ludovice added between 1716 and 1746 to the Romanesque cathedral of Évora, culminates in the first grand Baroque dome erected in Portugal. This, the steeples of the spires and various door and window frames provided models for the architects of southern Portugal for the next half century.

Another of the prime works of the reign, the royal library presented by Dom João V to the University of Coimbra, which dates from 1716 to 1728 and is therefore contemporary with Mafra, has been attributed to Ludovice, but the style does not suggest him. The building records mention only the names of Gaspar Ferreira, an architect and wood sculptor of Coimbra, who between 1719 and 1724 directed the construction of the bookshelves, and a number of other minor craftsmen. The style of the splendid gilt woodcarving of the interior points to the Avignon sculptor Cláudio de Laprada (1682-1738), who, having emigrated to Portugal before 1700, spent the first years of the century working at Aveiro and Coimbra in a similar manner before beginning in 1703 a distinguished career as a wood sculptor in Lisbon. The resemblance of the interior arches of the library, strangely ornamented with pointed motifs projecting from the soffits, to the stone arch of the façade, which in turn is practically identical to that of the church of the Senhor das Barrocas in Aveiro, unquestionably by Laprada, seems to justify the attribution to this little-known Frenchman of the general design of the library of Coimbra.

Essentially a one-story building, though with several basement layers, the library consists of three great wainscoted rooms, which make it the chief civil counterpart of the wooden church interiors of the Joanine period. Three lofty marblized arches with gilt brackets, garlands and targes lead to a portrait of the founder, attributed to the Italian painter Giorgio Domenico Duprà, surrounded by curtains parted by putti simulated in polychromed wood. The walls are hidden by great bookcases in two stages, the lower with long tapering *gaine* supports like those of French tables of the late seventeenth century. These were covered with *chinoiserie* decorations in green, scarlet and gold by Manuel da Silva of Lisbon in 1723. In the same year António Simões Ribeiro and Vicente Nunes began to decorate the ceilings with illusionistic architectural paintings like those of such contemporary churches as Nossa Senhora da Pena and the Menino Deus in Lisbon. The resulting combination of brilliant colours, richly gilt surfaces and grandiose Baroque forms, in spite of unfortunate restorations, creates a magnificent effect characteristic of the best Joanine art.

The third great undertaking of the reign and by far the most monumental is the noble aqueduct of Águas Livres (Free Water) which the king gave to the city of Lisbon. Constructed between 1729 and 1748, under the direction of the architect Custódio Vieira and the engineer Manuel da Maia, it extends for 61,040 feet and is borne on one hundred and nine arches of *pedra lioz*. The most spectacular are the fourteen of the section

IV (OPPOSITE) João Frederico Ludovice: Mafra. Interior of the basilica, begun in 1717

are heavier than the best French taste would have permitted. They suggest the kind of woodcarving that the Portuguese placed over the cornices of Rococo altarpieces and at the top of mirrors and the backs of chairs. The panelled lintel of the doorway and the Borrominesque surround of the window above, the latter a forerunner of a popular Pombaline theme, show how little inclined eighteenth-century Portuguese architects were to depart from the Italian style. This main façade block, handsomely flanked by one-story wings, fronts on a parterre of privet and box containing two Rococo English lead fountains, which is the beginning of a series of formal gardens that envelop the various south and east façades of the palace of Queluz.

Plate 250

Two of these belong to the second campaign of building. This started in 1758, just before Dom Pedro's marriage to his niece, the future Dona Maria I, when João Baptista Robillon (Jean-Baptiste Robillon, died 1782), a French artist who had worked for the eminent Parisian silversmith Thomas Germain, was employed to extend Queluz at a lower level, at the left of the garden façade. The new work and especially the east front are less happy, for this is 'silversmith' architecture, in which an accretion of statues and reliefs overwhelms the pilasters and windows. The design is, however, held together by a Doric paired colonnade suggesting that of Héré de Corny's Intendancy palace in Nancy. This leads at the southwest corner to a sumptuously decorated stairway descending to a canal, bridge and fountain faced with colourful tiles, beside which William Beckford, the English dilettante, ran a race in June of 1796 with one of the maids of honour of Dona Carlota Joaquina, Princess of Brazil.[13]

To this second phase of construction belongs the former throne room, created with the assistance of another French decorator, Antoine Collin, by the distinguished Lisbon wood sculptor Silvestre de Faria Lobo (died 1769), who worked for decades at Queluz. The great feature of the room is the sinuously shaped white-and-gold ceiling over which are strewn delicate French Rococo tendril motives. They contrast both with Grossi's lustier Italian version of this ornament at the church of Paulistas and the wooden ceiling of almost a hundred polygonal compartments in the boardroom of Nasoni's palace for the Third Order of St Francis at Oporto, carved in 1748 by José Martins Tinoco, probably on designs of the architect. Compartmented ceilings of this sort, which developed from those of churches like that of Marvila in Santarém, were the principal decorative elements of eighteenth-century country houses, along with the stone balusters and parapets of stairs leading from the entrance vestibules to the principal apartments above. These are especially handsome in the north of Portugal, where by the middle of the eighteenth century the dramatic novelties and profuse ornament of Nasoni's style, both in the carving of granite and the designing of gilt woodwork, had produced a number of distinguished local schools.

Plate 80

Plate 79

Plate 29

Plate 68

All have in common the carving in granite of powerful decorative forms alive with an urgent sense of being, unknown in Portugal since the early sixteenth century. Frequently this ornament takes the form of fantastic shells and vegetation, but these conventional Rococo themes are given an entirely new interpretation that changes a delicate feminine art into something intensely vigorous and earthily dramatic. It is a style unique in Europe which has the closest connections with the contemporary woodcarving of the churches of northern Portugal.

This can be seen in the spectacular window frames of an unfinished country palace of the Portocarreiro family at Vila Boa de Quires in the Douro valley near Marco de Canaveses. This romantic ruin is said to have been constructed by a Spanish architect between

Plate 61

V (OPPOSITE) Coimbra. Interior of the library of the university, begun in 1716

1745 and 1750, and this would account for the curvaceous windows of a sort found all over the Spanish-speaking world that flank the principal doorway. But it was the gilded wooden cornices of Oporto churches that influenced the upper windows, with their lambrequins and simulated curtains and the inverted pediments of Nasoni. The crinkled asymmetrical foliage and undulant lintels of his late style appear in other parts of this extraordinarily picturesque composition, together with a profile in the lintel of the doorway that seems to come from the skirting of the Chippendale category of Oporto chairs.

Plate 250
Plate 62

More conventional is the noble façade of the Lobo Machado house in Guimarães, where the lintel forms are taken directly from those of Nasoni. The superbly carved voluted and inverted pediment forms of the window cornices are also derived from his work in Oporto. But here they have been rearranged and given a more powerful expression, perhaps by a member of the Cunha Correia Vale family of local architects and sculptors, one of whom, named José, designed before 1784 the not unrelated façade of the chapel of the Third Order of St Dominic in Guimarães. The wonderful swinging lines of the cornice of the Lobo Machado house, which draw together the whole sumptuous design, come directly from the architecture of the neighbouring city of Braga.

This ancient place, the seat of the primates of Portugal, enjoyed an artistic Renaissance under the rule, from 1741 to 1789, of the royal archbishops Dom José and Dom Gaspar de Bragança, illegitimate brother and son respectively of Dom João V. This period of opulence produced the most brilliant of the local schools of the north headed by the sculptors José Álvares de Araújo (died 1762) and Frei José de Santo António Vilaça and the architect André Ribeiro Soares da Silva (active *c.* 1753 until his death in 1769). The last of these men, described in a document of the latter year as a *simples curioso* or amateur, seems to have invented the two principal formulas of the Braga style. One of these is the cornice already noted, in which a flaring pedimental form is set over the apex of an abruptly rising curve to produce a dramatic motif that takes the place of the conventional pediment in the centre of the façade. The other basic formula is the use throughout of a design of twisted and ruffled shells which owe something to Nasoni but more to contemporary Augsburg engravings, which are a Rococo version of the seventeenth-century *Ohrmuschelstil* or Auricular style of southern Germany.

Plate 63

The developed style is seen in the chapel of Santa Maria Madalena on the hill of Falperra above Braga, designed by André Soares and built between 1753 and 1755 by the masons João Rodrigues and Domingos Alves, who also carved the statues. It has a masterful small façade, where simulated towers, doorway, window, niche and cornice all seem to coalesce into one scintillating plastic mass. On the basis of this design there has been

Plate 64
Plate 77

attributed to Soares the Casa do Raio in Braga, erected in 1754-5 for João Duarte de Faria, whose façade offers a startling contrast to that of Queluz. The expression of force inherent in the style reaches its climax in another attributed palace of the same date, the

Plate 65

city hall of Braga, where stripped of superficial ornament the plastic grandeur of the eccentric forms involved is fully felt. The building overlooks across an ample square one wing of the archepiscopal palace, completed in 1751, where the decorative shells which André Soares was later to develop seem first to have made their appearance.

In the interior province of Beira Alta, a simpler and flatter style of ornament obtained, which local masons individualized by the use of tasselled bibs beneath conspicuous granite window frames in a series of stately two-tower church façades, which frequently rise theatrically on hill tops. Most of the great structure of Nossa Senhora dos Remédios

Plate 67

at Lamego was built between 1750 and 1760 (the towers date from the nineteenth

69 (OPPOSITE) João Grossi: Lisbon. Church of the Paulistas. Detail of the vault of the nave, *c.* 1760

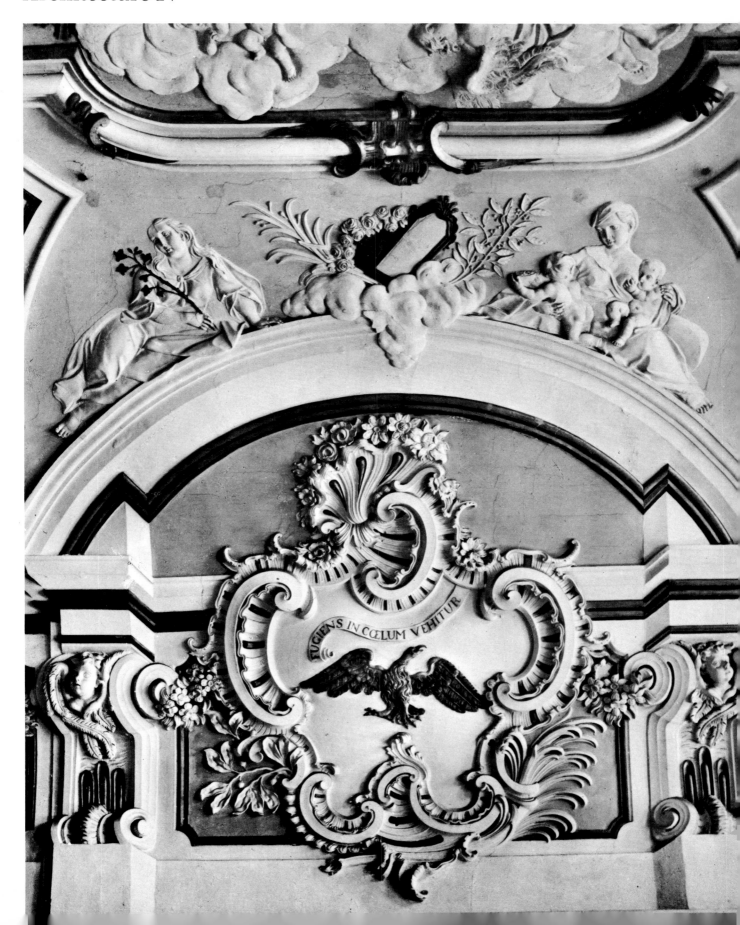

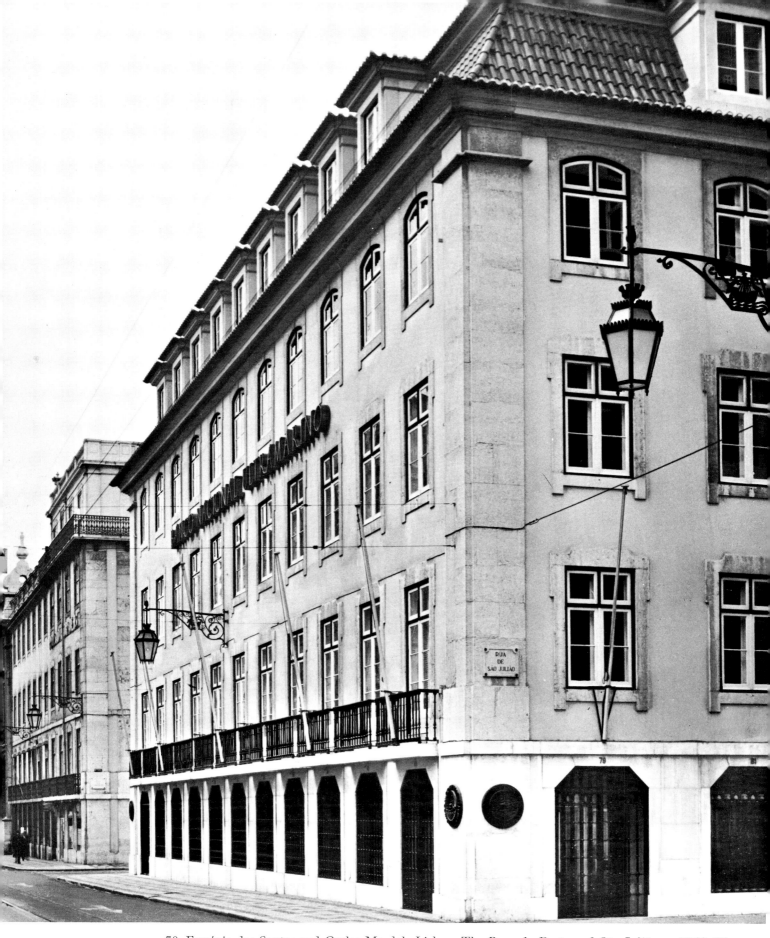

70 Eugénio dos Santos and Carlos Mardel: Lisbon. The Ruas da Prata and São Julião, *c.* 1756–70

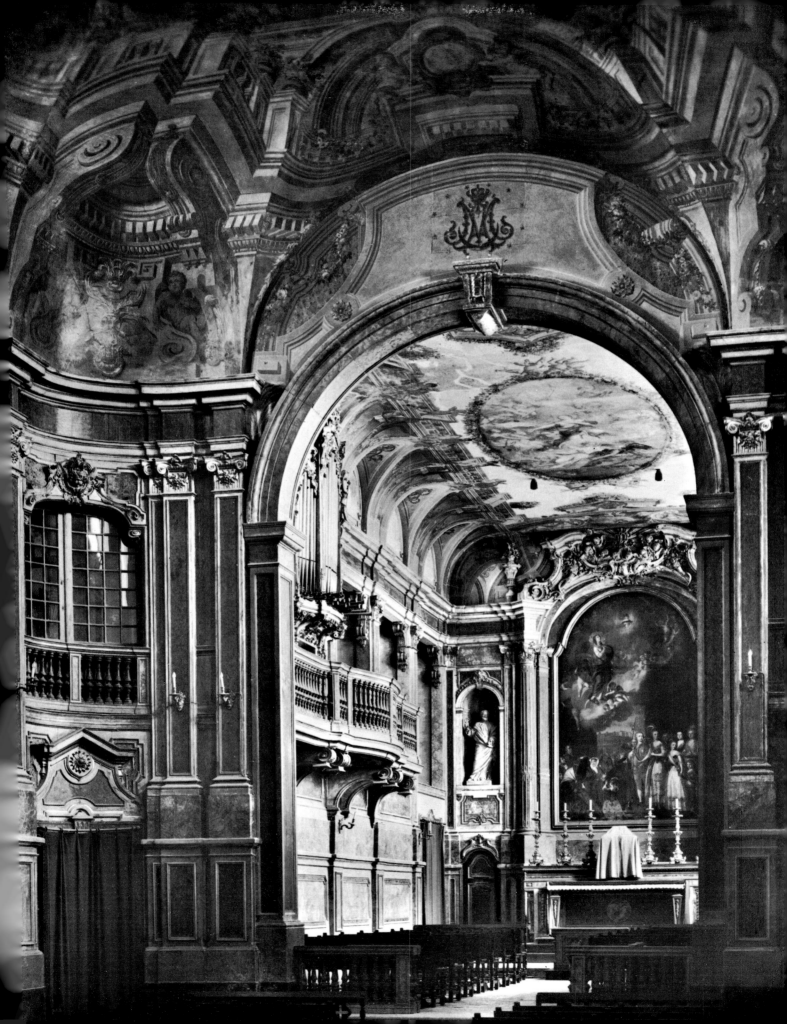

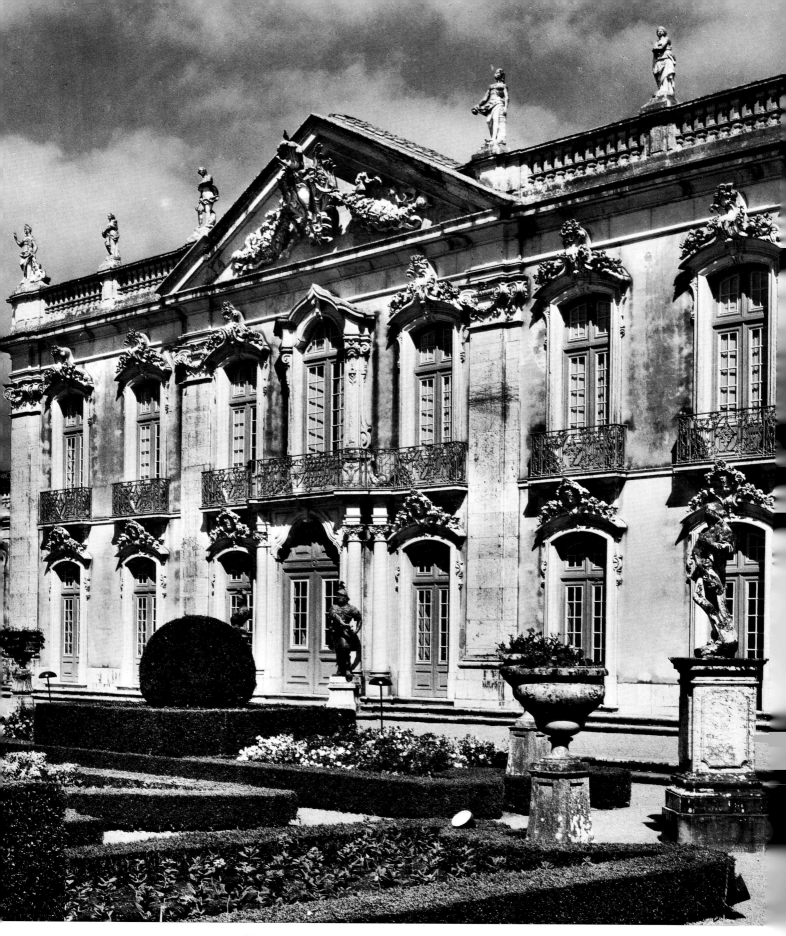

77 Mateus Vicente de Oliveira: Queluz. The Palácio Nacional. Garden façade, 1747–52

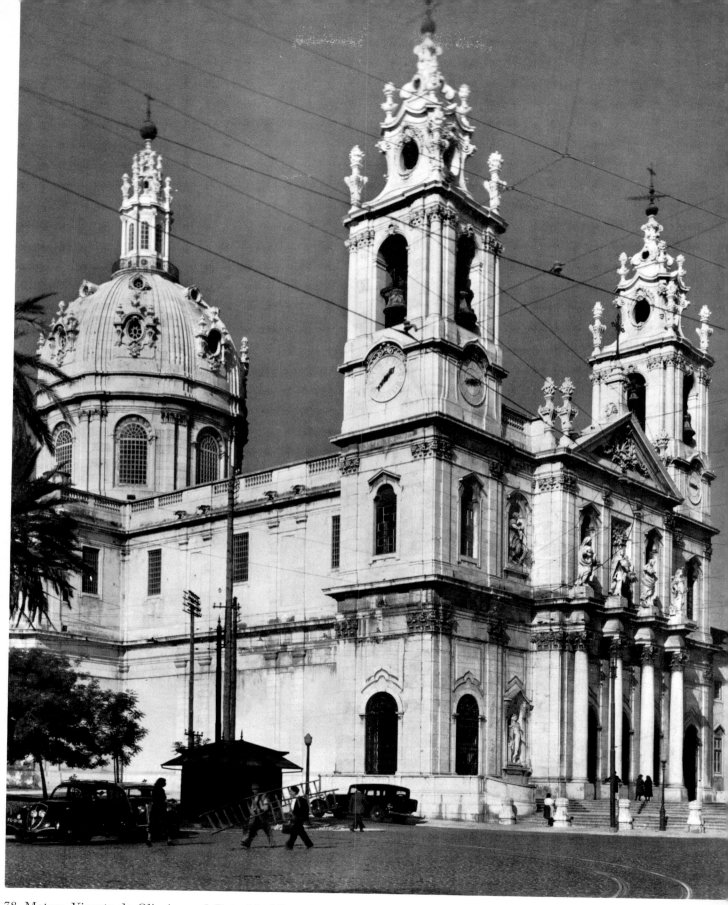

78 Mateus Vicente de Oliveira and Reinaldo Manuel dos Santos: Lisbon. Basilica of the Sagrado
Coração (Estrêla), 1779–90

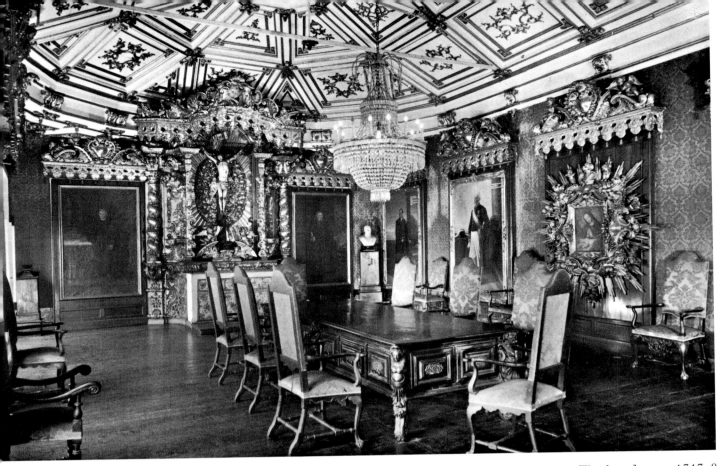

79 Nicolau Nasoni: Oporto. Building of the Third Order of St Francis. The boardroom, 1747–8
80 Antoine Collin and Silvestre de Faria Lobo: Queluz. The Palácio Nacional. The former throne room, c. 1758–68

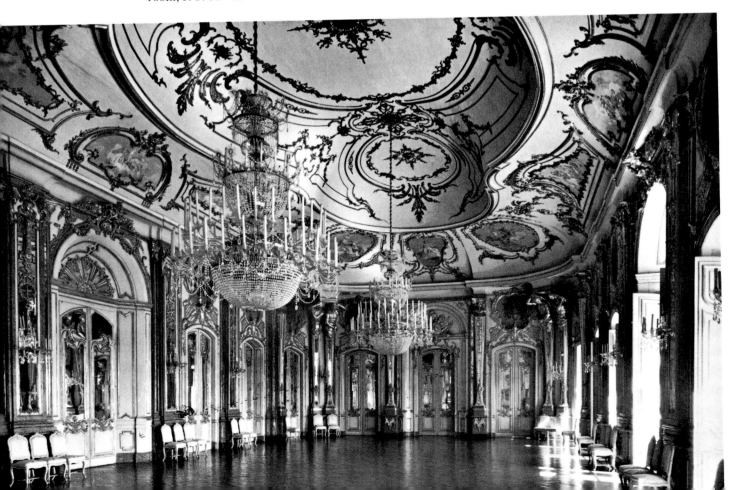

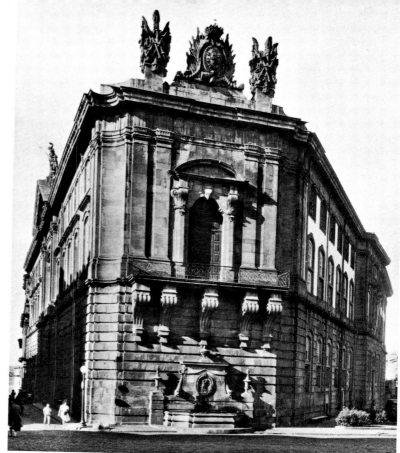

81 Oporto. Prison of the Relação do Porto, *c*. 1765–96

82 John Whitehead: Oporto. The British Factory, begun in 1785

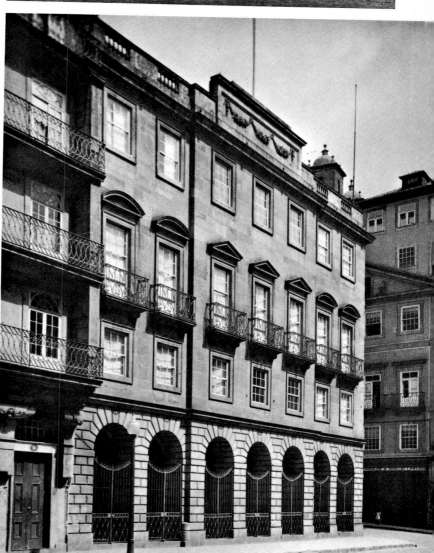

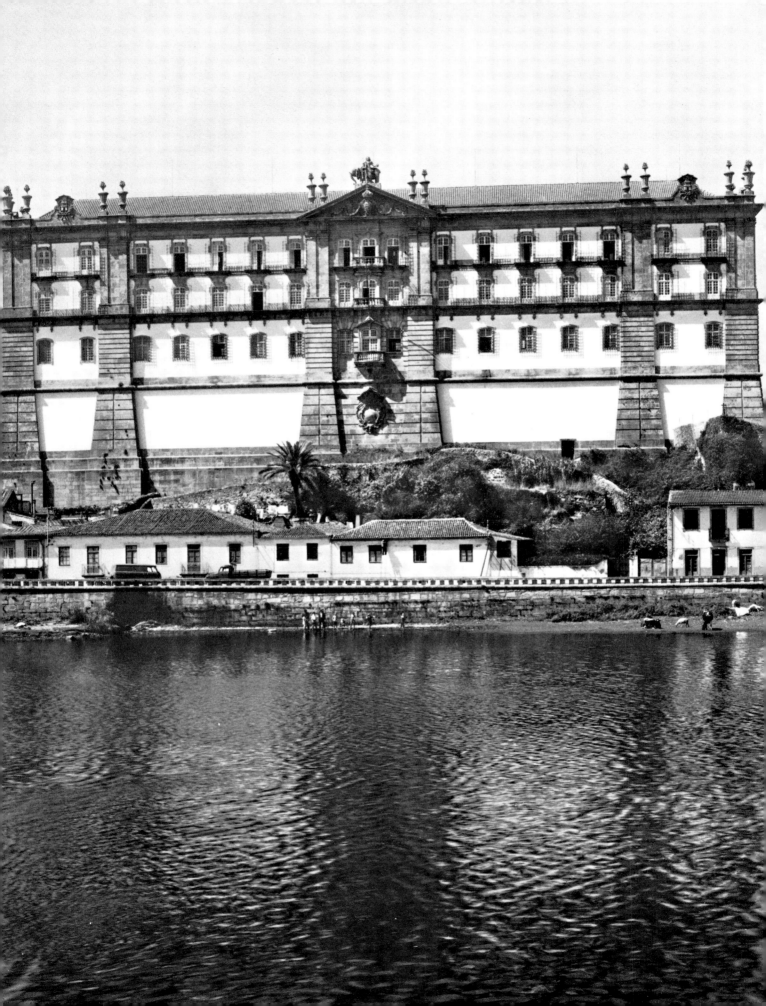

83 (OPPOSITE) Henrique Ventura Lobo: Vila do Conde. Convent of Santa Clara, begun in 1777
84 (ABOVE) Carlos Luís Ferreira Amarante: Braga. Church of Nossa Senhora do Pópulo, *c.* 1775–80

85 José da Costa e Silva: Lisbon. Theatre of São Carlos, 1792
86 (OPPOSITE) José da Costa e Silva and Francisco Xavier Fabri: Lisbon. Palace of Nossa Senhora da Ajuda, begun in 1802

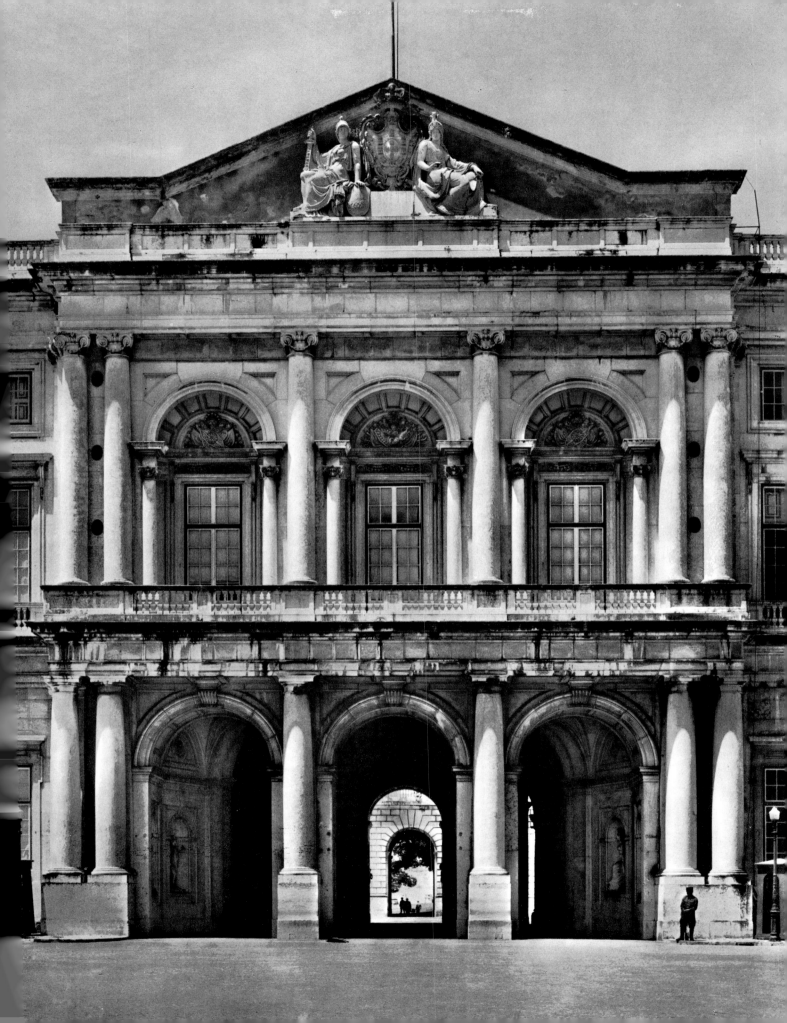

87 António Pinto de Miranda and Luís Chiari: Oporto. Church of the Third Order of St Francis. Detail of the nave vault, *c*. 1794–1805

88 Sintra. The arch of Seteais, *c*. 1802

century), by an unknown architect who lightly suggested the Falperra window and cornice and hinted, in the niche of the Virgin, at a similar one by Nasoni at Nossa Senhora da Esperança in Oporto. This church is preceded by a great stairway laid out in tiers of terraces with devotional chapels and allegorical fountains and statues. Religious gardens of this sort are frequently found as an approach to the great pilgrimage churches of the north. The façade of the church of the Misericórdia of Viseu, which was begun in 1775, by António da Costa Faro (active 1757-86), a master mason of Canigueiro de Vilar de Besteiros, offers the broad, rather simply decorated granite portal characteristic of several buildings in that city. It faces the façade of the cathedral and completes one of the most beautiful squares in Portugal.

Plate 142
Plate 66

The Rococo was abandoned earlier in Oporto than Lisbon. This may have come about through the importance of the English colony of wine merchants and the fact that their consul John Whitehead (1726-1802) was an amateur architect who enjoyed close relations with the powerful governor João de Almada e Melo (died 1786), a relative of the Marquis of Pombal, who also was interested in building. Through Whitehead plans were obtained from John Carr of York (1723-1807) for the hospital of Santo António. He designed an enormous five-part Palladian edifice, the largest of its sort outside England, which in 1769 some of the same masons who had worked for Nasoni in a very different style began slowly to erect. In 1785 Consul Whitehead started to build his own British Factory, an exclusive club of the gentlemen of the wine trade, which is a beautifully proportioned arcaded version of a Robert Adam town house in London, located in the old Rua dos Ingleses, where all the buildings have a similar classicizing restraint. British influence is also found in the use of sash windows which are frequently mentioned in contracts and other documents of the late eighteenth century as being 'in the English taste'.

Plate 82

To this new architectural atmosphere Governor Almada made his own contribution in the form of a great wedge-shaped structure for the law courts, called the Relação of Oporto, and their prison. Begun shortly after his appointment in 1765 and completed in 1796, it is thought to represent Almada's slightly awkward interpretation of a Pombaline design from Lisbon. Certainly the paired pilasters and the towering window of the angle façade suggest this. The influence of the Relação can be seen, on the one hand, in the superbly sited convent of Santa Clara at Vila do Conde, on the River Ave just above Oporto, begun by the mason Henrique Ventura Lobo of Adaúfe in 1777. On the other, it appears in much more original fashion in the work of the most distinguished of the late eighteenth-century architects of northern Portugal, Carlos Luís Ferreira Amarante (1748-1815), the son of a choirmaster of Braga.

Plate 81

Plate 83

His work began with a number of private houses in that city which still show the influence of the style of Manuel Pinto de Vilalobos. After his marriage in 1771 Amarante designed a new façade for the Augustinian church of Nossa Senhora do Pópulo which is notable for crisp and simple lines and the handsome effect of the columns and pilasters framing the great arched window in the middle. The Pópulo design served as the basis for that of the church of Bom Jesus do Monte, built between 1784 and 1811 on a hillside near Falperra at the top of a long religious garden like the one at Lamego, the last stages of which were designed by Amarante. In the Bom Jesus façade he expanded the Doric columns and balcony and filled the pediment with reliefs of the symbols of the Passion like those he had previously placed at the sides of the Pópulo window. Only in the spires of the two churches is there any suggestion of the curving plastic forms of the Baroque and Rococo tradition. This was also to disappear in Amarante's last work in

Plate 84

Plate 142

Oporto, where he went as a military engineer in 1802, which includes a part of the present edifice of the Faculty of Sciences of the University of Oporto.

This building and others, like the fine hospital of the Misericórdia of Viseu, planned in 1793 by Jacinto de Matos and Manuel Alves Mocamboa, are the results of events that took place in Lisbon and Oporto just after 1790, when the Portuguese version of international Neo-Classicism made its appearance. This was achieved by stripping the Pombaline formulas of their Baroque and Rococo overlay and augmenting the scale of the Renaissance residue that remained. Portuguese Neo-Classicism was a quite traditional expression that shunned the parade of temple porticos and flanks which in other countries set the tone of the new style. When contemporary motifs were borrowed, it was most often from Italy, rather than London or Paris, thanks to a number of Portuguese who studied in Rome and to various Italians who came to work in Portugal.

Plate 85
A case in point is the Lisbon theatre of São Carlos, which was erected in 1792 in the space of six months for a group of wealthy bourgeois investors. The architect José da Costa e Silva (1747-1819), who in 1780 had returned from a decade's residence in Rome, used as principal features in the design an Italianate rusticated *porte-cochère* and severe pilastered façade, that come straight from Giuseppe Piermarini's La Scala theatre in Milan, of 1776-8. Later, in 1802, on a hill overlooking the district of Belém, the immense

Plate 86
new palace of Ajuda was begun on plans of Costa e Silva in collaboration with the Italian architect Francisco Xavier Fabri (Francesco Saverio Fabri), who died in 1807. The monumental central pavilion has an arcade that echoes the Villa Albani-Torlonia in Rome and a vista through a courtyard that evokes the engravings of Piranesi. But the two

Plate 72
angle towers go back through the Pombaline pavilions of the Praça do Comércio to the

Plate 153
tower of the Casa da Índia of Lisbon's sixteenth-century Italian architect Filipe Terzi.

Equally Italianate, though in a different sense, is the grace and elegance of much of the ornament that goes with the first buildings of the Classical Revival in Portugal. The theatrical arch rising like a stage set between two identical blocks at the residence of the

Plate 88
last Marquis of Marialva at Seteais in Sintra brings to mind the eighteenth-century decoration of the Villa Borghese in Rome. This arch was designed by an unknown architect to commemorate a visit paid to the property, now a luxurious government hotel, by the Prince and Princess of Brazil in 1802. The delicate garlands and panelling of the arch are similar to those of the stucco decorations on the barrel vault of the nave of the

Plate 87
church of the Third Order of St Francis in Oporto, begun in 1794 by António Pinto de Miranda with a façade in the style of Carlos Amarante. The plaster decorations, which date from 1798, are the work of another Italian, Luís Chiari (Luigi Chiari, active c. 1795-after 1835), who made, as will be shown in other chapters of this book, a capital contri-

Plate 256
bution to the classical phase of Portuguese woodcarving in Oporto.

These were the main currents of Portuguese architecture in the eighteenth century. It was dominated by Italian influences, set to work by imported architects. Two of these — Ludovice, who came to Lisbon in 1701, and Nasoni, who reached Oporto in 1725 — determined to a large degree the character of the architecture of the south and north respectively. Their influence lasted into the third quarter of the century. Then, after a brief Rococo excursion, Portuguese architecture returned to the Italian pathway, guided now by Roman Neo-Palladianism in Lisbon and by the English variety in the north. The century ended with the triumph of Italian classicism, which, as in Spain, coincided with a restoration to favour of some of the principles of Iberian Mannerism that had held sway for so long a period in the sixteenth and seventeenth centuries.

those of the Turks. They are gliding, to one's astonishment, past city walls and towers of markedly Hanseatic character. This exotic hybrid note is sustained by the presence on the arms of the lower tier of seats of small wiry figures of German-looking beggars, merchants and knights, which may be the work of that João Alemão ('German John') who in 1518 came from Seville to build retables at Santa Cruz and is known to have enlarged these choir-stalls, which are among the most original of the period in Europe.

This brilliant foreign intervention continued during the rest of the sixteenth century, when the Mannerist version of the Renaissance style was gradually imposed upon Portuguese woodcarving. The change was effected in part by the presence of such foreign masters as the Frenchman Francisco Lorete (François Loret[?]) in Coimbra or the Spaniard Diogo da Çarça (Diego de la Zarza) in Lisbon, to whom have been attributed the impressive choir-stalls of the Hieronimite monastery of Belém of c.1551. It was also brought about by the importation of Antwerp engravings whose strap and bar ornament deeply influenced the choir-stalls of the cathedral of Évora of 1562, as they did so much else in Portugal, and by the constant use, as in architecture, of the illustrated treatises of Sebastiano Serlio, the foremost source of inspiration in this period.

These ingredients are all present in the impressive retable of Nossa Senhora da Luz in Lisbon, given by a daughter of Dom Manuel, the Infanta Dona Maria, to a convent which she had founded. Finished about 1590, it is thought to have been designed by the Spanish goldsmith and painter Francisco Venegas, who was active in this capacity at the time of the union with Spain and whose paintings fill the panels of this altarpiece. The design, like the walls and vault of the chancel, has the elongated proportions and geometric ornament of Serlio's fundamental pattern book of Mannerist architecture and it follows the towering, many-storied models of such Spanish retables as that of the Escorial. The Serlian oval picture frames of the final stage, an elegant note that enlivens the whole composition, were repeated in similar retables at Santa Maria of Óbidos and the cathedral of Leiria, designed and constructed by Portuguese at the turn of the seventeenth century, on the lines of the Luz composition.

Plate 92

Meanwhile the brothers Gaspar and Domingos Coelho had built, between 1582 and 1596, a series of altarpieces in the cathedral of Portalegre following a new form destined to become typical of Portuguese composition for the next century and a quarter. The key elements are the concentric arches that give the whole design a closed appearance basically different from the open termination in separated units of the characteristic Spanish retable, as seen in the Luz example. This difference was long to distinguish the Spanish from the Portuguese altarpiece, the former ending often in a pedimented tabernacle with statues of the Crucifixion, the latter in a pair of arches that maintain the rhythm of the paired columns below, which gradually tend to frame statues rather than paintings, and literally enclose the terminal wall of the apse.

Plate 93

The new design is deeply architectural, in keeping with such grave geometrical church fronts as that of São Vicente de Fora. Equally architectural was the alternate scheme of a triumphal arch, symbolizing the force of the Counter-Reformation, which in the Dominican church at Benfica, outside Lisbon (c.1632), took the form of a Serlian three-part opening, like those of the great cloister at Tomar. This frames a gigantic sacrarium, formed of diminishing octagons, enriched with reliefs and decorated columns, that is another feature of the great Mannerist retables of the period 1600-75. These are based on silver counterparts, of Spanish derivation.

Plate 41

Plate 94

Plate 31

Plate 219

In the new Jesuit churches decorated at this time we can see the development of the

compact closed retable of the brothers Coelho in a series of monumental altarpieces, all of which are anonymous. The attic of the one at Lisbon (*c.* 1625) shows the roundel framed by curved panels that unites the group, and the decoration of the columns is still confined to the bottom third of the shaft. The altarpiece of the Jesuit church at Évora, probably built a few years later, is similar. In the side retable of the Virgin (*c.* 1650) of the former Jesuit church of Coimbra, now the New Cathedral, and the main retable of that of Funchal, dated 1660, the shafts of the columns are entirely decorated with luxuriant ornament in the form of stylized leaves, from which peer the heads of cherubim. This kind of decoration, which in Spain had enjoyed great popularity as much as a century before, leads directly to the spectacular walls of the circular reliquary chapel of the abbey of Alcobaça (1669-72), where this traditional framework has in large measure disintegrated under the pressure of a mass of gesticulating statues in niches and a crowded ring of agitated cherubs on the main cornice, the effect of which is already Baroque. In this glowing and glittering chamber, statues of Cistercian saints in terracotta are mingled with reliquary busts of wood, all polychromed with the utmost realism and redolent of a sensualism expressive of the life that William Beckford was to describe at Alcobaça at the end of the eighteenth century.[1]

Just prior to the decoration of this reliquary chapel, in 1666-8, a group of sculptors headed by one known only as Sousa carved the choir-stalls of the new Benedictine church of Tibães, near Braga, with the same sensuous, realistic images (this time representing saints of the order who made important contributions to the liturgy of the Church), caryatid herms, foliate friezes and reliefs of symbolic fruits, all of which play prominent parts in the first phase of Baroque wood sculpture, which reached its height in the first quarter of the eighteenth century.

I have called the style of this period the National style[2] because it maintained or revived so many elements of the past and used them in so original a fashion. The basic symbol is the old retable with concentric arches revitalized by the new ornament of twisted columns covered with grape leaves and phoenix birds (typifying the Eucharist and immortality respectively), which extends over the surface of the arches in a manner uniquely Portuguese. This all-over use of ornament goes back to Romanesque and Manueline church portals, the birds, leaves and occasional children and fantastic animals suggest Manueline stone sculpture, and there is ample precedent in the art of that period for the twisted shafts of the columns. Those of the National-style altarpieces seem, however, to have been derived, via Spain, from Bernini's baldachin at St Peter's in Rome, which influenced all Christendom in the seventeenth century.

The new retable, with its sculptural rather than architectural form and illusion of continuous movement, was employed in great quantity all over the country. To older chancels it brought new warmth and vigour, its curving lines and vibrant naturalism contrasting with the severe geometric panelling of the architecture. In other buildings the new gilt woodwork was allowed to fill the apse, cover the entrance arch and eventually to expand into the nave, in a series of opulent panels framing paintings, pulpits, decorative tiles and, in the area around Lisbon, dadoes of marble mosaic.

These 'golden churches' of the National style, made possible by the discovery of Brazilian gold at the close of the seventeenth century, were created in Lisbon, where they abounded in nunneries patronized by royalty and the high nobility. Since most of these were destroyed by the earthquake of November 1, 1755, we must turn to provincial examples to obtain some idea of the brilliance of the lost metropolitan interiors.

Plate 35

Plate 34

Plate 95

Plate 96

Plate 97

Plates 29, 37, 38, 98, 99

Plates 10, 11

Plate 1, Colour pl. II

The Gilt Wood Church Interior

Plate 98

Outstanding in this category is the former garrison chapel of Santo António in Lagos, in the province of Algarve, decorated by an unknown sculptor about 1715, whose personality expressed itself in curious reliefs of men and boys struggling with animals and fish. The painted vault is a post-earthquake addition that probably replaced a ceiling of framed painting like that of the Dominican nunnery of Jesus, now part of the museum of Aveiro. In the chancel of this second example, completed by António Gomes and Plate 99 José Correia of Oporto before 1725, the extravagant woodwork simulates late Gothic vaulting, a deceptive device peculiar to the wood sculptors of that city, which was repeated in the chancel of the Franciscan church of Bahia in Brazil. It was part of the tradition that produced the false squinches of wood in the Hall of Blazons at Sintra. Finally, National- *Frontispiece* style retables like those of the chapels at Lagos and Aveiro have open 'tribunes' containing a pyramid of shelves called a throne, created for the dramatic exposition, in a forest of candles, of statues or of a monstrance holding the Sacrament. This is another Portuguese invention of the period that further justifies the term 'National style' and is a capital contribution to the Baroque theatrical concept of the altarpiece that developed all over Europe at the close of the seventeenth century.

These church interiors glittering with gold were the first large Baroque ensembles to appear in Portugal, long before anything similar was developed in exterior architecture. Other grandiose compositions are found in the choir-stalls of some of the wealthy convents of the north, where seats of richly carved rosewood are combined with towering frames of gilt chestnut. Often these contain devotional paintings, like those of the nave and chancel, entirely surrounded by gold. The best example of this type of decoration is the enframement completed in 1725 by António Gomes and Filipe da Silva of Oporto Plate 101 for the one hundred and eight stalls of the royal Cistercian nunnery of Arouca. The Plate 100 even higher frame of the fifty choir-stalls of the Benedictine monastery of Oporto offers the alternative of polychromed reliefs, representing scenes from the life of St Benedict, another feature of the local *talha*, carved between 1717 and 1719, apparently by Marceliano de Araújo of Braga, under the direction of Gabriel Rodrigues of Landim. Both sets of choir-stalls make brilliant use of plume-like displays of acanthus leaves, which also appear in contemporary Portuguese ceramics, from which emerge nude children and the *Plate 178* Bérainesque dancers that were the forerunners of the large wooden candle-bearing angels that later came to serve as guardians for the high altars of major churches in northern *Plate 38* Portugal.

Meanwhile, the Italian architects, sculptors and goldsmiths employed by Dom João V, who began to reign in 1706, were influencing the later phase of Baroque woodcarving, which began in Lisbon in the second decade of the eighteenth century and extended to the rest of the country in the second quarter. The typical Joanine retable is taller and thinner than those of the National style. It abandoned concentric arches in favour of canopies and baldachins of architectural form with allegorical statues taken from the widely used treatise on perspective painting of Andrea Pozzo.[3] In the Joanine style, which continued until about 1750, Italian statues and reliefs in marble and bronze were imitated in gilt wood to provide heroic supports for columns modelled now more literally than before on those of Bernini's Petrine baldachin, or to decorate the walls of the chancel.

The transition to the new style can be seen in the apse of Nossa Senhora da Pena in Lisbon (*c*. 1713-20), carved by a number of *entalhadores* under the direction of Domin- Plate 103 gos dos Santos and the French sculptor Cláudio de Laprada (1682-1738), who may have designed the gigantic nude supporting figures that are the monumental Joanine counter-

Plate 102

parts of the small pirouetting angels of the earlier style. The new style appears in its most splendid form in the apse of the Lisbon church of the Paulista monks (1727-30), where the three tiers of gilt figure and decorative sculpture of the famous woodcarver Santos Pacheco (active *c*.1717-55) are set against coloured marbles beneath a vault painted to simulate architecture in the Italian Baroque taste.

Colour
plate VI

The Joanine style soon spread to the north, where the retables of the high altars of the cathedrals of Oporto and Viseu were designed by Santos Pacheco in 1727 and 1730. For at least two decades the woodcarving of Oporto was dominated by Miguel Francisco da Silva (active 1726-after 1746), who had come from Lisbon to work in the cathedral, a Romanesque building almost entirely redecorated in this period. His is the shimmering apse of the Franciscan nunnery of Santa Clara of Oporto, an Italianate Baroque *salone* installed in a Gothic church, which dates from 1730. The wall panels are filled with husks, targes and garlands not unlike those of the contemporary library of Coimbra, while the sensitively modelled cherubs reflect the style of the Roman statues that were now appearing in the royal work at Mafra. The heavy cornices and lambrequins of the doors and windows were to become typical of Oporto, Braga and the north in general, and the brilliant use of volutes in plastically moulded cartouches repeats a mannerism of the Italian architect Nicolau Nasoni (1691-1773), a friend and close associate of Miguel da Silva, whose designs for *talha* and church silver profoundly affected the Baroque and Rococo art of Oporto.

Plate 104

These elements can all be seen in grander scale in the interior of São Francisco, another Gothic church of that city redecorated in the eighteenth century. The work, which is largely anonymous, represents a succession of styles. The arches and ceiling of the nave belong to the National-style period. The chancel arch and the theatrical frame of the high altar are Joanine Baroque, while the central throne has the flaring lines and graceful ornament of the Rococo, which flourished in northern Portugal between *c*.1750 and 1785.

Plate 105

As in architecture, this style was developed with great originality in Braga, under the joint influence of Augsburg engravings and Nasoni's work in Oporto. The most distinguished ensemble is in the interior of the seventeenth-century Benedictine church of São Martinho of Tibães, just outside the city, which was redecorated between 1757 and 1760 by José de Álvares de Araújo, a master woodcarver of Braga who died in 1762 as he was finishing the immense Rosary retable in the church of São Domingos at Viana do Castelo.

Plates 63-5

This full and handsome *talha* of Tibães and Viana, all designed by the architect André Soares of Braga, whose church of Falperra and palaces in Braga have already been mentioned, is composed of frilled shells and volutes, gyrating perforated ribbons and flame-like cartouches, coordinated in powerful rhythms that constitute what is perhaps the most masculine expression of the Rococo ever produced in Europe. Araújo's gifted pupil, the Benedictine lay brother, Frei José de Santo António Ferreira Vilaça (1731-1809), took the Braga style to other monasteries in northern Portugal, strengthening and refining the plastic compositions, based on those of Tibães, as in his design for the

Plate 106

main retable of Pombeiro (Guimarães), which he carved in masterly fashion between 1770 and 1773. Recently I had the good fortune to discover this man's diary[4] which revealed a great activity in architecture, stone sculpture, furniture and iron work that makes him the Portuguese counterpart of a Brazilian contemporary, António Francisco Lisboa (1730-1814), called Aleijadinho, the outstanding eighteenth-century artist of South America.

89 (OPPOSITE) Olivier de Gand: Retable of the high altar. Coimbra, Old Cathedral. 1498

The Gilt Wood Church Interior

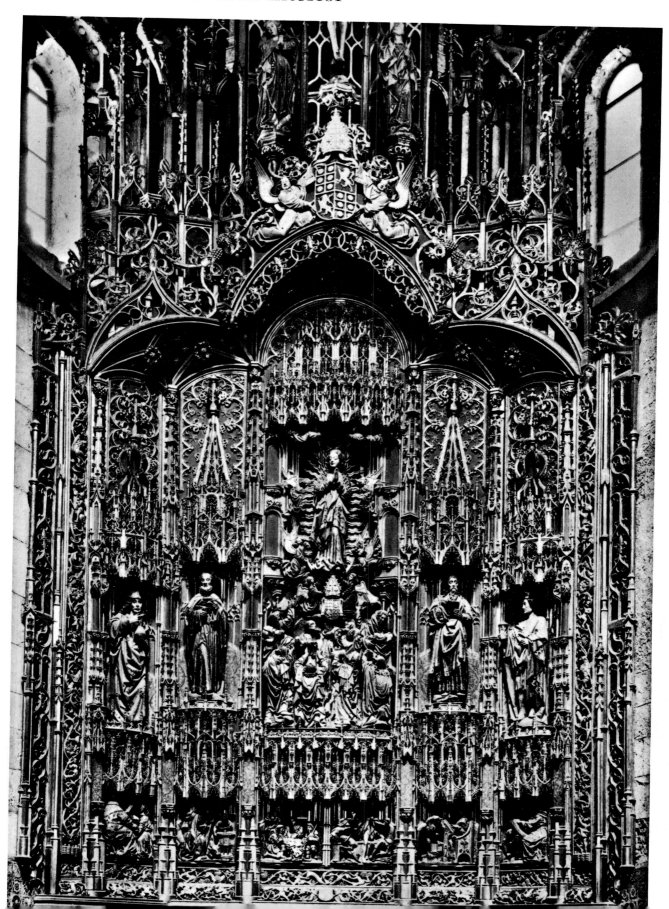

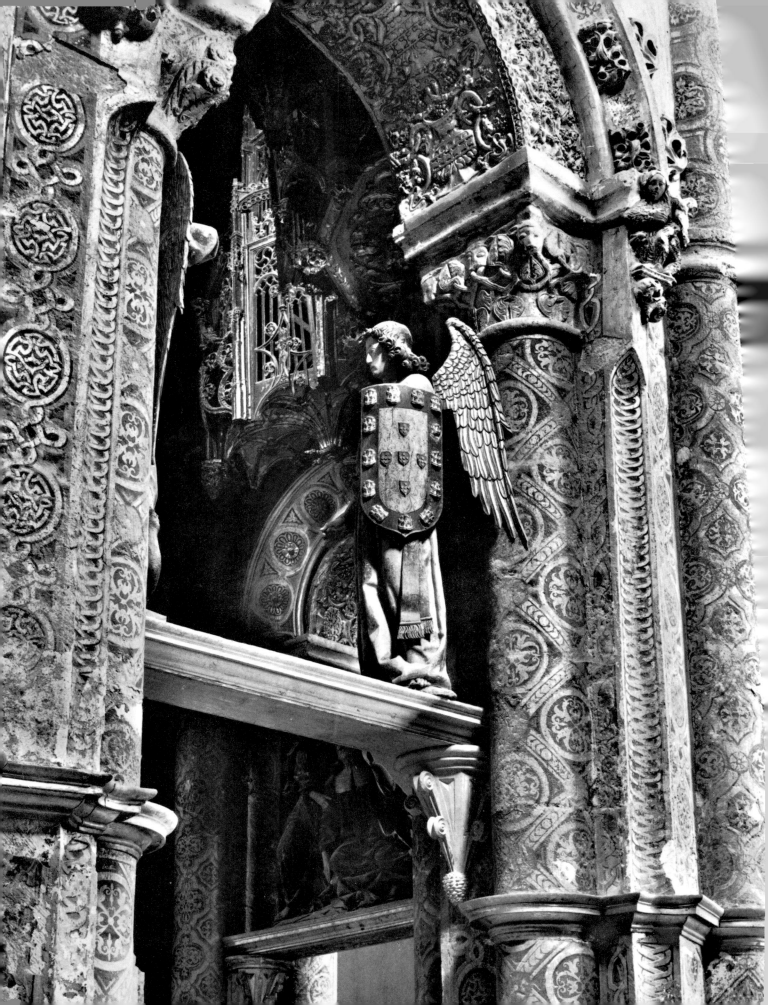

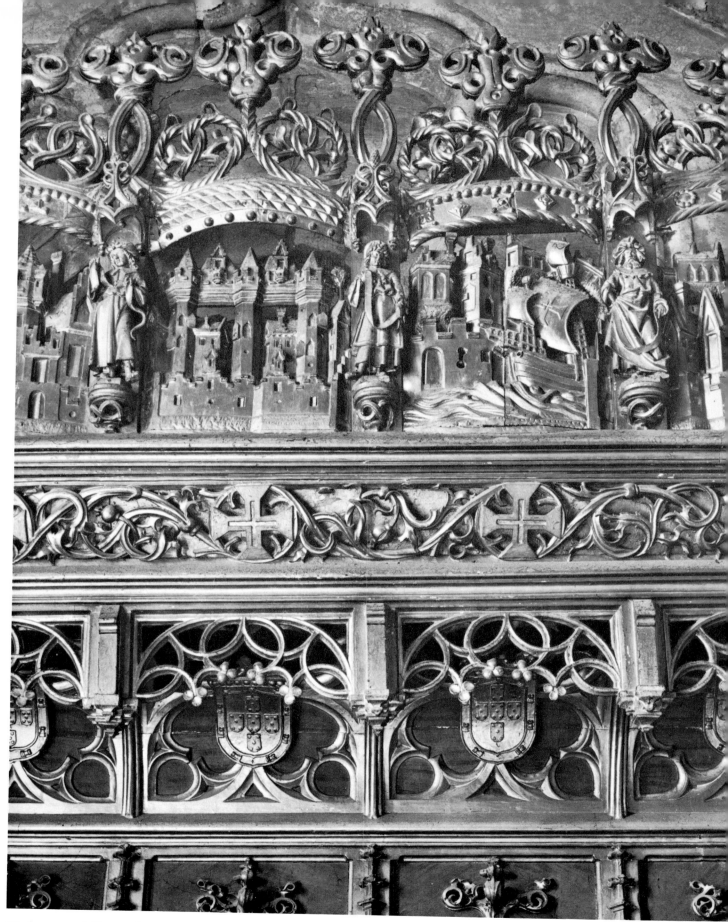

90 (OPPOSITE) Fernão Muñoz: A Guardian Angel. Tomar, Church of the Military Order of Christ. *c.* 1510
91 (ABOVE) Master Machim: Detail of the choir-stalls. Coimbra, Santa Cruz. Begun in 1513

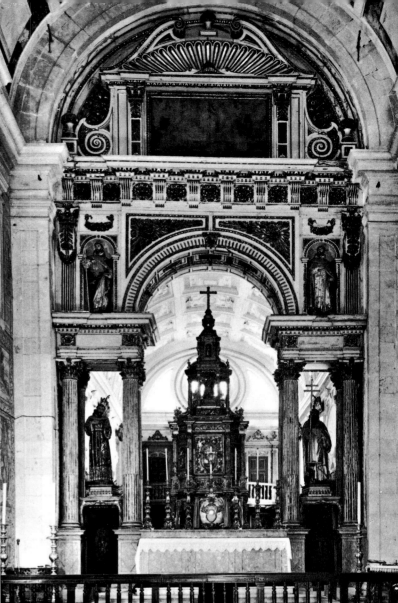

93 Gaspar and Domingos Coelho: Retable of the high altar. Portalegre Cathedral. *c.* 1590

94 Retable of the high altar. Lisbon, São Domingos de Benfica. *c.* 1632

92 (OPPOSITE) Francisco Venegas: Retable of the high altar. Lisbon, Nossa Senhora da Luz de Carnide. *c.* 1590

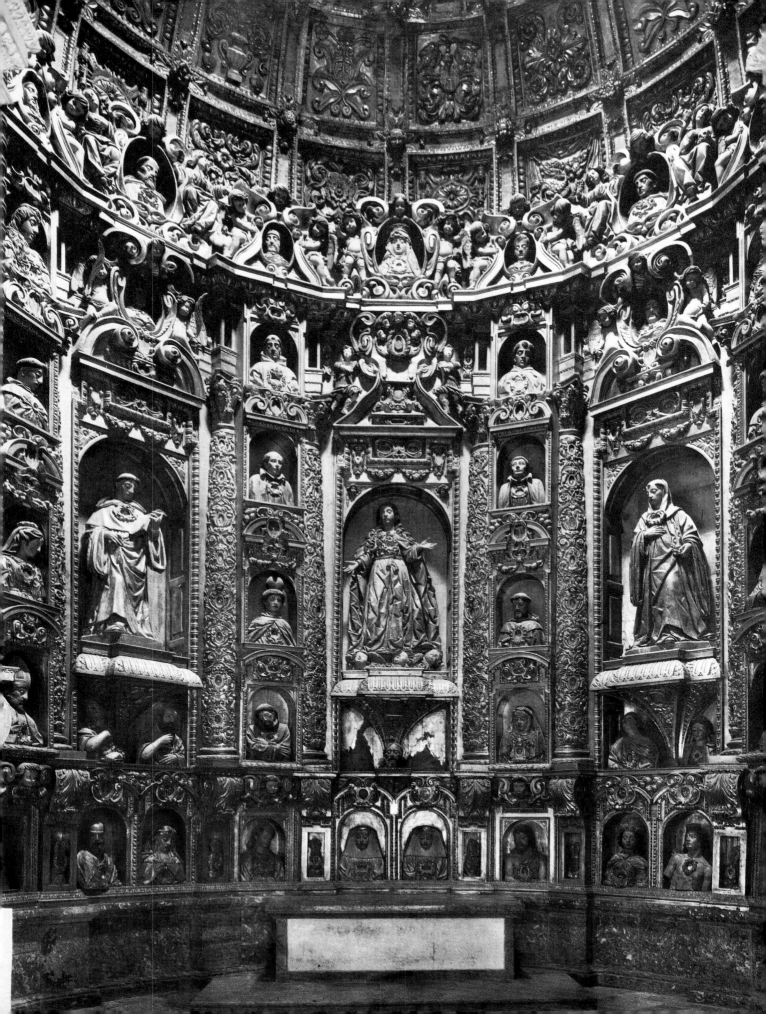

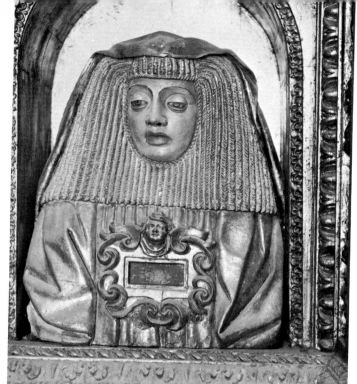

96 Reliquary bust of a Cistercian
saint. Alcobaça, Santa Maria.
1669–72

97 Detail of the choir-stalls.
Tibães, São Martinho. 1666–8

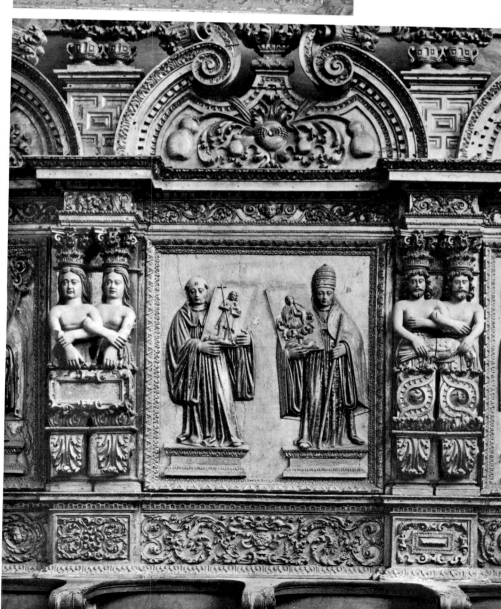

95 (OPPOSITE) Reliquary chapel.
Alcobaça, Santa Maria. 1669–72

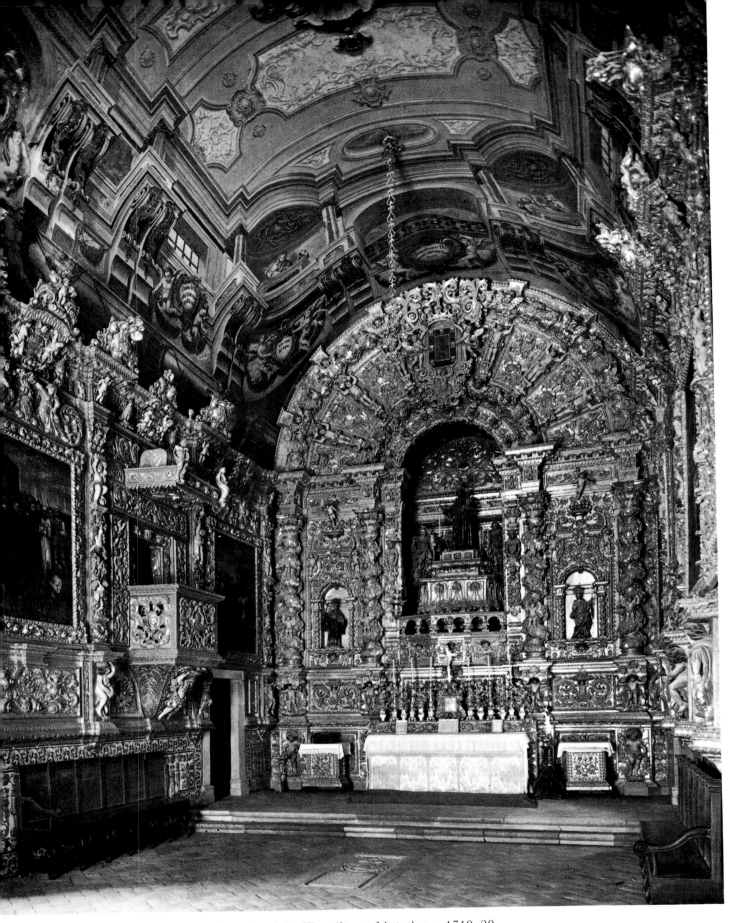

98 Lagos. Santo António. The gilt wood interior, *c.* 1710–20
99 (OPPOSITE) António Gomes and José Correia: The woodcarved apse. Aveiro, Dominican convent
of Jesus (Museu Regional). Before 1725

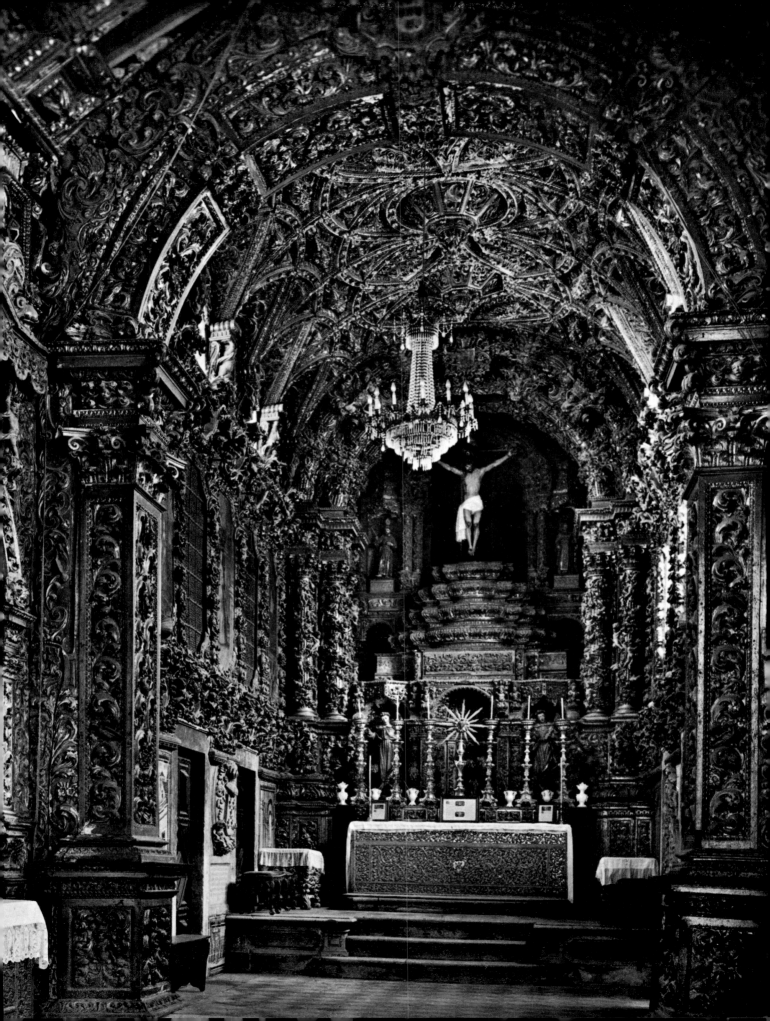

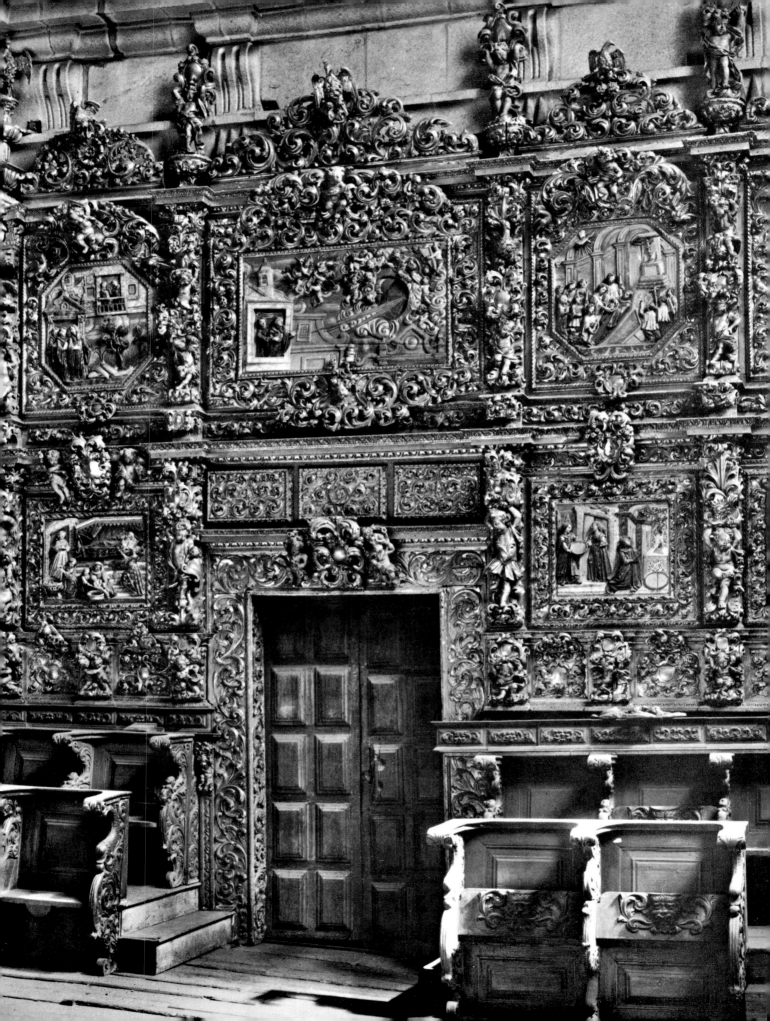

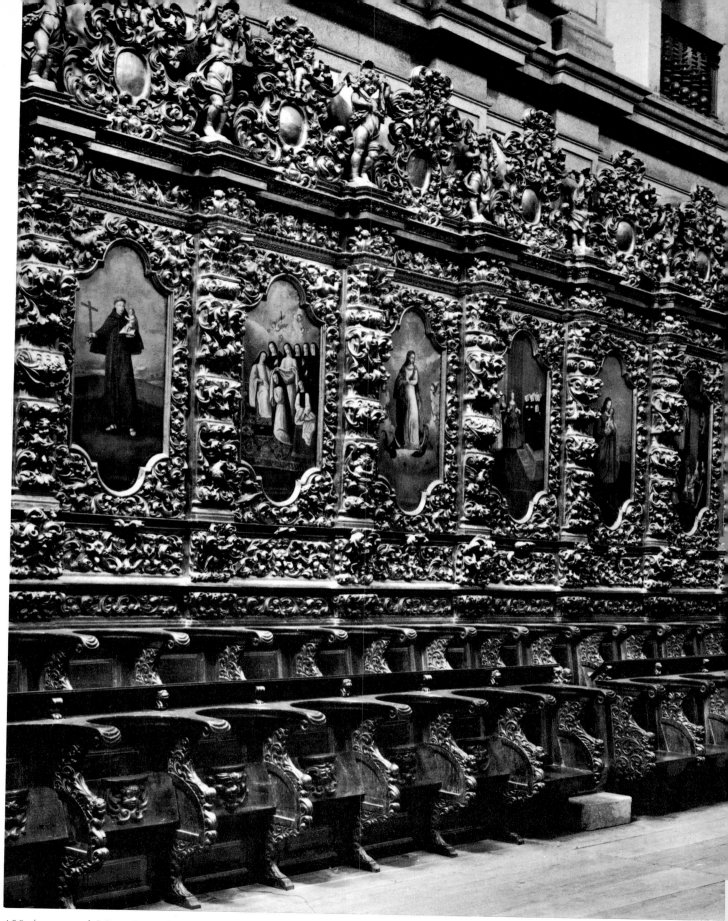

100 (OPPOSITE) Marceliano de Araújo: Choir-stalls. Oporto, São Bento da Vitória. 1717–19
101 (ABOVE) António Gomes and Filipe da Silva: Choir-stalls. Arouca, Santa Maria. 1725

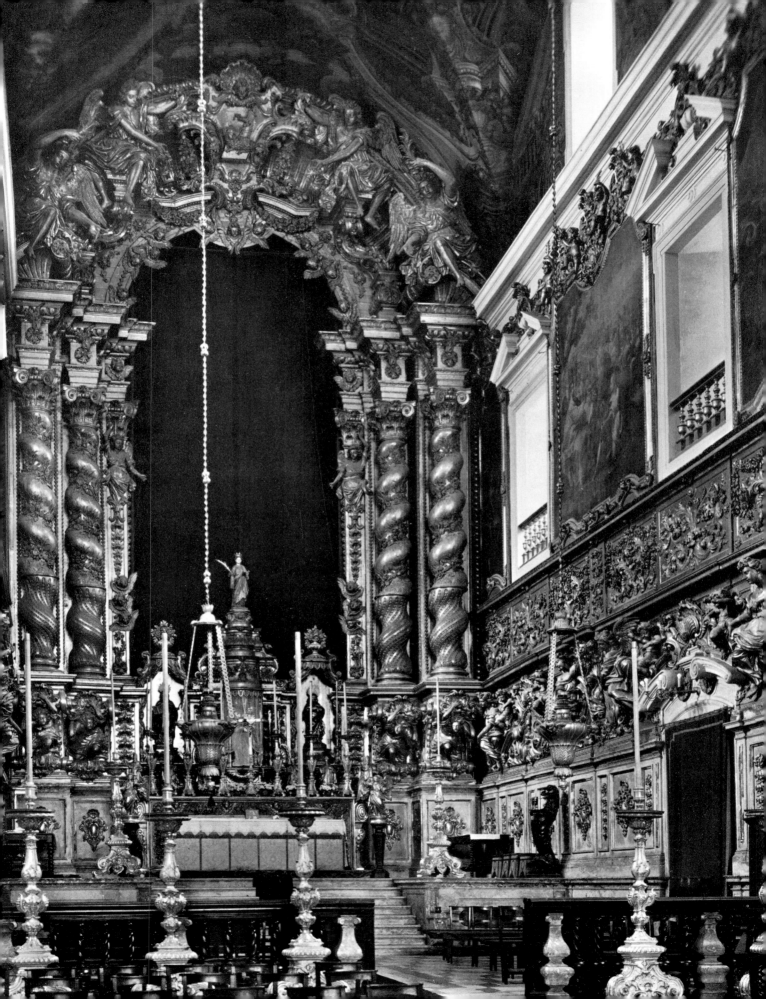

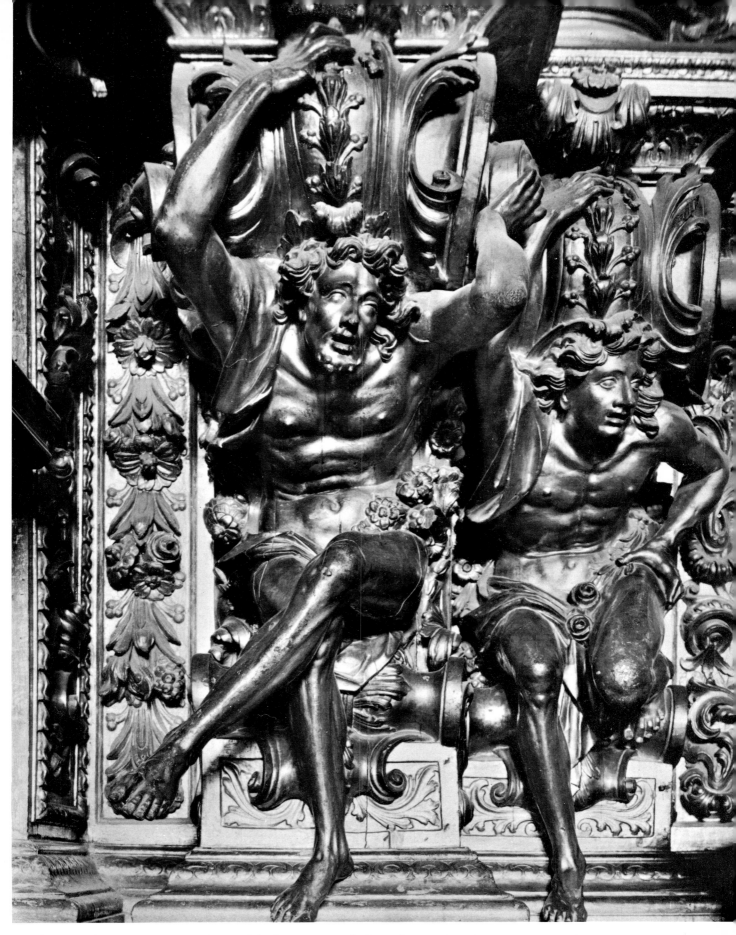

102 (OPPOSITE) Santos Pacheco de Lima: Woodcarved apse. Lisbon, church of the Paulistas. 1727–30
103 (ABOVE) Atlantid figures. Lisbon, Nossa Senhora da Pena. c. 1713–20

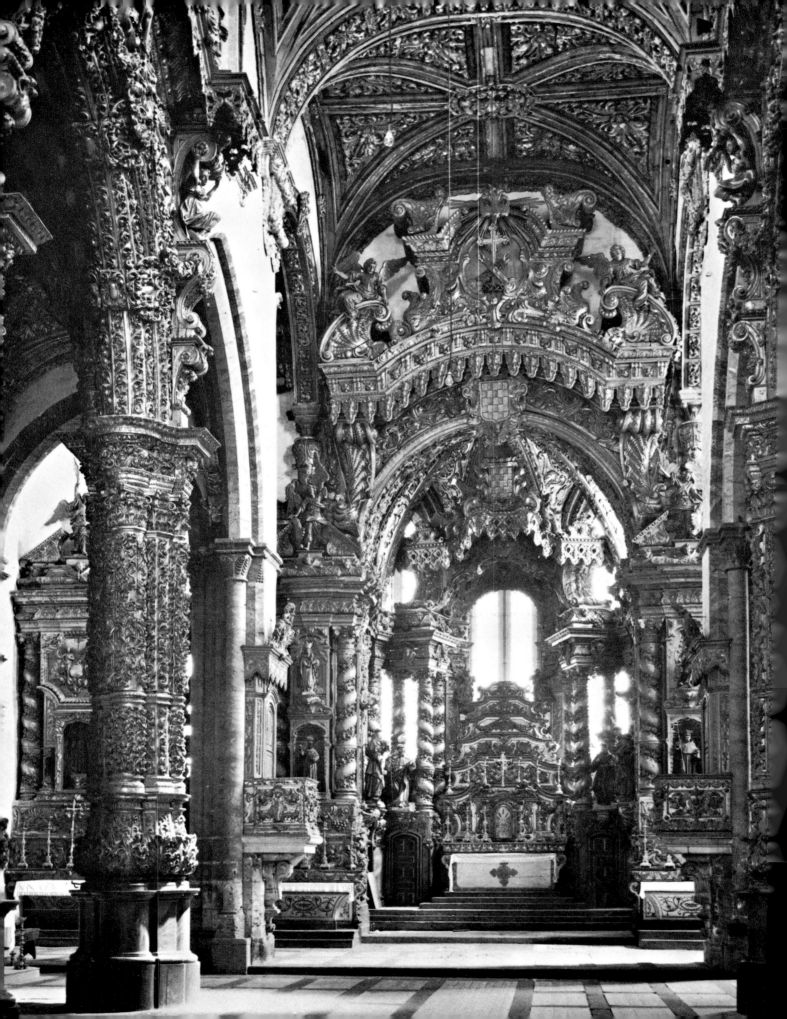

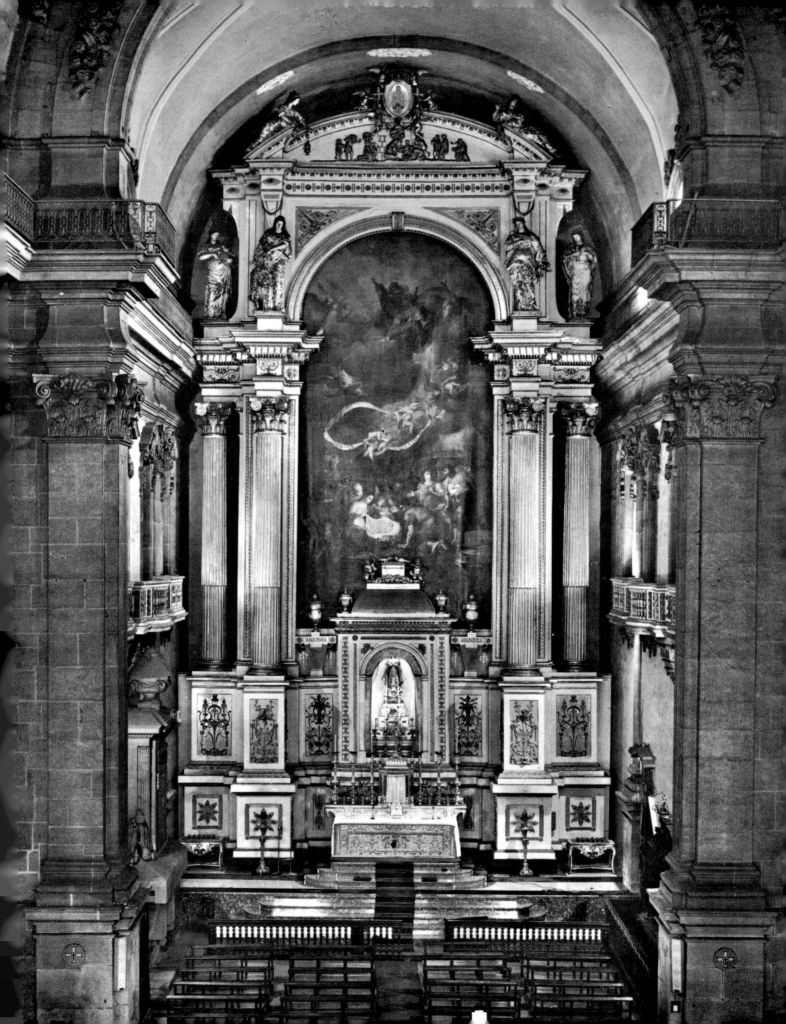

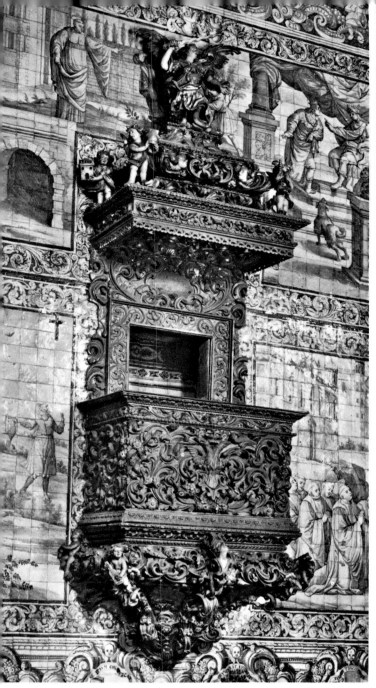

110 Pulpit. Barcelos, church of Nossa Senhora do Terço. Before 1730

111 Pulpit. Lisbon, church of the Madre de Deus. c. 1730–50

Very different from those of Braga are the Rococo retables of Évora, which had wide influence in the south. Instead of the dramatic plastic effects of the north, they offer delicate flat relief in patterns associated with those of neighbouring Spain, which create the impression of lace veils thrown over the Pombaline buildings of Lisbon. A capital example, the sumptuous interior of the Carmelite church of Nossa Senhora dos Remédios by Manuel and Sebastião Abreu do Ó, emphasizes the importance of the role that gilt woodcarving came to play in the churches of Portugal during the eighteenth century, for without it the building would be but a bare shell of plastered walls, vaults and un-decorated stone arches. *Plates 74-6*
Plate 107

In Lisbon the great *entalhador* Silvestre de Faria Lobo, who died in 1769, and his followers brought the art of woodcarving to its ultimate refinement of technique in such Rococo interiors as that of the royal chapel of Queluz, carried out in the years following 1750, which contains oval paintings by Dona Maria I and her sisters. The style lasted until the end of the century, when the architect Manuel Caetano de Sousa (1742-1802) designed the unique woodcarved interior of the chapel of Bemposta. *Plate 108*

One of the principal elements of the new style was the use of columns with straight plain shafts, a classicizing element undoubtedly derived from the chapel of St John the Baptist which Dom João V had obtained for the Lisbon Jesuit church from the Roman architect Luigi Vanvitelli in 1742. This chapel, built in Rome, dismantled and then reassembled in Lisbon in 1747, created a great sensation, for it is entirely decorated with lapis lazuli, ormolu, porphyry and agate. These materials were soon being imitated in gilt and painted wood, as in the chapel of Queluz. Everywhere reflections on canvas of the mosaic pictures of the altar and walls of Vanvitelli's chapel, many painted by Pedro Alexandrino de Carvalho (1729-1810), appeared in a framework of exquisite *talha*. These paintings had a profound effect on the Lisbon retable, for they diminished the importance of wood sculpture by eliminating the dramatic pyramidal thrones so long a feature of the Portuguese altarpiece. *Plate 76*
Plate 161

By 1790 the Rococo had fallen from favour in the wood sculpture of Oporto, where, as in architecture, both English and Italian influences militated in favour of Neo-Classicism. In 1794 the architect António Pinto de Miranda designed for the new church of the Third Order of St Francis what appears to be the first retable based on a Roman triumphal arch and it was carried out in gold-and-white woodwork, which became the norm for such designer-executants as Manuel Moreira da Silva, the foremost *entalhador* of Oporto in this period. In 1795, while working on this altarpiece, he was joined by the brilliant Italian sculptor Luís Chiari (active *c.* 1795-after 1835), who was soon to design stuccoes and furniture for this and other churches of Oporto, which were the first and finest of this style in Portugal. Especially interesting is the immense retable in the church of Nossa Senhora da Lapa, which dates from 1804-06, because the contract[5] states that it was to be built by Moreira da Silva on his own design corrected by the military engineer Carlos Luís Ferreira Amarante (1748-1815), architect of the churches of Nossa Senhora do Pópulo and Bom Jesus do Monte at Braga. In this work he was to be assisted by the sculptor Simão José de Brito. Characteristic of the influence of Chiari is the delicate spray-like ornament of the bases of the columns and the small structure called *camerim* over the altar, containing a miniature 'throne', like that behind the great arched opening which in the photograph is covered by a traditional painted curtain. This is decorated with an *Adoration of the Shepherds* by Joaquim Rafael da Costa (1783-1864), a pupil of Vieira Portuense, whose classical style he continued. *Plates 87, 256*
Plate 109
Plate 84

Art of Portugal

Of the objects of religious *talha* that make up the gilt wood interior the pulpits rank next in importance to the retables. In the seventeenth century these were generally composed of balustrades of Brazilian rosewood handsomely turned like the chancel railings, table legs and headboards of beds of the period. With the National style of the early eighteenth century, however, Portuguese pulpits began to be elaborately carved with acanthus leaves, cherubs, birds and other picturesque early Baroque devices. Characteristic of the best pulpits of this period in the north is the great example of the church of Nossa Senhora do Terço in Barcelos, formerly the nunnery of St Benedict. The pulpit is probably contemporary with the tiles of 1713 that surround it and may have been designed or executed by Ambrósio Coelho, a well-known *entalhador* of Barcelos. It displays as its most striking features the Hapsburg crowned double-headed eagle, which after the Spanish domination of 1580-1640 remained a popular decorative element in the art of Portugal, and the dramatic figure of St Michael atop the canopy which is attended by statues of children bearing the emblems of the Benedictine order.

Representative of the high Baroque of *c.* 1730-50 is the sumptuous pulpit of the royal nunnery of the Madre de Deus in Lisbon, perhaps by Félix Adaúfo da Cunha. The elegant box seems to be based on an engraving by Filippo Passarini published in Rome in 1698,[6] while the tempestuous volutes of the base and the mass of foliage above the door offer a foretaste of the rich and agitated Rococo style that characterized Braga in the third quarter of the eighteenth century.

Both pulpits have in common their opulent surfaces of gold and both fit into great ensembles of blue-and-white tiles that cover the walls around them. Those of the Madre de Deus were imported from Holland. Those at Barcelos, on the other hand, show the spectacular development the Portuguese gave to Dutch models. These tiles are by António de Oliveira Bernardes (1684-1732), the foremost tile painter of Lisbon in the early eighteenth century. Together with the gilt woodwork of the pulpits, the retables and various picture frames, they create a unique combination of surpassing richness that beyond all else is characteristic of the churches of Portugal in the first half of the eighteenth century.

Plate 110

Plate 111

Plate 186

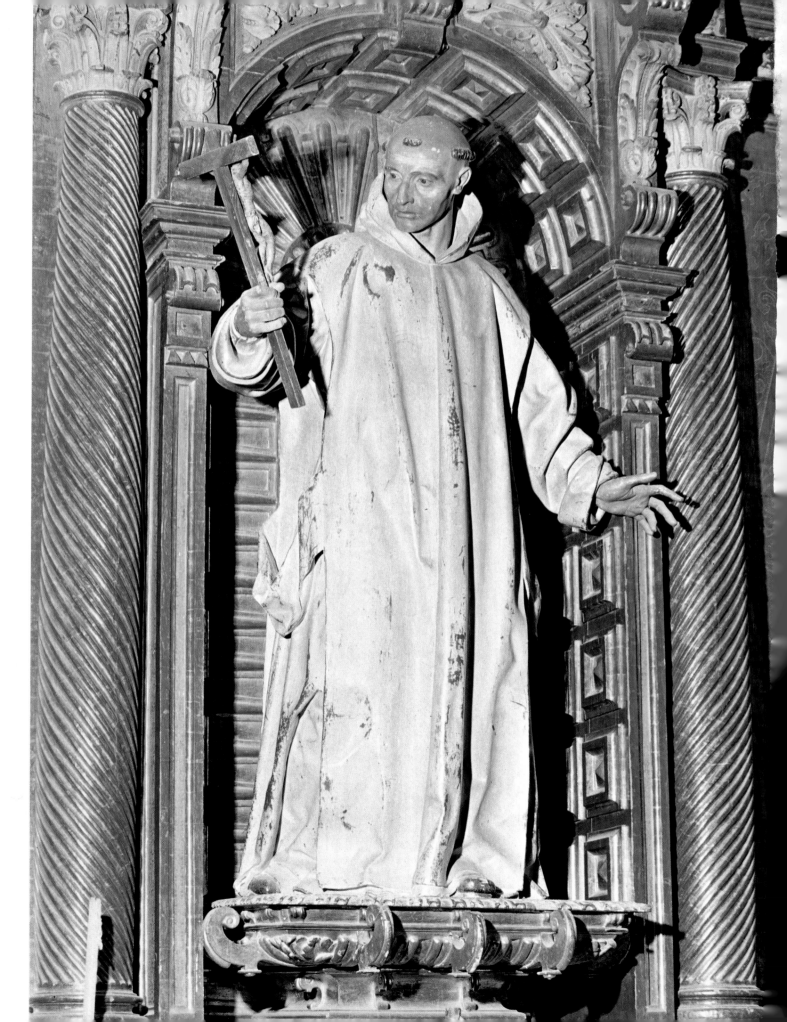

3 Sculpture

The nature of Portuguese sculpture was determined to a large extent by the materials available in different areas. In the north, above the Mondego River, the hard and heavy quality of the local granite led to forceful stylization which eliminates all delicate detail. In the central zone around Coimbra, on the other hand, the fine limestone of Ançã and Portunhos made possible sensitive characterization and subtle refinements of surface that gave pre-eminence to the sculpture of this region and led to its exportation to other parts of the country. At Lisbon, Évora and other centres of the south the presence of marble or its glittering substitute, the *pedra lioz* of the capital, invited grandeur and sumptuous ornament in sculpture, consonant with the needs of the court.

The history of this art begins with the severely stylized granite stelae of warriors found in the extreme north of Portugal and the monumental cult figures of sows from around Murça in the province of Trás-os-Montes, which were made by the pre-Roman Lusitanians. The Roman and early medieval periods produced little important sculpture that has survived. The Romanesque is represented chiefly by Byzantine-style foliate capitals with a few animals, birds and human figures very simply carved in granite for such churches as Paço de Sousa, Rio Mau (1151), Longos Vales and Bravães, which also has a famous sculptured portal. These are all located in the northern region between the rivers Minho and Mondego, which was the first part of the kingdom to be reconquered from the Moors, who had taken possession of Portugal, as they had of Spain, at the beginning of the eighth century. During their regime, which in the southern provinces lasted until the thirteenth century, sculpture was limited in large measure to geometric and deeply stylized forms because the representation of living things was strictly forbidden by the Koran.

The great phase of Portuguese medieval sculpture begins with the fourteenth-century Gothic. The finest monuments of this period are the limestone tombs of *c.*1360 at Alcobaça containing the bodies of Dom Pedro I (1357-67) and his tragic wife, the beautiful Inés de Castro, murdered by jealous nobles who suspected her of meddling in politics. Based on a Franco-Spanish formula of aristocratic figures lying stiffly upon sarcophagi richly decorated with Gothic architecture, these royal tombs transcend the high norm set by that of St Elizabeth in the convent of Santa Clara at Coimbra because of two spectacular reliefs of the Last Judgment and of a miniature rose window which they contain. There is no clue to their authorship beyond the fact that the French architectural forms are lightly modified to fit the Moorish-inspired traditions of the Iberian peninsula and this suggests a local master. Another distinguished achievement of the period are the devotional figures of the Virgin and saints by Master Pero of Coimbra, which reappear a century later in the more realistic but equally serene statues by Master Afonso that fill a room in the Coimbra museum with the soft glow of their tender glances and the gentle

VII (OPPOSITE) Manuel Pereira: St Bruno. Monastery
of Miraflores (near Burgos, Spain). First half of the 17th century

rustle of their smoothly clinging drapery. One tiny retable with two exquisite poly-chromed kneeling angels holding a chalice beneath a canopy is dated 1443.

The spirit and style of Master Afonso in the mid-fifteenth century was continued by Diogo Pires o Velho (the Elder), who in 1481 made the fine statue of the Virgin and Child for the Franciscan convent of Matosinhos, outside Oporto, now in the nearby parish church of Leça de Palmeira. To him is attributed the tomb of Fernão Teles de Meneses
Plate 114
in the Hieronimite church of São Marcos de Tentúgal (Coimbra), a monument in the Venetian taste of the period with a baldachin of drapery held up by hairy 'wild men' like those of the contemporary façade of San Gregorio at Valladolid in Spain. Beneath this canopy the young warrior, who died in 1477, lies upon a sarcophagus decorated with the arms of the Manuel and Teles de Meneses families. These are displayed in a setting of exotic foliage which constitutes the chief interest of the tomb, for not only do the tightly knit, keenly drawn leaves and artichokes foretell the sumptuous foliate ornament on Manueline portals and windows, but they harbour some of the first and finest expressions in art of the Portuguese contacts with Africa, in the form of a Negro's head, seated monkeys and three hippopotami.

These strange details appear also in the work of Diogo Pires o Moço (the Younger), active between 1511 and 1535, whose exact relation to the elder Pires is not known. He was the foremost native sculptor of the late Gothic period in Portugal and fortunately signed a number of his works. Among them are three works of 1514-15 — the tomb of João Coelho in the church of Leça do Balio on the outskirts of Oporto and a baptismal
Plate 115
font and votive cross which Coelho, a prior in the Portuguese branch of the Sovereign Order of Malta, presented to the same building. The octagonal font is supported by real-istic crocodiles with webbed feet and long slimy tails that seem to exhale an aura of the fever-haunted swamps and rivers of the Guinea coast. The basin is decorated with the maize-like *massaroca* fruit found frequently in Manueline architectural sculpture and on seventeenth-century tiles. Above this section of the font is set a long scroll framed by rope mouldings from which hang pomegranates like wax seals on a document. This extraordinary decoration is completed by the figure of a whimsical angel holding the shield of the donor, João Coelho, with a rampant heraldic lion. On a similar font attributed to Diogo Pires the Younger at the Old Cathedral of Coimbra, the arms of the Bishop Dom Jorge de Almeida (1483-1543) are supported by two angels with Negroid features in costumes that vaguely suggest Byzantine armour.

Plate 112
To this sculptor is also attributed the large angel with the royal arms of Portugal from the Augustinian monastery of Santa Cruz (Coimbra), a masterpiece of Manueline sculpture. The tall impressive figure has slit-like eyes and heavy lids typical of Diogo Pires the Younger, set in a characteristically Portuguese long face with prominent nose and large, sensuous lips, while the chaplet of flowers the angel wears recalls the rosettes along the rim of the baptismal font at Leça. There is a tender, reflective quality about this face that contrasts with the jaunty elegance of a polychromed wooden angel by
Plate 90
Fernão Muñoz, one of the Flemish-trained Spanish sculptors who worked at Tomar. The motif of a shield-bearing angel, derived from the late Gothic art of northern Europe, en-
Plate 149
joyed such popularity in Portuguese sculpture and painting of this period that it became almost a national symbol.

We have little or no knowledge of the men who carved the great decorative ensembles
Plates 3, 10, 12
of the Manueline doorways at Belém, Tomar and Batalha in the first two decades of the sixteenth century, which are assumed to have been designed by the architects. Nor do we

know the names of the sculptors who made the statues of the prophets, knights and apostles that accompany them. The finest are the figures of the apostles and the posthumous portrait of Prince Henry the Navigator on the jambs of the south portal of the royal convent of Belém, the architecture of which is by João de Castilho. These sturdy statues are excellent examples of the wave of Flemish bourgeois realism that swept over the Iberian peninsula at the turn of the sixteenth century. They give the impression of rugged burghers of Brussels, Antwerp or Ghent, while the image of the Virgin that crowns the immense portal has the broad hat and voluminous skirt that a Belgian housewife might have worn on her way to market. The same spirit infuses late Gothic sculpture in Braga and other northern centres, some of which has close associations with monuments in Galicia, across the frontier in Spain.

Plate 3

Both doorways at Belém contain classical medallions and *grotteschi* that show a keen awareness of Renaissance ornament. Of the two, however, the main entrance at the west end of the church is vastly more important because it is the first documented work of the French master Nicolau Chanterene (active *c.*1516-50), who transformed and dominated Portuguese sculpture of the sixteenth century. He is the first sculptor whose career in Portugal can be traced in anything approaching detail, but unfortunately nothing is known of him before his arrival. Some have argued that because of his knowledge of anatomy, classical ornament and the architectural orders, Chanterene must have been trained in Italy. His style however is essentially French. It developed over a quarter of a century in Portugal from picturesque experiments with Lombard ornament of the style of Francis I to a far deeper understanding of Renaissance form.

Plate 113

In the period 1516-20 Chanterene executed two royal commissions, at Belém and Coimbra, which established his reputation in Portugal. In January, 1517, he was at work on the late Gothic west portal of Belém, for which he supplied a series of statues, as well as the Renaissance plinths bearing heavy urns, that closely resemble later Portuguese silver. The statues are headed by the kneeling figures of Dom Manuel (1495-1521) and his third wife Maria, daughter of Ferdinand and Isabella of Spain, two compact figures whose square heads and resolute features typify all of Chanterene's later work. They are set dramatically against deep niches, accompanied by patron saints like the donors in the wings of Franco-Flemish paintings or the statues on the doorway of the Carthusian church of Champmol at Dijon in Burgundy. The figures of the sovereigns rest on plinths supported by the popular Portuguese shield-bearing angels, and these reappear on the jambs of the doorway. The others flutter spectacularly against the lintel, where their wings, emphasized by mouldings, conduct the eye upward to three groups of statues, representing the Annunciation, Nativity and Adoration of the Magi, occupying niches like tiny stages above the portal. These handsome figures, which recall French stone retables of the period, are framed by the bulbous columns, arabesque pilasters and scroll canopies that Chanterene was to use on other occasions.

He spent the decade 1518-28 at Coimbra, working first on the tombs of the first two kings of Portugal, Dom Afonso Henriques (1128-85) and Dom Sancho I (1185-1211), which Dom Manuel presented to the great church of Santa Cruz, and the now ruined screen of sculpture on the façade. In June, 1522, he undertook the large limestone altarpiece of the nearby church at São Marcos de Tentúgal, where he restated the theme of the Belém doorway, this time in full Renaissance form. At the sides, Aires Gomes da Silva, hereditary Regedor das Justiças, one of the great legal offices of the kingdom, and his wife are kneeling, with their saints, watching as though upon a stage a large company

Plate 116

of figures representing the Deposition of Christ, a subject popular at the time in France and soon to become so also in Coimbra, thanks to Chanterene and other sculptors. All three groups are drawn together by a huge triumphal arch of fantastic architecture, the depressed coffered vault of which suggests immediately the interior of the château of Chambord. In the spandrels are medallions with busts, one of the most popular motifs of Portuguese Renaissance architecture, while the grandiose composition ends in a lunette containing a relief of the Creator, destined to become almost as common in the later sculpture of this area.

Plate 117 Below this principal stage of the altarpiece of São Marcos there is an even richer display of Renaissance ornament in the canopies of statuettes, one of which, the St Sebastian, is the earliest-known Italianate nude in Portuguese sculpture, and around the niches containing scenes from the life of St Jerome, patron of the church. All are full of architecture and genre details, and one offers the fascinating combination of a Gothic chapel set beside an open staircase like that of Blois in France, against a background that appears to represent the great octagonal cloister of the convent of Belém, where Chanterene had been working.

Plate 118 So similar to these niches are those of the celebrated polygonal pulpit of Santa Cruz and so closely do the statuettes of the retable resemble the seated Church Doctors of the pulpit that one feels that the latter must also have been designed by Nicolau Chanterene, although it may have been carried out, at least in part, by another Frenchman, Jacques Loquin, to whom it was attributed by a monastic writer of the seventeenth century.[1] The density of the ornament, from the fantastic base in the form of a hydra-headed dragon, to the Manueline heraldry above the niches, suggesting that the pulpit was another royal gift, recalls the Plateresque decorators of Spain, whose work Loquin would have known when he worked in the cathedral of Córdoba before coming to Portugal. The richness of the pulpit was augmented by the blue-and-white Baroque Lisbon tiles added to the wall behind it in the eighteenth century.

Close examination of the São Marcos group of St Jerome and his monks makes it clear that the statue of a lightly polychromed angel from the Franciscan nunnery of Santa Clara in Coimbra is also the work of Nicolau Chanterene, for the faces and bearing of the figures are almost identical and the shield that the angel carries has the unusual subject of a Gothic chapel, very like the one in the background of the retable. The angel is shown in the same room of the Coimbra museum with a statue of the Virgin kneeling at a *priedieu*, the feet of which are ornamented with agitated scrolls like those of the Belém doorway. Although the two figures were not designed as a group, they seem to belong together, because of the vibrant youth and the spiritual beauty that unite them. Together they repeat the theme of the Annunciation which Chanterene had used earlier above the portal of the convent of Belém, but here the execution is far more subtle and the surfaces more expressive, thanks to the quality of the Coimbra stone.

Plate 119

Plate 120

There is the same intimate relationship between the mourning figures of St John and St Mary Magdalen in the centre of the tomb of Dom João de Noronha at Óbidos (1526-8) notable for the exquisite delicacy of its vertical and horizontal friezes of Italianate ornament, and the expressive faces of the heads in the soffits of the arch which established a tradition handsomely reflected in the portal of Atalaia. Here Chanterene established the pattern of the typical Portuguese Renaissance tomb — an opulently decorated arch, enclosing a sarcophagus on which cherubs display an inscribed plaque. Upon this sarcophagus there is either a group of Biblical figures, as here, or the kneeling effigy of the

Plate 121

Plate 28

deceased, as in the tombs of the cousins Dom Luís da Silveira and Duarte de Lemos, at *Plate 126* Góis and Trofa do Vouga respectively, or a recumbent figure, as in the immense tomb of the Bishop Dom Jorge de Melo at Portalegre (*c.* 1540), which is attributed to Chanterene. Most of these monuments share with the Noronha tomb a relief of the Virgin of the Assumption, Patroness of the cathedrals of Portugal, surrounded by angels, which Chanterene had first used in the tomb of Dom Afonso Henriques at Santa Cruz.

His next work was the alabaster altarpiece of the convent of Nossa Senhora da Pena at Sintra (1529-32), a larger edition of the retable of São Marcos, but with simpler yet grander architecture, and a new dramatic emphasis derived from the Noronha tomb provided by a Bellinesque relief of the dead Christ in the arms of angels, beneath a triumphant statue of the seated Virgin and Child, which goes back to the kneeling Virgin at Coimbra.

In 1533 Nicolau Chanterene appears in Évora, where he lived until 1540, in the company of the humanist Clenardus, who called him '*Sculptor insignis Nicolaus Cantaranus*', and his countryman, the Dean of the cathedral Jean Petit. In 1535 he was honoured with the title of royal herald by Dom João III and two years later produced the alabaster wall tomb of the royal Archbishop of Évora Dom Afonso de Portugal. This monument is *Plate 122* Chanterene's most classical work, in which by simplifying even further the architectural setting and eliminating sculptured figures, he concentrated attention upon a number of almost geometrically simple decorative forms. There is a touch of the humanists' scholarship in the play of scrolls and more than a slight suggestion of Mannerism in the grouping of niches within and around the tall thin central motif. Chanterene must have learned these things in the brilliant intellectual society of Évora, which maintained close relations with Italy and Spain. The fact that he did this so thoroughly is a reminder of the immense debt that Portuguese sculpture owes to this man who in a foreign land far removed from the centres of Renaissance development was able to progress from picturesque beginnings at Belém and Coimbra to the profound refinement and penetration of the Évora tomb. More than any other man Chanterene implanted the art of the Renaissance in Portugal and directed its subsequent growth. Had he remained at home, he would certainly have been considered one of the major French artists of his time.

Nicolau Chanterene's role was superficially continued in Coimbra by João de Ruão (Jean de Rouen, *c.* 1495-1580), a prolific but shallow sculptor active there from 1530 to 1580, who married a sister of the royal architect Marcos Pires. An early attributed work is the limestone retable in the rural chapel of the Misericórdia at Varziela, which together *Plate 123* with two smaller ones and a handsomely carved arch rises above the burial slab of the second Lord of Cantanhede, who is thought to have commenced the entire ensemble before his death in 1532. In a frame of decorated pilasters that suggests the Gaillon retable of St George and the Dragon (Louvre), which he could have known if he worked about 1517, as is thought, on the tomb of the Cardinal of Amboise in the cathedral of Rouen, João de Ruão presents a composition symbolizing humanity sheltered by the mantle of Our Lady of Mercy, which came into use all over Portugal after the establishment in 1498 by Queen Leonor, widow of Dom João II, of the first Santa Casa da Misericórdia. This institution rapidly became and still is the chief Portuguese charitable agency, maintaining hospitals and asylums for the poor and serving in the past as a prime patron of art.

The Virgin and angels of the Varziela retable show the influence of Chanterene; the faces of the spiritual and temporal rulers who kneel beneath Her cloak are profoundly French, while those of the female saints and the Virgin of the predella have a prettiness

which João de Ruão was to display constantly in his devotional statues. In comparison with those of Nicolau Chanterene, all these figures seem empty, repetitive and ill-constructed and this impression is intensified by the huge curved altarpiece of the apse of the cathedral of Guarda (1550-2), built on the lines of a Spanish Mannerist model, on whose shallow surface elongated figures move without substance or expression. In the chapel of the Sacrament of the Old Cathedral of Coimbra there is a smaller altarpiece of similar shape, the frame of which is thought to have been designed by João de Ruão in 1566.

From the same year dates the chapel of the Magi, which the widow of the African hero Dom João da Silva ordered for the family church of São Marcos to contain the tombs of her sons Dom Diogo, who in 1552 had served as ambassador to the Council of Trent, and Dom Lourenço, who was to die with the king Dom Sebastião in the massacre of the Portuguese army at al-Ksar al-Kabir, in 1578. João de Ruão, who in his last years was an architectural contractor, is associated with this handsome domed structure, the design of which still owes a good deal to the architectural sculpture of Chanterene. In the rich ornament, however, can be seen new motifs, geometric patterns, strap work and the strange bar ornament from Antwerp engravings which at almost this very time appeared on the Mannerist choir-stalls of the cathedral of Évora (1562). Under the force of this possessive decoration the architectural setting of the tombs disintegrates and the recumbent effigies are far inferior to such splendid kneeling figures of some thirty years before as the one ordered of an unknown sculptor by Duarte de Lemos, Afonso de Albuquerque's implacable opponent in Asia, for his family pantheon at Trofa do Vouga above Coimbra.

This statue has been attributed by Reynaldo dos Santos to Filipe Hodart (Philippe Hodart, active 1522-34),[2] another French sculptor who emigrated to Portugal by way of Spain, where he worked in the cathedral of Toledo in 1522-6. He is best known for a theatrical terracotta *Last Supper*, a group of large seated figures of Christ and the Apostles, which he made for Santa Cruz of Coimbra in 1530-4. Mutilated and incomplete, the statues, now in the museum of Coimbra, create an unforgettable impression of tension and strain, their bodies twisted by emotion, their faces tormented by a grief which expresses itself in gestures and grimaces that foretell El Greco. This dramatic emotional style, so uncharacteristic of the serene and gentle Portuguese temper, is found also in the kneeling figure of the knight of Malta, Cristóvão de Cernache, on his tomb in the church of Leça do Balio outside Oporto, which dates from 1567. Significantly made of terracotta, the material of the great Coimbra *Last Supper*, the agitated praying figure, movingly isolated beneath the broad arch of the tomb, reveals if not the hand, at least the influence of Filipe Hodart.

Far from this tempestuous world are two polychromed statues of St Elizabeth and St Mark the Evangelist, which are among the finest works of the Renaissance school of Coimbra. The former is in the Coimbra museum, having been removed from the retable in the Sacrament chapel of 1566, where the St Mark still occupies one of the shallow Mannerist niches designed, it is thought, by João de Ruão. Since the work is believed to have been carried out by the Portuguese sculptor Tomé Velho, who later worked with the Frenchman in the new church at Matosinhos, some scholars consider the two statues to be by this artist.

If they are, they prove that Tomé Velho (active 1561-1621), of whom very little that is definite is known, was a much finer sculptor than João de Ruão, for the figures exist

Plate 124

Plate 125

Plate 126

Plate 128

Plate 127

Plate 129

beneath their drapery, like those of Chanterene, and their personalities are clearly presented and defined. Both have real grandeur of bearing, suggested perhaps by some work of Hodart, and both express a national dignity and pride, along with, as Martin Soria has said, the eminently Portuguese qualities of 'spirituality, warmth, serenity and human understanding'.[3] Nothing could exceed the subtle delicacy with which the folds of the garments are rendered, and nothing could express more suitably the elegant epoch which was now coming to its close. These statues of *c.* 1566 represent the culminating phase of a movement which under the impulse of the French Renaissance had been developing for over half a century in Portugal, in an area especially suited to the purpose because of the remarkable qualities of its soft, expressive limestone.

In the last quarter of the sixteenth century stone sculpture declined in importance and never regained the position it had previously held throughout the country. Retables were now made of gilt and polychromed wood, and these carried on the late Renaissance ornamental tradition that had first developed in stone. Thus the altarpieces of the 'architectural' phase (*c.*1575-1650), designed by the brothers Coelho and the craftsmen who *Plate 93* worked for the Jesuits, employ strapwork and other Mannerist ornament that appears in the late style of João de Ruão. From the mid-seventeenth century onward, however, the woodcarved retable acquired its own ornament, quite independent of sculpture in stone. The latter with a few exceptions, mostly at Lisbon in the circle of the court, was reduced to the rank of a secondary art, restricted to the making of sarcophagi, fountains, garden figures, architectural ornaments and other objects destined to be used in places or for purposes that require stone rather than wood.

The rise of the woodcarved altarpiece brought with it sculptors who specialized in the making of devotional images of wood to be set in the niches and compartments of the retables which at first were occupied by paintings, as in that of Nossa Senhora da Luz *Plate 92* in Lisbon. There and in other centres the *imaginário* who made these statues seems to have been considered socially superior to the *entalhador*, who made the frame of the altarpiece, although on occasion the entire work was undertaken by the same individual. Manuel de Almeida, a celebrated wood sculptor of the early eighteenth century in Oporto, was granted privileges of nobility 'because he makes nothing but images'.[4] Later in the century the figure sculptor Joaquim Machado de Castro was made a member of the Military Order of Christ, an honour hitherto reserved for architects and engineers.

With the great expansion of monastic churches that occurred in the period of the union of Portugal with Spain (1580-1640) came a demand for retables and images that continued until the end of the eighteenth century. While most of the production was anonymous and undocumentable, the work of a few of the wood sculptors can be distinguished. Undoubtedly the greatest of these is Manuel Pereira (1588-1683) of Oporto, whose extremely long life was spent for the most part in Spain, where he went, like Velázquez's grandfather, in search of better commissions. He seems to have worked almost exclusively for the religious orders and that is symptomatic of the age.

Pereira's best-known work is the statue of St Bruno in an altarpiece at the Carthusian monastery of Miraflores outside Burgos. The white-clad figure holds in one hand a *Colour* crucifix, to which he turns his head intently, while the fingers of the other hand are *plate VII* raised in a slightly distracting Baroque gesture. The creased face is represented with realism but without the exaggeratedly emotional expression typical of Spanish sculpture at this time. Pereira's St Bruno is detached and blandly expressive of that Portuguese serenity or quietude already noted in this book, to which we shall frequently return.

These qualities are even more apparent in Pereira's large crucifix and stately Virgin of the Rosary, both mentioned in 1662, which were sent from Madrid to ornament the transepts of São Domingos at Benfica in Lisbon.

Other Portuguese wood sculptors of the seventeenth century, about whom very little as yet is known, expressed in their work a bucolic calm and satisfaction. In the sculpture of Coimbra, where the devotional figures and reliefs of the great Castilian master Gregorio Fernández (1576-1636) exercised considerable influence, most of the tragic quality was expelled and instead of a feeling of suffering the statues exude a spirit of placid well-being. Nor do they commit themselves to the theatrical attitudes and gestures which Italian Baroque fashion was making increasingly common in other countries of Europe. Those effects will appear only in certain rare works of the first half of the eighteenth century, when Portuguese artists, after the long immobility of the seventeenth, eventually adjusted themselves to livelier poses and emotive expressions.

In the late seventeenth century certain of the great monastic communities had their own sculptors, some of whom worked in quite distinct manners. Two years ago I had the good fortune to discover the manuscript biography of the monk Cipriano da Cruz Sousa of Braga, who entered the Benedictine order in 1676. From then until his death in 1716 he made statues and reliefs for the Benedictine churches of Tibães and Coimbra, including *Plate 131* the stately gilt and polychromed wood *Pietà* now in the museum of Coimbra. This handsome group of about 1685, which has been considered Spanish, is typical of the grandeur of the sculptor's work and the serenity of his spirit. It also shows his limited ability to deal freely with the human figure and his inhibiting tendency to schematize folds of drapery. For the University of Coimbra Frei Cipriano da Cruz made a stone statue of an attractive young woman laden with allegories posing as Knowledge, which stands behind the library, and for the church of Tibães the Virtues and Benedictine kings of the sacristy and the saints of the façade in vividly painted terracotta.

The latter material became typical of the Cistercian monastery of Alcobaça, where a group of sculptors between *c.* 1670 and 1690 transformed the medieval buildings with retables, reliquary busts and standing figures of terracotta, some of which were brilliantly painted while others were left without colour. All have in common the use of sensuous lips and large heavy-lidded eyes, rounded necks and cheeks and luxuriant hair that have reminded critics of the style of Alonso Cano, a contemporary sculptor of southern Spain.

Plate 95, 96 The series of Alcobaça statues begins with the decoration, in 1669-72, of the Sanctuary, a circular reliquary chapel at the end of the sacristy already mentioned in Chapter 2, which displays a fascinating collection of busts containing relics, some carved in wood, representing monks and nuns and ladies and gentlemen in the dress and coiffure of the time. Above these busts are the towering figures of bishop saints and the Virgin, which *Plate 129* in the pride of their bearing are related to the fine stone statues of the Sacrament chapel of the cathedral of Coimbra. Standing images of this sort representing patriarchs of the church and Cistercian abbots were placed in the apse of Alcobaça in the years between 1675 and 1678.

They are now on display in the chapter house of the convent along with a celebrated Annunciation group, which may be the work of a certain Frei Pedro, who is known to have made a number of terracotta statues in 1676 for Frei Jerónimo de Saldanha of Alcobaça. Nothing could express better the dignity and detachment of most seventeenth-century Portuguese figure sculpture than these handsome but listless statues, dressed in voluminous garments whose folds repeat the complex masses of their hair. The angel

of Lisbon (1743), which survived from the bridge of Alcântara, destroyed in the Lisbon earthquake of 1755.

All of these artists are eclipsed by the fame of Joaquim Machado de Castro (1731/2-1822), the most celebrated Portuguese sculptor of the eighteenth century, whose reputation in based in large measure on his equestrian bronze statue of Dom José. Born in Coimbra, where the local museum now bears his name, Machado de Castro was trained by José de Almeida. In 1756 he became Giusti's principal assistant and remained at Mafra, working on the marble altar reliefs until 1770, when he was chosen to make the equestrian statue, destined to occupy the centre of the Praça do Comércio, the broad new waterfront square which was the crowning feature of the rebuilding of earthquake-torn Lisbon by the all-powerful minister, Marquis of Pombal. Plate 136

The project went back to 1759/60, when the engineer Eugénio dos Santos had prepared drawings for an equestrian monument to the king. Santos died soon after, but Castro was obliged to follow his designs, based on a project of Louis XIV's decorator Charles LeBrun. The manner in which he did this, substituting serpents for the cumbersome lion the horse was to tread on, is in itself no small accomplishment, for it conveys to every part of the monument a Rococo lightness of touch and grace of movement that entirely transforms an academic scheme. In preparation for the work, which took five years to complete, Machado de Castro made a sketchbook, which is now at the Lisbon museum, and in 1810 published an account of the entire experience.[10] Denied access to the king, who was already suffering from the diseases that were to end his reign in 1777, he subordinated the head to the helmet, whose floating plumes launch a thread of movement that passes through the horse to the Rococo targe with the royal arms on the front of the base, designed by Reinaldo Manuel dos Santos, another of the architects who were rebuilding Lisbon. From here augmented, it passes to the two groups flanking the pedestal, one of which represents, in true LeBrun fashion, *Triumph Leading a Rearing Horse*, the other *Fame Conducting an Elephant*, in allusion to the Portuguese conquests in the East. The bronze was successfully cast in one operation by General Bartolomeu da Costa, who was the first Portuguese to perform such a feat. He then celebrated his achievement by producing the first Portuguese porcelain, which was used for a commemorative medal set into rings. The statue was dedicated in a great ceremony on June 6, 1775, presided over by the Marquis of Pombal, whose portrait appears on the front of the base of the monument. This is one of the most colourful of all the great equestrian statues of Europe, for the surface of the bronze has acquired a brilliant green tonality, which stands out with scintillating effect against the blue of the sky and the water and the shimmering whiteness of the base and its allegorical statues, in the splendid setting of the eighteenth-century square. *Plate 72*

In the subsequent reign of Dom José's daughter, Dona Maria I (1777-1816), Machado de Castro became the official sculptor of Portugal, designing no less than four royal tombs, the first since the late sixteenth century. For the queen's new basilica of the Sacred Heart, he provided a series of colossal marble statues (1777-83), executed by an assistant, José Joaquim Leitão, who had worked on the allegories of the equestrian statue. These were followed by others in wood for the new baldachin of São Vicente de Fora. The results are disappointing, the forms are inflated, the surfaces dry and the expressions mechanical. In 1783 Castro portrayed his patroness, Dona Maria I, in a marble statue for the Mafra estate of the Interior Minister and Inspector of Public Works, Marquis of Ponte de Lima, which has stood for over a century at the entrance to Plate 137

the National Library. The statue, carried out in part by the sculptor's favourite pupil, Faustino José Rodrigues (born *c.* 1736), shows the queen at the age of fifty depicted in a surprising combination of a Houdon-like plumed bust, full of Rococo realism, with a body encased in armour covered by an imperial mantle, decorated with incipient Neo-Classicism.

If in statues of this sort Machado de Castro seems stiff and artificial, an entirely different aspect of his art is revealed by a number of religious subjects in wood and clay that can be identified as his work. All are graceful, effortless Rococo masterpieces that seem to have developed directly from the style of his master, José de Almeida. In 1766 Castro signed and dated a *presépio*, or Christmas crèche, for the cathedral of Lisbon, made of many terracotta figures of shepherds, magi and angels, like those of eighteenth-century Naples. On the basis of this work it seems possible to attribute to Machado de Castro an enchanting polychrome clay group of the Holy Family returning from Egypt, a favourite subject at the time in Portugal. Traditional are the tricorn hats of the sacred figures and the travelling boots of St Joseph, though here they resemble sandals. The group is presented in the Aveiro museum in an eighteenth-century case painted with sprigs of flowers in blue, rose and gold, which was a favourite form of decoration in the rich nunneries of the time.

Colour plate IX

'We know no better modelled clay figures of peasants than those of this rare artist of the last century.'[11] With these words Cirilo Machado praised the *presépios* of António Ferreira, who competed with Machado de Castro in the making of elaborate *presépio* groups for the Carthusians of Laveiras, the nuns of the Madre de Deus and for the queen's own basilica of the Sacred Heart. Now in most cases dismounted, Ferreira's compositions were distinguished for three categories of lithe porcelain-like figures — the peasant spectators, mentioned above, the music-making angels and the long processions of exotically clothed horsemen, which can be seen in the museums of Lisbon and Coimbra.

Plate 138

The making of gaily painted terracotta figurines, which in the early seventeenth century had delighted Philip III of Spain when he visited Estremoz in the Alentejo, flourished in the eighteenth century at Aveiro, where a number of sculptors signed and dated their work. One of the most attractive is the relief of the Virgin surrounded by angels made by Joaquim Marques dos Santos in July, 1782. The long Portuguese face and short body of the Virgin and the circular grouping of the angels offer a Rococo restatement, in terms of folk art, of the seventeenth-century Alcobaça statues or the kneeling figure by Jacinto Vieira. St Mary here appears as advocate of the souls in Purgatory, who are seen suffering in flames below Her feet. This cult of the *Alminhas* was one of the most popular in Portugal during the eighteenth century, and some reference to it is found in almost every church.

Plate 139

Plates 130, 132

Nowhere is it so evident as in the district to the north of the River Douro, from Oporto through the old province of Minho, where the roads are lined with tiny shrines decorated with Rococo shells, urns and garlands massively carved of dark local granite. In this area, where water seems to spring up at every step, fountains abound and constitute the chief artistic expression of the countryside as well as the largest and generally finest group of outdoor sculpture in the nation. The handsomest fountains were made *c.* 1550-1750 on the sixteenth-century Italian model of water falling from graduated basins. There are early examples in the squares of Viana do Castelo and Guimarães and a notable series given by various archbishops to the city of Braga in the late seventeenth and early eighteenth centuries.

112 (OPPOSITE) A Guardian Angel. Coimbra, Museu de Machado de Castro. Early 16th century

Sculpture

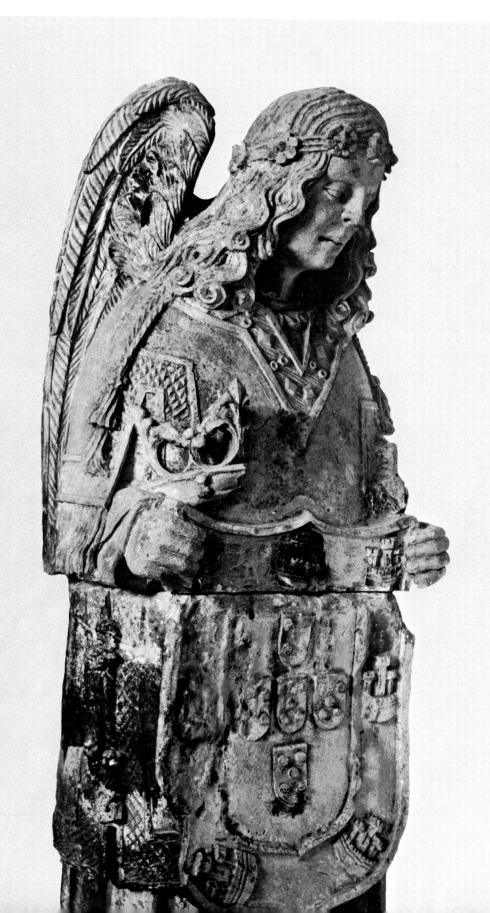

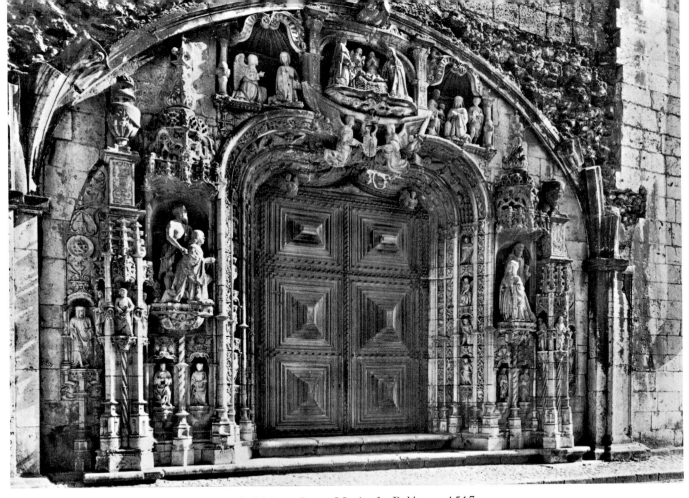

113 Nicolau Chanterene: The west portal. Lisbon, Santa Maria de Belém. *c.*1517

114 Detail of the tomb of Fernão Teles de Meneses. São Marcos de Tentúgal. Late 15th century

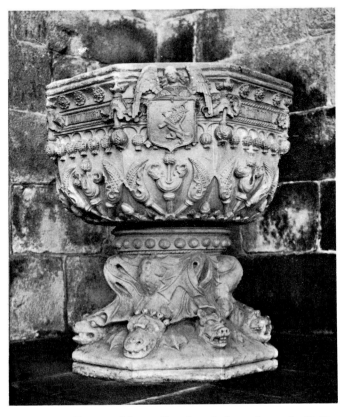

115 Diogo Pires o Moço: Baptismal font. Leça do Balio. 1514–15

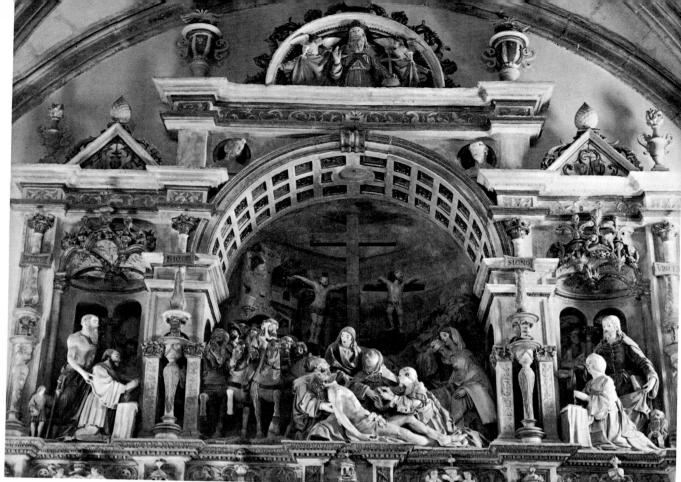

116 Nicolau Chanterene: Detail
of the Silva family retable.
São Marcos de Tentúgal. 1522

117 Nicolau Chanterene: Detail
of the Silva family retable.
São Marcos de Tentúgal. 1522

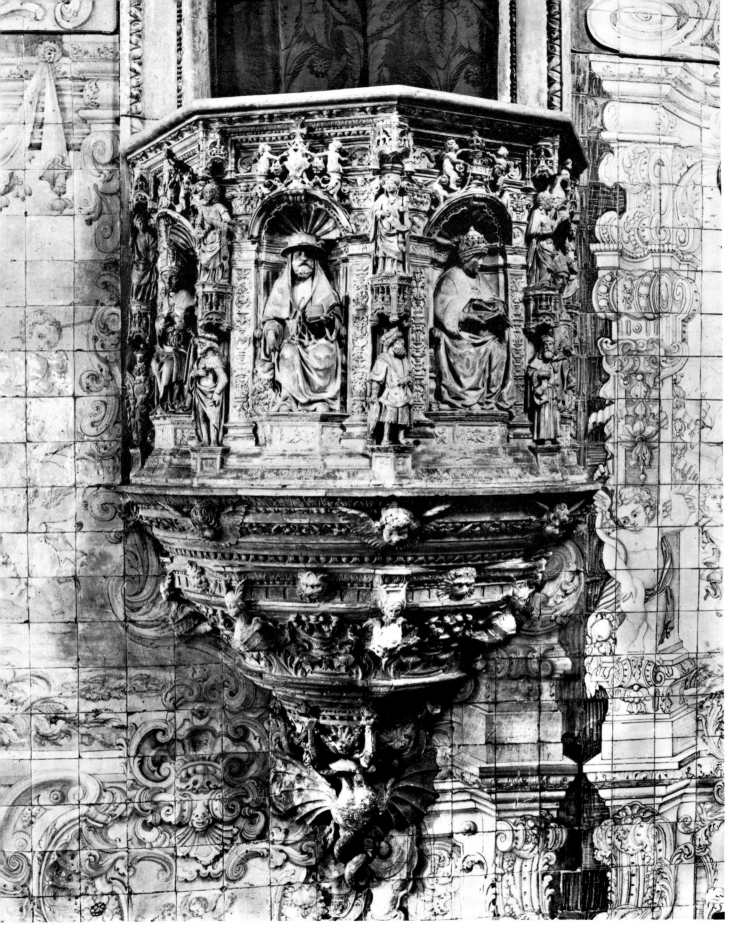

118 Nicolau Chanterene: The pulpit. Coimbra, Santa Cruz. *c.* 1518–28

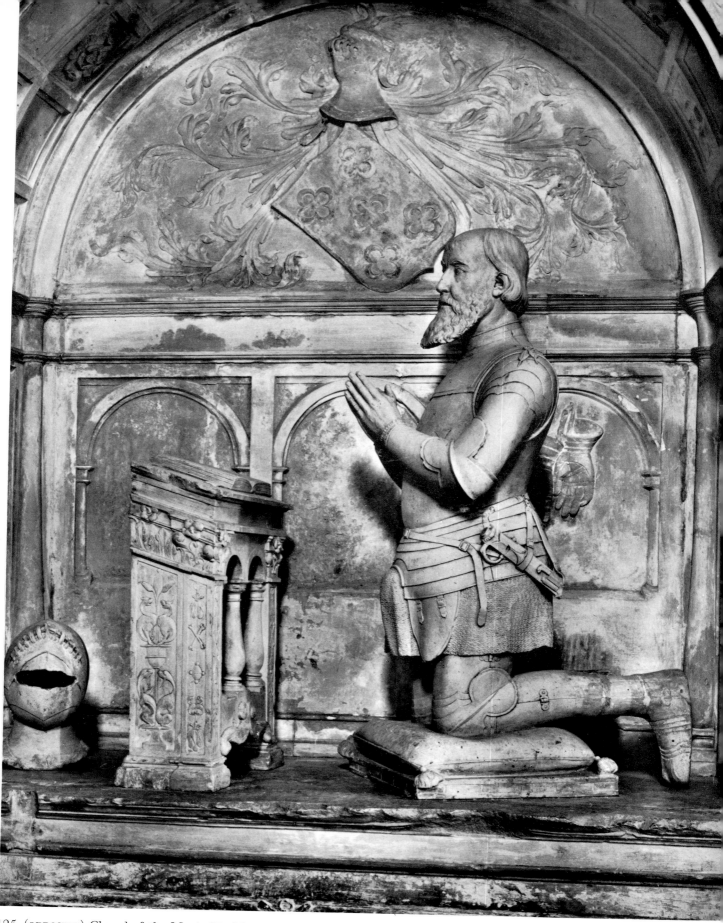

125 (OPPOSITE) Chapel of the Magi. São Marcos de Tentúgal. 1566
126 (ABOVE) Detail of the tomb of Duarte de Lemos. Trofa do Vouga. *c.* 1535–46

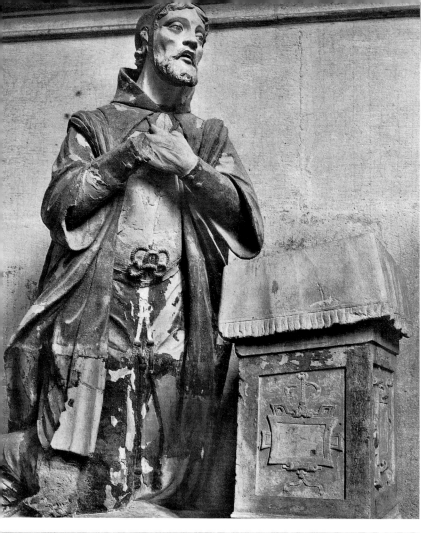

127 Detail of the tomb of Frei Cristóvão de Cernache. Leça do Balio. 1567

128 Filipe Hodart: Figure from the Santa Cruz *Last Supper*. Coimbra, Museu de Machado de Castro. 1530–4

129 (OPPOSITE) St Mark. Coimbra, Old Cathedral. 1566

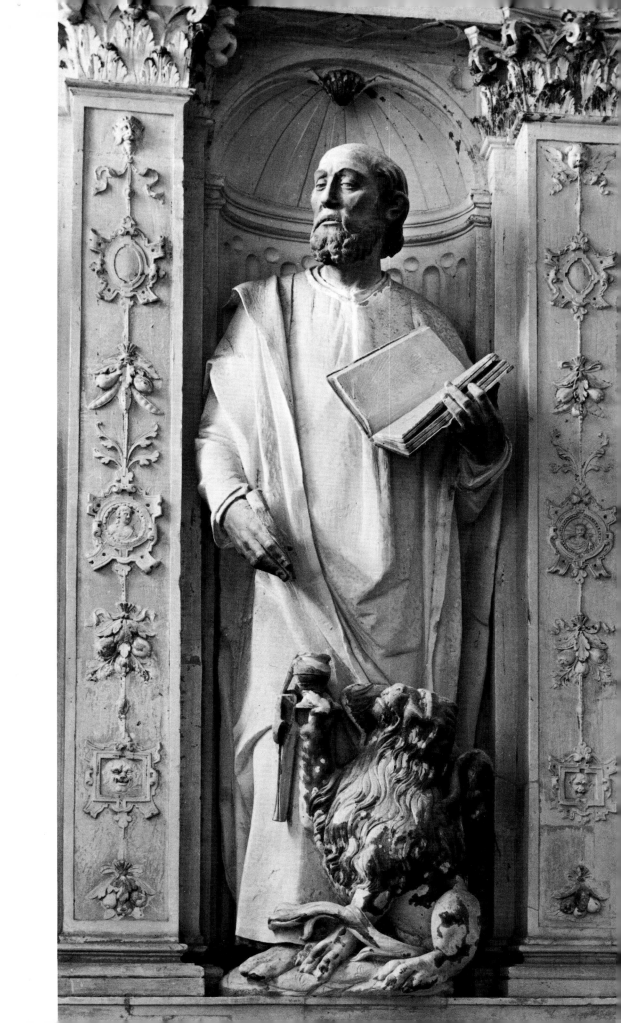

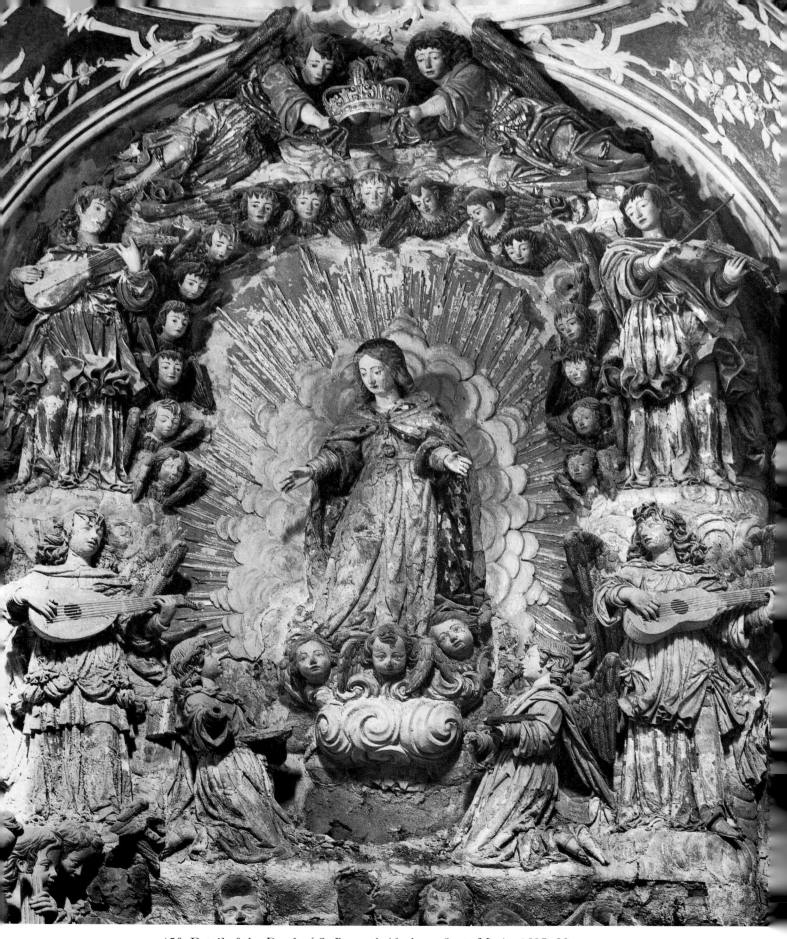

130 Detail of the *Death of St Bernard*. Alcobaça, Santa Maria. 1687–90

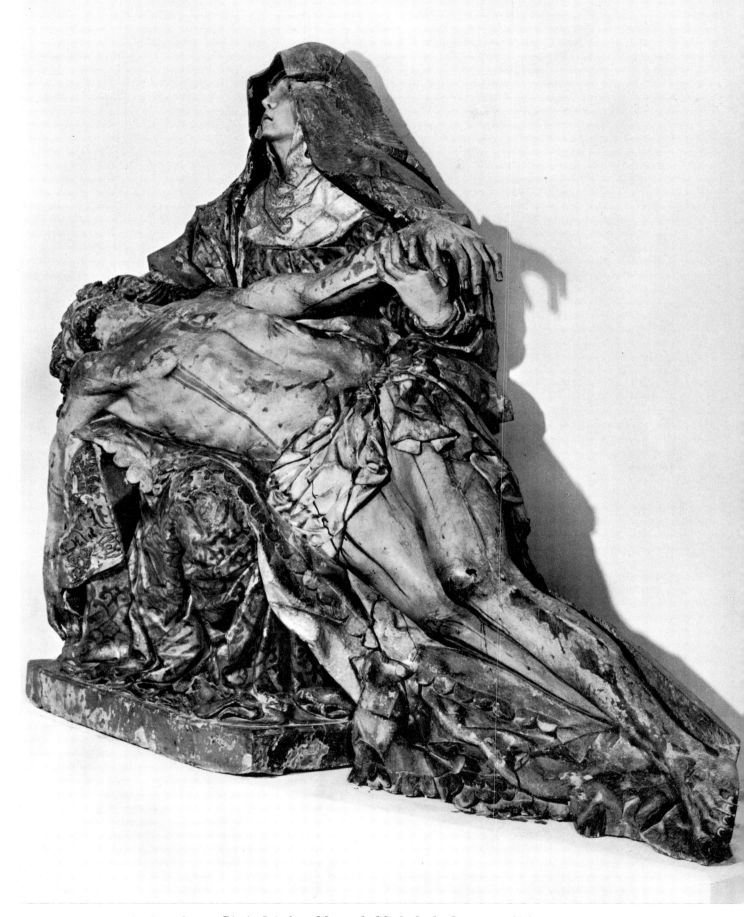

131 Frei Cipriano da Cruz Sousa: *Pietà*. Coimbra, Museu de Machado de Castro. *c.* 1685

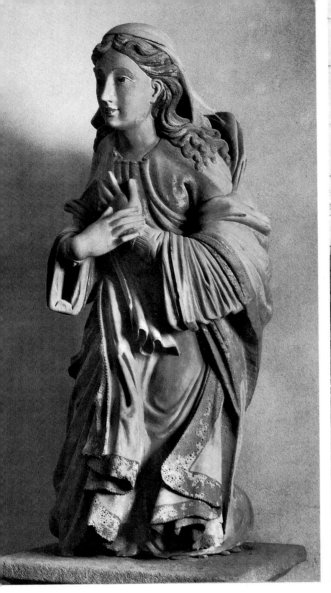

132 Jacinto Vieira: Virgin Annunciate.
Arouca, Santa Maria. *c.* 1723–5

133 Cláudio de Laprada: The portal of Estudos Gerais remodelled
as a monument to Dom José. Coimbra, the University. 1701 and later

134 (OPPOSITE) Alessandro Giusti: Bust of Dom João V. Lisbon,
Palácio Nacional de Belém. *c.* 1745

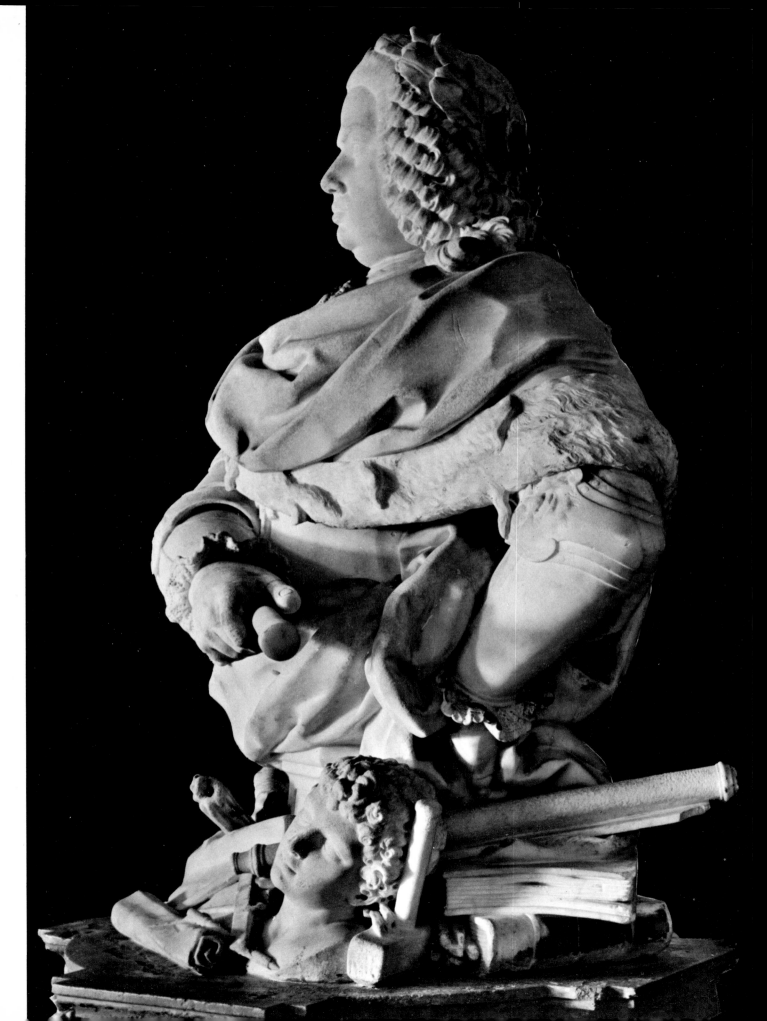

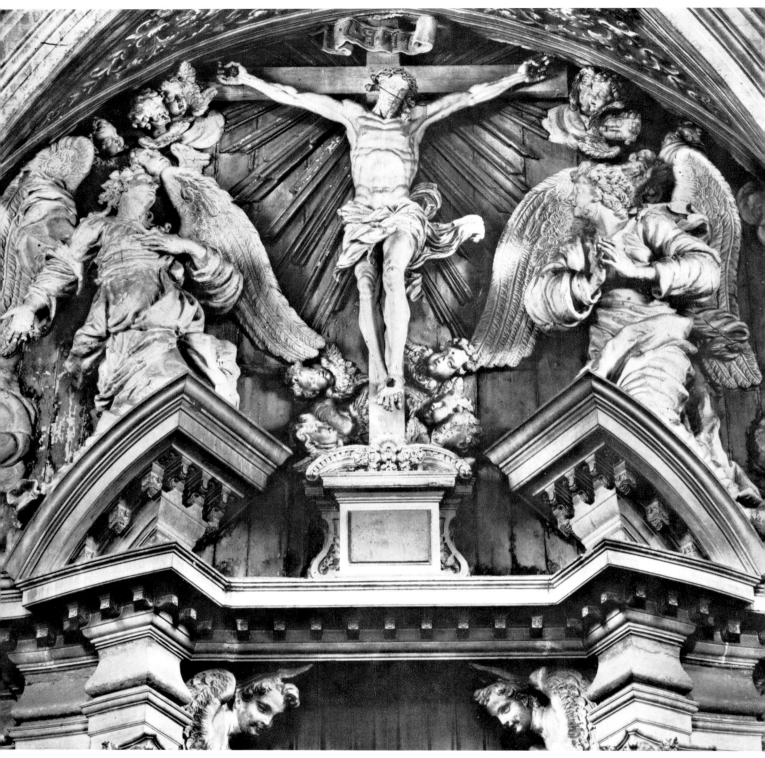

135 José de Almeida: *The Crucified Christ between Angels*. Lisbon, Church of Santo Estêvão. 1730
136 (OPPOSITE) Joaquim Machado de Castro: Equestrian statue of Dom José. Lisbon. 1775

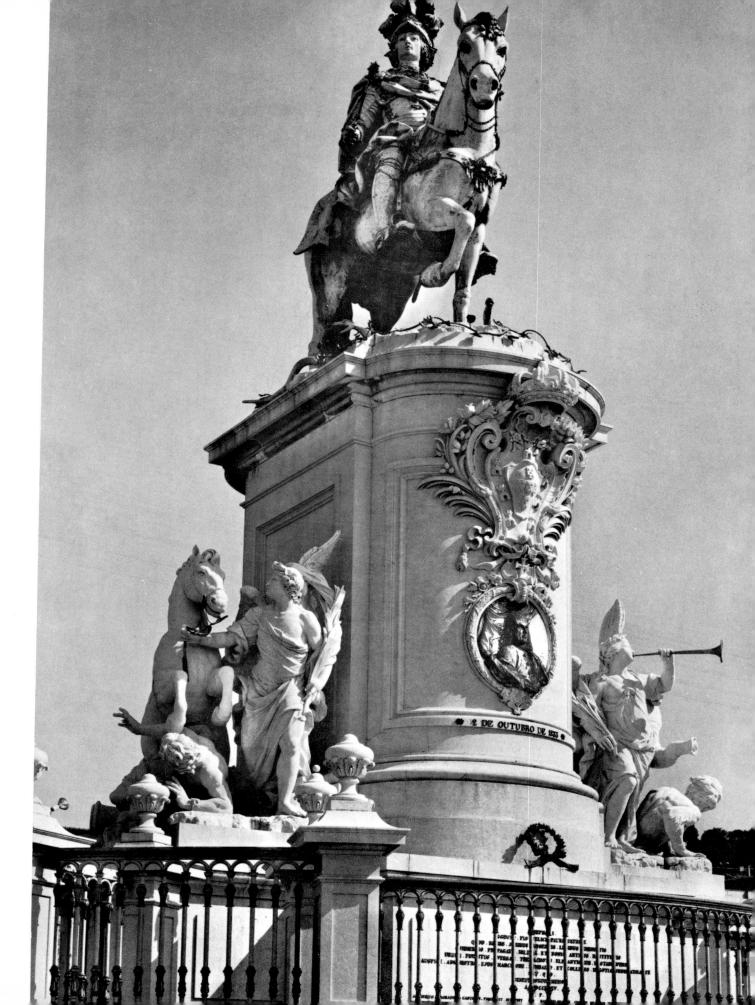

2 DE OUTUBRO DE 1833

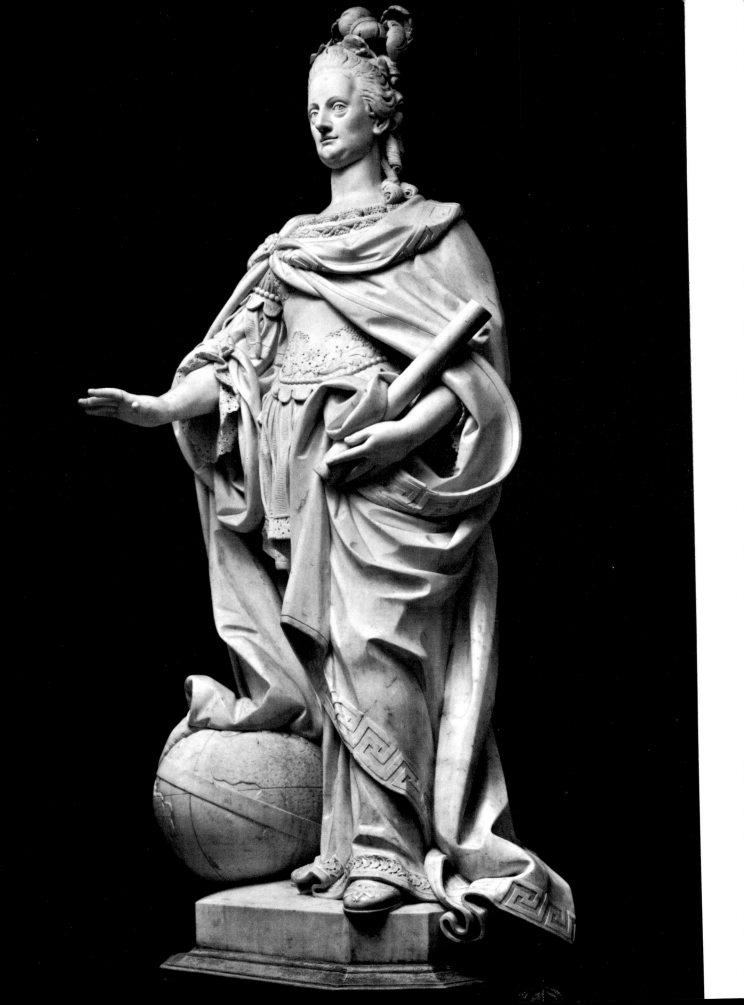

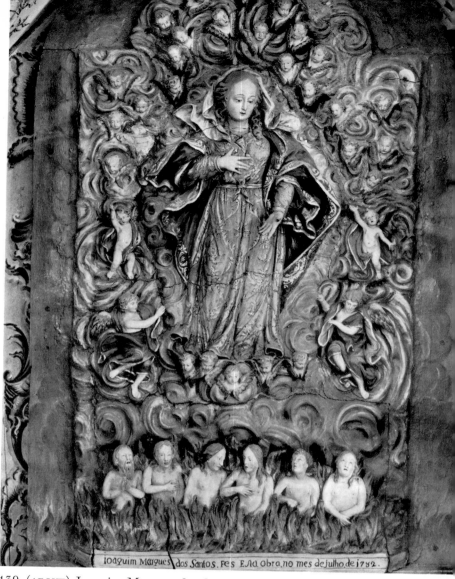

137 (OPPOSITE) Joaquim Machado de Castro: Dona Maria I. Lisbon, Biblioteca Nacional. 1783

139 (ABOVE) Joaquim Marques dos Santos: *The Virgin with the Souls in Purgatory*. Aveiro, Museu Regional. 1782

138 (LEFT) António Ferreira: Figures from a scene of the Nativity. Lisbon, Museu Nacional de Arte Antiga. Late 18th century

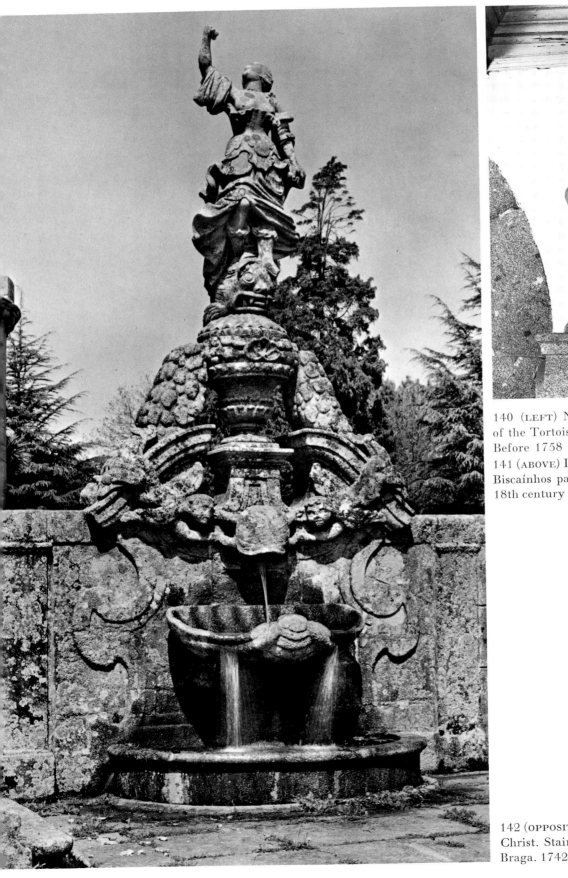

140 (LEFT) Nicolau Nasoni: Fountain
of the Tortoise. Oporto, Quinta da Prelada.
Before 1758

141 (ABOVE) Decorative statue. Braga,
Biscaínhos palace. Second half of the
18th century

142 (OPPOSITE) Fountain of the Wounds of
Christ. Stairway of Bom Jesus do Monte,
Braga. 1742

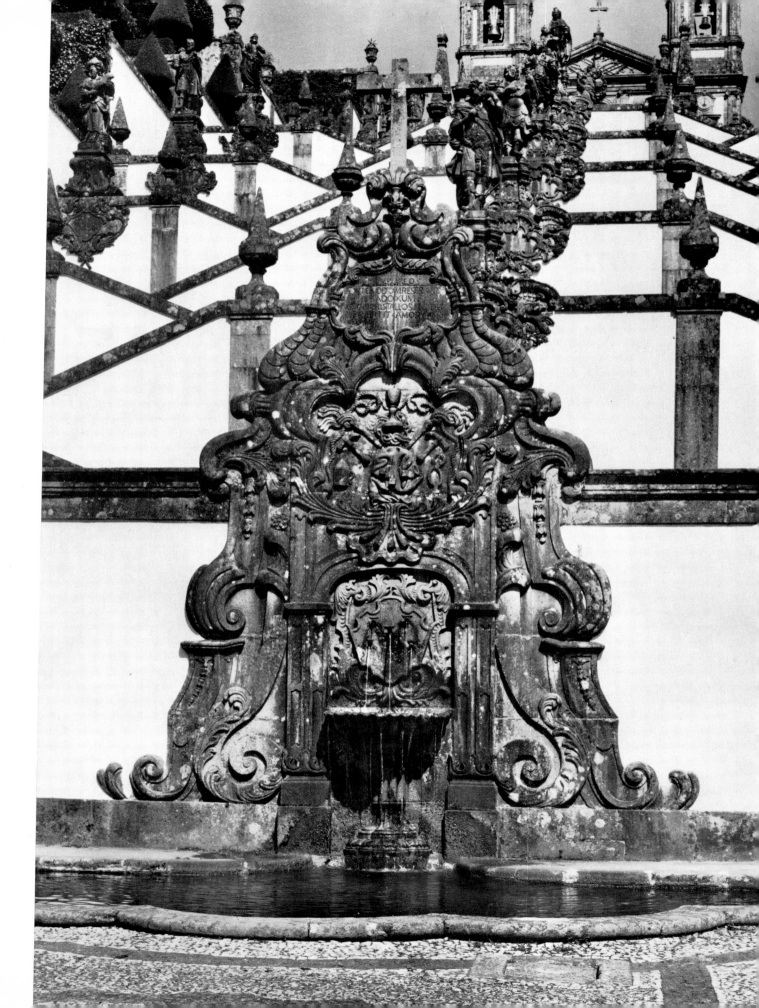

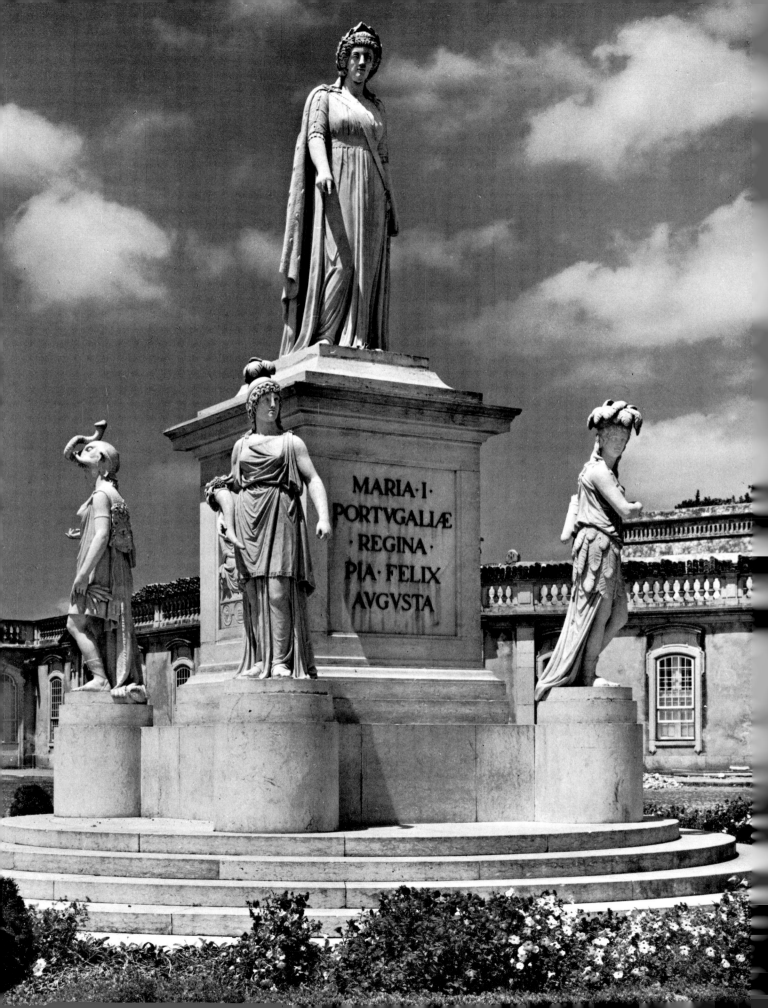

MARIA·I·
PORTVGALIÆ·
REGINA·
PIA·FELIX
AVGVSTA

Fountains in the form of Baroque statues, seen constantly in Joanine tiles, appear to have been introduced to Oporto by the Italian architect Nicolau Nasoni, who used them in the gardens he designed for the country houses with which he ringed the city in the period 1735-60. A description of that of Prelada, made before 1758, mentions a half dozen, only one of which, the Tortoise fountain, has survived. This spectacular vertical composition takes its name from the turtle held above the wall basin by flying putti, whose heavy, stylized forms go back to the Romanesque sculpture of the Minho. The same impression is created by the grimacing dolphin above, on which there pirouettes a richly dressed young woman. The fountain, which is drawn together by an urn and weighty garlands, is characteristic of a hearty robust style, created by the hard resistant nature of the stone, that is found in every period of art in northern Portugal.

Plate 140

The great Archbishop of Braga, Dom Rodrigo Moura Teles (1704-28), laid out in 1723 the first section of the enormous staircase leading up a hillside to the shrine of the Bom Jesus. Each landing was subsequently decorated with a wall fountain containing a figure symbolizing one of the senses, with water falling from eyes, nose, mouth or an ear. These are flanked by statues of Biblical figures, probably inspired by Nasoni's, that grow more and more Rococo as one ascends the stair. Some wear the turbans and oriental cloaks and beards of Manueline woodcarving and painting, a widespread exoticism of this period, which explains the costumes of the statues of the prophets at Congonhas do Campo, carved in soapstone by Aleijadinho, the foremost sculptor of colonial Brazil.

Plate 142

This granite sculpture of the region around Braga reached its zenith in the 1750s and 1760s, with the decoration of the church of Falperra, the exterior and stair of the Raio palace, presided over by a statue of a mustachioed 'Mexican' in pantaloons and turban, and in the palace and gardens of Biscaínhos. Here one is welcomed by reliefs of bowing gentlemen resembling the halbardiers of the tiles, who beckon toward fountains and gazebos decorated with ruffled shells and asymmetrical volutes, which, like all the Braga Rococo, have a strong flavour of Augsburg decorative engravings. These decorations and the charming fountain of a kneeling boy, which the great Benedictine sculptor Frei José de Santo António Vilaça made in 1785 for a garden at Tibães, are the stylized northern counterparts of the marble sculpture in the gardens of the royal palace of Queluz and the Pombal estate at Oeiras, outside Lisbon, made by the court sculptors Silvestre de Faria Lobo and Joaquim Machado de Castro.

Plates 63, 64

Plate 141

The latter lived until 1822 and therefore witnessed the change at the end of the eighteenth century from the Rococo to Neo-Classicism. The new style was first seen in Lisbon in 1797, in the monument to Maria I, now at the palace of Queluz, executed by João José de Aguiar, who had been a pupil of Canova in Rome. The design, however, is said to have come from Francisco Xavier Fabri, the Italian architect of the palace of Ajuda, who did so much to promote Neo-Classicism in the capital before his death in 1807.

Plate 143

Plate 86

The severely rectilinear new monument shows the unhappy queen (insane since 1792) rigid in classical costume, pointing to four Graeco-Roman female figures, symbolizing the four continents, in all of which Portugal still possessed dominions. It offers an impressive contrast to Castro's earlier portrait of the queen and a close parallel with the statuettes of the Wellington silver, designed by the painter Domingos António Sequeira in 1811. The monument to Maria I paved the way for more archeological effects in the large group of allegorical statues set in niches in the circular vestibule of the palace of Ajuda, by Aguiar, Faustino Rodrigues and Joaquim José de Barros Laborão, who were

Plate 137
Plate 236

143 (OPPOSITE) F. X. Fabri and João José de Aguiar: Monument to Dona Maria I. Queluz. 1797

the principal sculptors of the new style of the early nineteenth century. Unfortunately the flight of the court to Brazil in 1807 put an end to their activities. A few years later, in 1822, Adrien Balbi complained that there were almost no sculptors in Portugal and found '*très peu de gloire*' in the fine arts in general.[12] It was not until the second half of the nineteenth century that something approaching the achievements of Chanterene or Machado de Castro was attained in the work of the late classical sculptor António Soares dos Reis (1847-89) of Oporto and his pupil António Teixeira Lopes (1866-1942).

who were soon to dominate painting at the court of Dom João III, in the second quarter of the century.

His sojourn in the capital gave to Grão Vasco a fuller, more monumental style, along with some knowledge of Renaissance forms. These are seen in the modelling of the powerful head of the large *St Peter*, painted for the cathedral of Viseu, the majestic sweep of the drapery, the Italianate shell at the top of the throne, which suggests a Germanic engraving, and even more in a sense of measured space. This continues beyond the hieratic seated figure to the distant landscape seen through a pair of arches, which reveals trees and other details characteristic of the artist's native Beira.

The late work of Vasco Fernandes, like the signed *Pentecost* of Santa Cruz in Coimbra, which is dated 1535, expresses intense emotion through carefully contrived agitated Mannerist poses. He retained, however, the old Flemish types for the figures of the holy women in the centre of the painting. These are found also in the masterpiece of Cristóvão de Figueiredo (active 1515-43), a *Deposition of Christ* for the high altar of Santa Cruz of Coimbra, painted in 1529-30, which in this particular may have influenced Grão Vasco's painting for the same building. The *Deposition* is dominated by the impressive faces of the two spectators at the right, which in spite of the softer modelling employed approximate the heroic portraits that Nuno Gonçalves had painted some sixty years before. For this reason Reynaldo dos Santos has recently attributed to Cristóvão de Figueiredo another fine seated *St Peter*, this time at São Pedro de Tarouca near Lamego, a church which the artist is known to have visited on several occasions.[5]

Gregório Lopes (*c.* 1460-1550), who was also a pupil and the son-in-law of Jorge Afonso, is the most sensuous of the painters of the second quarter of the sixteenth century, the one who most frequently displays the splendid work of the goldsmiths of the period, and the one most concerned with effects of light. These points are all illustrated in the attributed *Mass of St Gregory*, a panel from the altarpiece of the church of São João Baptista at Tomar, which dates from 1538-9. Typical are the round faces of the young deacons, the attention given to candlesticks and censer and the glittering surface of the arch that frames the choir. There the light darts from one group of chanting Magnascolike monks to another and their excited gestures foretell the dramatic highlights and the emotional contortion of the figures in the backgrounds of Gregório Lopes' Passion retable (*c.* 1540-5), from the monastery of Santos-o-Novo, now in the Lisbon museum.

Bearing a family resemblance to the work of these two painters and their *confrère* Garcia Fernandes (active *c.* 1514-65) are the panels of the Santa Auta altarpiece, which commemorates the arrival in 1517 of relics of a companion of St Ursula at the convent of Madre de Deus. The scene of the procession is a Carpaccio-like spectacle of friars marching in the midst of canopies and richly caparisoned boats toward the Manueline doorway of the convent. They are watched by devout women in a decorated tribune at the left, one of whom is the foundress Dom João II's widow, queen mother Leonor, who commissioned these gaily coloured festive paintings before her death in 1524.

The festive spirit and brilliant colours of the *Arrival of the Relics of Santa Auta* bring to mind similar scenes in some of the illuminated manuscripts which represent another important aspect of Portuguese painting in the first half of the sixteenth century. Here once again the creative impetus came from the painters of Flanders and northern France through the importation of illuminated books of hours or devotional reading for the use of the royal family, one of which, now at the Morgan Library in New York, belonged to that same Queen Leonor who founded the Madre de Deus convent. The *Book of Hours*

Plate 146

Plate 147

Colour plate X

Plate 148

Colour plate XI

XI (OPPOSITE) *Arrival of the Relics of Santa Auta at the Church of Madre de Deus*. Lisbon. Museu Nacional de Arte Antiga. *c.* 1520

of Dom Manuel, at the Lisbon museum, which is one of the handsomest manuscripts of this sort in existence, is thought to have been made in Portugal because of certain local usages found in the miniature paintings of the labours of the months with which the illustrations begin. Among the royal artists who have been suggested as the author of these paintings is the Flemish miniaturist António de Holanda (active 1527-51), who illustrated several manuscripts with family trees. The finest of these are on the surviving leaves, now at the British Museum in London, of a genealogy of one of Dom João III's brothers, the Infante Dom Fernando (1507-34). They date from 1530-40 and were made jointly with Simon Bening, who worked in Flanders while Holanda remained in Portugal, the former in most cases painting what the latter had drawn.

The most interesting leaf, which represents the section of the royal line stemming from the twelfth-century Afonso Henriques (reigned 1128-85), contains a spectacular aerial view extending from the city of Lisbon past the monastery of Santa Maria of Belém and the Manueline Tower, isolated as it originally was on an island beyond the forts at the mouth of the Tagus, all the way to the palace at Sintra. Broad vistas of this sort are also found in manuscripts of some of the historical chronicles and in the greatest monument of Portuguese illuminating of the first quarter of the sixteenth century, the sixty volumes of the *Leitura Nova.* This is a collection of copies of older documents in the royal archives which Dom Manuel ordered a number of artists to make. Some of the best of the illuminated frontispieces, beginning with the king's proud title 'Dom Manuel, by the grace of God King of Portugal, Lord of Guinea etc.' are the work of

Plate 149
the miniaturist Álvaro Pires. In a leaf dated February 28, 1516, he combined tapestry, heraldic angels, Flemish music-making cherubs and ornamental birds in a network of sprawling acanthus foliage like that which was still being used, a quarter century later, in the genealogy of Dom Fernando by António de Holanda. At the bottom of the page there is a radiant Flemish landscape dominated by a distant castle.

Some of the handsomest of sixteenth-century illuminations are the illustrations for technical treatises. One of the richest of these is the great compendium of heraldry called *Livro da Nobreza,* commissioned by Dom Manuel, which is among the treasures of the national archives of the Torre do Tombo in Lisbon. Illustrated by António Godinho (fl. 1516-57) between 1516 and 1528, it contains superlative Gothic calligraphy and Roman lettering, the latter in extravagant Renaissance frames, along with page after page of brilliantly coloured coats of arms displayed in the midst of luxuriant foliage like those carved inside the cloister of Santa Maria of Belém. Another of these great treatises is the *Livro das Fortalezas,* also at the national archives, which consists of crisp detailed line drawings by Duarte de Armas (active 1510-23) of the forts and castles erected all over the Portuguese world.

Many of these buildings appear again in the wonderful series of charts and atlases drawn and illustrated during the sixteenth century, which are the major Portuguese contribution to the technical knowledge of the Renaissance and the natural outcome of the intensive study of navigation launched by Prince Henry the Navigator and his brothers. They belong, with few exceptions, to the category of portolan or coastal charts, a type of map invented in the thirteenth century, where the coastline of a continent, island or archipelago is painstakingly represented in lively colours on parchment. These maps were made by specialists who were sometimes distinguished cosmographers as well as illuminators.

The series begins with the charts of Pedro Reinel and his son Jorge (active *c.* 1500-40)

and the great Atlantic atlas of Lopo Homem (active *c.* 1524-65) at the Bibliothèque Nationale in Paris. It numbers among its masterpieces the work of Bartolomeu Velho (died 1538), Diogo Homem (*c.* 1520-76), the son of Lopo, Sebastião Lopes (active *c.* 1558-96) and Luís Teixeira, the outstanding figure at the close of the sixteenth century.

They were all surpassed, however, by Fernão Vaz Dourado (*c.* 1520-80), the son of a Portuguese nobleman and an Indian woman, who spent most of his life in Goa. His six surviving atlases with one hundred and fifteen sheets, dating from 1568 to 1580, are distinguished by their beautiful borders and decorative devices based on Serlio's designs. In the words of Armando Cortesão, the foremost authority on Portuguese mapmaking of the Renaissance, 'the perfection of the drawing, the delicacy of the illumination, the richness of the decoration, and, above all, the perfect taste with which everything is balanced show that Vaz Dourado was not only a good cartographer but also a consummate artist.'[6] Typical of his work is the elegantly restrained delineation of the coast of Plate 150 South America from the mouth of the Amazon to that of the Rio de la Plata, from an atlas of 1575 now at the British Museum, which is dedicated to Dom Sebastião and was probably presented to that unfortunate monarch shortly before his death by the Viceroy of India Dom Luís de Ataíde.

When Gregório Lopes died in 1550, his title of royal painter passed to his son Cristóvão (1516-94), who painted Dom João III and his wife Dona Catarina, sister of the Plate 151 emperor Charles V, on several occasions. The kneeling portrait of the queen, which serves as a pendant to that of Dom João III on the other side of the choir of the Madre de Deus, both of which are attributed paintings, owes much to the meticulous likenesses of the Flemish Mannerist Antonis Mor, who worked in Lisbon in 1552 with his Spanish pupil Alonso Sánchez Coello. The figure of the queen's patroness St Catherine, however, recalls the Florentine Mannerist Bronzino. Lopes was much more of a colourist than either of his mentors and this has led to the attribution to him of the head of a young nobleman in the Lisbon museum, which glows with brilliant tones and highlights suggestive of Veronese. This kind of portraiture, though in a harder, more linear form, continued with the paintings of Dom Sebastião (1557-78) by Cristóvão de Moraes (active 1557-71) and the remarkable anonymous portrait of an old woman with a rosary (Lisbon museum) which has more than a superficial resemblance to the contemporary statue of St Elizabeth at Coimbra.

By the end of Dom João III's reign in 1557 all traces of Flemish influence were disappearing from Portuguese painting and the art was about to enter a long period of decline which reached its depths at the time of the union with Spain (1580-1640), when there was no longer a royal court to administer patronage or to send promising young painters to study in Italy. Previously Dom João III and his family had provided scholarships for most of the men who became the outstanding artists of the last quarter of the sixteenth century, including the writer Francisco de Holanda (1517-84), son of the miniaturist António. Trained as a painter in Rome, he is best known for his drawings of fortifications and ruins in Italy and for his book *Da Pintura Antiga* of 1548, in which he incorporated the text of some dialogues which he had had with Michelangelo. Published only in the late nineteenth century, this manuscript had little or no influence in the dissemination throughout Portugal of the aesthetic of late Italian Mannerism, which produced in Spain the decoration of the Escorial.

That function was performed in Portugal by the painters Fernão Gomes (1553-1610),

Gaspar Dias (active 1560-90), António Campelo (active *c.* 1590) and Francisco Venegas (active 1575-90). The last was a Spaniard who spent most of his life in Lisbon, where after 1582 he served as Philip II's court painter. He is said to have designed the frame of *Plate 92* the retable of Nossa Senhora da Luz and is known to have collaborated with Diogo Teixeira on the eight panels which fill it. This altarpiece represents one of the first appearances of the cold and arid style, derived from Correggio, Raphael and the Florentine Mannerists, which briefly found favour at various courts of Europe in the last years of the sixteenth century. It is a style in which expressionless faces and inanimate gestures were considered a virtue and gray flesh and pallid drapery became almost a universal rule.

This style was continued into the seventeenth century by Simão Rodrigues of Lisbon (active 1562-1620), who in 1612 signed a contract to paint the retable of the chapel of the University of Coimbra. According to Adriano de Gusmão, he was also the author of *Plate 93* at least parts of the altarpiece of the cathedral of Portalegre, which dates from around 1582.[7]

In his documented work Simão Rodrigues collaborated with Domingos Vieira Serrão (*c.* 1570-1632), a painter of Tomar who worked for the Order of Christ and in 1619 replaced Amaro do Vale as Philip III's 'painter in oils'. When the Spanish monarch visited Lisbon in 1619, Domingos Vieira made a drawing of the waterfront palace square, showing the triumphal arches erected for the occasion near the tower of the Casa da Plate 153 Índia, which had been recently constructed on plans of Filipe Terzi. It was engraved by João Schocquens and appeared as the frontispiece of Juan Bautista Lavaña's book on the royal visit.[8] This was published at Lisbon in 1622 and is the most sumptuous publication of the period in Portugal.

Slightly later than Vieira's expansive view are the topographical paintings of Dirk Stoop, the Dutch artist who accompanied Catherine of Bragança to her marriage with Charles II in London, one of which represents the same square while another seems to have served as the basis for a remarkable view of the monastery and fort of Belém which Plate 154 is signed by Filipe Lobo (1650-73). It shows the original appearance of the church tower and the monastery structure, which was rebuilt in the nineteenth century, and the entrance porch lost in the earthquake of 1755, which only recently has been replaced. The numerous sombrely clad figures in the foreground, among them a Negress with a basket, recall the existence of many portraits from the first half of the seventeenth century, which offer one of the most interesting aspects of the painting of this time.

Some of these portraits are related to Dutch art, more, however, to the formulas of the Spaniards Juan Pantoja de la Cruz and Diego Velázquez, who was a friend of one of the Portuguese portraitists, the Marquis of Montebelo (active 1630-50). A resident at the court of Madrid, where he enjoyed a great reputation as a painter, he is remembered for his self-portraits and those of his children, who wear an air of deep self-satisfaction on their mistily painted faces.

More characteristic of this school of portraiture are the sharply silhouetted likenesses of Domingos Vieira (*c.* 1600-78), who painted Portuguese society at the time of the restoration of independence (1635-50). The solemn dark clothing of these people, ridiculed by the English when they appeared in the suite of Catherine of Bragança, set against backgrounds of black, won for this painter the sobriquet of 'O Escuro' (the Dark) with which he was distinguished from Domingos Vieira Serrão. From this murky mass the faces, hands and coats of arms detach themselves with force. It is the application of

tenebroso principles to portraiture with none of the subtleties of Caravaggio or Veláz-
quez, whose full-length standing figures are obviously suggested by Vieira's *Dom Miguel
de Almeida, Count of Abrantes.* On the great black cape of this chamberlain of Dom
João IV's queen, Dona Luisa de Gusmão, is emblazoned the red-and-white cross of the
Military Order of Christ. This is given the same importance accorded the fluffy hood
that appears in Vieira's portraits of Dona Maria Antónia de Melo, of the Carvalhais
family, Dona Margarida Moreira and Dona Isabel de Moura (Lisbon museum). In the
museum of Évora there is a group of anonymous royal portraits of the children of Dom
João IV, including a delightful standing likeness of Catherine of Bragança as a girl, whose
head suggests the reliquary busts of Alcobaça.

Plate 152

Plates 95, 96
Plate 132

Similarly the statues of Jacinto Vieira are evoked by the pious ladies who throng
through the works of Josefa d'Aiala, called Josefa de Óbidos (*c.* 1630-84). Born in
Seville, she was the daughter of a Portuguese painter named Baltasar Gomes Figueira
and the Spanish lady Catarina de Ayala y Cabrera. Josefa was taken as a child to Óbidos,
where she spent her life painting in the atmosphere of a convent such sentimental reli-
gious subjects as the Christ Child in the form of a dressed statue, the Holy Family, the
symbolic Lamb and the mystical Marriage of St Catherine. An early version of the Mar-
riage, painted on copper in 1647, displays the artificial lighting, the dainty, fussily clad
figures and the obsessive piety that were the artist's stock in trade. Occasionally, as in the
retable of St Catherine of 1661 in Santa Maria at Óbidos, she ventured successfully to
a larger style and fresher colours. At the end of her life she painted her own versions of
the Spanish *bodegón* still lifes in the style of Zurbarán, transforming these sober sub-
jects into a riot of costly containers decked with ribbons and sprigs of flowers, which
overflow with the pastries and candies for which Portuguese nunneries were famous. A
detail of a still life which Josefa dated in 1676 shows a Baroque bowl of scalloped form
typical of Portuguese silver of the late seventeenth century.

Plate 155

Plate 156
Plate 224

Like Domingos Vieira 'O Escuro' and Josefa de Óbidos, the other religious painters of
this age, led by Marcos da Cruz (1649-98) and Bento Coelho da Silveira (*c.* 1628-1708)
employed the *tenebroso* lighting of the Baroque, but little else, for they were essentially
Mannerists untouched by the revolutionary changes that took place outside Portugal in
the seventeenth century. In this respect they were like the architects of Portugal who
were contented, with few exceptions, to repeat the old formulas of Serlio and Herrera
down into the eighteenth century, and totally distinct from the leaders of Spanish
painting.

The change came, as in sculpture and architecture, with the arrival of foreigners who
roused Portuguese artists from their lethargy and launched the Joanine age. One of the
most influential was Vincenzo Bacherelli (1682-1745) of Florence, who had acquired
from his master Alessandro Gherardini a command of the illusionistic architectural per-
spective painting derived from Pietro da Cortona which had become traditional in that
city for the decoration of ceilings and vaults. In Portugal these were habitually decorated
with many coffered panels painted in the flat style of Simão Rodrigues or with a series of
medallions surrounded by acanthus swirls, like those applied to the nave vault of the
Misericórdia of Viana do Castelo by Manuel Gomes in 1720. Here the borders are filled
with vases of flowers and children dancing upon a balustrade, as in the *albarrada* tiles of
the period.

Plate 157

These modest efforts at illusion were shattered by Bacherelli, who demonstrated what
could be done with massive frames of false architecture seen from below, where the eye

can wander past protruding targes and jutting balconies, through gilded colonnades and vistas of vaulted halls to open areas revealing the sky, over which allegorical figures pass on clouds. His ceiling in a room at the entrance to the monastery of São Vicente de Fora, which dates from 1710, led to a flock of commissions which brought him such wealth that he was able to set himself up as a merchant when he returned to Italy about 1720. Although most of Bacherelli's work perished in the earthquake of 1755, two mutilated ceilings in the old palace of the Counts of Alvor, now a part of the Museu Nacional de Arte Antiga in Lisbon, seem to be by him. In comparison with the best work of this sort, seen for example in the drawings of Guiseppe Galli called Bibiena, Bacherelli's style is heavy-handed and the details ill-drawn. A similar, though more fantastic interpretation of this *quadratura* painting was brought in 1725 to Oporto by Nicolau Nasoni (1691-1773), who painted false cupolas, balconies and colonnades on the walls and vaults of the cathedrals of Oporto and Lamego, before devoting himself, after 1740, almost exclusively to architecture.

In the north the innovations of Nasoni never succeeded in breaking the hold of the older types of ceiling decoration. In Lisbon, however, Bacherelli formed a school which supplied ceilings for a number of churches built or redecorated as a result of the influx of wealth from Brazilian gold. A few of them escaped the earthquake, among them the nave ceiling of Nossa Senhora da Pena, by Bacherelli's pupil António Lobo, who died in 1719, that of São Paulo by Jerónimo de Andrade (1715-1801) and the vault of the chancel of the church of Paulistas, decorated about 1730 by António Pimenta Rolim (active 1715-c.1750). The ceilings of the three rooms of the royal library at Coimbra were painted in perspective style by António Simões Ribeiro and Vicente Nunes in 1723-4. In Lisbon the taste for this kind of decoration, nurtured by extravagant Italian stage settings at the royal opera, endured through the Pombaline period until the end of the eighteenth century, when Pedro Alexandrino de Carvalho (1729-1810) gave it a last spectacular expression in the chancel of the royal chapel of Bemposta. Portuguese perspective decoration is generally thinner than the Italian, especially in the use of false architecture, and the figures in the centre are seldom truly 'seen from below'. They tended to be painted, as in the vast early eighteenth-century decoration of the ceiling of the nave of the Jesuit church at Santarém, like figures in easel paintings affixed to the vault or ceiling surface.

What Bacherelli had done for perspective painting Giorgio Domenico Duprà (1689-1770) did for portraiture, for he gave it a new vigour and luminous colour absent since the days of Cristóvão Lopes. A Savoyard who was later to work in Turin, Duprà was hired in Rome, where he had been painting the exiled Stuarts, by Dom João V's ambassador the Marquis of Fontes, whose famous Italian state coaches are in the carriage museum in Belém. Arriving in 1719, Duprà spent a decade in Portugal, departing in 1730, like Bacherelli, with rich rewards. His most important work was a series of portraits of Dom João and his family in the panelled ceiling of the Sala dos Tudescos at the Bragança palace at Vila Viçosa. Two of these, painted in 1719-20, representing the short-lived Infante Dom Pedro (1712-14) and his sister Dona Bárbara, who lived to be queen of Spain, show the beguiling costumes, sumptuous settings and fine Baroque gestures that also appear in the grand portrait of Dom João V at the end of the library in Coimbra, which is attributed to Duprà.

Two Frenchmen also contributed to Portuguese portraiture of the Joanine period. The first was Jean Ranc (1674-1735), court portraitist in Madrid, who came to paint the

Plate 158

Plates 57-60

Colour
plate V

Plate 76

Plate 159

who may have sat for Vieira's oval allegory of painting in the museum at Lisbon. While in London he learned to paint portraits in the style of Raeburn and Hoppner, religious allegories and other paintings with the sentimental classicizing figures of Benjamin West, Copley and Bartolozzi, and was also deeply affected by English landscape painting. Indeed, Vieira's most impressive pictures are his landscapes with figures, like the Correggesque *Leda and the Swan* of the Lisbon museum and the extraordinary *Flight of Marguerite of Anjou* in that of Oporto, in which the struggling figures are over-whelmed by the grandeur of the dark and towering forest. The majestic effect of the natural setting, the haunting glimpse through the trees of a Gothic house, as well as the choice of subject prove that the painter, before his death at Madeira in 1805, had become an apostle of the romanticism which was to ennoble the last works of Domingos António Sequeira.

Plate 168

This painter, next to Nuno Gonçalves the greatest that Portugal has produced, lived from 1768 to 1837. He studied with Vieira in Rome in 1788 and there conceived an admiration for him which he always expressed. Sequeira so distinguished himself as a student that he was made an instructor at the Accademia di San Luca in Rome before returning to Portugal in 1795 with a pension from the Crown.

In Lisbon Sequeira tried unsuccessfully to establish a new academy of art which would provide a real incentive to painters. Disillusioned by this failure, he spent the years 1798-1802 in the Carthusian monastery at Laveiras, where he painted two dramatic pictures of *St Bruno in Prayer*, one prostrate on the ground (Lisbon museum), the other standing in a cavern (Oporto). When he emerged from Laveiras, he became court painter, charged along with Vieira with the decoration of the palace of Ajuda and in 1805 succeeded the latter as director of the art academy in Oporto. There he became in-volved in the politics of the French invasion, of which he seems to have approved, for he painted an allegory of *Lisbon Sheltered by Junot*, the leader of the invading army (Oporto museum). After the liberation this cost him six months in jail.

Plate 86

Sequeira weathered this storm, portrayed Wellington, Beresford (the British governor of Lisbon) and other political figures as well as members of the aristocracy who had not fled with the royal family to Brazil. He also designed and supervised in 1811-16 the making of the monumental silver service offered by the Portuguese government to the Duke of Wellington in gratitude for his victories in the Peninsular War. Like Francisco Goya an outspoken liberal, Sequeira accepted enthusiastically the triumph of the Constitutionalists in 1820. But with the victory of absolutism three years later in both Spain and Portugal, Sequeira, like Goya, went into exile in France. In Paris he exhibited at the famous Salon of 1824 and, competing against Delacroix, Lawrence, Géricault, Prud'hon and Baron Gros, won a prize for his now lost painting of the death of Camões, the national poet of Portugal. It is possible that Sequeira may have met Goya at this time. The last decade of his life was spent in Rome, where he died, loaded with honours, in 1837.

Plate 236

Sequeira's early work is well represented by the huge *Allegory of the Casa Pia* in the Lisbon museum, which he painted in Rome in 1792 in honour of the founder of the official orphanage of Lisbon (Casa Pia) and patron of the arts, the Intendant Pina Manique, Dona Maria I's chief of police, who, clad in a black judicial gown, stands beside a statue of his sovereign. The picture is full of allegorical figures drawn and pleasingly coloured in the sentimental Neo-Classical Italian vein that stems from Anton Raphael Mengs, a prettified British version of which Vieira Portuense was to learn in

Plate 169

London. The faces of Pina Manique and the men standing at the extreme right of the painting, suggesting the youthful Goya, are so strongly constructed and gracefully painted that they prove that Sequeira was a born portraitist.

They lead directly to the elegant but deeply sensitive portraits of the early nineteenth century, the *Viscount of Santarém and His Family* (1805-10) seated and standing in an English-style room, full of subtle colours (Lisbon museum), the exquisite *Count of Farrobo as a Boy* (1813), leaning nonchalantly against a luminous wall, in the manner of Goya (Lisbon museum), related to which there is a splendid, though water-stained, charcoal drawing in the same collection. The strongly defined forms and beauty of outline in these portraits bring to mind the style of Ingres. These qualities can also be found in the two portraits of Sequeira's children and the charcoal study of Beresford (*c.*1815), all in the Lisbon museum.

Meanwhile Sequeira had painted in 1810 an allegory honouring the Prince Regent, the future Dom João VI, which offers great contrasts to the earlier allegory of 1792. The principal difference is the new use of light that brilliantly sweeps across the firm sculpturesque figures in the foreground. In the sky, above a distant view of Lisbon harbour, appears a vision of the Prince Regent surrounded by allegorical women, whose forms become diaphanous in a misty light. In a sketch for an allegory of the royal family beyond the seas in the collection of the Duke of Palmela, which Sequeira painted about the same time, he allowed the figures of Dom João VI, his wife and children, whose poses recall Goya's family of Charles IV of Spain, to disintegrate in brilliant shimmering splashes of colour. In this painting the hues of the sky, the sea, the jewelled gowns and uniforms create an impressionistic effect, also reminiscent of Goya, reaching a climax in the sketch in the Lisbon museum for a standing portrait of the king. Curiously, there is no evidence that Sequeira ever visited Spain or saw any of Goya's portraits.

Sequeira's last works are all in this style. The best are the charcoal studies for Biblical scenes like the *Adoration of the Magi* and *Epiphany* of 1828, the *Ascension* and *Last Judgment* of 1832 (all in the Lisbon museum), in which the figures are drenched in a warm and mystic glow that partakes of the grandeur of both Rembrandt and William Blake. There is also a parallel with the late fantasies of Goya, where light was used for the same dramatic and romantic effects. But, as all writers on Domingos António Sequeira have pointed out, there is a vital difference between the two painters, for Goya was a profound pessimist, Sequeira a triumphant optimist. His paintings breathe a serene security based on abiding conviction of the future, as well as a lyric joy in mankind and a gentle and confiding faith. Here once again are tellingly restated the spiritual differences between Spain and Portugal which through the centuries have so significantly distinguished the art of the two Iberian nations, and which are particularly evident in most paintings by Portuguese artists.

Painting

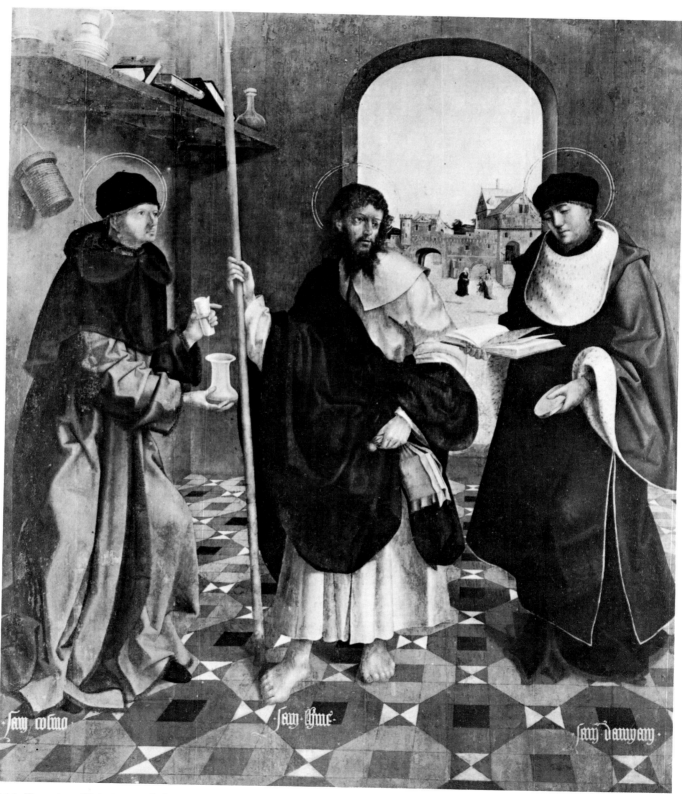

144 Francisco Henriques: *Saints Thomas, Cosmas and Damian*. Lisbon, Museu Nacional de Arte Antiga. *c.*1500–18

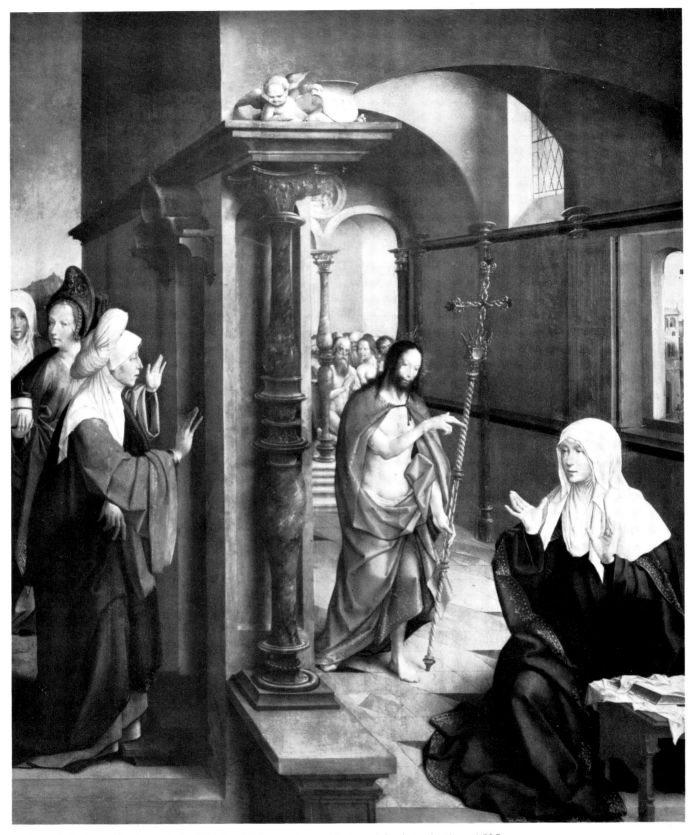

145 Frei Carlos: *Christ and the Virgin*. Lisbon, Museu Nacional de Arte Antiga. 1529

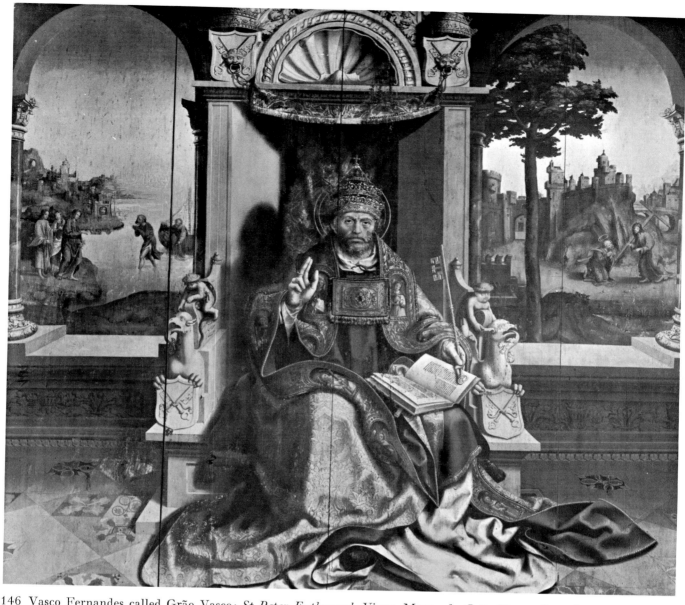

146 Vasco Fernandes called Grão Vasco: *St Peter Enthroned*. Viseu, Museu do Grão Vasco. Second quarter of the 16th century

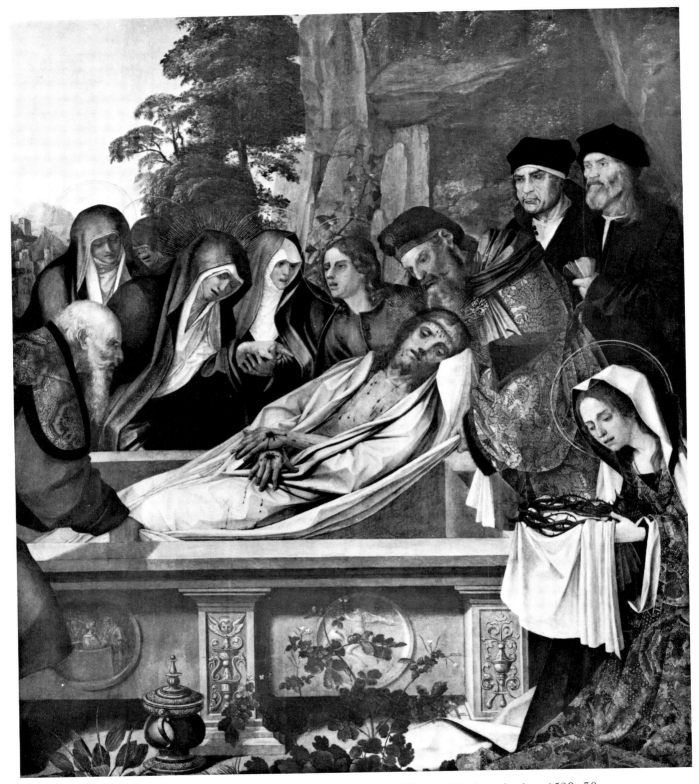

147 Cristóvão de Figueiredo: *Deposition of Christ*. Lisbon, Museu Nacional de Arte Antiga. 1529–30

152 Domingos Vieira, called 'O Escuro': Dom Miguel de Almeida, Count of Abrantes.
Lisbon, Direcção Geral da Fazenda Pública. *c*. 1635–50

153 Domingos Vieira Serrão: View of the Casa da Índia in Lisbon (Detail of the frontispiece of J. B. Lavanha, *Viagem da catholica real magestade del rey d. Filipe II*, Madrid, 1622)

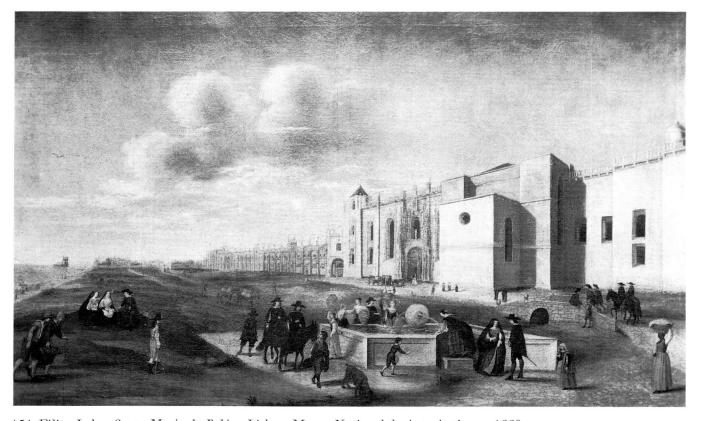

154 Filipe Lobo: *Santa Maria de Belém*. Lisbon, Museu Nacional de Arte Antiga. *c.* 1660

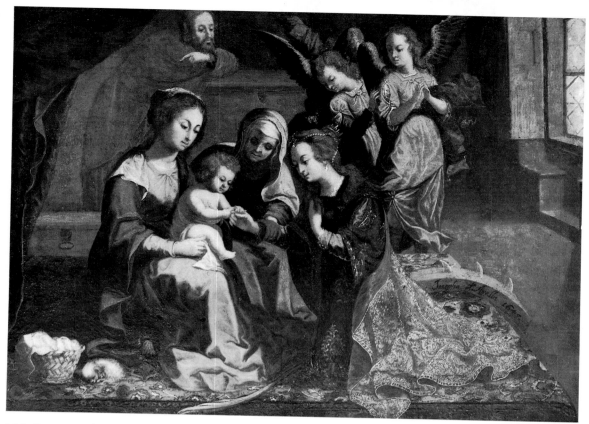

155 Josefa de Óbidos: *Mystic Marriage of St Catherine*. Lisbon, Museu Nacional de Arte Antiga. 1647

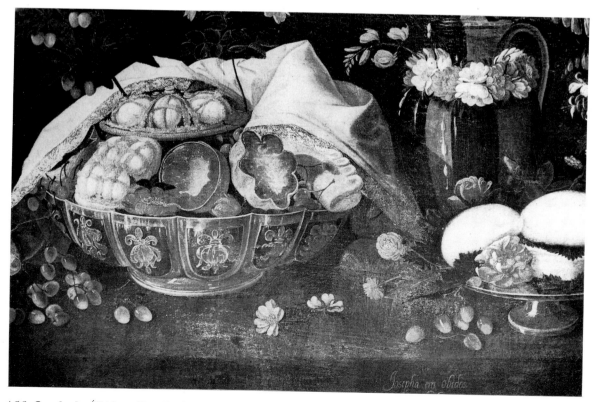

156 Josefa de Óbidos: Detail of a still life painting. Santarém, Museu Biblioteca Braancamp Freire. 1676

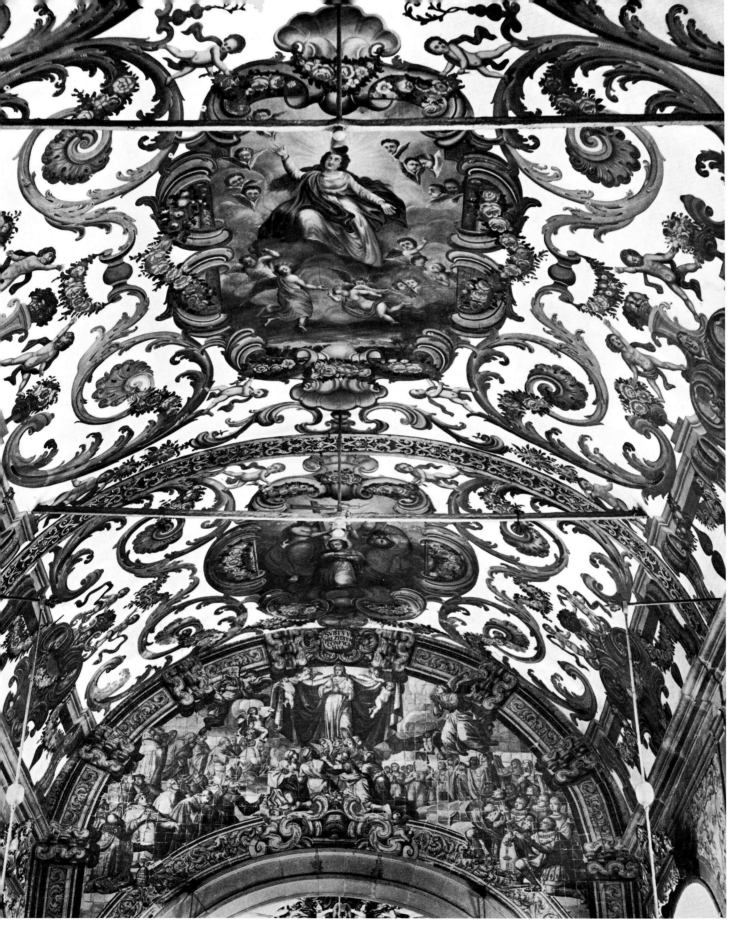

157 Manuel Gomes: Painted ceiling. Viana do Castelo, Santa Casa da Misericórdia. 1720
158 (OPPOSITE) Vincenzo Bacherelli: Detail of the ceiling of the *Portaria* of São Vicente de Fora.
Lisbon. 1710

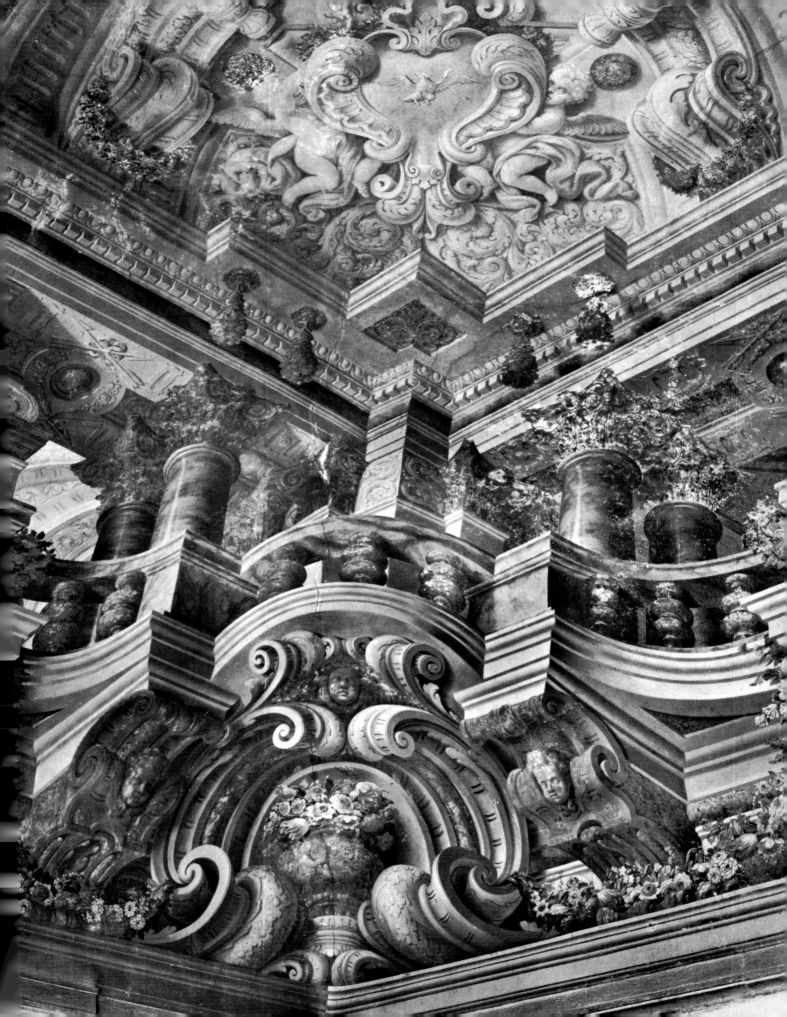

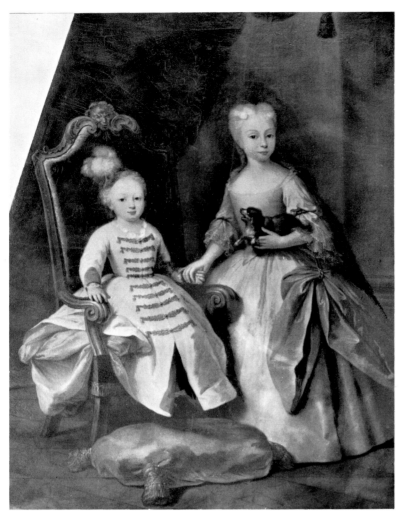

159 Giorgio Domenico Duprà: The Infantes
Dom Pedro and Dona Bárbara. Vila Viçosa,
palace of the Dukes of Bragança. 1719–20

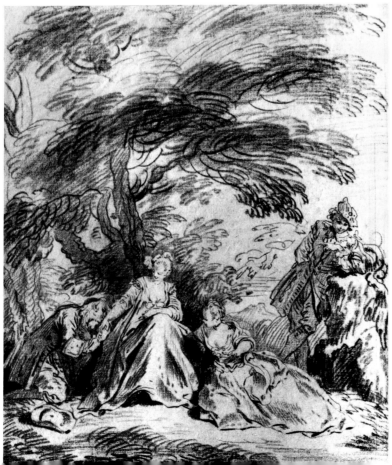

160 Pierre-Antoine Quillard: Drawing of a
Fête Galante. Lisbon, Museu Nacional de
Arte Antiga. *c.* 1726–33

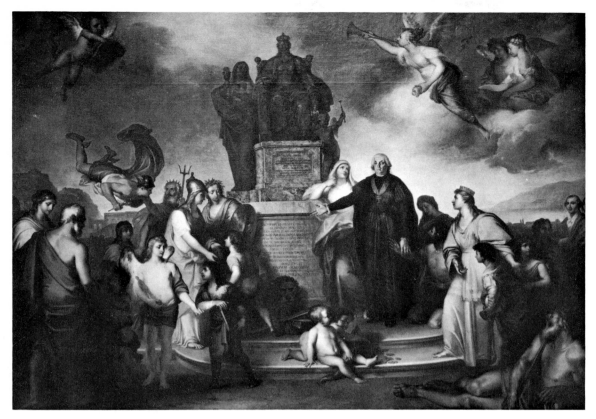

169 Domingos António Sequeira: *Allegory of the Casa Pia of Lisbon*. Lisbon, Museu Nacional de Arte Antiga. 1792

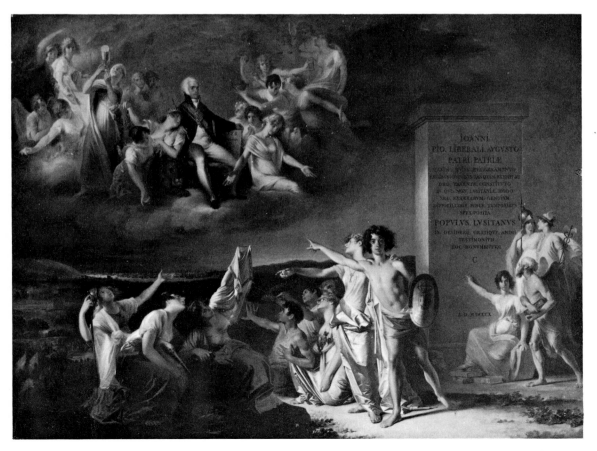

170 Domingos António Sequeira: *Allegory of Dom João VI*. Lisbon, Museu Nacional de Arte Antiga. 1810

171 Domingos António Sequeira: Drawing for a portrait of the Count of Farrobo. Lisbon, Museu Nacional de Arte Antiga. Early 19th century

5 Ceramics

THE TILES

Decorative tiles were made all over Europe in the period between 1500 and 1800, but nowhere were they used on such a scale, for such a variety of purposes or in so many different patterns as in Portugal, where they represent, along with gilt woodcarving, a truly national form of decoration. The centre of the industry was always Lisbon, which in the seventeenth and eighteenth centuries exported millions of tiles to all parts of Portugal, including the chief centres of provincial manufacture, Coimbra and Oporto, as well as across the seas to Brazil. So important are the tiles as an adjunct to the interior and exterior architecture of the country that they overshadow the faience plates, vessels and figurines produced in Portugal in the same places, especially during the eighteenth century.

The concept of tiles as a covering for walls, floors and even ceiling vaults goes back to the Moorish culture which Portugal shared with Spain. It was from the latter country and particularly Seville that the earliest surviving tiles in Portugal were imported. They date from the late fifteenth century and especially from the prosperous period of Dom Manuel (1495-1521), who filled his palace of Sintra with Sevillian tiles, some of which are thought to have arrived in 1503. Following the royal example, the great Renaissance Bishop of Coimbra, Dom Jorge de Almeida, in the same year and from the same source ordered tiles to cover the walls of the Romanesque Old Cathedral, most of which were removed in a too thorough restoration. There are other important revetments of Spanish *mudéjar* tiles at the church of Jesus in Setúbal, the nearby country house of Bacalhoa, which has recently been restored to its sixteenth-century splendour, the former convent of Nossa Senhora da Conceição in Beja and the museum of Abrantes, installed in the Gothic church of Santa Maria do Castelo.

Plate 172

Almost all these tiles have mosaic designs in tin-glaze colours, produced by compartment techniques to keep the colours from running during the process of firing. Sometimes they were made by the *cuerda seca* or cloisonné process, where the compartment barriers are level with the surface of the tiles. Slightly later the surer method of *cuenca* or *arista* was adapted, wherein the depressed colour areas (*cuencas*) are separated by ridges (*aristas*) raised beyond the tile surface, as in champlevé enamels. Still other tiles were made in the form of reliefs, which took the shape of leaves and fleurs-de-lis, some of which are thought to have been made in Portugal. These different techniques are clearly explained by exhibits in the recently created tile museum (Museu do Azulejo), set up for the Calouste Gulbenkian Foundation in the former convent of Madre de Deus in Lisbon by João Miguel dos Santos Simões, the undisputed authority on tile making in Portugal and one of the most distinguished art historians in Europe.

In the sixteenth century these early techniques were superseded by the Italian Maiolica process of painting directly on smooth-surfaced tiles. It was brought to the Iberian

peninsula by the Italian Francesco Niculoso of Pisa, who reached Seville before 1500 and may later have come to Portugal. The new tile pictures, sparkling in a wide variety of colours, offered the Portuguese one of the first demonstrations of Italian Renaissance arabesques and other ornaments which were to serve for over a century as the basis of tile decoration. The revolution brought about by Niculoso Pisano's activities coincided roughly with the importation of Florentine Della Robbia reliefs of glazed terracotta which were used, as in Spain, France and England, for the decoration of important buildings.

*Colour
plate XI*

This early Italian version of Renaissance ornament was soon succeeded by the more complex and often perplexing decoration of the Flemish Mannerists, which, as already noted, deeply influenced Portuguese sculpture in the second half of the sixteenth century. The yellow-and-green tiles made in 1558 for the palace of Vila Viçosa in the province of Alentejo by Jan Bogaert of Antwerp have medallions set in a framework of drapery swags, urns, ewers, twisted shields and the strange metal bars of the *ferronnerie* style propagated by the popular engravings of Cornelis Floris, Cornelis Bos and Pieter Coecke van Aelst. The medallions and bars, together with equally common 'leatherwork' scrolls and birds, appear in the celebrated tile panels of the Rivers in the south porch of Bacalhoa, recently identified by Santos Simões as the work of Marçal de Matos, a Portuguese pupil of the Flemish ceramist Philippe de Goes, one of which is dated 1565.[1] The *ferronnerie* or metal-bar style continues in the equally famous chapel of the church of São Roque in Lisbon, where the blue-and-yellow arabesque tiles are signed by Francisco de Matos, probably a relative of the Bacalhoa master, and dated 1582. The last phase of the style appears in the intricate polychrome decoration of the staircase of the chief Benedictine monastery of Lisbon, now in the Museu do Azulejo, which dates from *c*.1630. Here miniature bars entwined with foliage, satyrs and masks dominate shrunken medallions containing the coats of arms of religious orders then represented in Portugal.

Plate 173

Plate 174

Two different tendencies are found in Portuguese tiles of the seventeenth century, one maintaining naturalism, the other returning to the stylization of the late fifteenth century. In its simplest form this can be basic geometric patterns contrasting dark blue or green with white tiles, as in the apse of the church of Jesus at Setúbal and above the chancel arches of that of Marvila at Santarém, the latter dated 1617 and 1620. Other tiles imitate contemporary textiles, like flamboyantly patterned damasks and cut velvets, in which blue and yellow on a background of white become the almost exclusive colours, and stylized leaf and petal forms, together with the maize form or magnolia kernel called *massaroca* of Manueline sculpture, are the favourite designs. Provided with handsome borders in which Serlian mouldings are combined with stylized foliage, these tiles are called *azulejos de tapete*, because of their resemblance in a general way to Muslim rugs. This is especially true of those in the parish church of São Quintino, near Alenquer, where above a dado of later tiles they resemble a collection of carpets hung on the wall. Occasionally these tiles incorporate devotional panels of the Virgin and of St Michael with the dragon, as in the great all-over covering of the interior of the Alentejan church of Alvito, part of which dates from 1647, of the apostles, as in the Misericórdia of Arouca, or of such rare and attractive subjects as a choir of angels with contemporary musical instruments that appears in the church at Atalaia.

*Plate 1
Plate 29*

Plate 175

Plate 176

In a sumptuous pattern found in the nave of Marvila, in the Augustinian churches of Grijó, near Oporto, and Santa Cruz of Coimbra, and many other places, the various stylizing tendencies are combined. The prominent dark and light tiles form lozenge patterns encasing smaller ones with textile designs, some of which are further enriched with

*Colour
plate XIII*

XIII (OPPOSITE) Pedro Nunes Tinoco: Coimbra, Sacristy of Santa Cruz, 1622-3

Lancret and Boucher. The new genre scenes that resulted are more elegant and imper- Plate 189
sonal than those of the 1720s, the gestures of the figures become mannered and their
costumes more elaborate, following the process of enrichment that had already taken
place in the borders. In the 1750s, under the influence of the fully developed Rococo
style, the borders grew increasingly asymmetrical and at the same time lighter, formed
only of wiry foliage and shells. Some designers now returned to the purely ornamental
subjects of the sixteenth and early seventeenth centuries. One series, known as the 'Neces- Plate 190
sidades' pattern, from the Lisbon palace of that name where it is found, emphasizes per-
forated serpentine targes and graceful curlicue branches. On these are perched phoenix
birds like those of English Chippendale furniture, which began to be imitated in Portu- Colour
plate XVI
gal at this time, and Chinese dragons that recall the *chinoiserie* tile panels also made in
Lisbon in the 1750s and later at the Bico do Sapato factory.

In this period also polychromy returned to favour. Possibly influenced by French por-
celains of Sèvres and Vincennes, it was especially used for the tinting in tones of olive
green, rose and violet of the garlands of flowers and fantastic urns that join shells and
palm branches in the Rococo borders. The subjects they enclose continued to be painted
in blue and white, with the exception of certain fine tiles that seem to have been made
in the royal factory of the Rato in Lisbon, founded in 1767, where the entire surface is
painted in areas of rose, yellow, light blue and grey. There are good examples represent- Colour
plate XIV
(bottom)
ing *fêtes galantes* on the garden terraces of the estate of the Marquis of Pombal at
Oeiras, outside Lisbon, now a museum of the Gulbenkian Foundation, and on a fountain
in the grounds of the nearby palace of Queluz.

The Rococo phase of tile making reached its height in the last quarter of the eighteenth
century, when polychrome marblizing, like that of contemporary Portuguese woodcarving,
was added to the foliate and shell borders. These were now designed in long sweeping lines
from which emerge architectural fragments, as in a notable series of religious scenes
exported from Lisbon for the new chapter rooms of the Minho monasteries of Santo Tirso
and Tibães in 1780 and 1785 respectively.

These frames were exaggerated in great panels of green, wine and blue tiles made in
Coimbra between *c.* 1760 and 1785, where the riotous display of the ornament is
equalled by the nervous complexity of the drawing. Their staggeringly involved de-
corations, filled with sparkling, crackling, endlessly revolving ornament, the finest ever Plate 195
produced in Coimbra, were widely exported to the churches and palaces of an area ex-
tending from Aveiro on the coast to Guarda on the eastern frontier — the old zone of the
Beiras. The Rococo tiles of Lisbon were also imitated for a time at a factory founded by
José Rodrigues da Silva e Sousa in 1770 at Juncal, between Leiria and Alcobaça. These
can best be seen in the parish church of the town, which is dated 1780. Typical of
these large blue-and-white panels, which are both weak in drawing and impoverished in
ornament, is one representing St Dominic receiving the rosary from a Virgin and Child Plate 194
that seem to have been directly inspired by a seventeenth-century terracotta statue in the
sacristy of the monastic church of Alcobaça.

The first reaction from the Rococo mode came with the so-called Pombaline tiles found
in many of the buildings erected in Lisbon after the earthquake of 1755. Frankly utili-
tarian in character, they consist of simple lozenges formed of a trellis of branches from
which sprout rosette blossoms, coloured blue and rose on a white background. These tiles
were apparently made from about 1760 to the end of the eighteenth century, when the
first classicizing patterns began to appear. The latter are composed of delicate spray-like

XIV (OPPOSITE TOP) António Vital Rifarto: Detail of the tiles of the cloister of the
cathedral of Oporto, made in Lisbon, *c.* 1730-4
(BOTTOM) *A Boating Party*. Detail of a panel of tiles at the former palace of the
Marquis of Pombal at Oeiras, made in Lisbon, *c.* 1760-75

Plate 192

Plates
232, 233

garlands, calligraphic patterns of straight rather than sinuous lines, chains of beads and other light and graceful motifs painted in pastel colours on a white background that recall the ornament of contemporary Portuguese silver and the painting of English furniture of the 1790s, which was imitated in Lisbon and Oporto. Although figures were sometimes introduced, as in the medallions of Augustinian saints treated like statues in the tiles of the cloister stair of Santa Cruz at Coimbra, and the lively blue-and-white scenes with classical borders depicting the rise of António Joaquim Carneiro from shepherd to hat factory owner, in the Museu do Azulejo, which are thought to date from 1806, the favourite patterns of this period were purely decorative. By the middle of the nineteenth century Portuguese tiles had returned again to stylized formulas and were frequently applied to the exterior of buildings for the same kind of effective all-over decoration previously given to interiors by the blue, yellow and white 'carpet tiles' of the seventeenth century. The practice seems to have originated in Brazil, whence it was brought to Portugal by returning emigrants. It is therefore one of the few instances of American influence on the art of Europe before 1900.

The element of colour, as essential to decorative tiles as to the rugs and tapestries they so often resemble, establishes to a large degree the history of the craft of tile making in Portugal. From its inception in the sixteenth century to the close of the seventeenth century polychrome surfaces were the rule. Then followed the period of blue-and-white tiles, which coincides with the first half of the eighteenth century, when this kind of tile was produced to the virtual exclusion of all other types. The fashion lived on in the second half of the eighteenth century, but was restricted to medallions in the centres of panels which were largely composed of immense borders of flamboyant Rococo design, in which the old effects of polychromy were at last restored to favour.

THE FAIENCE

Very little is known about the manufacture of faience, or fine glazed earthenware, in Portugal before the eighteenth century beyond the fact that Lisbon was the centre of production. Whether the plates and vessels were made in the same factories as the tiles cannot, however, be determined. No faience can with certainty be identified prior to the seventeenth century, when dated pieces begin to appear. Reynaldo dos Santos has nevertheless indicated certain vases and dishes in sixteenth-century paintings which he believes to be Portuguese products.[4] They all have a Spanish look,[5] which is not surprising considering the great influence of that country on the earliest Portuguese tiles and furniture and its continuation in the faience of the seventeenth century. The other abiding influence was that of Oriental porcelain, which ever since Vasco da Gama's historic journey in 1497-9 had been arriving at the port of Lisbon in ever increasing quantities, some of it commissioned by Portuguese and bearing their names with sixteenth-century dates. Much of it came by way of Goa and was therefore called *porcelana da Índia*; other pieces were acquired by Portuguese traders in Japan *c.*1550-1640, as the painted screens of that country relate. The rest was exported from the Portuguese city of Macau near Hong Kong. Together these sources made Lisbon the first market in Europe for the porcelains of China and Japan.

Given the great appeal to Europeans of these beautiful objects and the high prices they commanded, it was natural that Oriental porcelain should be imitated in faience by Portuguese potters. This 'counterfeit of China that is made in Lisbon'[6] had become a

172 (OPPOSITE) Champlevé and relief tiles. Sintra, Palácio Nacional. Early 16th century

Ceramics

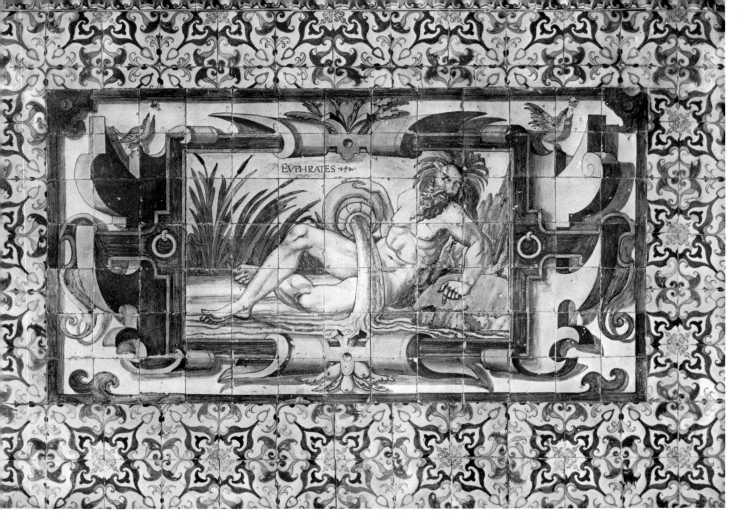

173 Marçal de Matos: *The River Euphrates*. Bacalhoa (Azeitão). *c.*1565

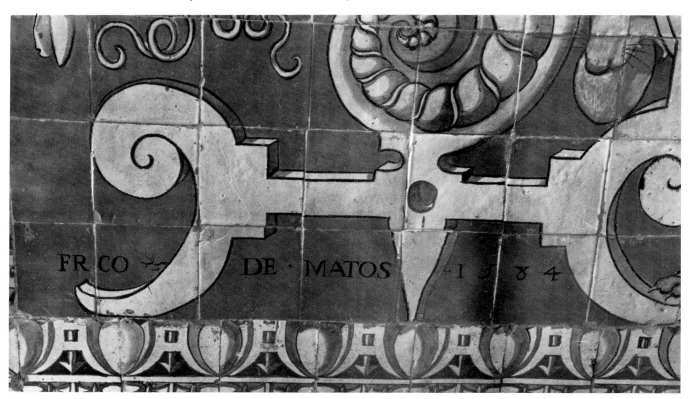

174 Francisco de Matos: Signature on tiles. Lisbon, São Roque. 1584

175 (OPPOSITE) Carpet and *albarrada* tiles. São Quintino, parish church. 17th and 18th centuries

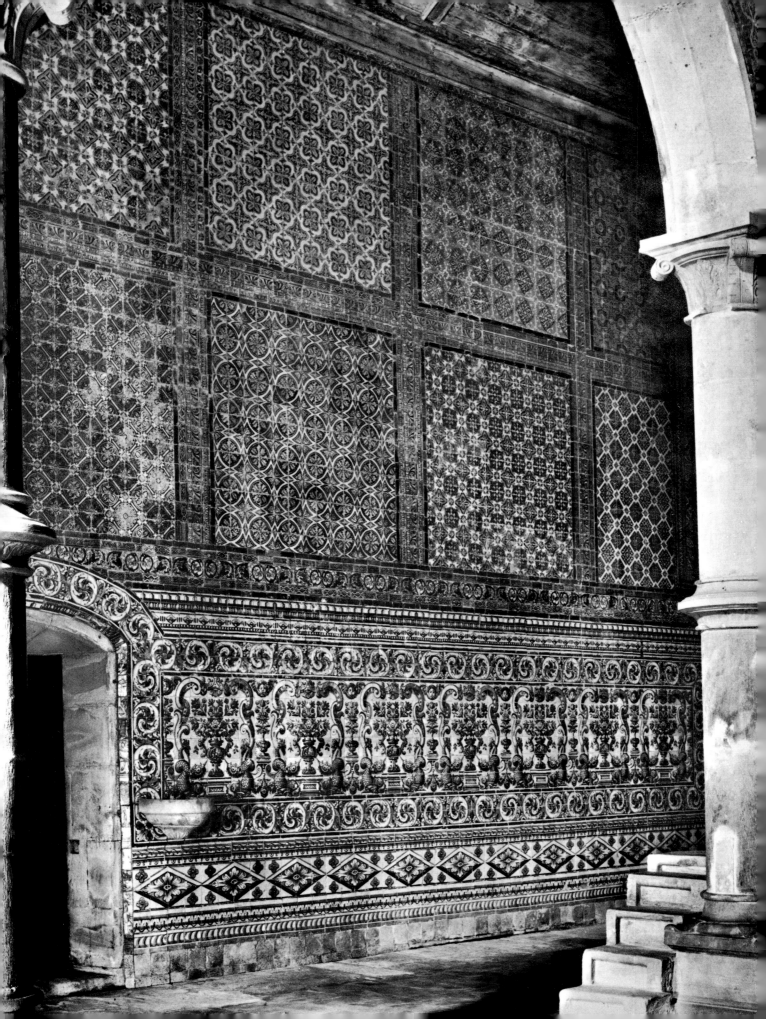

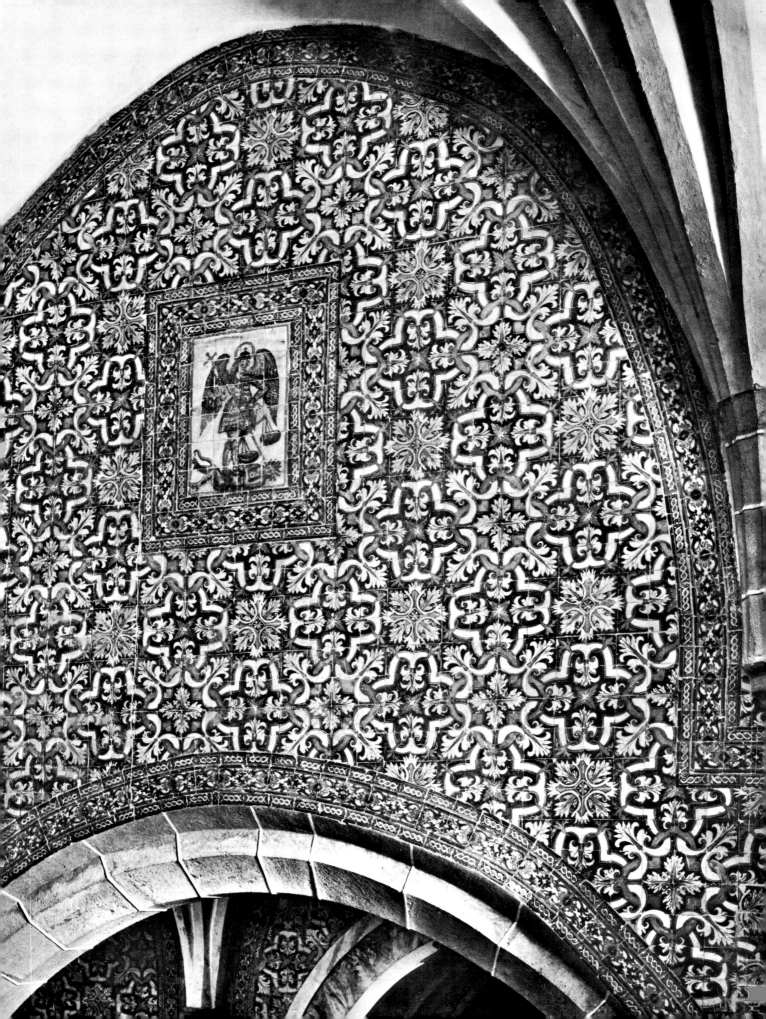

176 (OPPOSITE) Carpet tiles. Alvito, Nossa Senhora da Assunção. *c.* 1647

177 (RIGHT) Manuel João: Carpet tiles. Oporto, sacristy of the Santa Casa da Misericórdia. 1668
178 (BELOW) Acanthus and flower tiles. Évora, former Jesuit university. Late 17th or early 18th century

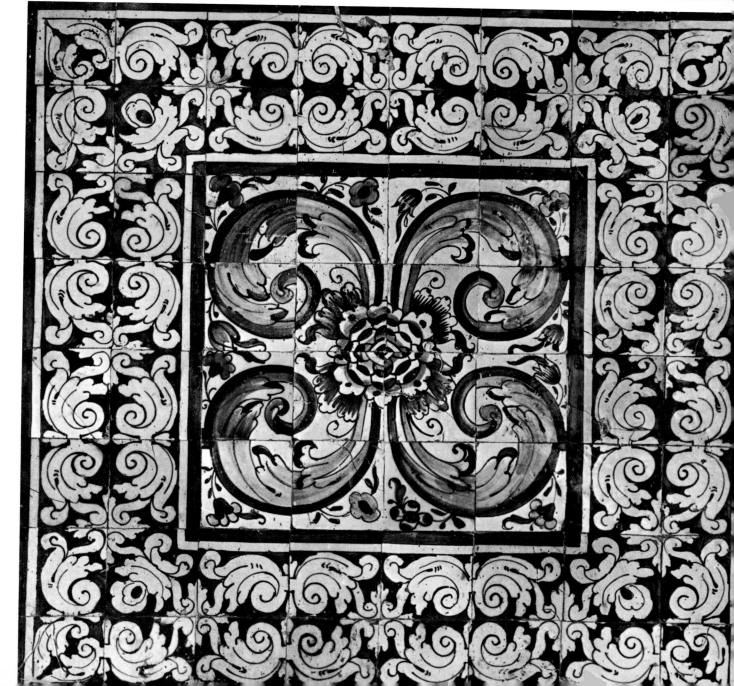

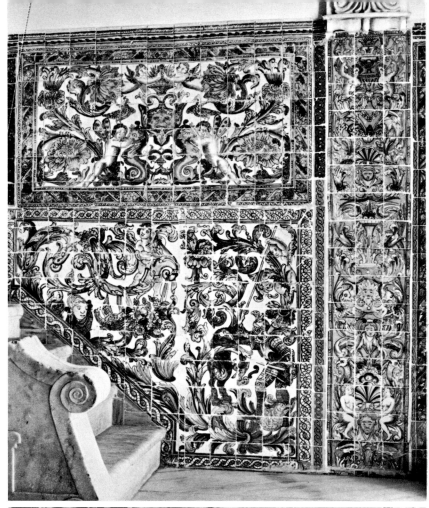

179 Arabesque tiles. Évora, former Jesuit university. c. 1625–50

180 Detail of an altar frontal of tiles. Almoster, Salvador do Mundo. Mid-17th century

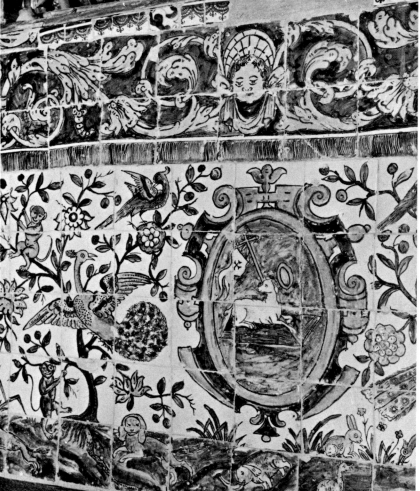

181 (OPPOSITE) Allegory of Poetry. Lisbon, palace of the Marquis of Fronteira. c. 1670

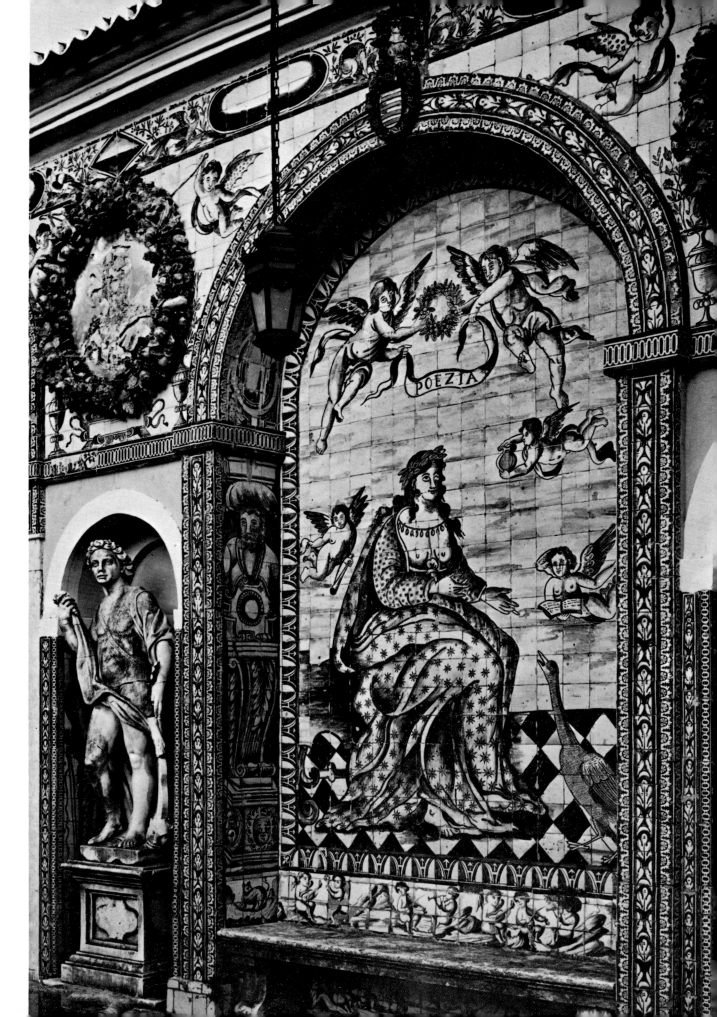

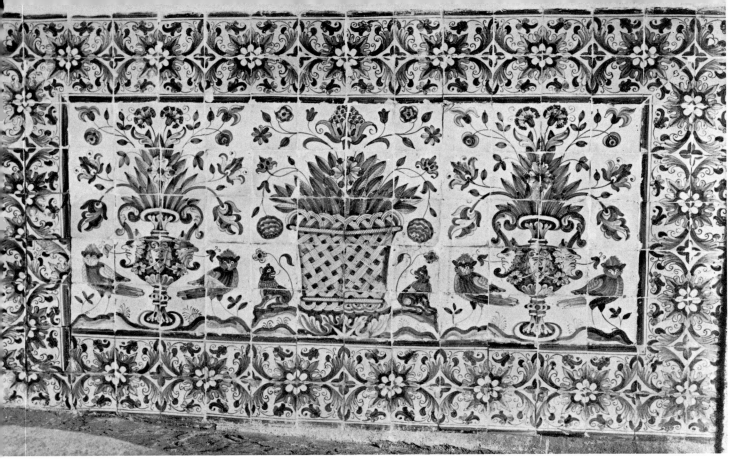

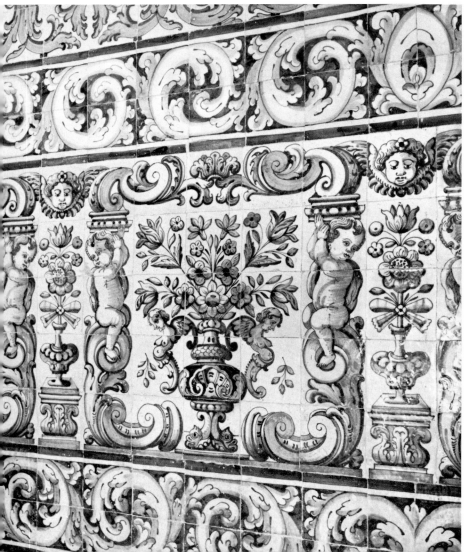

182 (ABOVE) *Albarrada* tiles (probably
Coimbra). Cathedral of Viseu. Late
17th century
183 (LEFT) *Albarrada* tiles. Óbidos, Santa
Maria. Early 18th century

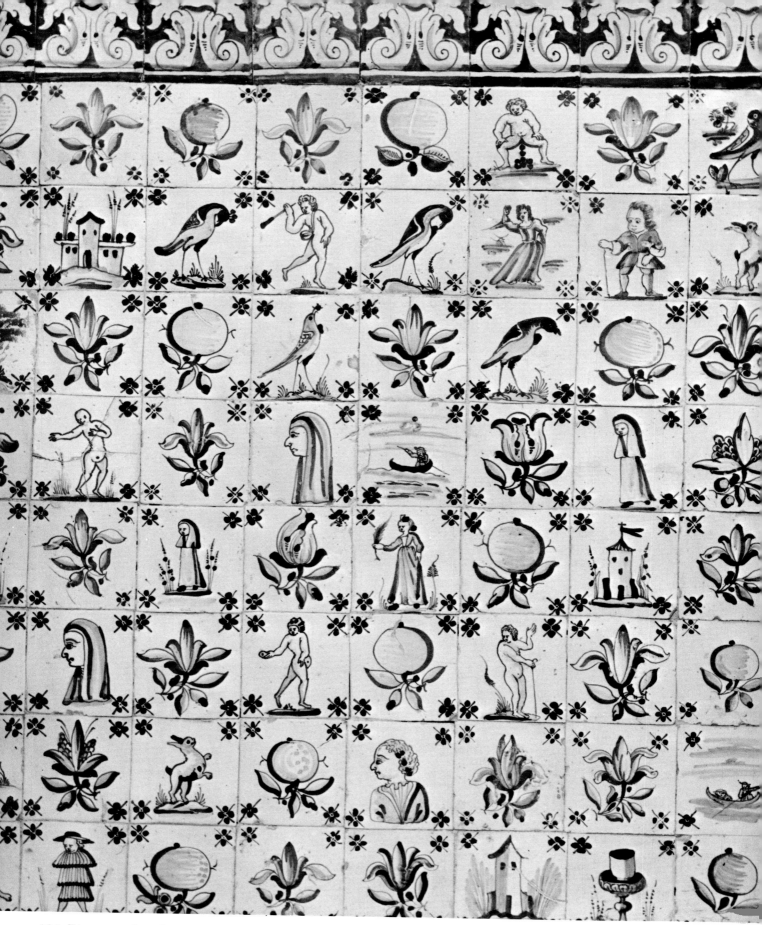

184 *Figura avulsa* tiles. Orgens (Viseu), São Francisco. *c.*1745

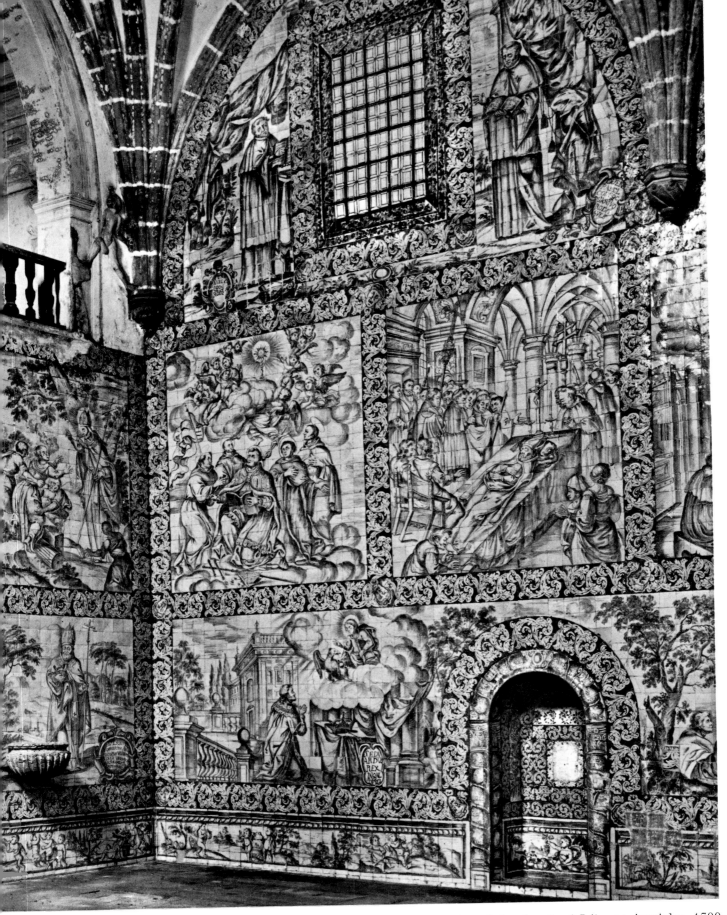

185 Gabriel del Barco y Minusca: Tiles of the interior of the church of Lóios at Arraiolos. 1700
186 (OPPOSITE) António de Oliveira Bernardes: *Christ in the Temple*. Viana do Castelo, Santa Casa
da Misericórdia. 1720

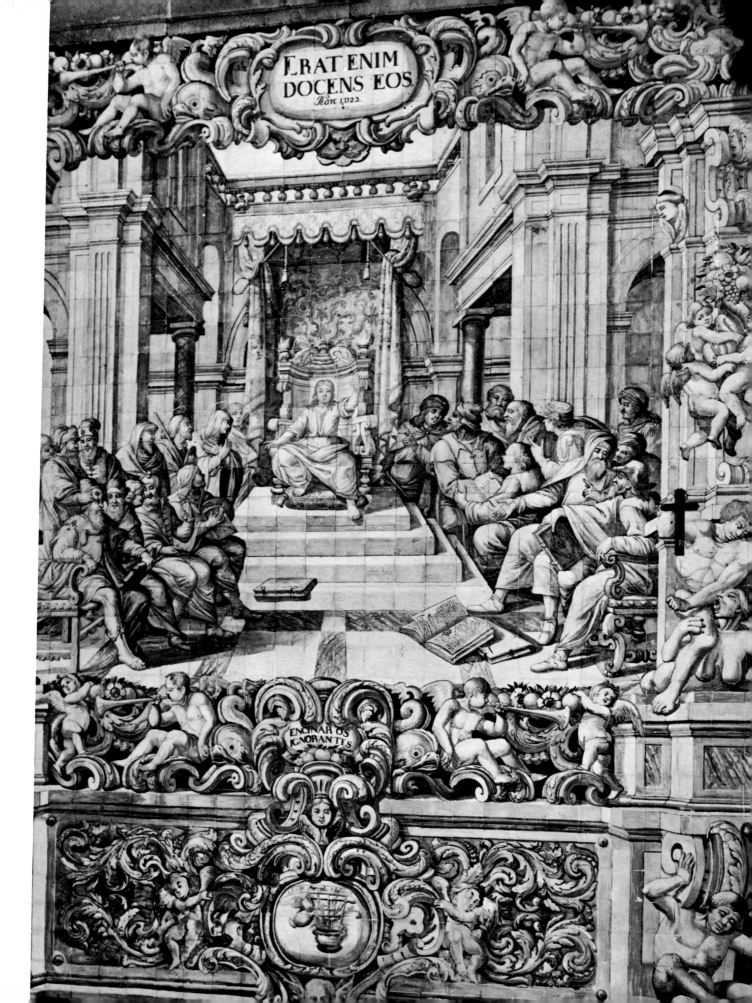

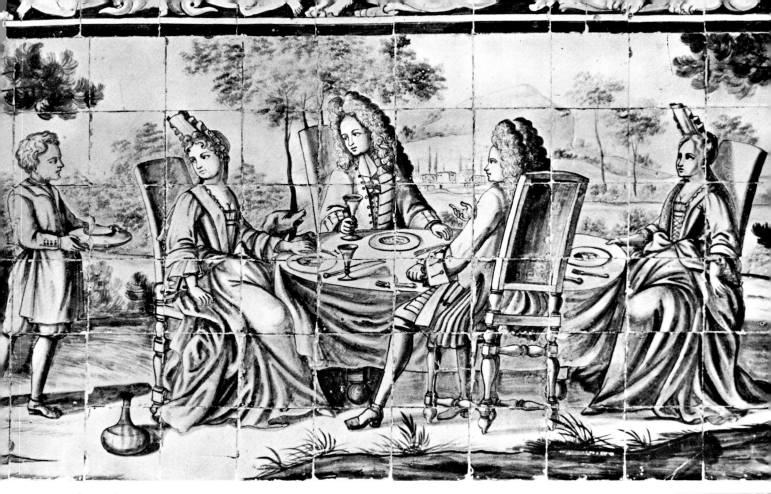

187 (ABOVE) The Master PMP: *An Outdoor Luncheon Party*. Camarate (Sacavém), Quinta do Portão de Ferro. *c.* 1725
188 (RIGHT) The Master PMP: *A Fête Galante*. Braga, Biscaínhos palace. *c.* 1725

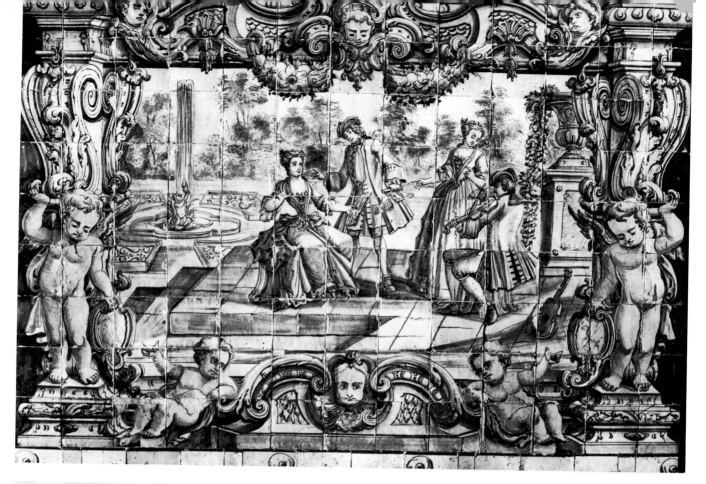

189 (TOP) *A Fête Galante*. Lisbon, Calçada do Combro, no. 17. *c.* 1750–40. Attributed to Bartolomeu Antunes, some of the tiles in this series are based on engravings of famous paintings by Watteau

190 'Necessidades' tiles. Santarém, the seminary. *c.* 1750–60

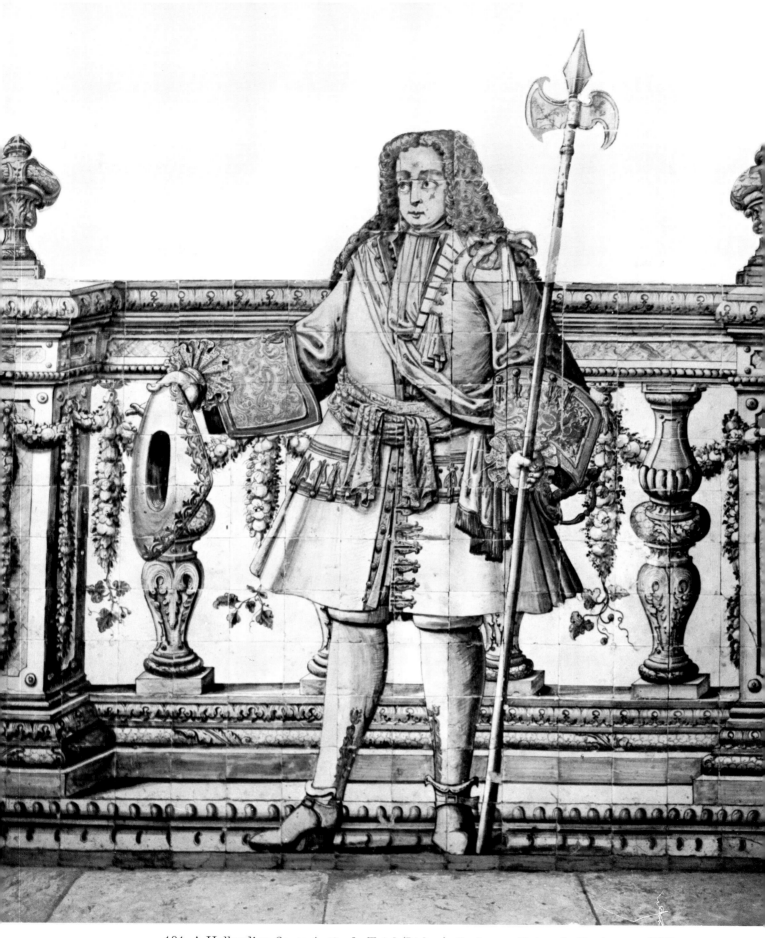

191 A Halbardier. Santo Antão do Tojal (Lisbon), the former Quinta do Patriarca. *c.* 1730

192 Decorative tile panel. Lisbon, Museu do Azulejo. *c.* 1800

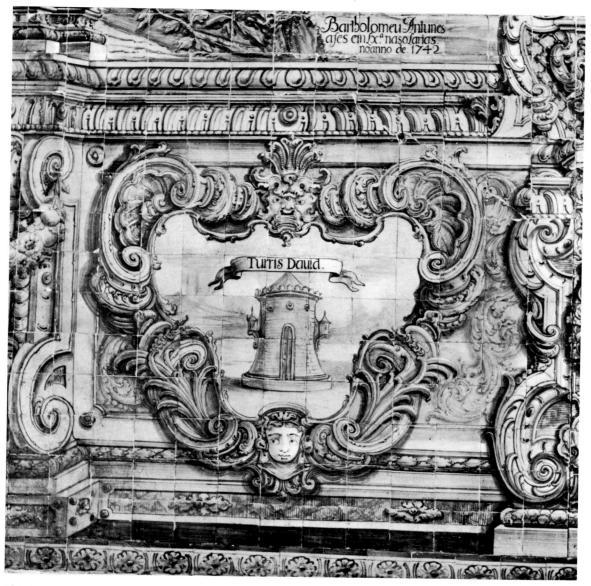

193 Bartolomeu Antunes: *The Tower of David* (a symbol of the Virgin). Vilar de Frades (Barcelos), former church of the Lóios. 1742

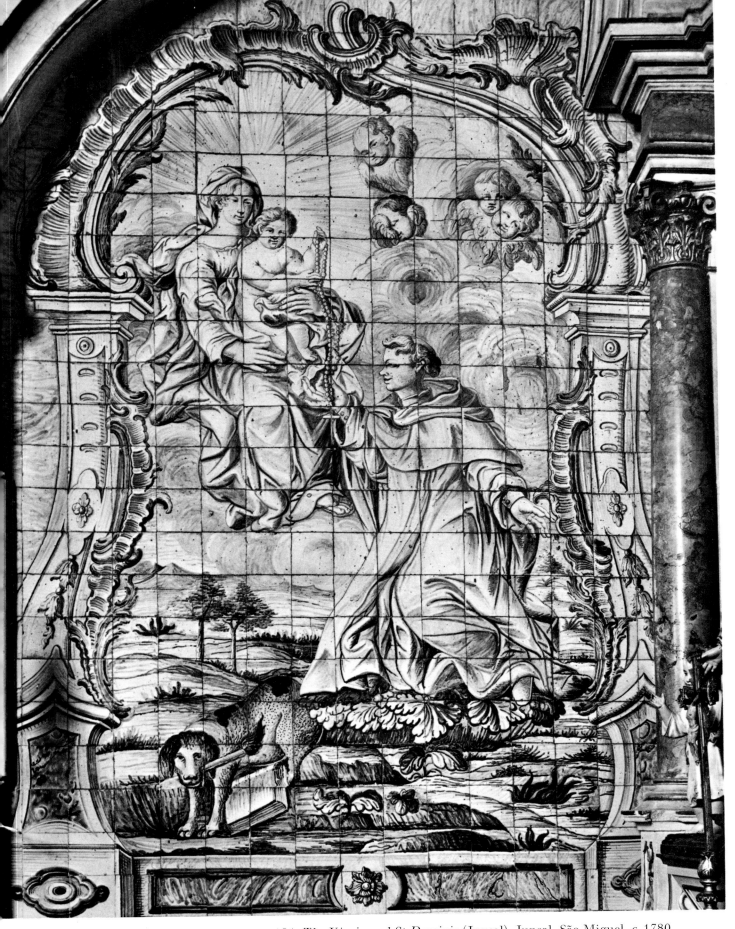

194 *The Virgin and St Dominic* (Juncal). Juncal, São Miguel. *c.* 1780
195 (OPPOSITE) *St Thomas Aquinas* (Coimbra). Cathedral of Aveiro. c. 1760–85

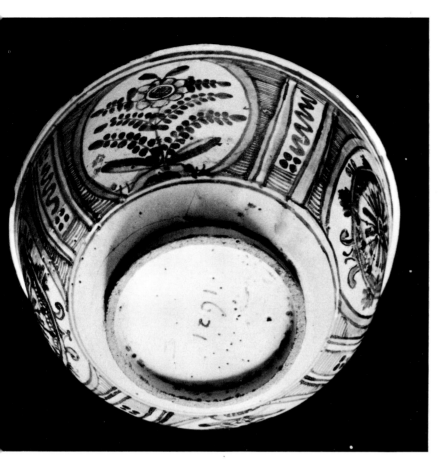

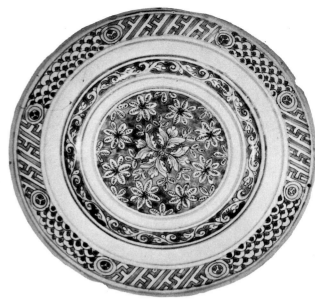

196 (LEFT) Faience bowl. Oporto, Museu Nacional de Soares dos Reis. 1621

197 (ABOVE) Faience plate. Lisbon, Museu Nacional de Arte Antiga. Early 17th century

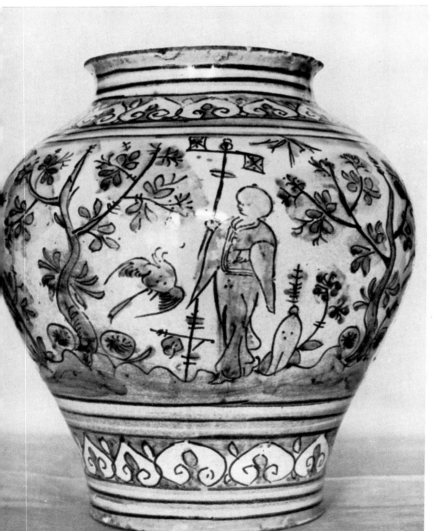

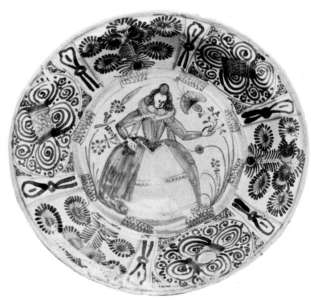

198 (LEFT) Faience vase. Lisbon, Museu Nacional de Arte Antiga. Early 17th century

199 (ABOVE) Faience plate. Oporto, Museu Nacional de Soares dos Reis. c. 1640–70

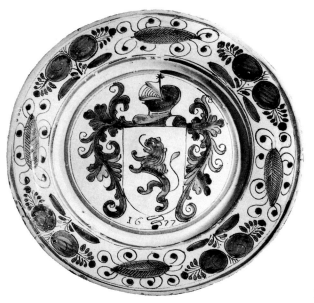

200 Faience plate with the Silva arms. Lisbon, Museu
Nacional de Arte Antiga. 1677
201 (BELOW) Faience plate. London, Victoria & Albert
Museum. Early 17th century

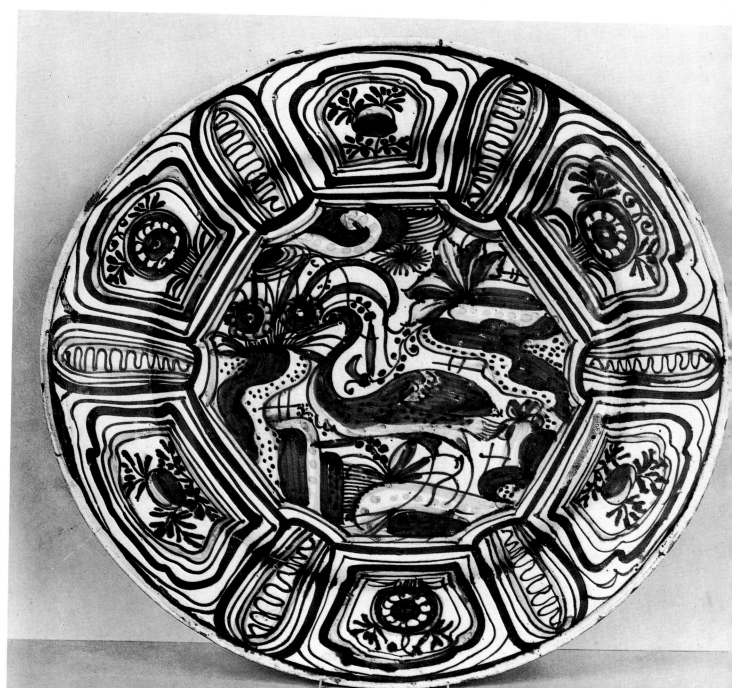

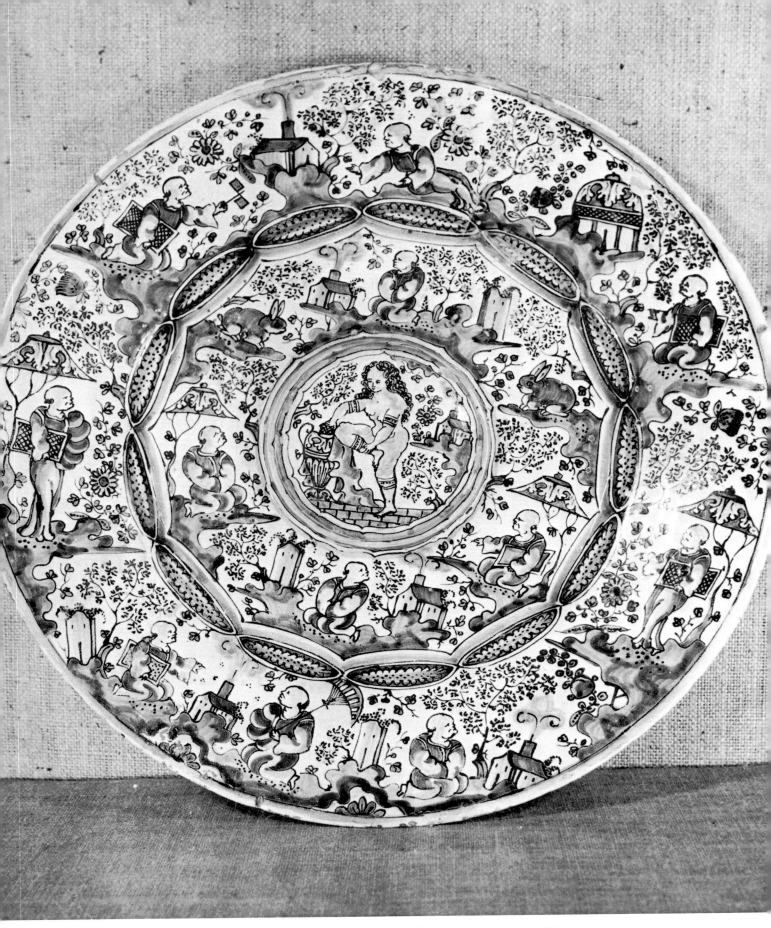

202 Faience plate. Lisbon, Museu Nacional de Arte Antiga. Late 17th century

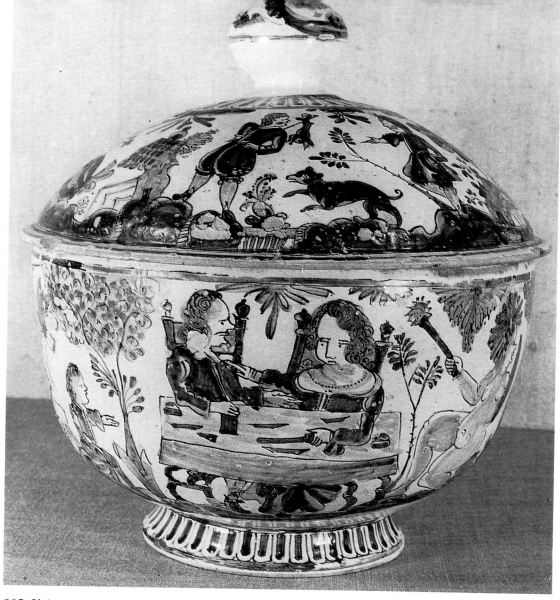

203 Faience tureen. Lisbon, Museu Nacional de Arte Antiga. Late 17th century

204 Faience plate. Lisbon, Museu Nacional de Arte Antiga. Late 17th–early 18th century

205 Faience plate (Coimbra). Oporto, Museu Nacional de Soares dos Reis. First half of the 18th century

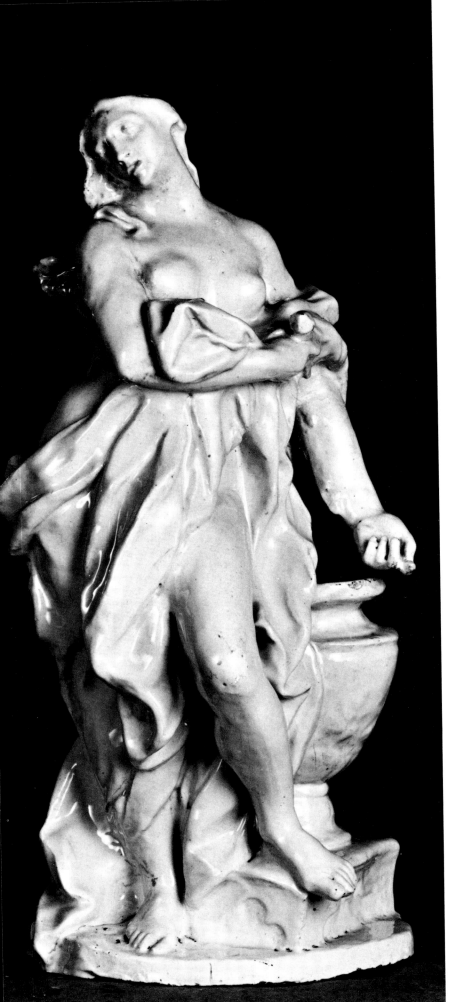

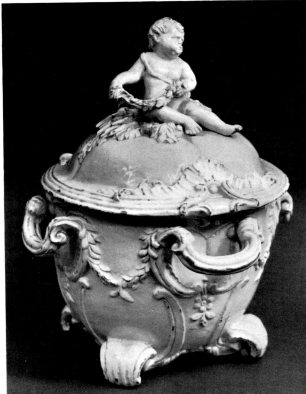

207 Tomás Bruneto: Faience covered dish (Rato).
Lisbon, Museu Nacional de Arte Antiga.
c. 1767–71

206 Tomás Bruneto: *Lucretia* (Rato). London,
Victoria & Albert Museum. c. 1767–71

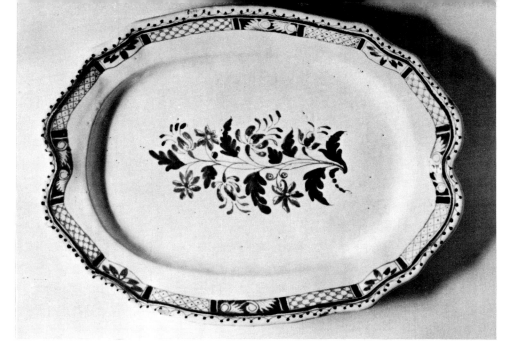

208 Sebastião de Almeida:
Faience platter (Rato). Museu
do Caramulo. *c.* 1771–8

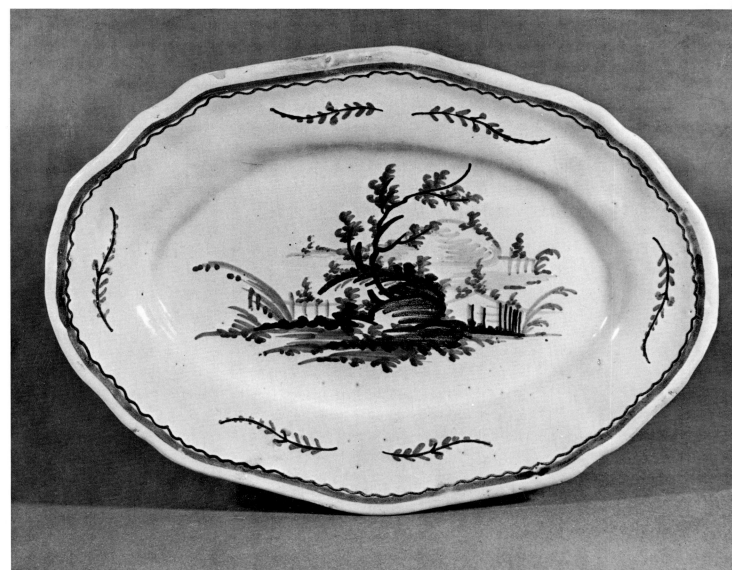

209 Faience platter (Bico do Sapato). Oporto, Museu Nacional de Soares dos Reis. *c.* 1800

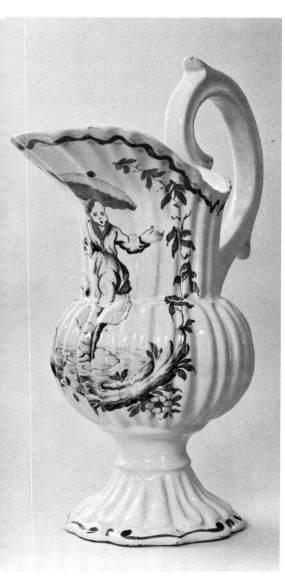

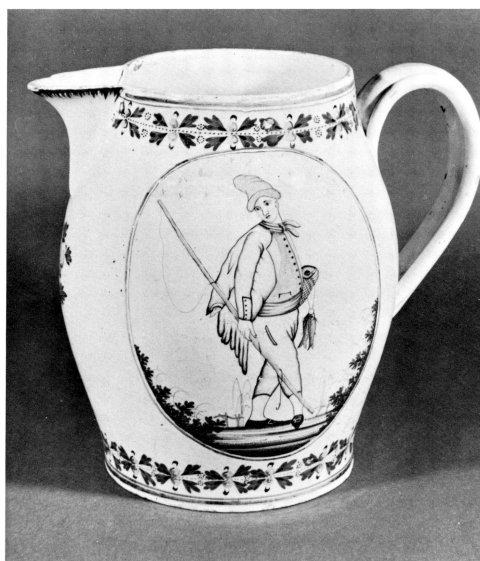

210 Faience ewer (Miragaia). Lisbon,
Museu Nacional de Arte Antiga.
Late 18th century

211 Faience pitcher (Cavaquinho). Oporto, Museu Nacional de Soares dos
Reis. Early 19th century

thriving business by 1619, when in honour of a visit of Philip III of Spain the potters erected a congratulatory arch showing the manufacture and exportation of 'that which China sold so dear now made in our own kingdom'.[7] This imitation coincided with a similar practice in Persia that produced the Kubācha ware of the early seventeenth century,[8] and it preceded by at least fifty years the imitation of Chinese porcelain by the Dutch at Delft, which in turn influenced factories in both England and Spain in the early eighteenth century. The Portuguese were therefore the first Europeans both to import and to copy in faience the porcelains of the East.

What they imitated was the blue-and-white Ming dynasty export ware, especially that of the reigns of the emperors Chia Ching (1522-66) and Wan Li (1573-1619).[9] The results, though coarse by comparison, are attractive and interesting because of the misunderstandings of Chinese painters' conventions and the avoidance of certain favourite Oriental subjects such as fish and dragons and the choice of others never used in China like lions and rabbits, both of which were traditional in Spanish ceramics.

The earliest pieces are closest to the Ming models. A bowl in the Oporto museum dated 1621 is decorated with compartments in the Chinese fashion, some of which contain flowering plants with the long oval leaves found in much of this Portuguese work. The flowers are, however, too stiff and symmetrical for a Chinese painter and the drawing too crude. A plate in the Lisbon museum has the same characteristics. The flowers of the centre are too regularly arranged and the patterns between the imbrications in the outer border represent but half of the standard Chinese swastika motif. A *kwan*-form vase in the Lisbon museum offers a freer and more graceful style of drawing, especially in the tree trunks and flying bird, which are quite close to Chinese painting. The standing figure is, however, too large in scale to conform to Oriental usage, which did not allow the human figure to dominate a landscape.

Plate 196

Plate 197

Plate 198

Typical of a different style of painting, in which the outlines are heavier and the contrasts stronger, is the heron plate at the Victoria and Albert Museum in London. Here again the painter has departed from Chinese custom, this time by not giving the bird's feet sufficient substance to make them convincing. This tendency to reduce Oriental forms to a number of lines is a characteristic of Portuguese faience particularly evident in the handling of flowers, which often are represented by oval designs surrounded by lines that suggest a many-legged insect. There is one just above the back of the heron. These schematized blossoms frequently appear in groups of five, as in the border of an octagonal plate, also at the Victoria and Albert, which is dated 1644. It belongs to a second period, beginning with the regaining of independence in 1640, in which the national arms or those of an individual, as here, constitute the principal decoration. Like the armorial pattern in eighteenth-century Chinese export porcelains, these coats of arms have nothing to do with Chinese art.

Plate 201

In the octagonal plate of 1644 the stylized flowers alternate with a rectangular object that seems to be a crude representation of the Chinese scroll painting symbol, surrounded by twisting ribbons. This is seen again in the border of a plate in the Oporto museum in the company of stylized flowers and a mysterious knot motif which has no relation to the painting of Oriental porcelain or Spanish faience. On the other hand, the central figure of a woman dressed in a farthingale, another European motif typical of the second period (*c.* 1640-70), is a common decoration of Catalan plates of the late sixteenth and early seventeenth centuries.

Plate 199

The border decoration found in these two plates survived in the Lisbon ware of a third

Plate 200

Plate 202

Plate 177

Plate 204

Plate 203

Plate 205

period, beginning around 1670 and extending into the eighteenth century. This is proved by quite a large number of plates, one of which, with the arms of the Silva family in the Lisbon museum, is dated 1677. Here, however, the composition has been simplified, the compartments have disappeared and the flower and leaf forms have been altered. We now have pairs of fruits resembling pomegranates from which sprouts a device suggesting the Graeco-Roman palmetto leaf. These alternate with a leaf surrounded by scrolls which because it looks like a spider is traditionally called *aranhão* by the Portuguese. The same 'open' type of border can be seen in a celebrated plate in the same collection, which though undated seems to belong to the third period, when the miniature buildings with paired windows above a door (the traditional façade of the Portuguese country chapel) that appear here in profusion were popular. The piece has an unusual amount of *chinoiserie* for this late stage, but it is significant that the centre contains a medallion with a nude European woman.

Other plates belonging to the late period have no suggestion of Chinese influence. An armorial plate in the Lisbon museum displaying the arms of the confraternity of St Elizabeth of Portugal of the former Franciscan nunnery of Santa Clara in Coimbra has two borders decorated with the lace motif found in such seventeenth-century tiles as those of the sacristy of the Misericórdia of Oporto of 1668. Another influence from the tiles of the very late seventeenth and early eighteenth century is the use of an ample border with acanthus frieze. The example chosen to illustrate this tendency is one of a group of Lisbon plates with large women's heads of a fantastic, stylized design, a type of decoration that has precedents in both Persian and Catalan wares. The composition is completed by two of the 'palmetto' forms attached to the fruit in the plate of 1677. A few more pieces, like a large tureen in the Lisbon museum, have scenes of everyday life, painted in a caricatural fashion that recalls the Dutch-inspired tiles of the gardens of the Fronteira palace in Benfica, one side of which shows a couple eating at a table apparently of lyre-type trestle support. Some late seventeenth-century plates, one of which is dated 1694, have scalloped surfaces like certain fine silver dishes of the period which probably inspired them.

Although the first half of the eighteenth century was a time of supreme achievement in the history of Portuguese tiles, the faience of this period is scarce and of limited interest. Among the most attractive pieces are the green-and-brown plates of Coimbra designed without decorative borders in which boldly drawn birds and human figures, probably influenced by Spanish pieces, occupy most of the lightly glazed surface. The same tendency, though appropriately accompanied by a graver sort of drawing, appears in the figures of St Benedict and St Scholastica on an Oporto mug of *c.* 1730 at the Lisbon museum, which bears an inscription stating that it was one of the first objects made at the factory of Massarelos in that city. The native industry seems to have suffered in this period from the competition of Chinese export porcelain, which now entered Portugal in enormous quantities, thanks to the prosperity brought about by Brazilian gold.

After 1765, however, the situation changed. Dom José's great minister the Marquis of Pombal wanted a prestige industry like that which Spain had acquired through the founding of the faience and porcelain factory of Alcora near Valencia in 1727 and the porcelain factory of Buen Retiro, established at Madrid in 1759. In 1767 Pombal created in Lisbon the Royal Factory of the Rato, named from a square beside which it was located, and to protect it he forbade the importation of other European wares. The first director was the talented Tomás Bruneto of Turin, one of a number of Italians prominently

associated with Portuguese faience in the late eighteenth century. These include Dr Domingos Vandelli, naturalist and ceramist in Oporto and Coimbra, who made some of the first successful experiments in Portugal with porcelain,[10] the production of which was not, however, to become firmly established until the founding of the factory at Vista Alegre, near Aveiro, by José Francisco Pinto Basto in 1824.[11]

Tomás Bruneto directed the Rato factory for only four years but he made this brief period, from 1767 to 1771, the most distinguished in its history. His most spectacular achievements were the white statuettes, busts (including one of Dona Maria I now at Queluz), boxes, looking-glass frames and small tureens that seem to have been inspired by earlier porcelains made at the Ginori factory of Doccia in Tuscany[12]. Bruneto, like his countryman Bustelli at Nymphenburg, succeeded in conveying a special animation to his figures, particularly to the putti holding garlands that ornament his containers for food and jewels, which are marked 'FRTB'. These were apparently designed in imitation of the elaborate and costly French Rococo silver whose long popularity in Portugal Bruneto probably hoped to challenge with these novelties. He also copied in polychromed faience the equally popular Chinese export porcelain tureens and animal head containers and created handsome small vases in various sizes inspired by Chinese shapes. To the white surfaces of the latter he applied delicate blue flowering sprays and branches which for the first time in the history of Portuguese ceramics approximated the grace and true knowledge of vegetable structure of real Oriental draftsmanship. Bruneto also imitated, though with less distinction, various French and Italian styles of figure painting. At the same time, in the vases and other objects marked with the arms of the Patriarchate of Lisbon, he gave his own sprightly interpretation of the blue-and-white acanthus patterns of early eighteenth-century Dutch-inspired Portuguese tiles.

Tomás Bruneto's successor Sebastião Inácio de Almeida (1771-9), a much less distinguished figure, is chiefly remembered for his blue-and-white platters and moulded Rococo tureens, for which he revived the compartmented borders of sixteenth-century Lisbon faience and standardized in stiff and regular compositions the lithe and fragile foliage of Bruneto. These conventions became the basis for most of the flower painting which played a pre-eminent role in the decoration of the faience of northern Portugal. Similarly the Rococo landscapes of Jean Pillement, with their bending trees and arching foliage, served as models for sketchy caricatures that are the identifying features of many of the products of the factory of Bico do Sapato, which after 1797 became the chief rival of the Rato in Lisbon. A third Lisbon factory, that of Custódio Ferreira Braga, of which very little is known, produced a number of large vases with circular medallions containing crudely painted land and water scenes as well as standing figures, two of the most popular decorative subjects of the period.

These reappear in the products of the numerous factories of the north, which were created in the wake of that of the Rato and at first imitated the Rococo forms and the painted decorations of Bruneto and Almeida. Subsequently English fashions became influential, as in the other arts. Cream-ware or Queen's ware was produced in Oporto, along with imitation Toby jugs and Staffordshire-type figures as well as Liverpool pitchers. The principal factory was that of Miragaia in Oporto, which was founded in 1775 by João da Rocha and later passed to Francisco da Rocha Soares, who before his death in 1829 controlled the factories of Santo António do Vale da Piedade (1785) and Cavaquinho (1789), both in Vila Nova de Gaia. Other factories were established at Darque, across the Lima River from Viana do Castelo (1774) and at Rocio de Santa Clara in Coimbra (1784).

Plate 206

Plate 207

Plate 208

Plate 209

Plate 210

Plate 211

6 Silver

Colour plate XI

In the museum of Setúbal, the former Franciscan nunnery of Jesus, famous for its early Manueline church, there are two anonymous paintings representing St Clare with an angel, of great interest for what they tell about Portuguese taste around the year 1500. One of these paintings is Flemish, the other a Portuguese copy in which certain significant changes have been made. First, the ascetic northern figures of the angel, the saint and her companions have given way to sensuous southern faces and forms. A similar change has taken place in the architecture of the background, where instead of bare surfaces there appears a sumptuous Manueline portal like that of the Madre de Deus, full of twisted growing forms from which sprout statues in niches with late Gothic canopies. There is also a Moorish-inspired window with tracery set in a round tower like those of certain Alentejan churches not far from Setúbal. Finally, one finds another strong contrast between the two paintings in the much richer gold elements of the Portuguese panel. The crown, the monstrance and the haloes have grown conspicuously in size and in opulence of decoration, some of which recalls the fantastic forms of the building in the background.

The Portuguese copy emphasizes the importance of great objects of gold and silver in the life of that nation in late Gothic times, and this impression is reinforced by the prominence of precious metal decorations in the costumes and surroundings of the figures in most Portuguese paintings of the sixteenth century. It is also borne out by a great many inventories and descriptions of ceremonies, dowries and embassies through which foreign eyes were dazzled by the magnificence of Portugal, where colossal sums were spent in the workshops of goldsmiths, for the enrichment of churches and convents and the adornment of the royal palaces and those of the principal nobility.

Lisbon and Oporto were the chief centres of gold and silver working, as they still remain, Lisbon pieces being frequently marked by a ship with two crowns, taken from the city's arms, and those of Oporto by the initial P. Fine silver was also produced in Braga, Guimarães, Évora and Coimbra, and the best work is distinguished by a luminous 'white' quality derived from the purity of the metal used. This was maintained by a municipal inspector, himself a goldsmith, who in the eighteenth century frequently imposed his *contraste*, an official mark of approval, which, like British hallmarks, is useful in determining the date of pieces that display it. Portuguese silver made in the three centuries from 1500 to 1800 shows in succession influences from Spain, Italy, France and, in the late eighteenth century, from England. These correspond to the changes in national taste found in other provinces of the national art, but with silver, as elsewhere, Portuguese characteristics in the choice of forms and of types of decoration are abundant. In spite of the tremendous destruction or dispersion of gold and silver objects, particularly in the Napoleonic invasion, enough of this treasure remains to prove that the Portuguese

By the middle of the sixteenth century Portuguese ecclesiastical silver had undergone the same transformation from Gothic to Renaissance style. This completely changed the design of the monstrance and the chalice, which were often combined in a single piece, from a linear to a plastic expression. The most conspicuous innovation is the use of a stem in the form of a vase or urn decorated with drapery, as in Spanish silver of the period, a form which had already appeared in Chanterene's sculpture for the west portal of Belém.

Plate 113

The richest example of the new design is the chalice made for the Lisbon Augustinians of São Vicente de Fora, which is dated 1546 on a targe engraved on the base of the bowl. This is decorated with straight raised bars found frequently in this type of silver, both in Portugal and Spain, in combination with lion masks. The rest of the ornament parallels that of sixteenth-century woodcarving. The neck of the vase has Italianate Mannerist volute masks like those of the old choir-stalls of the cathedral of Braga, while the cherubs' heads and drapery of the bowl of the cup of the chalice, which has kept its original bells meant to tinkle at the moment of elevation, are almost exactly like those of the chests of drawers in the sacristy of the cathedral of Miranda do Douro. Only the angular foot of the São Vicente de Fora chalice is reminiscent of Manueline shapes. By this time a new convex form was coming into fashion, but the old shape lingered on into the seventeenth century.

Plate 217

Plate 238

The new type of base appears on the celebrated hyssop bowl in the museum at Coimbra, which must date from before 1543, the end of the long reign of Dom Jorge de Almeida, the bishop whose arms it bears. This monumental piece has the same decisive and vigorous forms of the chalice and the same use of masks, but these are now combined with Flemish bar ornament already noted in tiles and wood and stone sculpture of a later date, which capriciously encases human figures, as in the choir-stalls of Évora and Belém. It is not uncommon to find decorative motifs appearing first in silver, perhaps because it was made for patrons whose exalted position made them the first to be aware of new styles, and also because silver, being portable, could teach its own lessons. At the top and bottom of the hyssop bowl run architectural chain motifs taken from Serlio, which in the lip of this extraordinary piece are combined with large brackets, like those used by Diogo de Torralva in the great cloister at Tomar and Diogo da Çarça in the choir-stalls of Belém.

Plate 218

Plates 93, 173

Plate 31

The same kind of bracket appropriately appears on the grand silver wafer box given to Tomar by Dom Sebastião before his tragic death in 1578. Here the design has returned to architecture, not as a capricious adornment, however, as in the Manueline silver, but as a basic setting for reliefs of the Evangelists and scenes of the Passion. These are framed here by paired decorated columns, like those of the contemporary retables of Portuguese churches. The scheme may have been inspired by the style of the famous Spanish silversmith Juan de Arfe, grandson of Enrique mentioned in connection with the monstrance of Belém, which also probably influenced such architectural designs in woodcarving as those of the sacrarium of the high altar at São Domingos de Benfica or the interior of the retable of the church of Nossa Senhora da Luz.

Plate 219

Plate 94
Plate 92

The architectural style of the late sixteenth century is as important in the history of Portuguese silver as the retable of concentric arches for the woodcarved church interior. It lasted throughout the seventeenth century and into the first quarter of the eighteenth. It is especially associated with the decoration of the sacrarium or sanctuary for guarding the Host, which, under Juan de Arfe's influence, came to be designed as a pyramidal

Plate 220

structure of many stories, ornamented with columns, entablature, balustrades and reliefs. Sometimes the sacrarium was combined with other elements to form an entire retable of elaborately worked silver, like that of the cathedral of Oporto, which has the distinction of being both documented and intact, except for the miniature balustrades of the sacrarium, replaced in 1875.

This is the earliest section of the great ensemble. It was begun in 1632 by Manuel Teixeira and his son-in-law, Manuel Guedes, who came from Lamego for this purpose in 1632. The first stage was finished in 1639; the second in 1641. The third zone was completed in 1647, while the fourth, made by Guedes with the assistance of Bartolomeu Nunes, dates from 1651. The sumptuous edifice that resulted resembles Juan de Arfe's monstrance of 1564-71 for the cathedral of Avila in the use of paired columns and predella reliefs of Old Testament scenes. The Oporto design is, however, even richer, because the many intercolumniations left open in Arfe's work were filled by Manuel Guedes and his associates with a dozen reliefs, the figures in which, like the statuettes on the balustrades, are designed in the flat elongated Mannerist fashion found in such

Plates 92, 93

paintings as those of the retables of Nossa Senhora da Luz and the cathedral of Portalegre.

A similar, though less complex sacrarium of silver was made in Lisbon by João de Sousa, as a royal gift for the high altar of the Hieronimite church of Santa Maria at Belém between 1663 and 1673, while the domed sacrarium and silver altar throne that accompanies it in the Lisbon church of the Comendadeiras de Aviz were begun in April 1699 by the brothers Manuel and Luís Rodrigues.

The second part of the Oporto silver retable to be completed was the antependium or altar frontal, which was finished in 1678. It is the work of a craftsman known only as Pedro Francisco 'the Frenchman', who contracted to make it in 1676 of 'low relief worked with flowers and in the foreign way, including figures where indicated, also in low relief'.[2] The reference to a foreign manner probably applies to the new design of flowing acanthus foliage applied all over the piece. This was a popular scheme all over Europe at the time disseminated by the engravings of Jean Lepautre and other masters of ornament. But what is characteristically Portuguese is the placing of acanthus volutes above and below the oval medallions with the four Evangelists, thus repeating a motif constantly emphasized in woodcarving and tile painting of the late seventeenth and early eighteenth centuries.

The acanthus style, with which the Baroque phase of Portuguese silver began, invaded domestic silver, where it dominated one category of handsome round dishes, which like those of the preceding century have centre discs placed in concentric circles. An out-

Plate 221

standing example in the Lisbon museum displays in the centre the traditional family arms, set now in Baroque acanthus mantling. Acanthus leaves with their flowers fill a surrounding convex zone and appear again in a broader register beyond, in which according to an Italian convention some leaves are grouped to form masks. This motif is then repeated in voluted cresting around the outer rim of the dish, according to a usage found also on some Portuguese faience plates of the seventeenth century. Throughout this piece there is the same plethora of ornament, lively rhythm and exuberant feeling of Manueline silver that is also seen in late seventeenth-century *talha*. In a few extraordinary examples the acanthus-style masks are combined with ships in full sail. There is a lordly example in the collection of the chapter of the cathedral of Lisbon, another in the José de Alpoim Collection at Viana.

Another category of Baroque dishes has panels filled with low reliefs of tulips, a motif of Dutch derivation, emerging from a wreath of tightly wrapped leaves, around which is set a collar of volutes and foliage. In a great example at the Victoria and Albert Museum, Plate 222 which is an eighteenth-century version of the form, thought to have been made in India, this collar contains exotic animals while a winged sea creature is embossed on the centre disc. Fantastic winged beasts like this were made as table ornaments along with small owls which recall the use of birds in marquetry and carving in some Indo-Portuguese case furniture.

A third group of dishes is decorated only with *gomos* or concave scallops radiating from a large central disc. These are related to an important group of sparsely decorated drinking bowls of scalloped form equipped with identical handles. These are thought to Plate 224 have been made in Portugal as early as the sixteenth century and to have influenced similar English pieces of the seventeenth century. Whether this is true or not is debatable, but there seems little doubt that the Portuguese *gomo*, like the 'paintbrush' foot in *Plate 247* furniture, affected Carolean silver. These dishes and drinking bowls of 'geometric' style are also related to a number of perfectly plain ewers and holy oil vessels (another genre originating in the sixteenth century) memorable for forms as handsomely stalwart as those of the Renaissance chalices and monstrances, of which there is a famous example, Plate 225 dated 1689, in the collection of the Duke of Palmela.

During the eighteenth century Portuguese silver, like the national furniture, lost much of its originality under the impact of a brilliant array of foreign influences. Under Dom João V (1706-50) these came principally from the Baroque style of Rome. With his successor, Dom José (1750-77), fashion shifted to the French and English Rococo. The classical style of Robert Adam entered Portugal in the reign of Dona Maria I (1777-1816) and during the regency of her son, the future Dom João VI (1792-1816), was joined by that of the French Empire.

Lisbon church silver of the first half of the eighteenth century was entirely dominated by the many sumptuous silver gilt pieces imported from Rome for the Patriarchal church, Mafra, and Vanvitelli's princely chapel of St John Baptist at São Roque, which brought to Portugal the sculptor Alessandro Giusti and masterpieces of silver by Antonio Carlo Guarnieri, Antonio Gigli, and other Italian goldsmiths, most of which are now exhibited in the Lisbon museum of São Roque.[3] During this whole period there worked in Lisbon João Frederico Ludovice (1670-1752), a German goldsmith turned architect who had been employed in Rome upon Pozzo's gilt bronze and marble retable of St Ignatius in the church of the Gesù. Although his major Portuguese work, including the silver sacrarium for the high altar of the Jesuit church of Santo Antão, begun shortly after his arrival in 1701, perished in the earthquake of 1755, enough of Ludovice's elaborate style is known through drawings to suggest that the bejewelled golden monstrance of the royal chapel of Bemposta may be his work.

This majestic composition, which is unmarked probably because, as in France, royally Plate 223 commissioned pieces required neither signature nor inspection symbols, is full of the devices emphasized in the contemporary engravings of silver made by Filippo Passarini in Rome and Jean Bérain and André-Charles Boulle in Paris. Especially significant are the constantly changing outlines, based on volute forms, which frequently merge with the heads of cherubs, the seated allegorical figures, the various pedestal motifs and the Borrominesque serpentine pediment, a motif destined to flourish in later eighteenth-century architecture, which may have appeared here for the first time in Portugal. These

forms, which were equally influential in Joanine woodcarving, were to characterize the bulk of Portuguese silver made throughout the eighteenth century.

On the other hand, in Oporto the Italian painter and architect Nicolau Nasoni (1691-1773), who frequently designed silver, evolved an ornament of his own, consisting of volutes, frilled shells and foliage combined in riotous asymmetry, which appears in the arched niche added in several stages, between 1739 and 1755, to the silver altar of the cathedral of Oporto. The great silversmith João Coelho de Sampaio, who was one of the executants of this design, disciplined Nasoni's fantastic ornament into an elegant and lively language, which he shared with other Oporto craftsmen. Among them was the Master M F G, who made for the cathedral of Lamego in the period 1758-68 the silver frontal of the chapel of the Blessed Sacrament. In this great *tour-de-force*, which imitates both textile and embroidery, the spirochete-like style of Nasoni appears in the ornament surrounding vignettes that contain various symbols of religion and the Mass. The detail here illustrated shows a monstrance of the period, a motif popular also in the woodcarved retables of Oporto, along with the very uncommon device of the table of the Biblical shew bread, which displays the cabriole legs with claw-and-ball feet borrowed from England by Joanine cabinetmakers.

For his domestic silver Dom João V turned to France, ordering several Rococo services from Thomas Germain, the great craftsman of Louis XV, whose portrait of *c.* 1725 by Largillière is now in the collection of the Calouste Gulbenkian Foundation in Lisbon. This silver was destroyed in the earthquake of 1755, but much more was subsequently commissioned by the Crown and the rich Duke of Aveiro from Germain's son François-Thomas, Jacques Ballin, G.-A. Jacob and Ambroise-Nicolas Cousinet. These collections, of well over a thousand pieces, now at the Lisbon museum, in addition to other pieces in the Gulbenkian treasure, make the Portuguese capital the pre-eminent place for the study of French Rococo court silver. Its influence on the eighteenth-century silversmiths of Portugal was constant and profound, especially in certain categories which seem to have been considered showpieces, chief among which was the ewer with matching bowl of repoussé silver.

The earlier pieces, like one made by the Lisbon master known only by his initials AL, established the so-called helmet type, in combination with a huge applied handle in the form of a bent female herm figure, characteristic of French Regency silver of the first decades of the eighteenth century. The fluted surface of this Joanine ewer is sparsely decorated with engraved and applied ornament including diaper work and Bérainesque arabesques of shells and volutes related to the pendants at the base of the monstrance of Bemposta. Full Rococo forms associated with the reign of Dom José (1750-77) are seen in an exceptionally fine ewer with basin in the Guerra Junqueiro collection in Oporto. Here the entire surface of the pieces appears to be shifting and changing before one's eyes according to the formulas of Juste-Aurèle Meissonier, who succeded Bérain as royal draftsman in Paris and deeply influenced the developing Rococo style. Characteristic of his fantastic ornament is the water-like motif of the base of the bowl and the interlocking volutes that outline both ewer and basin. Typical of French Rococo practice in general are the engraved and repoussé roses and the swirled surface of the bowl of the ewer, which forcefully emphasizes the impression of nervous movement produced by the curving, broken outlines of this masterly object.

Similar swirled surfaces, though more rigorously co-ordinated within handsome pear-shaped bodies, are found in another important category of French-inspired silver, that

of the ebony-handled coffee-pot. In an outstanding example marked SA in the Lisbon museum the long sinuous Rococo lines of the swirling are emphasized by convex finger-like sections of irregular extension, ornamented by bands of punching that contrast with the naturalism of the flowers and foliage around the spout and the celery-like leaves that seem to sprout from the three applied voluted feet. Feet of this sort were sometimes given to teapots of typically British 'reversed pear' shape, creating an effect more original than graceful. Others were provided with conventional bases decorated with asymmetrical ornament implementing the reliefs which decorate the shoulders and spouts of these luxurious objects. Still others have as their chief adornment an all-over fluting that harks back to the Joanine ewer. An especially fine example of this type in a private collection in Oporto bears the mark of the premier eighteenth-century silversmith of that city, João Coelho de Sampaio, and the device of Domingos de Sousa Coelho, who held the post of assayer in Oporto between 1758 and 1768.

The first signs of the Classical Revival appear in Portuguese silver in the early 1770s. In 1772 the court goldsmith Luís José de Almeida made two silver plaques with oval portraits of Dom José and his queen, Maria Ana Victoria of Spain, now in the Lisbon museum, set in frames that imitate jewelled ribbons. The oval medallions and their bases, which contain engraved views of contemporary constructions on the Lisbon waterfront, have a new simplicity of form and sobriety of ornament, but there is still some Baroque agitation in the drapery at the top of the plaques. In a third silver portrait made by Almeida in 1773, representing the sovereign's studious, short-lived grandson, Dom José (1761-88), then Prince of Beira, even this has disappeared, and the likeness is set in a pseudo-classical tablet based on those used in French portrait engravings of this time. Around the inner frame of the medallion the silversmith placed bead or pearl motifs not unlike those that constantly recur in the fully developed Neo-Classical silver of the reign of the Prince of Beira's mother, Dona Maria I.

This was in great part inspired by the type of silver made popular in London in the late 1760s by the architect and decorator Robert Adam, in which discreet 'bright-cut' engravings of rigid leaves, swags and geometric bands replaced the opulent repoussé ornament of the Rococo age, while classical lamps, vases and urns inspired the shapes of all types of vessels. The new English manner was particularly popular in Oporto, where, as we have seen, Consul John Whitehead designed the British Factory in 1785 in the Adam style. The numerous English wine merchants imported fine silver from London, which served as models for such Oporto craftsmen as Luís António Teixeira Coelho, José Pereira Ribeiro, Manuel José Dias Ferreira, Domingos Moreira Maia and José Coelho de Sampaio, assayer of the city between 1768 and 1810.

The three pieces of Portuguese Adamesque silver here illustrated are all from Oporto. The coffee-pot, whose body is ornamented with gadrooning and delicately incised ribbons and honeysuckle vines set in an oval composition, offers a striking contrast to the earlier example from Lisbon influenced by the French Rococo. The teapot of drum shape, like those made by Paul Revere about 1790 in Boston, has practically the same type of decoration on a partially fluted surface. In a virtually unique altar vessel modelled on an Adam sugar container the whole surface is fluted, while ornamentation is limited to slight bands of beading and gadrooning and the finial urn. This stately object, one of a pair marked by the silversmith IOC, bears the arms of Dom João de Magalhães e Avelar, Bishop of Oporto from 1816 to 1833, and the mark of Alexandre Pinto da Cruz, assayer of Oporto between 1810 and 1818.

Plate 229
Plate 230
Plate 231
Plate 235
Plate 82
Plate 232
Plate 229
Plate 233
Plate 234

Art of Portugal

At the close of the eighteenth century some church silver was made in the heavy sculptural style associated with the empire of Napoleon I and in particular the plates of Percier and Fontaine's *Recueil de décorations intérieures*, published in Paris in 1801. The silver gilt monstrance of the church of the Third Order of St Francis of Oporto by Luís António da Silva Mendonça, which dates from 1796,[4] is a good example of this work. By far the most important, however, is the spectacular set of more than a thousand pieces of banquet silver offered by the Portuguese government to the Duke of Wellington in gratitude for his delivery of the nation from French invaders. The Wellington Plate, as it is called in London, was made in the arsenal of Lisbon, between 1811 and 1816, by some 142 craftsmen on drawings by the court painter Domingos António Sequeira, some of which survive in the Lisbon museum. Models were made from them by the silversmith João Teixeira Pinto.

Plate 236

With his taste for allegory Sequeira provided the unifying motif of nymphs celebrating Wellington's triumph. Some appear as dancing figures around the candelabra; others serve as siren supports for massive oval tureens. These are the handsomest pieces of the set, which reaches the climax of theatricality in the octagonal centrepiece supported by Napoleonic sphinxes. Here three lictor's fasces, symbolizing the victories of Britain, Portugal and Spain in the Peninsular Campaigns, are surrounded by four more nymph-like figures representing the four continents accompanied by their attributes. The Wellington silver, as Charles Oman has observed,[5] was designed by a painter with the same classical taste as Prud'hon and Flaxman and executed in a technique slightly inferior to that of the great Parisian silversmiths Odiot and Biennais or the London virtuoso Paul Storr. It also represents a style which is the classical counterpart of the Roman Baroque manner exemplified by the work of Ludovice, and with it the great tradition of Portuguese silver comes to an end.

212 (OPPOSITE) Silver-gilt chalice of Tomar. Lisbon, Museu Nacional de Arte Antiga. **Early 16th century**

Silver

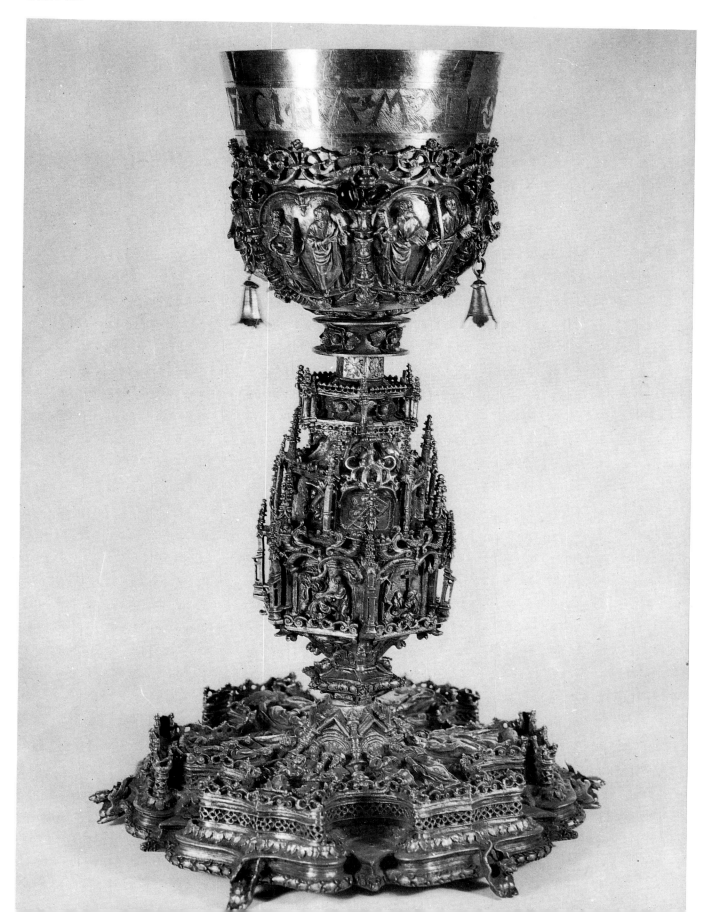

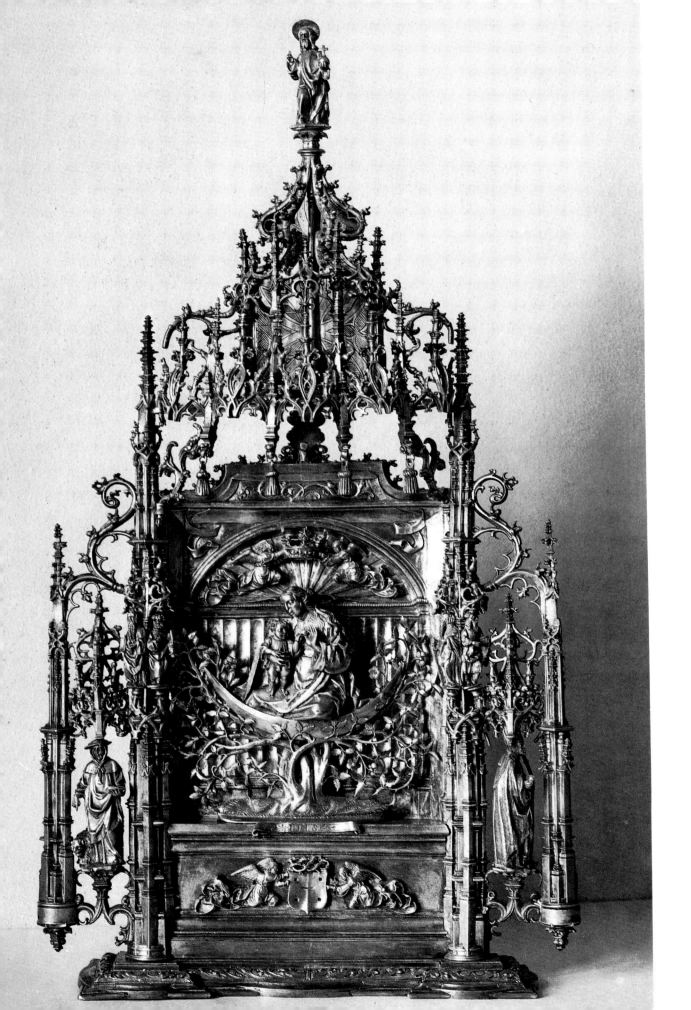

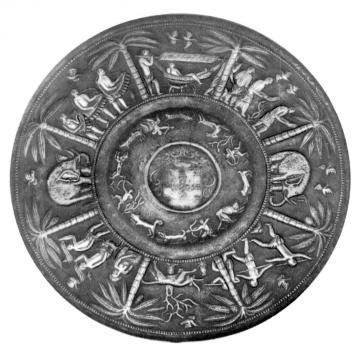

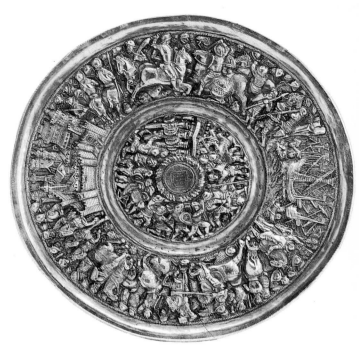

214 Silver-gilt dish. Lisbon, Palácio Nacional da Ajuda. Early 16th century

215 Silver-gilt dish. London, Victoria & Albert Museum. c. 1525–40

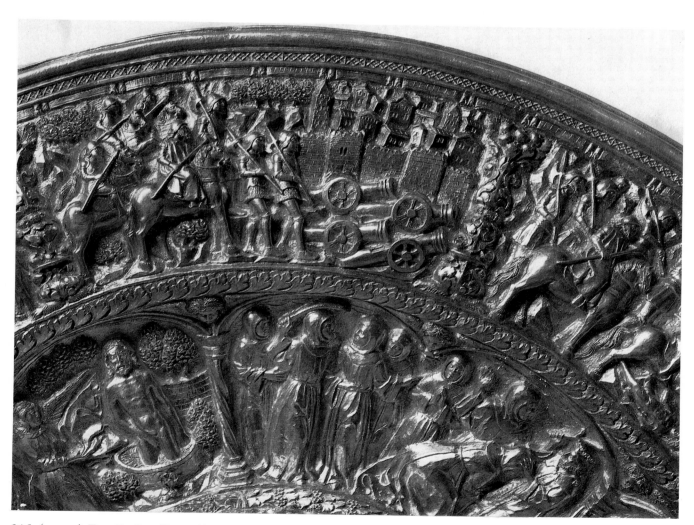

216 (ABOVE) Detail of a silver-gilt dish. Vienna, Kunsthistorisches Museum. c. 1535

213 (OPPOSITE) Silver porta-pax of Nossa Senhora do Espinheiro. Lisbon, Museu Nacional de Arte Antiga. Early 16th century

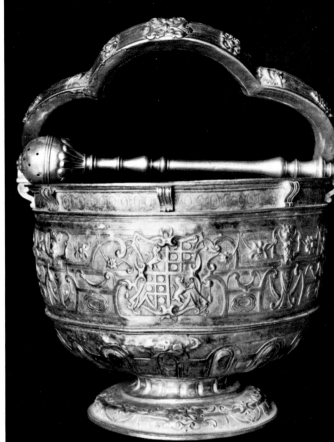

218 (RIGHT) Silver hyssop bowl of Dom Jorge de Almeida. Coimbra, Museu de Machado de Castro. Before 1543

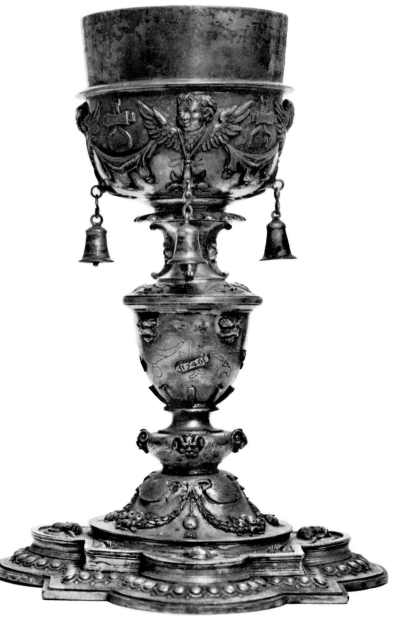

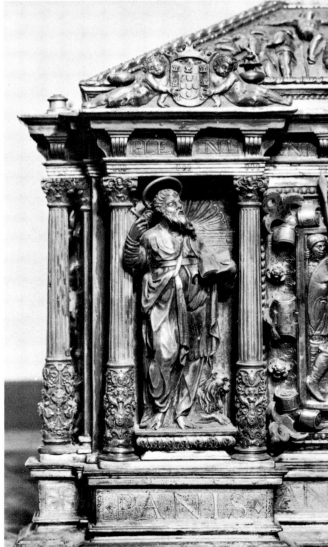

217 (ABOVE) Silver-gilt chalice of São Vicente de Fora. Lisbon, Museu Nacional de Arte Antiga. 1546

219 (RIGHT) Detail of the silver wafer box of Tomar. Lisbon, Museu Nacional de Arte Antiga. Before 1578

220 (OPPOSITE) Manuel Teixeira, Nicolau Nasoni and others: Silver altarpiece. Cathedral of Oporto. 17th and 18th centuries

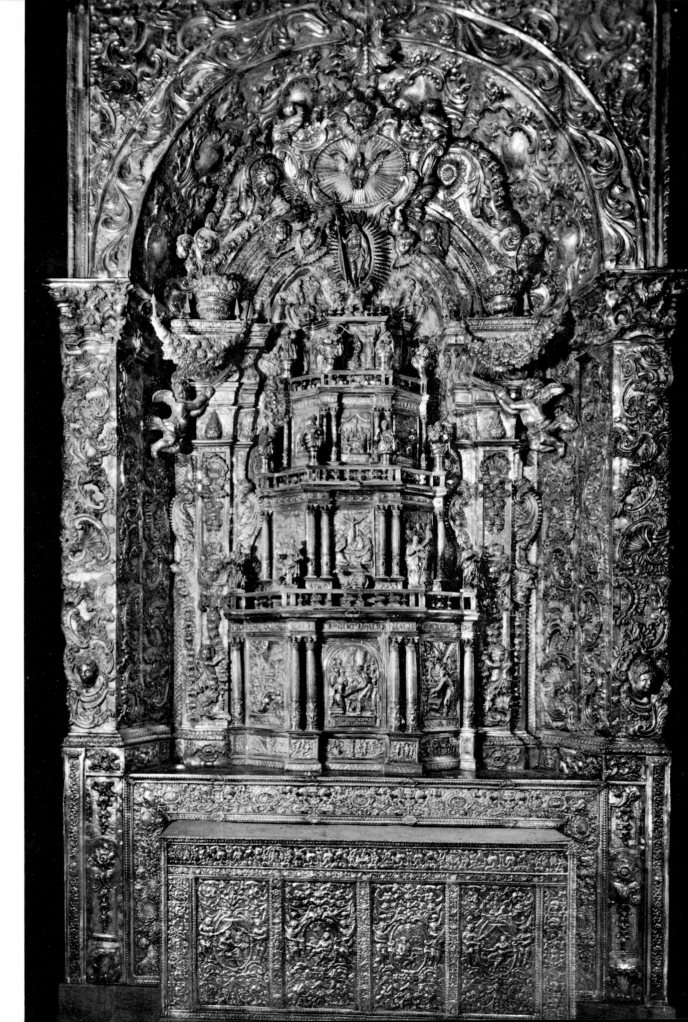

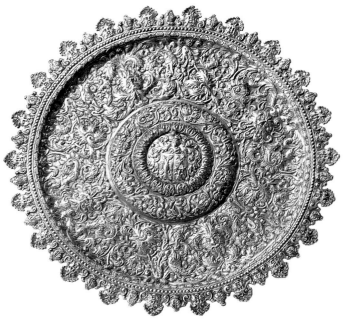

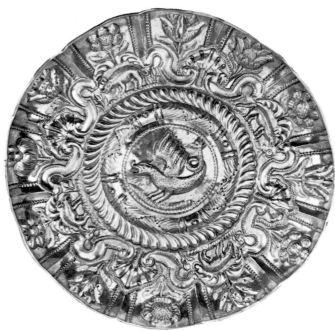

221 (TOP) Silver dish. Lisbon, Museu Nacional de Arte Antiga. Late 17th century

222 (BOTTOM) Silver dish. London, Victoria & Albert Museum. *c.* 1750

223 (RIGHT) João Frederico Ludovice: Silver-gilt monstrance of Bemposta. Lisbon, Museu Nacional de Arte Antiga. First half of the 18th century

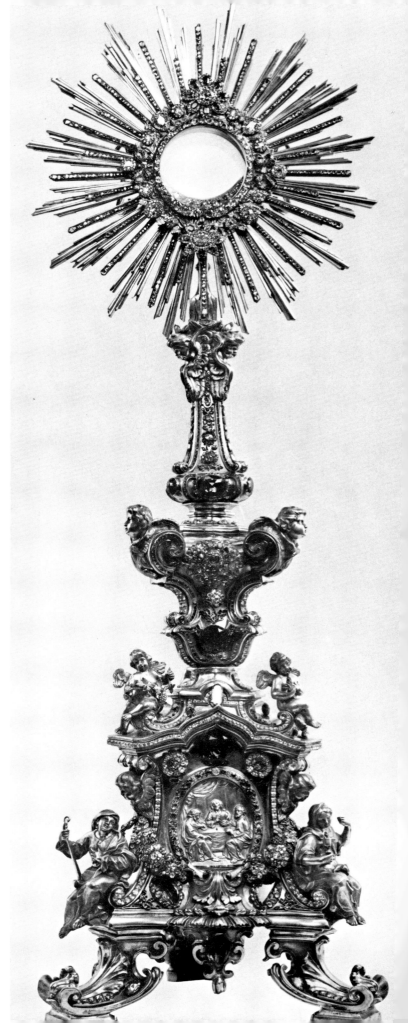

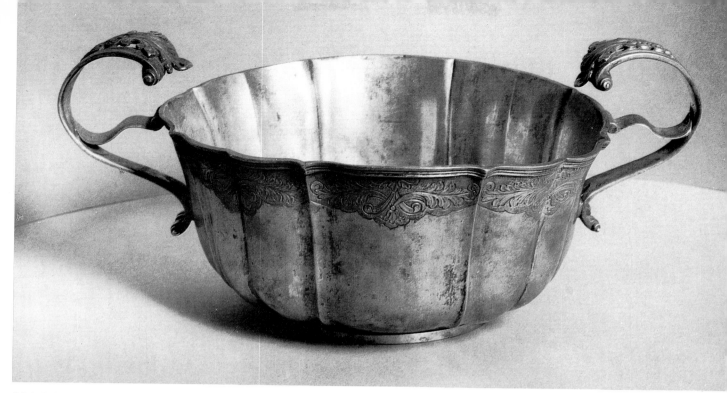

224 Silver bowl. Lisbon, Museu Nacional de Arte Antiga.
17th century

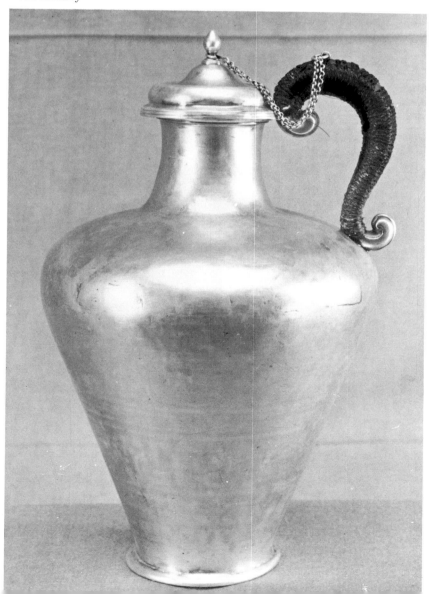

225 Silver pitcher for holy oils. Lisbon,
Duke of Palmela. 1689

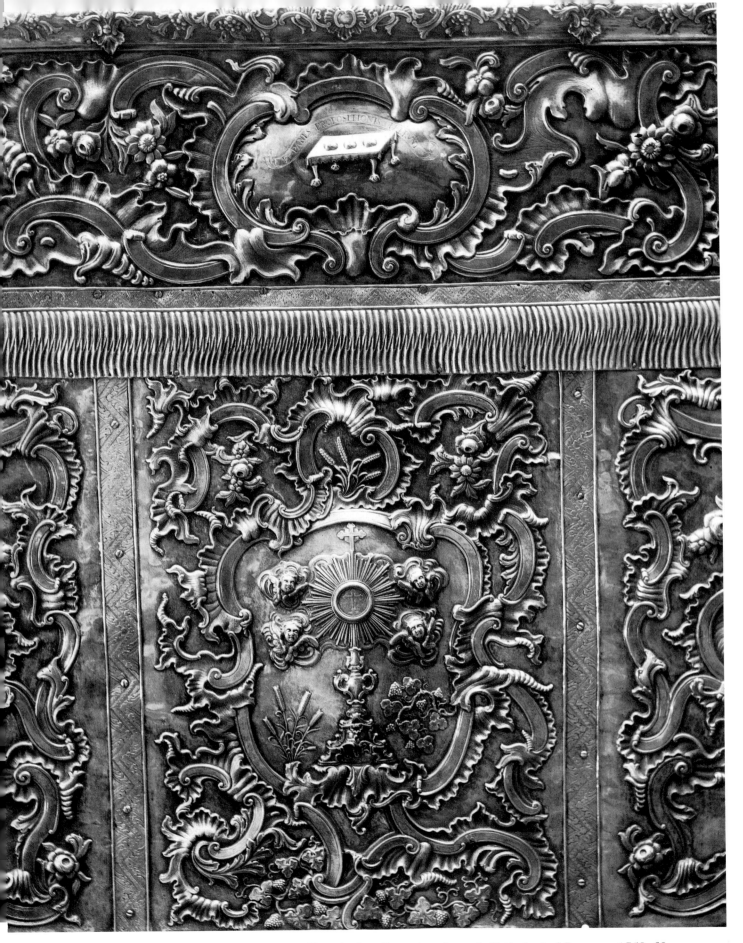

226 The Master MFG: Detail of a silver altar frontal. Cathedral of Lamego. 1758–68

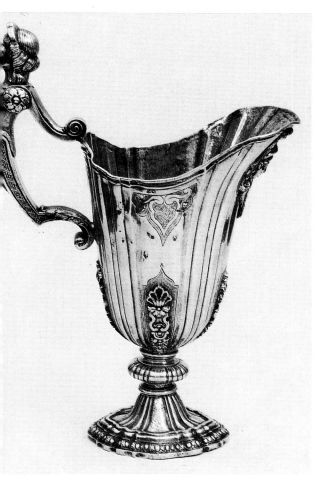

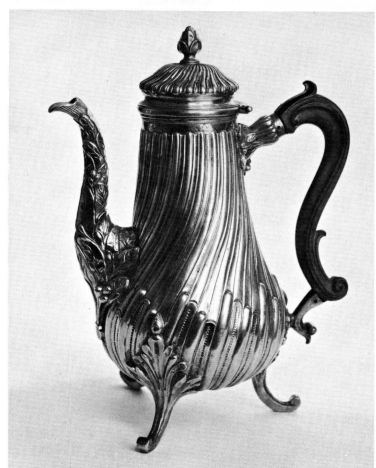

227 The Master AL: Silver ewer. Ponte de Lima, Count of Aurora. Early 18th century

228 (BELOW) Silver ewer and basin. Oporto, Casa-Museu de Guerra Junqueiro. c. 1750–75

229 The Master SA: Silver coffee-pot. Lisbon, Museu Nacional de Arte Antiga. c. 1750–75

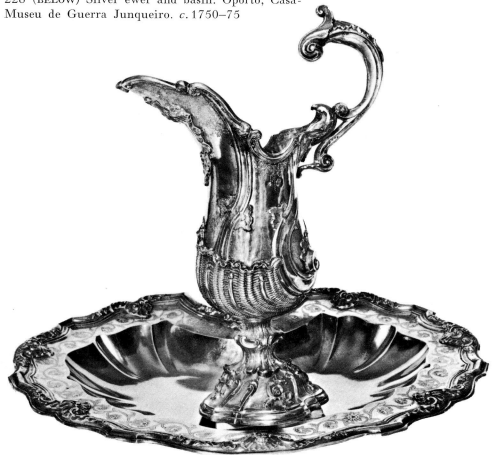

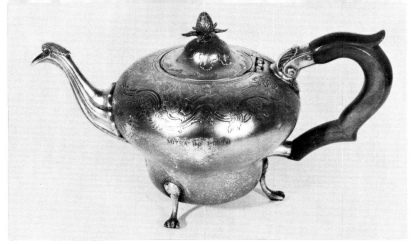

230 Silver teapot. Oporto, Museu Nacional de Soares dos Reis. *c.* 1750–75

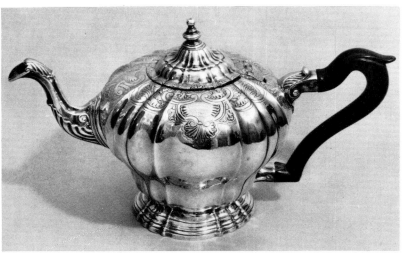

231 João Coelho de Sampaio: Silver teapot with the arms of Souto Freitas, of the Casa da Fábrica. Oporto, Dona Maria da Conceição Cyrne de Bourbon e Távora. *c.* 1758–68

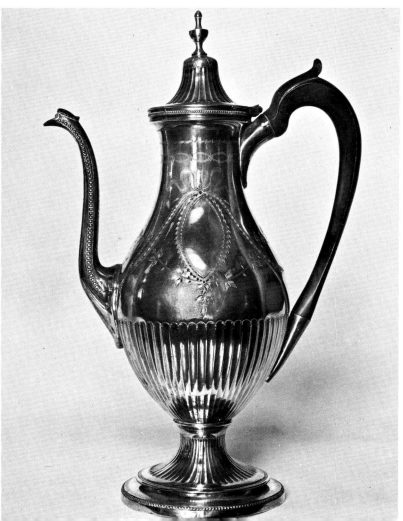

232 Silver coffee-pot. Oporto, Casa-Museu de Guerra Junqueiro. Late 18th century

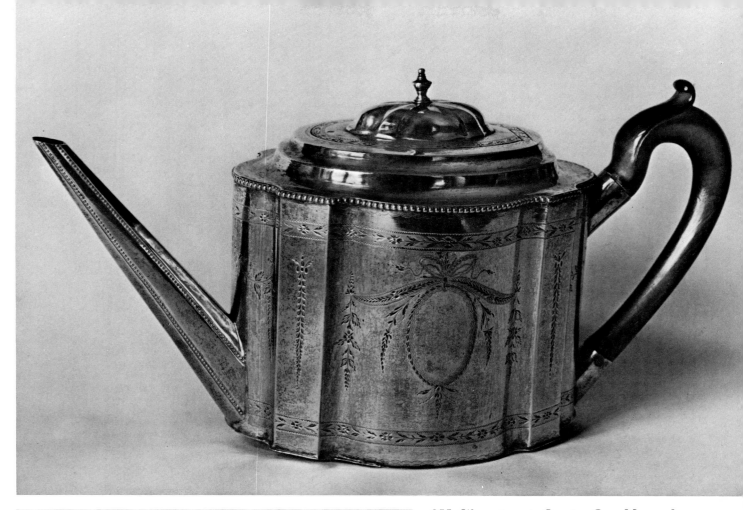

233 Silver teapot. Oporto, Casa-Museu de Guerra Junqueiro. Late 18th century

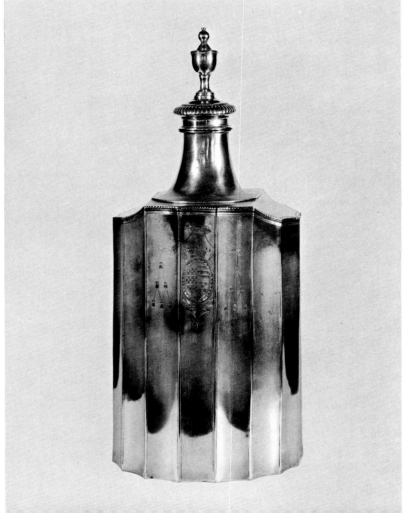

234 The Master IOC: Silver altar vessel. Oporto, Museu Nacional de Soares dos Reis. *c.* 1816–18

235 Luís José de Almeida: Silver plaque
of Dom José, Prince of Beira. New York City,
Hispanic Society of America. 1773

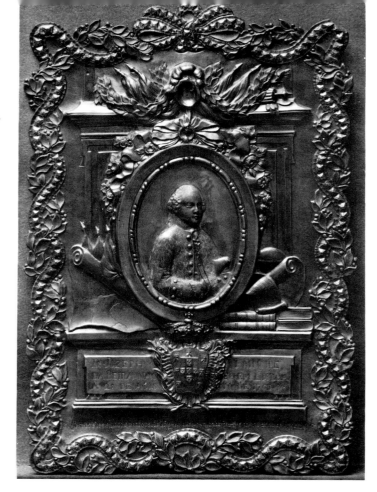

236 Domingos António Sequeira: Silver
covered dish from the Wellington Plate.
London, Apsley House. 1811–16

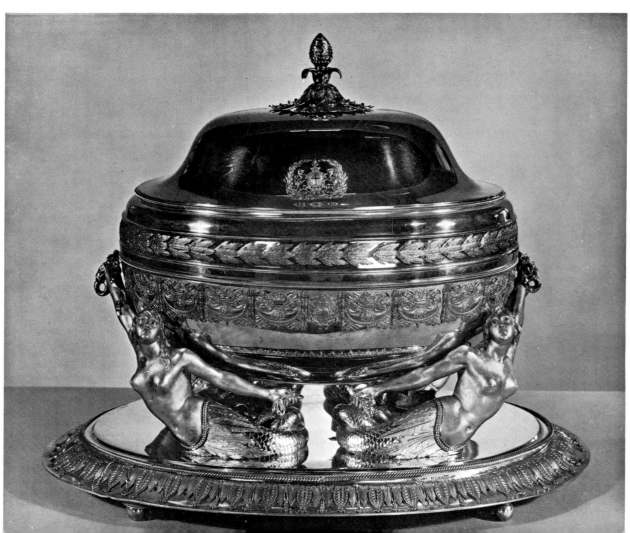

7 Furniture

Portuguese furniture achieved its handsomest and most original expression in the seventeenth century. In this period and particularly after 1640, when the nation had regained its independence from Spain, certain monumental forms appeared, along with special techniques of great distinction, which won for Portuguese cabinetmaking a high place in the annals of seventeenth-century furniture. Much of this originality was lost in the eighteenth century, when Portugal like the rest of Europe followed the superlative fashions of Paris and London. Even in this period of constant imitation, however, the Portuguese were never slavish borrowers, for they were continually combining one foreign motif with another, often with no regard for chronological niceties, but with generally attractive and sometimes quite impressive results.

From the standpoint of material Portuguese furniture differs from that of the rest of Europe. Chestnut, sparsely used elsewhere, was by far the most popular wood. Also, the finest pieces from 1600 onward were generally made of Brazilian rosewood, called *pau preto* or *jacarandá*, to cite only two of the many names given to this dark and lustrous material, which was the first of the American tropical woods to be used extensively by European cabinetmakers. The Portuguese therefore anticipated by at least a century the English discovery of mahogany, which was esteemed for the same reasons as rosewood, namely its handsome warm colours and veining, its strength and at the same time workability, and its resistance to the boring of insects.

Unfortunately very little is known about Portuguese cabinetmakers, for they rarely signed their furniture or contracted to make it, except in the case of churches and convents. Almost no bills have been found, but occasionally church records reveal the names of craftsmen who made specific chairs or tables, and some of these can be identified. The diary of Frei José de Santo António Vilaça (1731-1809), the great Benedictine wood sculptor of Braga, makes him the best documented of Portuguese cabinetmakers, for the quantity of surviving furniture which he records having designed and in many cases executed by far exceeds the known work of any other master.[1]

Equally scarce is information about Portuguese furniture before 1600, very little of which exists. The Lisbon museum has a Gothic coffer chair with linenfold and tracery carving, which is said to have been used by Dom Afonso V (1438-81), but there is no proof that it was made in Portugal. In the same museum and elsewhere there are sandalwood chests with fantastic designs of birds and animals burned into their surfaces, which are said to have been made in India in Manueline times. An early Renaissance wardrobe of Flemish style in the museum of Portalegre has fifteen profile portraits in medallions like those of the doorway of Tomar. The *prie-dieu* of the tomb of Duarte de Lemos at Trofa do Vouga, which dates from the second quarter of the sixteenth century, is a meticulous replica in stone of a fine piece of richly carved French furniture of the period.

Plate 11
Plate 126

Plate 238

Plate 237

This suggests the presence in Portugal of French cabinetmakers along with such sculptors as Nicolau Chanterene and João de Ruão. Mannerist strapwork and fantastic masks decorate the chest of drawers in the sacristy of the cathedral of Miranda do Douro, which if it is not of Spanish origin is the finest piece of surviving Portuguese furniture of the sixteenth century. A handsome coffer bench in the choir loft of Santa Maria at Óbidos has the same severely panelled architectural back framed by pilasters found in the choirstalls of Celas at Coimbra, made by the sculptor Gaspar Coelho before his death in 1605, and in those of São Domingos de Benfica, which probably date from about 1630.

Colour
plate XIII

This simple and dignified architectural style, like that of contemporary retables and silver, served as the basis for Portuguese church furniture of the early seventeenth century. The finest pieces were often decorated with thin strips of ivory inlaid in rosewood veneered on chestnut in geometric designs which suggest Spanish influence. This is the type of decoration found in the sacristy of the Jesuit church of São Roque in Lisbon (*c.* 1620-35) and in that of Santa Cruz at Coimbra, constructed on designs of Pedro Nunes Tinoco between 1622 and 1623. One side of the long room is occupied by a great chest of drawers, the model for which was made in 1634 by Samuel Tibau, a native of Montpellier in France, who was married in Coimbra in 1628 and two decades later contracted to build the retable, now destroyed, of the Dominican church in that city.[2] This not uncommon activity as sculptor and furniture maker also produced the great cupboard of the sacristy of Santa Cruz, where gilt reliefs of kneeling angels and cherub heads are added to the ivory inlay.

Plate 239

Plate 42
Plate 33

The seventeenth-century architectural style reached its climax in the two large cupboards of the sacristy of the abbey of Alcobaça, a room called 'gorgeous and glistening, worthy of Versailles itself' by the English traveller William Beckford, who saw it in 1796.[3] The cupboards, set into the wall according to a custom which the Portuguese took to Brazil, are dated 1664 in gilt metal numbers and letters applied to the frieze of the centre section. This part contains, for the use of the monks entitled to say mass, no less than sixty-six small drawers, veneered in rosewood and ebony and set above a fallboard decorated with inlaid intersecting ornament that recalls certain geometric tiles of the period. The upper section, designed like the pedimental screen of a seventeenth-century church, is surmounted by a cartouche with the Cistercian arms and flanked by vase ornaments similar to those used at the cloister of the Serra do Pilar in Vila Nova de Gaia.

During the second half of the seventeenth century the surface of Portuguese furniture became animated with panelling, applied metal, turning, decorative planing and carving. Through much of it runs a current of influence from Holland, which seems to have exported fine furniture to Portugal along with blue-and-white tiles. In addition, the captaincy of Pernambuco in Brazil was held by the Dutch from 1632-54, and this is also thought by some to have influenced Portuguese furniture.[4]

Plate 100

Chief among the pieces that came from Holland were the stately four-door oak cupboards of Renaissance style decorated with friezes of acanthus leaves, which, applied to Portuguese church furniture like the choir-stalls of São Bento da Vitória in Oporto, inspired the expression 'Dutch carving'. Larger version of these Netherlands cupboards were made in chestnut and decorated in a number of ways that give them their Portuguese character. One is the carving of panels in flat, curved foliate forms like those on the bases of altarpieces of the architectural style. Another is the use of brass plates pierced in complex Neo-Moorish designs. A third is the parallel grooving called *tremido*, inspired

by north European 'wave' or 'flame' patterns produced by the same technique. This type of ornament, made with a special plane invented in Germany, was probably more widely used in Portugal than anywhere else in Europe. Some pieces of furniture were entirely covered with *tremido* planing.

Plate 241

Another type of furniture borrowed from The Netherlands in the seventeenth century is the high *bufete*, which in Portugal was made to resemble the lower two-thirds of the cupboard. A majestic example in the Bragança castle museum at Guimarães shows another type of Portuguese decoration of this period, which combines large raised panels (*almofadas*) with strangely projecting lozenge forms enriched by various mouldings. A similar *bufete* in the museum of Viana do Castelo has a front entirely decorated with black and gold japanning even finer than that of the bookcases of the library of the University of Coimbra, which date from the 1720s. The pagoda designs on the Viana *bufete* suggest the influence of the *Treatise on Japanning* of John Stalker and George Parker, published in London in 1688. These exotic decorations, extremely rare in Portugal before 1700 but not uncommon thereafter, offer an interesting parallel to the Chinese influence on the seventeenth-century faience of Lisbon and Delft, examples of both of which are displayed on these two *bufetes*.

Plate 242

Plate 240
Colour plate V
Plates 165, 167

Dutch furniture seems also to have served as the source of the brilliant Baroque turning used in the legs and stretchers of Portuguese tables and stands in the second half of the seventeenth century. In both Holland and northern Germany it was customary to make draw tables with legs composed of heavy ball and disc turning combined with sections of spiral form. Very similar designs appear in Portuguese pieces, but the effect is altogether finer, because of the sharper profiles and more delicate forms of the turned areas, made possible by the use of strong yet easily worked rosewood, which permitted virtuoso-like designs found nowhere else in Europe. As a result the balls, discs, reels and spiralling shafts of Portuguese rosewood turning produce a unique impression of rapid movement, of forms revolving and exploding, which is deeply expressive of the spirit of Baroque art. This turning was supplemented by many small panels of convex and concave form and enlivened by pierced brass plates applied at the junction of stretchers and legs.

Plates 243, 244

Tables of this sort range in size from monumental examples of ten or more feet in length to small stands supporting *contadores*, which are the Portuguese contribution to the European luxury cabinet of the seventeenth century, the universal showpiece of the age. They differ from those of other countries by not employing doors or fall boards, ornaments above the cornice or any colour or extraneous materials save pierced metal, relying for their effect upon the beauty of the rosewood decorated according to the regular formulas of panelling and carving. *Contadores* of this sort with their stands are mentioned in Benedictine inventories of the 1670s, which suggests that they had already been in production for some time.

Another category of luxury cabinets and tables consists of the so-called 'Indo-Portuguese' pieces, of which next to nothing is known despite the considerable quantity in existence. Said to have been made in Goa and the other Portuguese cities on the west coast of India in the seventeenth century and possibly in Portugal as well, they are built of teakwood and decorated with inlay of ebony, ivory, bone and some Brazilian woods. One type offers inlaid vine patterns and fantastic beasts with ivory eyes. Another category is covered with a textile-like inlay composed of a mesh of small circles combined with ivory flowers set in ebony borders. The technique, an extremely fine version of the *certosina* inlay popular in northern Italy in the Renaissance, derives from Mogul

Plate 245
Plate 246

decoration. 'Indo-Portuguese' ornament appears also on tables with legs in the form of standing figures, the finest of which, like those on a great piece in the museum at Caramulo, have faces of ivory. Other tables have raking legs which together with trestle supports of lyre or yoke form were Spanish-inspired alternatives to the national type with straight turned legs of *jacarandá*.

Another type of furniture borrowed from Spain is the bed with headboard and canopy decorated with arcades. This architectural motif, common in Spanish furniture of the seventeenth century, was enhanced in the Portuguese beds of this category by the use of pierced brass plates and many audaciously turned finials. The latter, called *bilros*, were employed also as pendants at the head and foot of beds of a national type, which like the case furniture of rosewood combine Baroque turning with carved foliage and *tremido* ornament. They were made in single as well as double size, unlike the rich beds of the rest of Europe. Some Portuguese state beds, decorated with turned ebony and plates of repoussé silver, became so famous that they were collected by Louis XIV at Versailles.

Plates 167, 185 In the first half of the seventeenth century the commonest type of Portuguese chair was made, like those of Spain, with a simple square frame of wood and several pierced scroll stretchers. Seats and backs were made of cloth or leather (often stamped with the initials or arms of the owner) held in place by large brass studs. Another type in which the frame is composed of spiral turning was inspired by the so-called Louis XIII armchairs of France. These were reproduced with great care, including the miniature human and animal masks carved at the tips of the arms.

Plate 247 Chairs of these types were replaced, probably quite late in the seventeenth century, by a new form of chair, which became the national type, for it was accommodated in the eighteenth century to the cabriole leg and revived in the late nineteenth. Called simply the leather chair or *cadeira de sola*, it has legs and arm supports of a variety of turnings (but almost never spiral), which when rosewood is used have the same sharpness and convey the same sense of movement found in the case furniture. These chairs have two decorative features. One is the large front stretcher in the form of a richly carved Baroque scroll, the other is the high back of leather, which is sometimes painted but more frequently embossed and incised with very delicate and handsome designs. These often *Plate 183* offer vases flanked by nude children, like the *albarrada* tiles of the period, coats of arms (especially those of prelates) or medallions with women holding flowers or birds, a motif also found in tiles.

Two kinds of foot were commonly used. The first is the international 'bun' or 'onion' type, the second a flaring form with parallel incisions, which the Portuguese called *pé de pincel* or 'paintbrush' foot. This appears also in English furniture of the late seventeenth *Plate 247* century, in relation to which it is called the Spanish foot, although all evidence points to the fact that it was invented in Portugal.

If the Portuguese contributed this motif to English furniture, they received much more from British sources. The tendency to imitate the fashions of London, which dominated the first half of the eighteenth century in Portugal, began with the return in 1693 of Charles II's childless widow, Queen Catherine of Bragança, who brought with her a great deal of English furniture. With the Methuen Treaty of 1703 trade with England enormously increased and furniture was exported from London to Lisbon and Oporto. The London chairmaker Giles Grendy is known to have worked for the Peninsula trade, and English furniture can be seen in Portuguese tiles along with many pieces modelled locally upon it.

Furniture

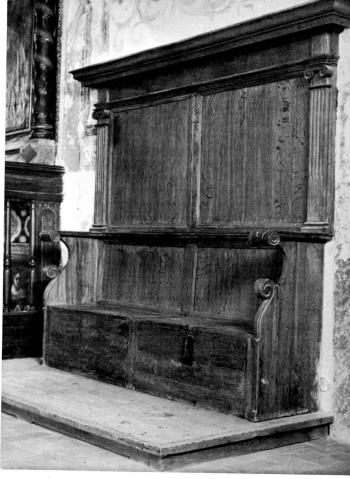

237 (RIGHT) Bench with high back. Óbidos, Santa Maria.
c. 1600
238 (BELOW) Chest of drawers. Sacristy of the cathedral
of Miranda do Douro. *c.* 1550–75

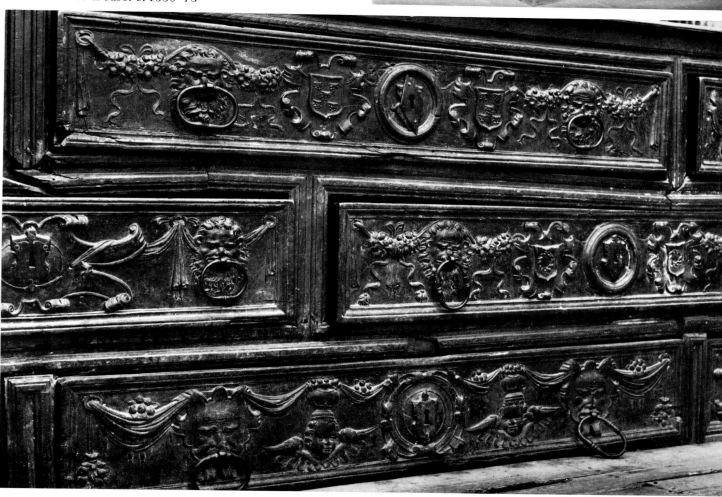

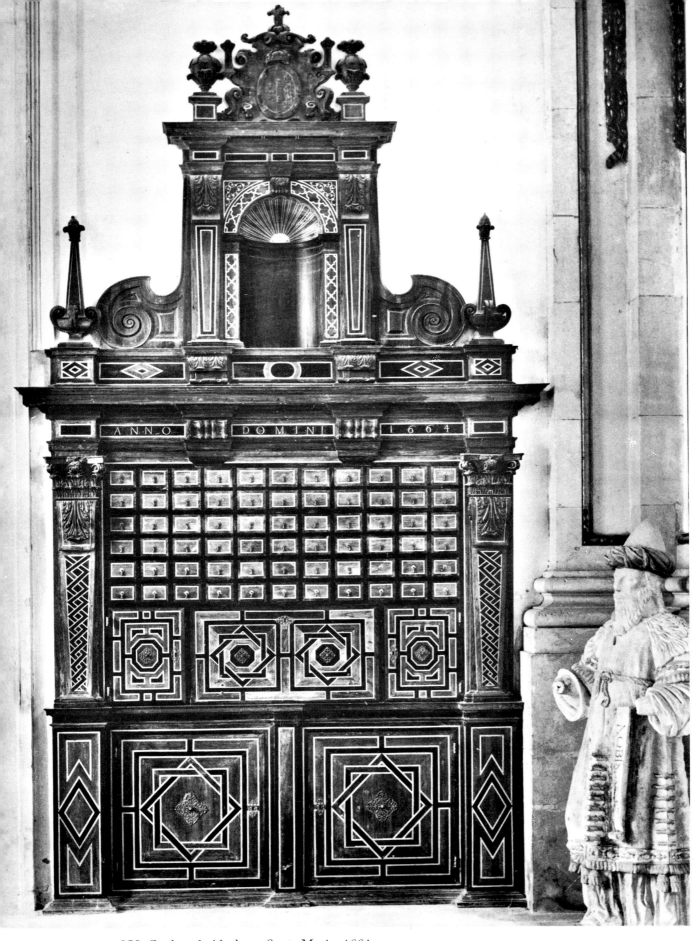

239 Cupboard. Alcobaça, Santa Maria. 1664
240 (OPPOSITE) Buffet cupboard. Viana do Castelo, Museu Municipal. Late 17th or early 18th century.
The plates are Delft

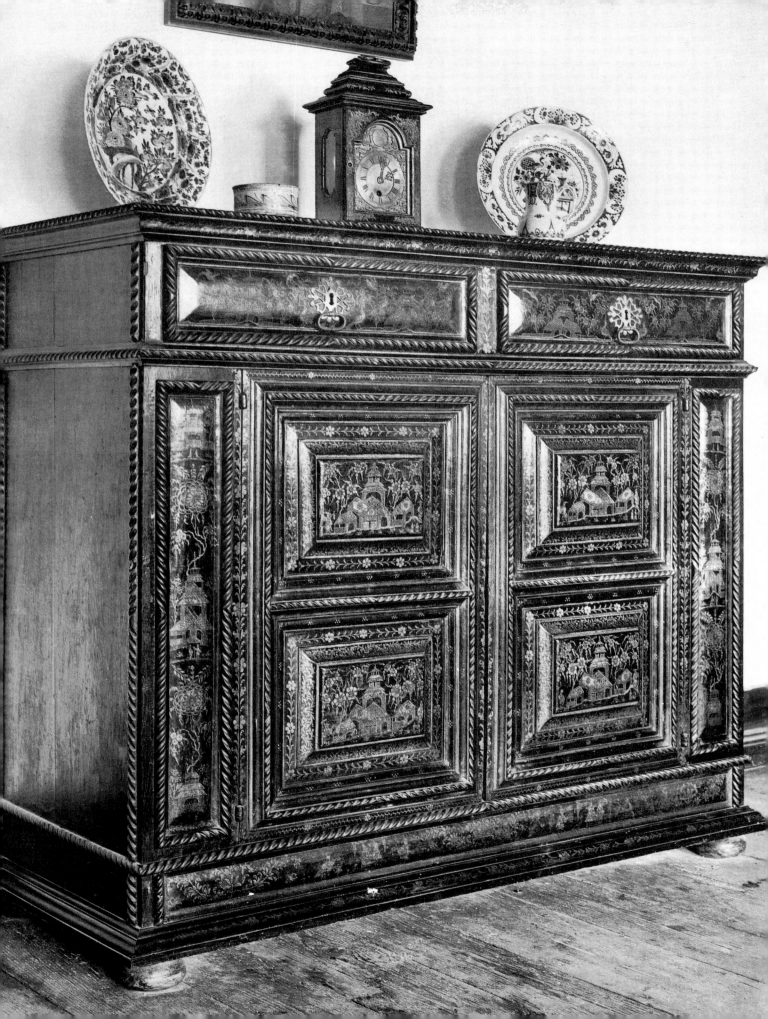

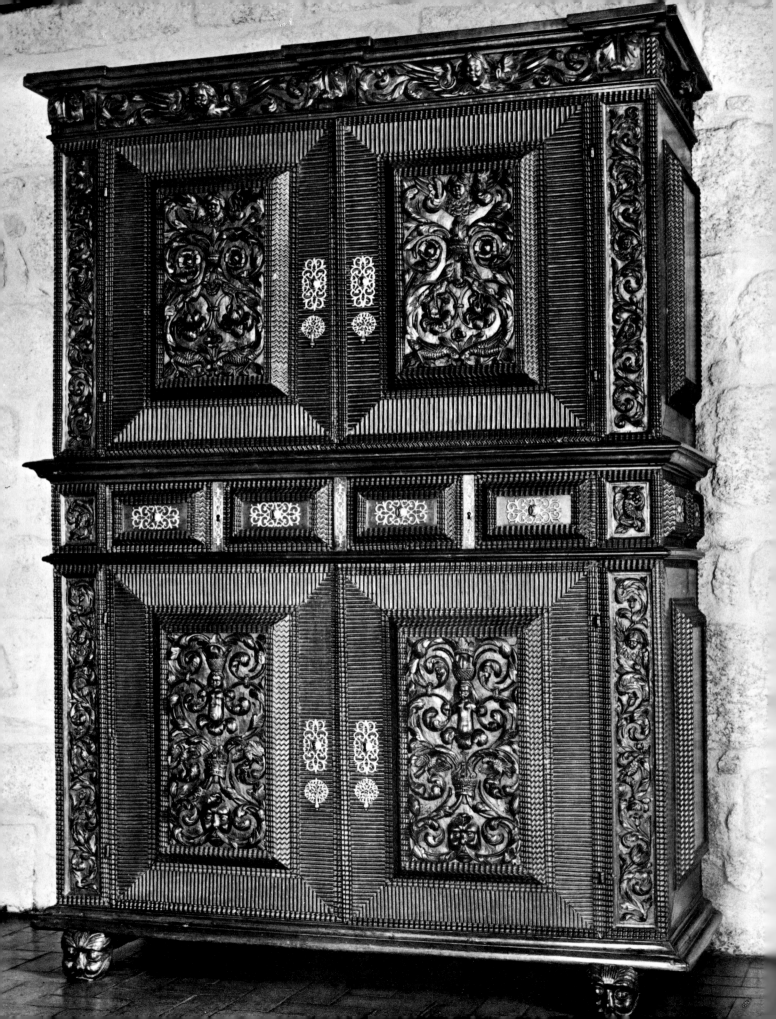

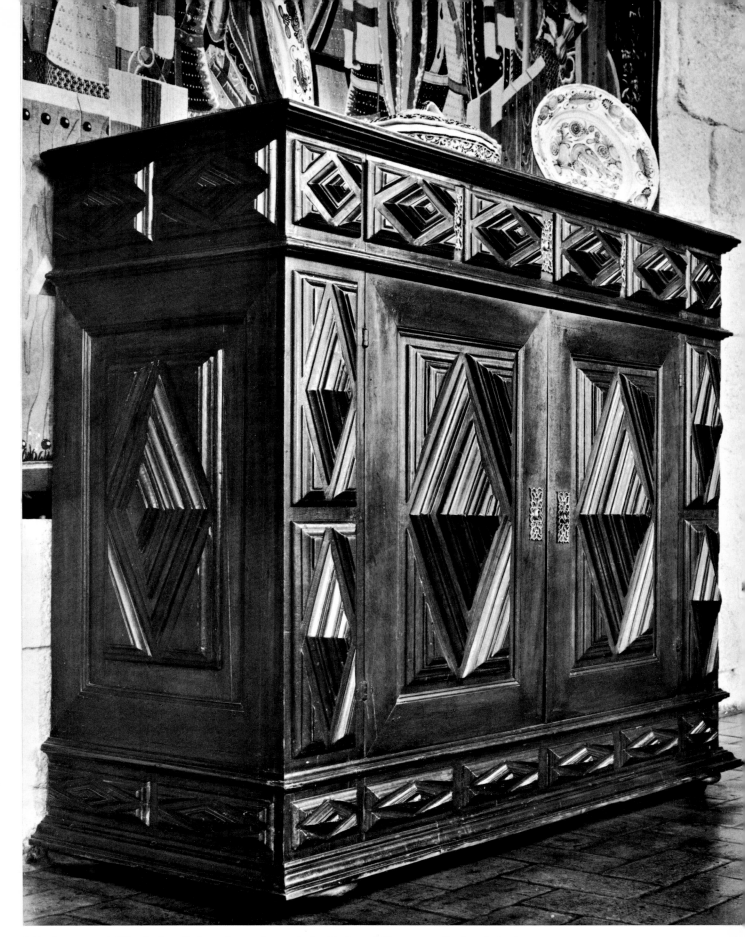

241 (OPPOSITE) Wardrobe. Guimarães, palace of the Dukes of Bragança. Style of the late
17th century
242 (ABOVE) Buffet cupboard. Guimarães, palace of the Dukes of Bragança. 17th century.
The plates are Portuguese

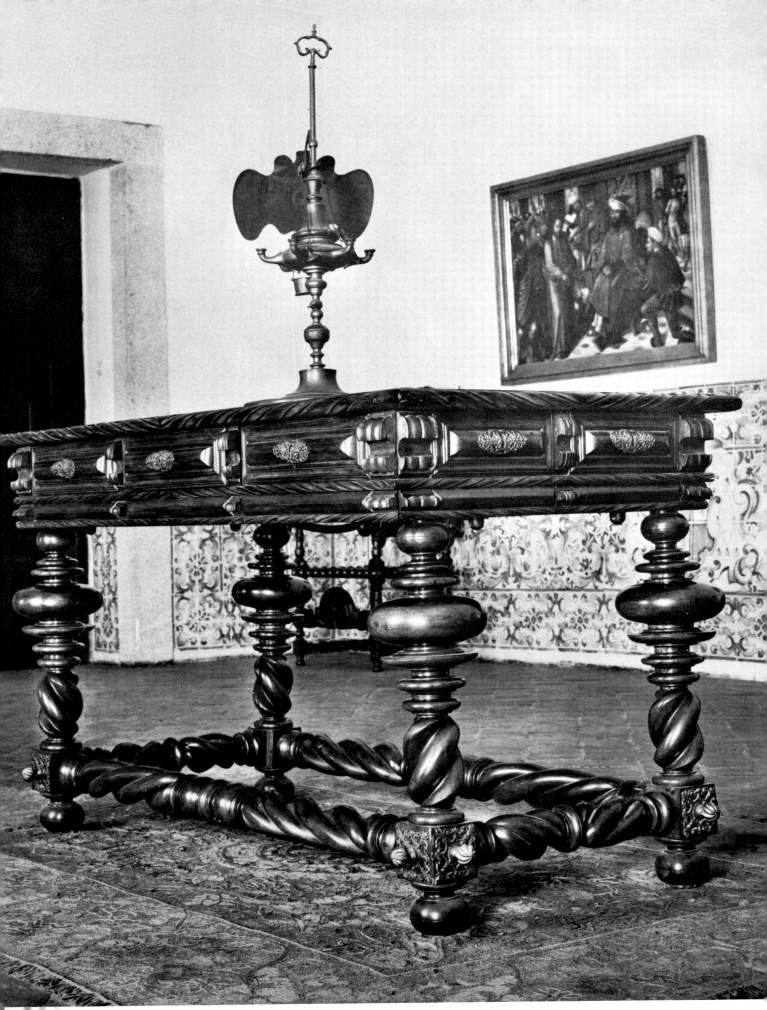

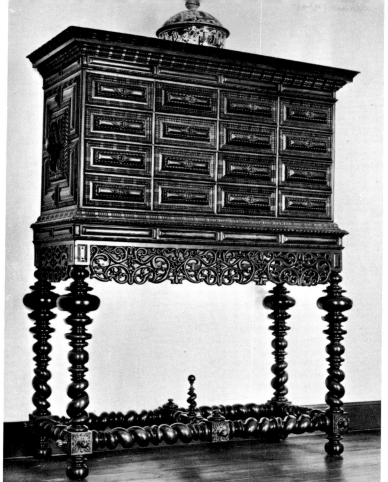

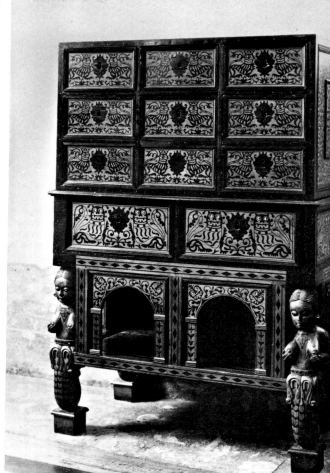

244 (ABOVE) Cabinet on stand. Évora, Museu
Regional. Late 17th century
245 (ABOVE RIGHT) Indo-Portuguese cabinet.
Lisbon, Museu Nacional de Arte Antiga. 17th century
246 (RIGHT) Detail of an Indo-Portuguese table.
Museu do Caramulo. 17th century

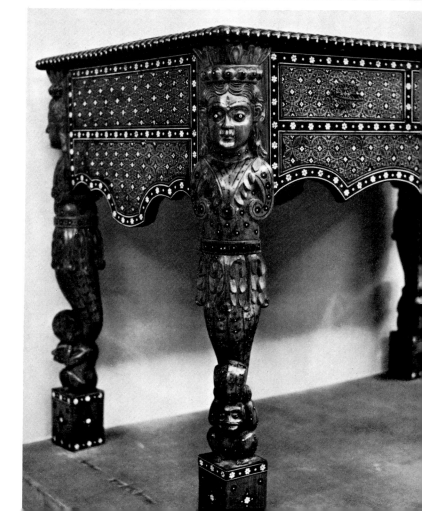

243 (OPPOSITE) Table. Évora, Museu Regional. Style
of the late 17th century

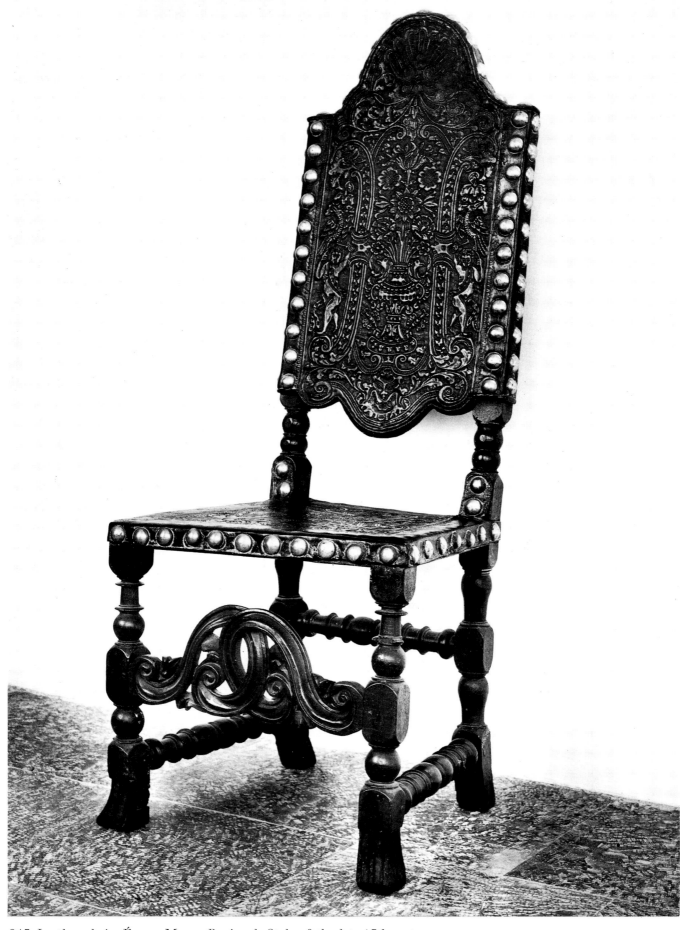

247 Leather chair. Évora, Museu Regional. Style of the late 17th century

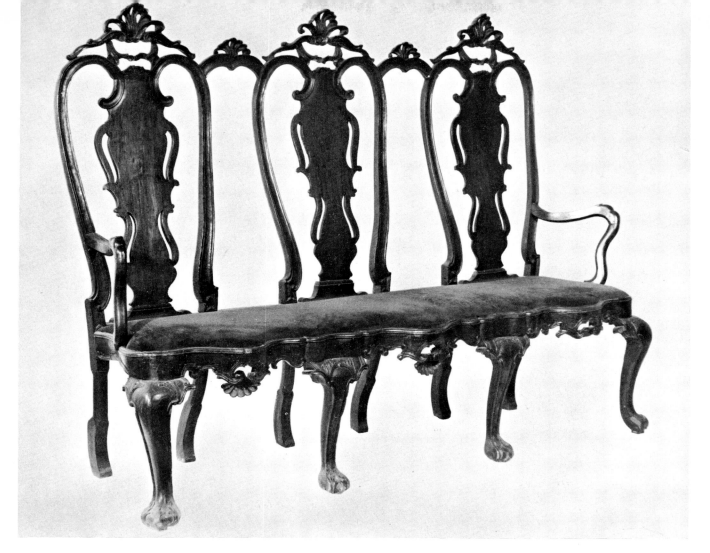

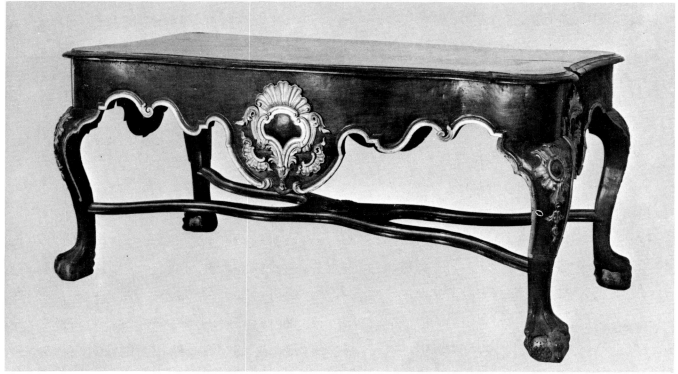

248 (TOP) Settee. Oporto, Museu Nacional de Soares dos Reis Mid-18th century
249 (BOTTOM) Side table. Lisbon. Museu Nacional de Arte Antiga. Mid-18th century

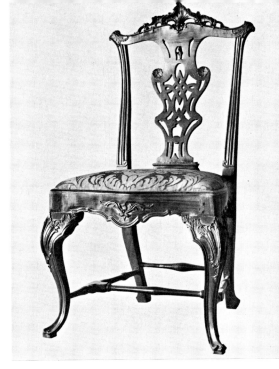

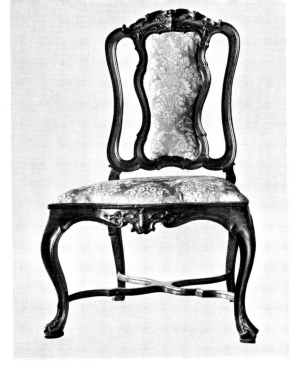

250 Side chair. Viana do Castelo, Museu Municipal. *c.* 1760–75

251 Side chair. Viana do Castelo, Museu Municipal. *c.* 1760–75

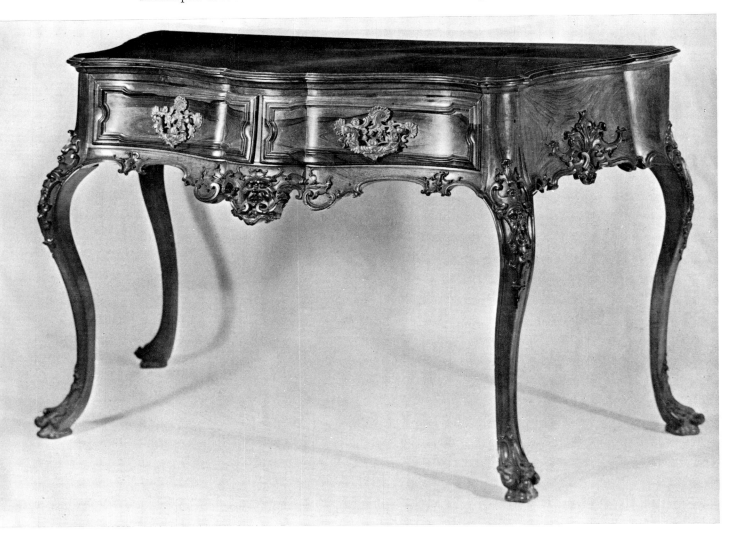

252 Side table. Oporto, Museu Nacional de Soares dos Reis. *c.* 1750–75

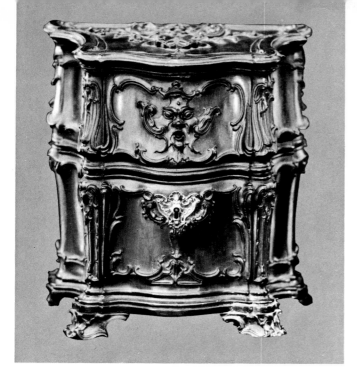

253 Knife box. Oporto, Museu Nacional de Soares dos Reis. *c.*1750–75

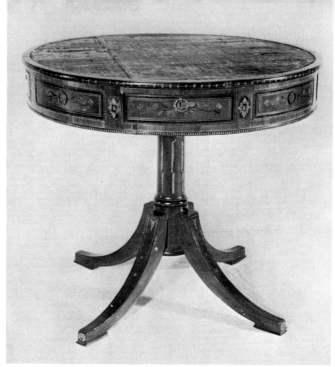

254 J. J. Raposo: Drum table. Lisbon, Fundação Ricardo Espírito Santo Silva. Late 18th century

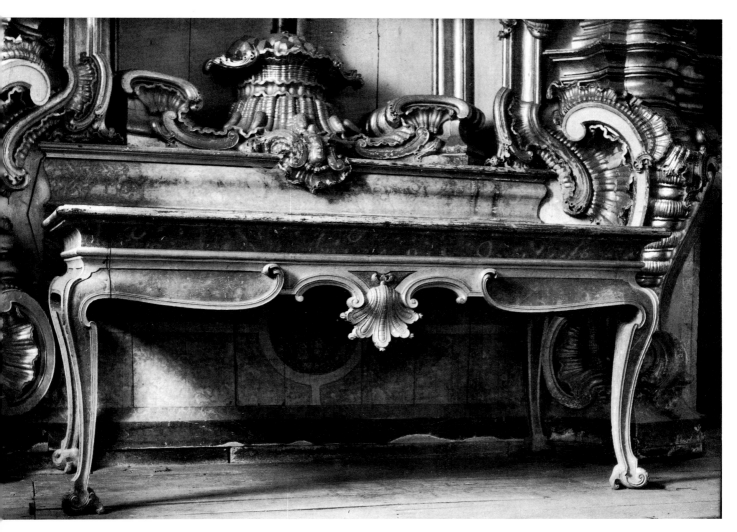

255 Frei José de Santo António Vilaça: Sacristy table. Tibães, São Martinho. 1792–3. The table was executed by Francisco Xavier da Silva of Braga and painted by António José Amorim, of Lisbon. The carving in the background is by José Álvares de Araújo on a design of André Soares

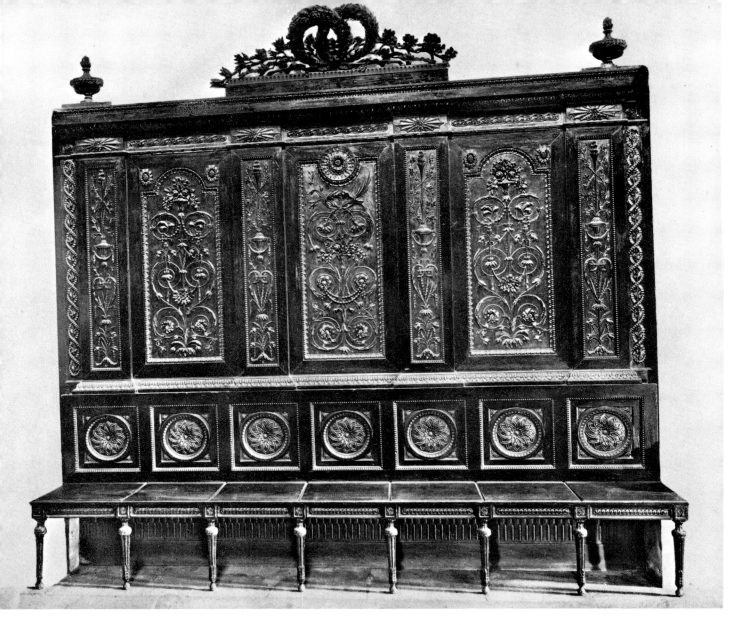

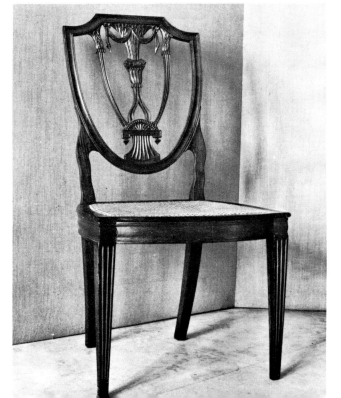

256 (ABOVE) Luís Chiari: Bench with high back. Oporto, Third Order of St Francis. 1798

257 (LEFT) Shield-back side chair. Lisbon, Museu Nacional de Arte Antiga. *c.* 1800–10

OPPOSITE

258 (TOP) Detail of an armchair. Lisbon, Palácio Nacional da Ajuda. *c.* 1800

259 (BOTTOM) Painted day-bed. Lisbon, Fundação Ricardo Espírito Santo Silva. *c.* 1800

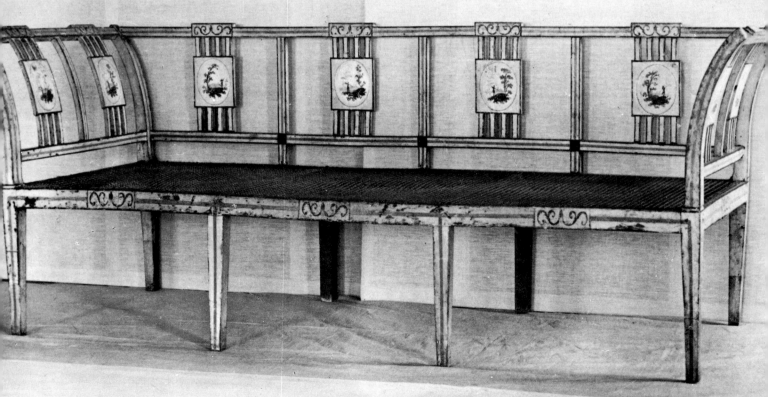

Textiles

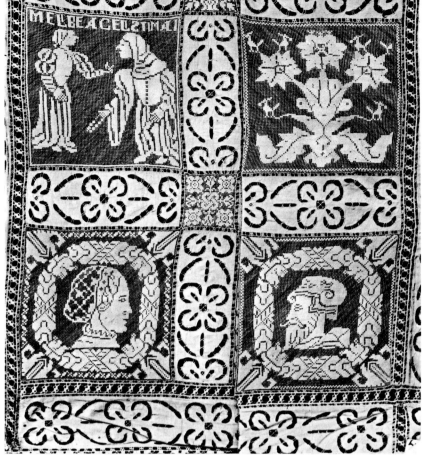

260 Detail of a lace bed cover. London, Victoria & Albert Museum. Late 16th or early 17th century

261 Detail of an embroidered Indo-Portuguese bed cover. Boston, Museum of Fine Arts. Late 16th or early 17th century

262 Embroidered Indo-Portuguese bed cover. Lisbon, Museu Nacional de Arte Antiga.
Late 17th century

263 Bed cover embroidered in the
style of Castelo-Branco. London,
Victoria & Albert Museum.
18th century

264 Detail of an Arraiolos carpet.
Lisbon, Museu Nacional de Arte
Antiga. Late 17th or early 18th
century

Early in the reign of Dom João V (1706-50) the traditional high-backed armchair was modified with William-and-Mary-style vase turning and decorated with carved shells and garlands taken from the engravings of Daniel Marot, the French Huguenot decorator who came to London with William of Orange. Joanine tiles prove the popularity of gate-leg tables, like the one made by Cristóvão Gomes, in 1732, for the cathedral of Funchal, and also of a bulbous kind of leg that appears in the chairs ordered in 1746 for the church of São Domingos in Viana do Castelo. *Plate 187*

By this time, however, Joanine furniture was being transformed by the English Queen Anne style, which introduced to Portugal the Rococo element of the cabriole leg, the Chinese splat back and the use of pad, slipper and claw-and-ball feet, all of which were to linger into the second half of the eighteenth century and be combined with various decorative motifs that post-date the style. Occasionally the English forms were repeated literally, as in a pair of walnut armchairs at the new Museu do Azulejo in Lisbon. More frequently, however, the Portuguese exaggerated certain elements, elongating the hooped backs and bending the block feet of the rear legs in powerful curves, flattening the balls of the claw-and-ball feet and carving the claws in a series of bead-like forms. Another Portuguese feature is a large carved apron between the front legs, which was applied both to chairs and case furniture. It is seen in the remarkable set of fourteen chestnut upholstered armchairs made in 1748 for the boardroom of the Third Order of St Francis in Oporto by José Fernandes Neves for 1.80 *milreis* each. Shell, shield and other carving, as well as profile mouldings were gilded in many chairs and tables made in northern Portugal, where the prevailing wood was chestnut. A fine parcel gilt Queen Anne table in the Lisbon museum emphasizes the strong and heavy effect of this Joanine furniture, which vividly contrasts with the delicacy of form and ornament found in that of the second half of the eighteenth century. *Plates 250, 251* *Plate 248* *Plate 249* *Plate 79* *Plate 249*

Much of this delicacy was made possible by the use of rosewood, which was preferred to all other material in the period of the full Rococo style, during the reign of Dom José (1750-77). The ease with which it is carved permitted ornament of extraordinary delicacy, while its strength allowed cabriole legs with slenderer ankles and more audacious curves than those of the furniture of England and France, which now supplied almost all the models for Portuguese cabinetmakers.

Outstanding among these are the chairs with elaborately pierced splats and Chinese cresting made on the lines of those illustrated in Thomas Chippendale's *Gentleman and Cabinet Maker's Director*, first published in London in 1754. These 'Chippendale' chairs were produced in such quantities in Portugal that they gave rise to the legend, still by no means dead, that the celebrated English designer had himself sojourned in Oporto. One of the most popular versions has a flaring lozenge in the centre of the splat. Portuguese elements of this chair are the spidery ornament atop the cresting board, which suggests the Rococo cornices of the windows at Queluz, the use of extremely thin stretchers to guarantee the slender cabriole legs, the rippling profile of the skirt, like the rim of a Rococo silver tray, and the attenuated triple volutes of the dainty 'pipe' feet *(pé de cachimbo)*. Still another characteristic is found in the bursts of petal and plume ornament in the centre of the cresting yoke. *Plate 250* *Plate 77*

Inventories of the palace of Queluz and the estate of the Duke of Aveiro made in the 1750s reveal a quantity of furniture imported from France.[5] This included the small and graceful Louis XV upholstered *fauteuils* that appear to have been the chief rivals of the 'Chippendale' chairs. In Portugal new categories of chairs were produced with elements

Plate 251

of both types. One has a back with the typical French 'violin' shape combined with an English plain wood splat or an upholstered one; another has a trapezoidal version of this back filled with a lattice of English Neo-Gothic forms. To the former type, with upholstered splat, are related the Rococo beds, which, as Andrew Ciechonowiecki has observed, are different from those of any other nation.[6] They have headboards based on the *violonné* shape with sumptuous frames enclosing upholstered panels and surmounted, like the frames of contemporary looking-glasses, by serpentine plinths and delicately cascading garlands.

Among the showpieces of this period are the tables decorated with spidery carving like the chairs and carried on the same fragile-looking, exaggeratedly curved legs. Some are round, like the well-known example belonging to the Espírito Santo Silva Foundation, whose top has four hinged leaves for playing different kinds of games and one for the Plate 252 coiffure and the toilet. Others are the *mesas de encostar*, a console form with slanted sides, the finest of which have blocked fronts like contemporary Dutch furniture. These pieces also offer a startling contrast between the elaborate linear mouldings of the drawers and the sparkling leaf and spray carving of the knees and skirts, in which fantastic masks sometimes appear. The same effects occur in the wonderfully proportioned and decorated *papeleiras*, the Portuguese version of English slant-front writing desks. These have their own wide form of voluted feet, found also in contemporary silver. All of these features Plate 253 reappear in an extraordinary knife box at the Oporto museum, one of the masterpieces of Portuguese Rococo furniture, where the intricate flowing forms of the carving are repeated in the exquisite details of the tiny lockplate of silver.

Another and very different aspect of Portuguese Rococo furniture is represented by the elaborately carved and gilt ecclesiastical thrones, benches and tables of the great Benedictine wood sculptor Frei José de Santo António Vilaça of Braga, many of which are men- Plates 63, 105 tioned in his recently discovered diary. Like the architect André Soares, the sculptor José Álvares de Araújo and other contemporary artists of Braga, he was deeply influenced by the extravagant asymmetrical ornament of engravings published at Augsburg in the 1740s and 1750s. His early work, like the gilt chestnut table in the apse of the monastery of Tibães, is almost pure sculpture, in the bold, intense south German style of Franz Xaver Habermann, whose furniture prints show the same unusual double-volute foot used on this table. Frei José de Santo António continued the tradition of sculptural church furniture set by such Baroque *entalhadores* of Oporto as António Gomes and Luís Pereira da Costa, who in the early eighteenth century had fashioned pairs of tables for the serving of the mass to be set at the feet of their retables in many churches of the north. About 1775 the Benedictine monk abandoned gilding in favour of polychromed surfaces imitating marble. At the same time his taste grew more linear, as with supreme disconcern for chronology he drew his models from the early eighteenth-century French Rococo Plate 255 style. Although he worked until about 1796, he was only slightly affected by Neo-Classicism.

That movement had begun in furniture, as in all the other arts, in the first years of the reign of Dona Maria I (1777-1816). At that time, under continuing influences from London and Paris, straight lines replaced curves, and rosewood, which had served so well the purposes of the Rococo, was to a certain extent superseded, as mahogany was in England, by satinwood and other light-coloured materials. These were used for the veneers, inlay and marquetry that now replaced the delicate carving of the period of Dom José, along with gilt and painted surfaces. With the new fashions in furniture came a new style

XVI (OPPOSITE) A Portuguese drawing-room of the late 18th century. Lisbon, Museu de Artes Decorativas da Fundação Ricardo Espírito Santo Silva

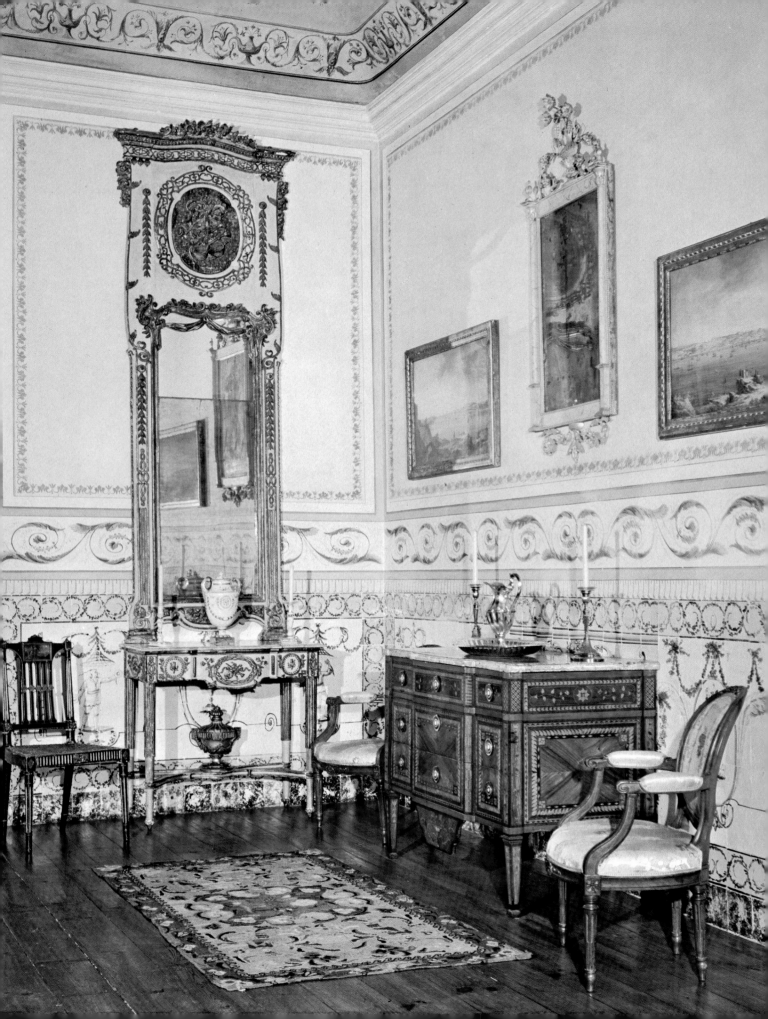

of decoration, seen in a room of the period in the decorative arts museum in Lisbon, where pastel-coloured classical designs are painted on the walls and ceilings above the ever present dado of tiles. In this period more attention was given to ornamenting the interior than formerly, when carved wooden ceilings and door and window cornices were practically the only decorations employed.

Colour plate XVI

The showpieces of the new classical style were chests of drawers and the towering *trumós* (French *trumeau*). The latter, which were generally used in pairs, are tall mirrors, frequently with elaborately framed pictures at the top, above console tables. The *trumó* tables, which are the only type of richly carved furniture of this period, evolved from earlier Rococo examples accompanied by oval looking-glasses. Their style, like that of the armchairs that accompany them, is Louis XVI. So also the chests of drawers of the *estilo Dona Maria I* are simplified statements of the great French *commodes* of the age of Riesener and Weisweiller. Their Portuguese character is emphasized by disproportionately large aprons and by the vivid contrasts between dark and light Brazilian woods found in the marquetry veneering, which employs generally vine and geometric patterns. These Louis XVI chests of drawers replaced earlier ones designed in the curved Louis XV style decorated with flower marquetry with which figures were occasionally combined. Gilt metal drawer pulls were used in these Rococo pieces, while enamelled handles were frequently applied under English influence to the classicizing chests of drawers, which were the first to make regular use of marble tops.

Several cabinetmakers of the late eighteenth century are now known, among them Domingos Tenuta, who made a number of cylinder desks, one of which he signed in 1790. In the Espírito Santo Silva collection in Lisbon there is a small drum table signed by J. J. Raposo of the Loreto district of Lisbon, veneered and decorated with discreet marquetry in the English style of the end of the eighteenth century. The same style with many direct borrowings from the pattern books of George Hepplewhite (London, 1788) and Thomas Sheraton (1791-4) appears in a series of important drawings by the Oporto cabinetmaker José Francisco Paiva in a private collection in Lisbon. Representing tall clocks, linen presses, tea tables, bedroom furniture, etc., these drawings are of the greatest interest because many are dated between the years 1785 and 1795 and bear the names of the well-known persons who ordered them.

Plate 254

The most brilliant of all the known cabinetmakers of the period was the Italian wood sculptor Luís Chiari (active *c.* 1795-after 1835), who at the beginning of his career in Portugal decorated the church of the Third Order of St Francis in Oporto. From 1798 date the two rosewood benches of the chancel of this church, which demonstrate with exquisite clarity the Italian Neo-Classical style of the period that grew out of the designs of Piranesi. Chiari also made a number of ceremonial tables, including a pair with *trumós* in the Oporto museum, which have the same elegant decoration.

Plate 256
Plate 87

Carved rosewood also appears in the numerous chairs and settees based on Hepplewhite and Sheraton design produced in Lisbon and Oporto, where a large colony of English wine merchants commissioned Consul Whitehead's Adam-style design for the British Factory building. A fine example of a Portuguese Hepplewhite chair shows its national character by the use of a cane seat and the high position of the beautifully carved shield back. Another very popular type has an oval frame with Neo-Gothic splats.

Plate 82
Plate 257

Furniture continued to be painted with Chinese designs throughout the eighteenth century. At its close a new kind of painting appeared in chairs, settees and daybeds, inspired by the romantic landscape studies of Jean Pillement, a French painter who

Plate 258

Plate 259

*Colour
plate XVI*

Plate 209

worked in Oporto and Lisbon between 1780 and 1785. The finest examples are the oval panels on the backs of a set of ten armchairs and a sofa made for a royal yacht of João VI and appropriately decorated with carved gilt dolphins. The paintings, executed in coloured varnish on satin, perhaps by Pillement's pupil Joaquim Leonardo da Rocha, contain views of ports in a picturesque setting of cliffs and windblown foliage, peopled by angular personages and their dogs. This seems to have been the point of departure for the decoration of furniture, with figures of hunters, dogs and foliage painted in a sketchy style on the pine or chestnut of the frames. The application, against a light background of grey, cream or gold stripes, won for them the name of *doiradinhas* or 'little gilt chairs'. Similar landscape vignettes appear on the faience plates and tureens made at the Lisbon factory of Bico do Sapato about 1800.

8 Textiles

The chronicles of the kings of Portugal and the inventories of their possessions and those of the nobility and high clergy abound in references to fine textiles, which seem to have been used as extensively in Portugal to cover furniture and ornament the fronts of buildings on gala occasions as elsewhere in Europe. Before they became wedded in the late sixteenth century to the almost exclusive use of black, in imitation of the court of Spain, the Portuguese wore rich costumes of damask and velvet, which made a great impression when they travelled abroad on embassies or escorted royal princesses to their marriages at foreign courts.

*Colour
plate X*

Most of these handsome textiles seem to have been imported from Italy, France, The Netherlands and Spain, but there is documentary proof of a wide range of materials made in Portugal at an early date. The silk industry, introduced by the Moors, is mentioned in a tax law of 1253, and there are references to silks, along with velvets and damasks made at Bragança in the extreme north-eastern corner of the country from the fifteenth to the eighteenth centuries. Dom João V (1706-50) encouraged Frenchmen like Robert Godin (1731-4) to produce silk in the capital, and later the Marquis of Pombal established a royal silk factory there as one of his protected industries, for which Jean Pillement is thought to have made some designs. The factory existed from 1757 until 1834. Very few, however, of these Portuguese silks, satins, damasks, taffetas and velvets have survived or can be identified.

Between 1776 and 1783 tapestries were made at Tavira in the southern province of Algarve, at a factory established by Pierre-Léonard Margoux and his Portuguese assistant Teotónio Pedro Heitor. Their work, which is undistinguished, is represented by a long *verdure* panel in the museum of Figueira da Foz, on the coast near Coimbra, and a scene from the life of Joseph in the Lisbon museum. The royal family possessed a great collection of Flemish and French tapestries, most of which was lost in the earthquake of 1755. Much more common, however, were the embroidered textiles called *colchas*, found in all the principal Portuguese museums, which were used both as wall hangings and as covers for beds. Along with the embroidered rugs of Arraiolos they constitute the finest and most original Portuguese textiles that have survived from the past.

What may be the earliest dated *colcha* belongs to a category found elsewhere in Europe, consisting of bed covers composed of a chequerboard of square and rectangular panels of filet with netting combined with others of linen decorated with cut-out drawn-work panels. An example in the Lisbon museum has the date 1615 above a passant lion in one of the filet panels. The rest represent saints, couples, a siren, symbols of Christ's Passion, animals and birds. *Colchas* of this sort probably correspond to the bedspread ornamented with lace mentioned in an inventory of 1593 from Elvas, a fortress town on the Alentejan border with Spain. The smaller filet panels are of special interest because they resemble seven-

Plate 177
Plate 260

Plate 28

teenth-century tiles thought to imitate lace. Another *colcha* of this type in the Victoria and Albert Museum, which because of the costumes worn by the numerous figures in the filet panels is considered to be sixteenth-century, has representations of the labours of the months with inscriptions in Portuguese. The figures of Pride and Envy are also identified in that language, along with certain scenes from the Spanish fifteenth-century play *La Celestina*. There are angels, sirens, flowers and profile portraits of men and women set in wreaths that recall the sculpture around the doorways of Nicolau Chanterene and his school and the reliefs on the doors of the sixteenth-century cupboard at Portalegre. This is the only Portuguese textile that directly reflects the Renaissance art of the sixteenth century.

Another much more important category of *colchas* consists of those of the so-called Indo-Portuguese variety, which date from the sixteenth to the eighteenth centuries. Some were made in India for Portuguese, with Portuguese inscriptions, figures, ships, etc., while others appear to have been executed by Portuguese in imitation of the Indian originals. They are all embroidered in silk in chain-stitch on cotton, which is sometimes quilted, and make use of a wide variety of colours.

John Irwin, of the Victoria and Albert Museum, has proved that the most important group of Indian bed covers was made in Bengal, which exported to Malacca, as the Portuguese Tomás Pires noted in 1515, 'very rich and beautiful bed-canopies... and wall-hangings like tapestry'.[1] Among the items included in the ransom paid by the Cardinal King Dom Henrique to the Sultan of Morocco for the body of the young king Dom Sebastião, after the battle of al-Ksar al-Kabir in 1578, were four 'embroidered bedspreads of Bengal... worked in silk with birds and hunting scenes and foliage fringed with yellow and white threads'.

These *colchas* of India, which measure roughly nine by ten and a half feet, are embroidered with the yellow threads of the wild silk called Tussar, or Tussore, in designs which cover the entire surface. They are laid out in rectangular panels and borders and sometimes have concentric discs in the centre containing the most important figures. These are generally Indianized Europeans with costumes of the sixteenth to seventeenth centuries. They are surrounded by genre scenes, the most popular of which are hunting parties and ships manned by Portuguese sailors, which are often escorted by fish and

Plate 261

marine monsters. These, according to John Irwin,[2] are derived from the iconography of the Great Flood in the Vaishnava cult, which flourished in Bengal and not at Goa, where these fine *colchas* are sometimes said to have been made. They were probably exported through the port of Hoogli, founded by the Portuguese in 1537. The capture of this place in 1632 by the Mogul forces may have put an end to the trade in these Bengal embroideries, which, like the contemporary painted screens and the lacquers of Japan, the carpets of Persia and the ivories of Ceylon and Africa, offer memorable impressions of the Portuguese abroad in the days of their great commercial and imperial adventures. These Tussar embroideries, as they are sometimes called, are especially notable for the way in which the most disparate figures and objects are rhythmically drawn together in a flowing movement which permeates every section of the piece. The design of many of the details, alive with tingling energy, like those of certain Persian carpets, seems to have been influenced by Chinese porcelains.

Possibly at Hoogli and later in Goa and in Portugal itself *colchas* were embroidered in conventional silk in imitation of those of Bengal and other Indian centres. In this work some motifs were borrowed from China and from Persian carpets, the tight full com-

partments as well as the rhythmic organization of the figures and decoration gradually disappear, and a new kind of composition emerges in which animals, birds and humans are set in great open spaces, usually in rigid balance but with no specific relation to one another.

A good example is the Indo-Portuguese *colcha* at the Lisbon museum with three horsemen in the centre. These are surrounded by animals, dragonfish like those in Indo-Portuguese silver, vases of flowers suggesting Persian carpets and potted plants on stands that recall Chinese porcelain and lacquer. In the border are men and women at work, which may be a survival of the labours of the months of medieval and Renaissance manuscript illumination and sculpture, while at the angles there are double-headed eagles, a popular Portuguese decorative device seen in the fine pulpit at Barcelos. The costumes of the figures and the remarkable resemblance of the various musicians to those in the *chinoiserie* painting of the choir-stalls of the convent of Jesus at Aveiro, dated 1731, suggest that the embroidery is also of that period. In spite of the diversity of influences it reveals, the faces of the numerous riders all have distinctly Indian features.

In Portugal embroidered *colchas* were made throughout the country generally with strong regional characteristics. The most celebrated are those of Castelo-Branco, in the central eastern province of Beira Baixa, which date in the main from the eighteenth century (one is dated 1768) and in the vivacity of their colours and traditional designs are not unlike the contemporary Anglo-American crewel-work. Embroidered in silk on home-made linen, the *colchas* of Castelo-Branco were designed with a minimum of compartments, a running vine sometimes taking the place of the conventional border. The most spectacular design is that of an asymmetrical tree growing from stylized rocks or earth, which may have been inspired by the tree of life in imported Indian cottons. From this tree grow tulip-like flowers, while on its branches and beneath them birds are perched. These are generally doves, but Brazilian parrots are also represented. The embroiderers were also fond of carnations and pomegranates, which they sometimes displayed in vases like the *albarradas* of early eighteenth-century tiles. Occasionally Chinese and Persian 'cloud' motifs occupy the centre of the bed covers of Castelo-Branco, which are always notable for the strong rhythm that flows through their embroidered foliage.

The town of Arraiolos in the province of Alentejo is as famous for its rugs as Castelo-Branco for its *colchas*. These were embroidered on canvas or linen in the wool which abounds in that region and by the third quarter of the seventeenth century were being exported to other parts of the country. A document of 1710, cited by Maria José de Mendonça,[3] states that a large carpet was woven in the Alentejo for the Old Cathedral of Coimbra during the period of the bishop Dom Frei Álvaro de São Boaventura, from 1672 to 1683. Another, now in the Lisbon museum, was owned by the great Franciscan nunnery of Vila do Conde, above Oporto. In 1757 Father Luís Cardoso wrote of Arraiolos that 'there is in this town a carpet factory which exports to other parts of the realm'.[4] In December of 1787 William Beckford, the English traveller and essayist, noted that at Arraiolos 'I laid a stock of carpets for my journey, of strange grotesque patterns and glaring colours, the produce of a manufactory in this town which employs about three hundred persons'. He added that 'my carpets are of essential service in protecting my feet from the damp brick floors. I have spread them all around my bed and they make a flaming exotic appearance'.[5] The industry, still functioning in various parts of the country, continues to impress and delight foreign visitors and is probably today the best-known expression of the popular art of Portugal.

Plate 262

Plate 222

Plate 110

Plate 263

Plate 183

Plate 155

Its origins, like the making of silk, probably go back to the Moorish past but there is no documented Arraiolos carpet before the seventeenth century. One of them seems to be represented on a table in the *Marriage of St Catherine* by Josefa de Óbidos in the Lisbon museum, which is dated 1647. Maria José de Mendonça, who has written the best study of Arraiolos carpets, has pointed out the resemblances between certain examples, probably of the early seventeenth century, like the Madre de Deus rug at the Lisbon museum, and fifteenth-century Spanish rugs of Alcaraz. Both are composed almost entirely of a design of knot-like elements repeated uniformly in field and border.

*Colour
plate XVI*

Plate 264

Later the enormous contemporary carpets of the royal Persian looms of Herat and Isfahan, imported for use in great Portuguese convents, were imitated in the embroidered rugs of Arraiolos. One of the finest of these, at the Musée des Arts-Décoratifs in Paris, has three 'cloud' medallions enclosing double-headed eagles in the centre, each of which is flanked by peacocks. Other rugs of Arraiolos can be associated with Persian carpets of the so-called *polonaise* type and with Kurdistan patterns. Gradually a standard simpler type developed in which birds and animals surround a coarsened version of the 'cloud' medallion. In these rugs, where dark-blue motifs on a yellow ground predominate, there are stags and lion-like figures comparable to those of the first *albarrada* tiles, peacocks, turkeys, geese, ducks, doves and also parrots *(papagaios)*. The last of these birds are especially associated with carpets of the first half of the eighteenth century, including the one from Santa Clara at Vila do Conde, and may have inspired the term *tapete de papagaios*, or 'parrot rug', which appears constantly in the inventories and church records of northern Portugal of the second half of the eighteenth century and is the only reference to carpets that these papers contain. Since we know that rugs from Arraiolos were sent as far away as Vila do Conde and that wall-hangings made by Francisco Mailhol at his factory in Estremoz not far from Arraiolos in the period of Dom José (1750-77) were commonly called *papagaios*,[6] it is tempting to wonder whether all those carpets referred to in inventories by the same term may not have been made in the Alentejo.

Very few Arraiolos rugs are dated. There is one with two pairs of confronted running stags in the museum at Alpiarça in the Ribatejo with the date 1764. That of 1752 appears on another rug in a private collection which has in the centre the figure of a man serenading a woman with his guitar. Above and below them are two pairs of rampant lions, each with his keeper. These stiff frontal figures recall other serenaders embroidered on Indo-Portuguese *colchas*. The same is true of a horseman with hounds on a famous though damaged rug from Arronches, now in the Lisbon museum, thought to date from the end of the seventeenth century.

The decoration of Arraiolos carpets of the second half of the century grew increasingly attenuated and sparse. A new influence appears from French Aubusson carpets, which in the early nineteenth century almost entirely obliterated the old Spanish and Persian decorations with fashionable 'classical' decorations from the French Empire period. The same unfortunate change took place in the decoration of Portuguese faience, silver and furniture and was felt to some degree in the major arts as well. In the nineteenth century the nation's art became almost entirely the captive of French styles, and has never entirely regained its independence.

Notes and bibliographies

Chapter 1

FOOTNOTES

1 *(page 24)* Eugénio de Andrea da Cunha e Freitas, *Os mestres biscaínhos na matriz de Vila do Conde*, 'Anais da Academia portuguesa da história', 2 serie, vol. XI, 1961, pp. 179–96.

2 *(page 49)* *A arquitectura em Portugal na época de d. Manuel e nos princípios do reinado de d. João III*, 'História da arte em Portugal', Oporto, vol. 2, 1948, pp. 244–5.

3 *(page 49)* The present apse replaced an earlier Manueline structure. It was begun by order of Queen Catherine, the wife of D. João III, perhaps on plans of Diogo de Torralva.

4 *(page 50)* *Art and architecture in Spain and Portugal and their American dominions, 1500 to 1800*, Harmondsworth, 1959, p. 103.

5 *(page 54)* James Kavanaugh Murphy, *Plans, elevations, sections and views of the church of Batalha*, London, 1795, plate 14.

6 *(page 54)* Reynaldo dos Santos, *O manuelino*, Lisbon, 1952, p. 26.

7 *(page 56)* Giorgio Vasari, *Lives of the most eminent painters, sculptors, and architects*, London, vol. 3, 1891, pp. 120–1.

8 *(page 83)* Eugénio de Andrea da Cunha e Freitas, *O mosteiro da Serra do Pilar no século XVI, notas de história e de arte*, Oporto, 1964.

9 *(page 86)* *Op. cit.*, p. 106.

10 *(page 87)* Canon Francisco Pacheco Pereira, *Hoc utilissimum, vere novum ac celeberrimum opus quatordicem in voluminibus elaboratum composuit R. D. Franciscus Pacheco Pereyra in hac bracharensi ecclesia ... canonicus*, MDCCL.

11 *(page 103)* *D. João V e a arte do seu tempo*, Lisbon, vol. 2, 1962, p. 365.

12 *(page 105)* *Une ville de lumières: la Lisbonne de Pombal*, Paris, 1965.

13 *(page 107)* *Italy, Spain and Portugal with an excursion to the monasteries of Alcobaça and Batalha*, New York, 1848, part 2, p. 250.

BIBLIOGRAPHY

General: Bury, John B., *The arts in Portugal – architecture*, 'Portugal and Brazil, an introduction', edited by H. V. Livermore, Oxford, 1953, pp. 146–65; *Casas do Porto (século XV ao XX)*, Oporto, 1961; Haupt, Albrecht, *Die Baukunst der Renaissance in Portugal*, Frankfurt, 2 vols., 1890–5; Kubler, George, and Soria, Martin, *Art and architecture in Spain and Portugal and their American dominions, 1500 to 1800*, Harmondsworth, 1959, chapter 6; Lavagnino, Emilio, *L'opera del genio italiano all'estero: Gli artisti in Portogallo*, Rome, 1940; Lees-Milne, J., *Baroque in Spain and Portugal*, London, 1960; Santos, Reynaldo dos, *A arquitectura*, 'Oito séculos de arte portuguesa', Lisbon, vol. 2, 1965–6, pp. 1–248; Viterbo, Francisco Marques de Sousa, *Diccionario historico e documental dos architectos, engenheiros e constructores portuguezes e a serviço de Portugal*, Lisbon, 3 vols., 1899, 1900, 1922; Watson, Walter C., *Portuguese architecture*, London, 1908.

Specialized: Battelli, Guido, and Coelho, Henrique Trindade, *Filippo Terzi, architetto e ingegnere militare in Portogallo (1577–97)*, Florence–Lisbon, 1960; Bazin, Germain, *Réflexions sur l'origine et l'évolution du baroque dans le nord du Portugal*, 'Belas Artes', no. 2, 1950, pp. 3–15; Bury, John B., *Late baroque and rococo in north Portugal*, 'Journal of the Society of architectural historians', vol. XV, no. 3, 1956, pp. 7–15; Carvalho, Ayres de, *D. João V e a arte do seu tempo*, Lisbon, 2 vols., 1960–2; Chicó, Mário, *A arquitectura em Portugal na época de d. Manuel e nos princípios do reinado de d. João III*, 'História da arte em Portugal', Oporto, vol. 2, 1948, chapter 5; Chicó, Mário, and Novaes, Mário, *O gótico em Portugal*, Lisbon, 1957; França, José-Augusto, *Une ville de lumières: la Lisbonne de Pombal*, Paris, 1965; Pires, António Caldeira, *História do palácio nacional de Queluz*, Coimbra, 2 vols., 1924–6; Prado, Frei João de S. Joseph do, *Monumento sacro da fabrica, e solemnissima sagração da santa basilica do real convento ... de Mafra*, Lisbon, 1751; Santos, Reynaldo dos, *A arquitectura barroca e as suas origens*, 'História da arte em Portugal', Oporto, vol. 3, 1953, chapter 1; *O estilo manuelino*, Lisbon, 1952; *Plantas e desenhos barrocos*, 'Belas Artes', no. 2, 1950, pp. 58–62; *O estilo pombalino e o neoclassicismo*, 'História da arte em Portugal', Oporto, vol. 3, 1953, chapter 5; Smith, Robert C., *A igreja de S. Bento da Vitória à luz dos 'Estados' de Tibães*, Oporto, 1968; *João Frederico Ludovice, an eighteenth century architect in Portugal*, 'Art bulletin', vol. XVIII, no. 3, Sept. 1936. pp. 273–370; *Nicolau Nasoni, arquitecto do Porto*, Oporto, 1967; Taylor, René, *John Carr e o hospital de Santo António do Porto*, 'Belas Artes', no. 15, 1960, pp. 13–31; Viterbo, Francisco Marques de Sousa, and Almeida, R. Vicente de, *A capella de S. João Baptista erecta na egreja de S. Roque*, Lisbon, 1900.

Chapter 2

FOOTNOTES

1 *(page 130) Italy, Spain and Portugal*, New York, 1848, part 2, pp. 211–15. This was in June, 1795.

2 *(page 130) A talha em Portugal*, Lisbon, 1963, chapter 5.

3 *(page 131) Perspectiva pictorum et architectorum*, Rome, 2 vols., 1693–1700.

4 *(page 132) Livro de rezam do irmão fr. Jozé de Santo Antonio Villaça natural de Braga do terreiro de S. Lazaro* (Braga, Arquivo Distrital e Biblioteca Pública, Tibães, no. 728).

5 *(page 153)* Oporto, Arquivo Distrital, P8, N401, fls. 63v.–65.

6 *(page 154) Nuove invenzioni*, Rome, 1698.

BIBLIOGRAPHY

Brandão, Domingos de Pinho, and Smith, Robert C., *Alguns retábulos e painéis de igrejas e capelas do Porto*, Oporto, 1963; Carvalho, Ayres de, *Novas revelações para a história do barroco em Portugal*, 'Belas Artes', no. 20, 1964, pp. 29–81; Peres, Damião, *A escultura em madeira no século XVI*, 'História da arte em Portugal', Oporto, vol. 2, 1948, chap. 9; Santos, Reynaldo dos, *A escultura em Portugal*, Lisbon, vol. 2, 1950; *A talha barroca dos altares*, 'Oito séculos de arte portuguesa', Lisbon, vol. 2, 1965–6, pp. 249–88; Smith, Robert C., *A talha em Portugal*, Lisbon, 1963.

Chapter 3

FOOTNOTES

1 *(page 158)* Luís Reis Santos, *Jacques Loquin escultor francês do século XVI em Portugal*, 'Belas Artes', nos. 13–14, 1959, pp. 27–38.

2 *(page 160) Oito séculos de arte portuguesa*, Lisbon, vol. 1, 1963, p. 333.

3 *(page 161) Art and architecture in Spain and Portugal and their American dominions, 1500 to 1800*, Harmondsworth, 1959, p. 187.

4 *(page 161)* Robert C. Smith, *Alguns artistas que trabalharam para a Venerável ordem terceira de S. Francisco, no Porto*, Oporto, 1965, p. 27.

5 *(page 163) A escultura em Portugal*, Lisbon, vol. 2, 1950, p. 64.

6 *(page 165) Novas revelações para a história do barroco em Portugal*, 'Belas Artes', no. 20, 1964, pp. 29–81.

7 *(page 166) Colecção de memorias relativas ás vidas dos pintores e escultores, arquitectos e gravadores portuguezes, e dos estrangeiros, que estiverão em Portugal*, 2nd ed., Coimbra, 1922, p. 203.

8 *(page 166) Op. cit.*, p. 194.

9 *(page 166) Os escultores José de Almeida e A. Giusti*, 'Belas Artes', no. 19, 1963, pp. 27–38.

10 *(page 167) Descripção analytica da execução da estatua equestre, erigida em Lisboa à gloria do senhor rei fidelissimo d. José I . . .* Lisbon, 1810.

11 *(page 168) Op. cit.*, p. 205.

12 *(page 194) Essai statistique sur le royaume de Portugal et d'Algarve*, Paris, vol. 1, 1822, p. XVII.

BIBLIOGRAPHY

Carvalho, Ayres de, *D. João V e a arte do seu tempo*, Lisbon, vol. 2, 1962; *A escultura em Mafra*, Lisbon, 1950; Feio, Salvador Carvão de Eça Barata, *A escultura de Alcobaça*, Oporto, 1945; Kubler, George, and Soria, Martin, *Art and architecture in Spain and Portugal and their American dominions, 1500 to 1800*, Harmondsworth, 1959, chapter 10; Macedo, Diogo de, *Escultura barroca do século XVII*, 'História da arte em Portugal', Oporto, vol. 3, 1953, chapter 3; *João José de Aguiar*, Lisbon, 1944; *Machado de Castro*, Lisbon, 1958; Pamplona, Fernando de, *Dicionário de pintores e escultores portugueses ou que trabalharam em Portugal*, Lisbon, 4 vols., 1954–9; Peres, Damião, *A escultura no século XVI*, 'História da arte em Portugal', Oporto, vol. 2, 1948, chapter 6; Santos, Reynaldo dos, *A escultura*, 'Oito séculos de arte portuguesa', Lisbon, vol. 1, 1963–4, pp. 242–388; *A escultura em Portugal*, Lisbon, vol. 2, 1950; Smith, Robert C., *Early works of Claude de Laprade and the style Louis XIV in Portugal*, 'Gazette des Beaux-arts', vol. XLIV, Oct. 1954, pp. 163–90; *Frei Cipriano da Cruz, escultor de Tibães*, Oporto, 1968; Sousa, Ernesto de, *Para o estudo da escultura portuguesa*, Lisbon, 1965; Viterbo, Francisco Marques de Sousa, *Notícias de alguns esculptores portugueses ou que exerceram a sua arte em Portugal*, Lisbon, 1900.

Chapter 4

FOOTNOTES

1 *(page 195) Quatro diálogos da pintura antiga*, edited by Joaquim de Vasconcellos, Oporto, 1918, p. 91.

2 *(page 196)* Reynaldo dos Santos, *Nuno Gonçalves*, London, 1955, p. 13.

3 *(page 196)* Reynaldo dos Santos, *As tapeçarias de Arzila*, Lisbon, 1925, pp. 65–6.

4 *(page 197)* Reynaldo dos Santos, *Nuno Gonçalves*, p. 13.

5 *(page 199)* Reynaldo dos Santos, *Oito séculos de arte portuguesa*, Lisbon, vol. 1, 1963–4, p. 84.

6 *(page 201)* Armando Cortesão, *Portugaliae monumenta cartographica*, Lisbon, vol. 3, 1960, p. 23.

7 *(page 202)* Adriano de Gusmão, *Simão Rodrigues e seus colaboradores*, Lisbon, n.d., p. 7.

8 *(page 202)* João Baptista Lavanha, *Viagem da catholica real magestade del rey d. Filipe II*, Madrid, 1622.

9 *(page 205) Últimas acções do duque d. Nuno Álvares Pereira de Melo . . . relação do seu enterro*, Lisbon, 1730 (Robert C. Smith, *Some illustrations by Pierre-Antoine Quillard in Portuguese books*, 'Bulletin of the Fogg Art Museum', vol. VI, no. 1, Nov. 1936, pp. 8–13).

10 *(page 205) O insigne pintor e leal eposo*, Lisbon, 1780.

11 *(page 206)* Robert C. Smith, *Pinturas de ex-votos existentes em Matosinhos e outros santuários portugueses*, Matosinhos, 1966.

12 *(page 206)* He was also the author of four views of gardens at Benfica dated 1785 in the collection of the Musée des Arts-Décoratifs in Paris. There are two rooms painted by an unidentified pupil of Pillement in the palace of Seteais at Sintra.

BIBLIOGRAPHY

General: Kubler, George, and Soria, Martin, *Art and architecture in Spain and Portugal and their American dominions, 1500 to 1800*, Harmondsworth, 1959, chapter 18; Machado, Cirilo Volkmar, *Collecção de memorias relativas ás vidas dos pintores e esculptores, architectos e gravadores portuguezes*, Lisbon, 1823, Coimbra, 1922; Pamplona, Fernando de, *A pintura no século XVI*, 'História da arte em Portugal', Oporto, vol. 2, 1948, chapter 7; Santos, Reynaldo dos, *A pintura*, 'Oito séculos de arte portuguesa', Lisbon, vol. 1, 1963–4, pp. 13–240; Soares, Ernesto, *História da gravura artística em Portugal*, Lisbon, 2 vols., 1940–1; *Dicionário de iconografia portuguesa*, Lisbon, 3 vols., 1947–50; Viterbo, Francisco Marques de Sousa, *Notícias de alguns pintores portuguezes*, Lisbon, 3 vols., 1903–6.

Specialized: Academia Nacional de Belas Artes, *Personagens portuguesas do século XVII, Exposição*, Lisbon, 1942; Carvalho, Ayres de, *Domenico Duprà, 1689–1770*, 'The Connoisseur Year Book', London, 1958, pp. 78–85; Correia, Vergílio, *Sequeira em Roma*, Coimbra, 1923; Cortesão, Armando, *Portugaliae monumenta cartographica*, Lisbon, 6 vols., 1960; Ferrão, Julieta, *Vieira lusitano*, Lisbon, 1956; Gusmão, Adriano de, *Diogo Teixeira e seus colaboradores*, Lisbon, 1955; *Nuno Gonçalves*, Lisbon, 1957; *Simão Rodrigues e seus colaboradores*, Lisbon, n.d.; Holanda, Francisco de, *Os desenhos das antiqualhas que vio Francisco d'Ollanda pintor portugues*, ed. E. Tormo, Madrid, 1940; *Quatro diálogos da pintura antiga*, ed. J. de Vasconcelos, Oporto, 1896; Macedo, Diogo de, *Sequeira*, Lisbon, 1956; Passos, Carlos de, *Vieira portuense*, Porto, 1953; Peres, Damião, *A iluminura*, 'História da arte em Portugal', Oporto, vol. 2, 1948, chapter 10; Pillement, Georges, *Jean Pillement*, Paris, 1945; Santos, Luís Reis, *Estudos de pintura antiga*, Lisbon, 1943; *Gregório Lopes*, Lisbon, 1954; *Josefa d'Óbidos*, Lisbon, 1955; *Obras-primas da pintura flamenga dos séculos XV e XVI em Portugal*, Lisbon, 1953; *Vasco Fernandes*, Lisbon, 1946; Santos, Reynaldo dos, *O livro de horas da rainha d. Leonor de António de Holanda*, 'Belas Artes', nos. 13–14, 1959, pp. 3–6; *Nuno Gonçalves*, London, 1955; *A pintura do período barroco*, 'História da arte em Portugal', Oporto, vol. 3, 1953, chapter 4; *A pintura dos tectos no século XVIII em Portugal*, 'Belas Artes', no. 18, 1962, pp. 13–22; *Os primitivos portugueses*, Lisbon, 1940; *Les principaux manuscrits à peintures conservés au Portugal*, Paris, 1932; *Sequeira y Goya*, Madrid, 1929.

Chapter 5

FOOTNOTES

1 *(page 230) Die Fliesen Spaniens und Portugals*, 'Fliesen', Munich, 1964, pp. 69–70.
2 *(page 232)* João Miguel dos Santos Simões, *op. cit.*, p. 184.
3 *(page 234)* Cruz, António, *Os azulejos da sé*, Oporto, 1947.
4 *(page 236)* Reynaldo dos Santos, *Oito séculos de arte portuguesa*, Lisbon, vol. 3, 1967–8, pp. 10–15.
5 *(page 236)* The best publication on Spanish faience and porcelain is Juan Arnaud de Lasarte, *Cerámica y vidrio*, 'Ars Hispaniae', Madrid, vol. 10, 1952.
6 *(page 236)* Reynaldo dos Santos, *op. cit.*, p. 16.
7 *(page 261) Ibid.*

8 *(page 261)* Arthur Upham Pope, *A survey of Persian art*, London and New York, vol. 2, 1939, pp. 1651–3, pls. 789–94.
9 *(page 261)* See Soame Jenyns, *Ming pottery and porcelain*, London, 1953.
10 *(page 263)* The first successful experiments seem to have been the commemorative medals of Dona Maria I and Dom Pedro III in the museums of Lisbon and Oporto, which were made in 1773 by Gen. Bartolomeu da Costa, who cast in bronze Machado de Castro's equestrian statue of Dom José (plate 136).
11 *(page 263)* Robert C. Smith, *Vista Alegre, Portuguese porcelain of the nineteenth century*, 'Antiques', vol. LXXXVII, no. 4, April 1965, pp. 444–7.
12 *(page 263)* For reproductions of the work of this factory see Leonardo Ginori Lesci, *La porcellana di Doccia*, Milan, 1963.

BIBLIOGRAPHY

Queiroz, José, *Cerâmica portuguesa*, Lisbon, 2 vols., 1907, 1948; Santos, Reynaldo dos, *As artes decorativas*, 'Oito séculos de arte portuguesa', Lisbon, vol. 3, 1967–8, pp. 7–102; *As artes decorativas dos séculos XVII e XVIII – cerâmica e azulejo*, 'História da arte em Portugal', Oporto, vol. 3, 1953, pp. 315–71; *O azulejo em Portugal*, Lisbon, 1949; *A faiança portuguesa, séculos XVI e XVII*, Lisbon, 1960; Simões, João Miguel dos Santos, *Alguns azulejos de Évora*, Évora, 1945; *Os azulejos do paço de Vila Viçosa*, Lisbon, 1946; *Carreaux céramiques hollandais au Portugal et en Espagne*, The Hague, 1959; 'Corpo do azulejo português', no. 1, *Azulejaria portuguesa nos Açores e na Madeira*, Lisbon, 1963; no. 2, *Azulejaria portuguesa no Brasil (1500–1822)*, Lisbon, 1965; *Einfluss niederländischer Fliesen in Portugal und Brasilien, Die Fliesen Spaniens und Portugals*, 'Fliesen', Munich, 1964, pp. 177–94, 65–74; *Iconografia olisiponense em azulejos*, 'Olisipo', vol. XXIV, no. 95, 1961; Smith, Robert C., *A new museum of tiles in Lisbon*, 'Antiques', vol. LXXXIX, no. 6, June 1966, pp. 828–33.

Chapter 6

FOOTNOTES

1 *(page 265)* António Manuel Gonçalves, *A custódia de Belém*, 'Panorama', 1958, p. 2.
2 *(page 268)* Carlos de Passos, *O altar de prata da sé portuense*, 'Revista de Guimarães', 1939, p. 4.
3 *(page 269)* Lisbon, Santa Casa da Misericórdia, *Museu da arte sacra de São Roque*, Lisbon, 1964.
4 *(page 272)* Robert C. Smith, *Alguns artistas que trabalharam para a Venerável ordem terceira de S. Francisco, no Porto*, Oporto, 1965, p. 47.
5 *(page 272) The Wellington plate, the Portuguese service*, London, 1954, p. 9.

BIBLIOGRAPHY

Brandão, Domingos de Pinho, *Trabalhos de Nasoni ainda desconhecidos*, 'Boletim cultural da Câmara municipal do Porto', vol. XXVII, 1964, pp. 118–55; Chicó, Mário, *As artes decorativas em Portugal no século XV – a ourivesaria*, 'História da arte em Portugal', Oporto, vol. 2, 1948, chap. 4; Couto, João, and Gonçalves, António M., *A ourivesaria em*

Portugal, Lisbon, 1960; Lisbon, Museu Nacional de Arte Antiga, *Roteiro da ourivesaria*, Lisbon, 1959; Mendonça, Maria José de, *As artes ornamentais no século XVI*, 'História da arte em Portugal', Oporto, vol. 2, 1948, chap. 8; Oman, Charles, *The Wellington plate, the Portuguese service*, London, 1954; Oporto, Grémio dos Industriais de Ourivesaria do Norte, *Exposição de ourivesaria*, Oporto, 1964; Passos, Carlos de, *O altar de prata da sé portuense*, 'Revista de Guimarães', 1939, p. 4; Santos, Reynaldo dos, *As artes decorativas dos séculos XVII e XVIII – ourivesaria*, 'História da arte em Portugal', Oporto, vol. 3, 1953, pp. 226–315; Santos, Reynaldo dos, and Quilhó, Irene, *Ourivesaria portuguesa nas colecções particulares*, Lisbon, 2 vols., 1959; Smith, Robert C., *Nicolau Nasoni, arquitecto do Porto*, Lisbon, 1967, chap. 10.

Chapter 7

FOOTNOTES

1 *(page 285)* Chapter 2, footnote 4. Much of this furniture is published in Robert C. Smith, *Frà Giuseppe di Sant'Antonio mobiliere benedettino del settecento in Portogallo*, 'Antichità viva', vol. IV, nos. 5–6, 1965, pp. 44–55.
2 *(page 286)* Robert C. Smith, *Samuel Tibau and Portuguese ivory inlaid furniture of the seventeenth century*, 'Revista da Universidade de Coimbra', vol. XXI, 1962, 14 pp.
3 *(page 286)* *Italy, Spain and Portugal*, New York, 1848, part 2, p. 188.
4 *(page 286)* Andrew Ciechonowiecki, *Furniture of Spain and Portugal*, 'World furniture', edited by Helena Hayward, London, 1965, p. 105.
5 *(page 305)* António Caldeira Pires, *História do palácio nacional de Queluz*, Coimbra, vol. 1, 1924, pp. 146–72; Luís Bivar Guerra, *Inventário e sequestro da casa de Aveiro, em 1759*, Lisbon, 1952.
6 *(page 306)* Op. cit., p. 163.

BIBLIOGRAPHY

Cardoso, Augusto Pinto, and Nascimento, J. F. da Silva, *Cadeiras portuguesas*, Lisbon, 1952; Chaves, Luís, *O mobiliário*, 'Arte portuguesa', edited by João Barreira, n. p., n. d., vol. 1, pp. 359–94; Ciechonowiecki, Andrew, *Furniture of Spain and Portugal*, 'World furniture', edited by Helena Hayward, London, 1965, pp. 61–5, 103–6, 160–5, 270–1; Guimarães, Alfredo, and Sardoeira, Albano, *Mobiliário artístico português*, Oporto, 2 vols., 1924–5; Nascimento, J. F. da Silva, *Leitos e camilhas portugueses, subsídios para o seu estudo*, Lisbon, 1950; Sandão, Artur de, *O movel pintado em Portugal*, Oporto, 1966; Santos, Reynaldo dos, *As artes decorativas dos séculos XVII e XVIII – o mobiliário*, 'His-

tória da arte em Portugal', Oporto, vol. 3, 1953, pp. 372–404; Smith, Robert C., *Cadeiras de Portugal*, Lisbon, 1968; *Frà Giuseppe di Sant'Antonio mobiliere benedettino del settecento in Portogallo*, 'Antichità viva', vol. IV, nos. 5–6, 1965, pp. 44–55; *Dated looking glasses in Portuguese sacristies*, 'The Connoisseur', vol. CLXIII, no. 655, Sept. 1966, pp. 34–9; *Portuguese Chippendale chairs*, 'Antiques', vol. LXXXII, no. 1, July 1962, pp. 54–7; *Portuguese church benches of the eighteenth century*, 'The Connoisseur', vol. CLVII, no. 632, Oct. 1964, pp. 130–5; *Portuguese church benches of the eighteenth century, a second look*, 'The Connoisseur', vol. CLXI, no. 647, Jan. 1966, pp. 25–31; *Portuguese church tables*, 'The Connoisseur', vol. CLVII, no. 631, Sept. 1964, pp. 60–5; *Portuguese furniture of the seventeenth century*, I, 'The Connoisseur', vol. CXLIII, no. 577, May 1959, pp. 194–7; II, vol. CXLIII, no. 578, June 1959, pp. 268–71; *Portuguese Hepplewhite and Sheraton chairs*, 'Antiques', vol. LXXXII, no. 2, Aug. 1962, pp. 168–71; *Portuguese painted chairs*, 'Antiques', vol. LXXXIII, no. 6, June 1963, pp. 680–3; *Samuel Tibau and Portuguese ivory inlaid furniture of the seventeenth century*, 'Revista da Universidade de Coimbra', vol. XXI, 1962, 14 pp.

Chapter 8

FOOTNOTES

1 *(page 310)* *Indo-Portuguese embroideries of Bengal*, 'Art and letters; Journal of the Royal India, Pakistan and Ceylon society', vol. XXVI, no. 2, 1952, pp. 65–73.
2 *(page 310)* Ibid.
3 *(page 311)* *Tapetes de Arraiolos*, 'Arte portuguesa', edited by João Barreira, n. p., n. d., vol. 1, p. 302.
4 *(page 311)* *Diccionario geografico de Portugal*, vol. 1, p. 591. Arquivo Nacional da Torre do Tombo.
5 *(page 311)* *Italy, Spain and Portugal*, New York, 1848, part 2, pp. 120–1.
6 *(page 312)* Francisco Marques de Sousa Viterbo, *Artes e artistas em Portugal*, Lisbon, 1920, p. 81.

BIBLIOGRAPHY

Bastos, Carlos, *Arte ornamental dos tecidos*, Oporto, 1954; Cagigal e Silva, Maria Madalena de, *A arte indo-portuguesa*, Lisbon, 1966; Mendonça, Maria José de, *As artes ornamentais no século XVI*, 'História da arte em Portugal', Oporto, vol. 2, 1948, pp. 415–17; *Tapetes de Arraiolos*, 'Arte portuguesa', vol. 1, pp. 265–320; Moura, Maria Clementina Carneiro de, *Colchas de Castelo-Branco*, 'Arte portuguesa', vol. 2, pp. 217–84; Santos, Reynaldo dos, *As artes decorativas dos séculos XVII e XVIII*, 'História da arte em Portugal', Oporto, vol. 3, 1953, pp. 404–33.

Index

Figures in *italics* refer to plates